Contents

Aby Warburg and the Image in Motion

Frontispiece: Silhouette of Aby Warburg, cut out
and pasted on panel, around 1925.

Aby Warburg
and the Image in Motion

Philippe-Alain Michaud

Translated by Sophie Hawkes

ZONE BOOKS · NEW YORK

2007

© 2004 Urzone, Inc.
ZONE BOOKS
1226 Prospect Ave
Brooklyn, New York 11218

Originally published as *Aby Warburg et l'image en mouvement*
© 1998 Editions Macula.

Printed in the United States of America.

Distributed by The MIT Press,
Cambridge, Massachusetts, and London, England

Library of Congress Cataloging-in-Publication Data

Michaud, Philippe-Alain
 [Aby Warburg et l'image in motion]
 Aby Warburg and the Image in Motion / by Philippe-Alain
Michaud.
 p. cm.
Includes bibliographical references and index.
ISBN 978-1-890951-40-5 (pbk.)
1. Warburg, Aby, 1866–1929 — Criticism and interpretation.
2. Art — Historiography. 3. Motion in art. I. Title.

N7483.W36M4313 2003
709'.2 — dc21 2003042263

Knowledge: Movement

(The Man Who Spoke to Butterflies)

Aby Warburg's thought continues to set art history in motion. Or in *movements*, to be more exact, since he endlessly opened up and multiplied the objects of analysis, interpretative options, method-ological demands, and philosophical stakes. To set into motion, to open up, to multiply: Warburg's thought has not simplified life for art historians. If one really listens to it, it creates tension in the discipline — a fertile tension, to be sure, as witnessed in the re-newed interest, particularly in Germany, in Warburg's work and the lessons it affords.[1]

The situation in France is less favorable, even aside from the linguistic difference. On the one hand, the disciples of Henri Focillon have exhibited a certain antipathy to the fundamentally problematic and, truth be known, philosophical aspect of War-burg's thought.[2] Focillon himself wrote a whole book whose title included the word "survival" without recognizing — without knowing? — that such a concept in art history was first elaborated, worked out, and refined by Warburg in a work entirely devoted to the "afterlife" (*Nachleben*) of Antiquity.[3] After Focillon, André Chastel described the bacchic movements of Florentine art and Botticelli's nymphs without ever mentioning Warburg's funda-mental notion of the *Pathosformel*, or "pathos formula," with

which the German scholar — as one will read throughout this work — completely recast the question of gesture and movement in Renaissance art, on the basis of the art of Botticelli, nymphs, and the Dionysian.[4]

Structuralism's interest in theoretical problems, on the other hand, became polarized around the more systematic — and at first glance more operative — thought of Erwin Panofsky. Warburg was the true founder of the iconological discipline — although the discipline has tended to evoke Panofsky's name as its founding father.[5] In a history where the founder is no longer legitimate — and therefore tends to slide into oblivion, if not suppression — the theoretical questioning encouraged by the "pilot" disciplines of sociology and semiology would also reach an impasse on Warburg's founding role with regard to positions these disciplines recognize as central to their very existence. Thus could Pierre Francastel describe and carefully analyze the "figurative reality" of the relationships between painting and living spectacles in the Renaissance without being aware that Warburg had introduced this very analysis as early as 1893, in a study on Botticelli, and had developed it in particular in the *princeps* study — published in Italian — on the theatrical costumes of the Florentine Intermedi of 1589.[6]

Thus we have inherited a paradoxical situation with regard to this work. Warburg set art history "in motion" in a manner that no one would question: that is, he was the modern founder of the cardinal discipline called "iconology." But the fact that not all of his work has been translated and published in English, the language in which most of the work in this discipline takes place today, leads one to suspect that the word "iconology" no longer means, after Panofsky, in the Anglo-Saxon context of the "social history of art" what it meant to Warburg in the Germanic context of *Kulturwissenschaft*.[7] There is no doubt that the name Warburg

8

inspires in any art historian the respect due to the founder of a discipline. But respect, which I call "reference-reverence," is not enough to indicate assent. Often, in fact, it ends up — or facilitates — immobilizing and stopping movement. It is used to create a distance: either by considering the concepts of *Nachleben* and *Pathos-formel* as commonplaces, empty formulas, or generalities lacking theoretical substance; or by deciding that in the age of postmodernism these expressions have become outworn, archaic, passé. In either case, one would avoid problematizing Warburg's inventiveness as such, even though his inventiveness still needs to be thought out, "reworked" in its own movement.[8]

This is the first book on Warburg to be written in French. Its author, significantly, does not have a conventional career in art history.[9] His central interests — inasmuch as the idea of "center" has any currency in a problematic of displacement — extend from the byzantine quarrel over images in contemporary experimental cinema. What historians generally find reassuring about Warburg — his erudition, his use of textual sources and archives, his prosopography, and so on — holds our author's interest less than the idea of *movement*, movement conceived of both as object and method, as syntagma and paradigm, as a characteristic of works of art and a stake in a field of knowledge claiming to have something to say. Not that Warburg's erudite research is ignored in this book. But it is put into perspective; more precisely, it is recounted like a journey. And it is a strange journey, in truth, whose logic seems to follow less a linear narration than a "montage of attractions," to use an expression dear to Eisenstein.[10]

This book is first and foremost a journey toward the *image of motion*, that moment in 1893 when Warburg, in formulating his first theories on the "survival" of gestural expressions from Antiquity, published his first essay on Botticelli's *Birth of Venus* and

Spring. It then became a journey toward *image-motion* — and here I purposely use an expression from Gilles Deleuze, which seems to me to come up here and there in Philippe-Alain Michaud's work — when, in 1895, Warburg converted his historical quest into a geographical and ethnological displacement to the sierras of New Mexico, which culminated for him in the serpent ritual, in which, I imagine, the marmoreal contortions of the *Laocoön* of Antiquity writhed and *came alive* for him.[11] A third journey shows us what art history — in Hamburg, where the scholar established his famous institute — could become after that: a *knowledge-movement* of images, a knowledge in extensions, in associative relationships, in ever renewed montages, and no longer knowledge in straight lines, in a confined corpus, in stabilized typologies. Warburg's organic conception of his library, his iconographic archive — as seen in the extraordinary montages of his atlas *Mnemosyne* (figure 1) — is enough to show us the extent to which *setting into motion* constituted an essential part of his so-called method.

This essential part was likewise a cursed part.[12] Michaud has no position to protect in the cushy halls of academia; therefore, his work can treat this "cursed" part with the carefree attitude of a child at play: a Nietzschean gesture. But what is at issue here? Something that, I believe, does much to explain the ambivalence with which Warburg continues to be "respected" yet held at a distance as the founder of the iconological discipline. In this respect, Warburg did in fact "set art history in motion," but he did something more than that, something even worse. First of all, he "set in motion" the disciplinary framework of knowledge he helped to found — exceeding it from the start. By this, I don't mean only his considerable extension of *Kulturwissenschaft*.[13] Nor am I speaking only of the philosophical dimension that academic art history today sloughs off by creating a separate category for "theorists of art." I mean precisely the "montage of attractions" that his work

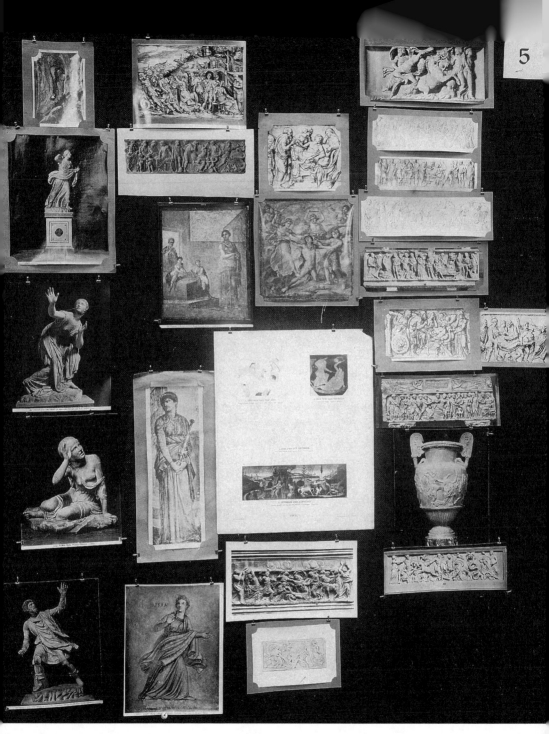

Figure 1. *Mnemosyne*, pl. 5. In *Mnemosyne*,
the atlas he started working on in 1923,
Warburg sought to create "an art history without
a text."

brings into play on every level. The originality of Michaud's point of view — in an art history turned toward cinema as the most pertinent way to understand the temporality of images, their movements, their "survivals," their capacity for animation — certainly does not lack epistemological and historical foundations. It has often been noted the extent to which the photographic apparatus — two slides projected side by side to allow for the minimum "montage" necessary for their comparison — helped to illustrate, if not establish outright, Heinrich Wölfflin's famous stylistic polarities.[14] From now on, according to the perspective presented in Michaud's book, we shall have to imagine what art history might become, with Warburg, in the age of its reproduction *in motion*.

But that is not all. In order to set art history in motion, Warburg's thought experimented with, even tested, this mobilization *on itself*. *To exceed* the epistemological framework of the traditional discipline was *to gain access* to a world open to multiple extraordinary relationships, dangerous even to consider: the nymph with the serpent (femininity, bestiality), painting with dance (represented movement, executed movement), Medici Florence with Native American New Mexico (historical past, present-day origins), and so on. This *excess* no less than this *access* contains something dangerous, something I would call *symptomatic*. It is dangerous for history itself, for its practice and for its temporal models: for the symptom diffracts history, *unsettling* it to some degree, since it is in itself a conjunction, a collision of heterogeneous temporalities (time of the structure and time of the rending of the structure).[15]

To invent a *knowledge-montage* in art history meant to renounce evolutionary — and teleological — schemata in place since Vasari. Warburg decisively "montaged" Giotto alongside Ghirlandaio without going into "influences" or the artistic "progress" from the

one to the other.[16] To create a *knowledge-montage* was therefore to reject the matrices of intelligibility, to break through the age-old guardrails. This movement, with its new "allure" of knowledge, created the possibility of vertigo. Even today, one need only browse through the shelves of the Warburg Library to feel — in an attenuated fashion, since we have but the result of a virtually endless process — the sort of vertigo that Fritz Saxl well knew how to prolong: The image is not a closed field of knowledge; it is a whirling, centrifugal field. It is not a "field of knowledge" like any other; it is a movement demanding all the anthropological aspects of being and time.

Warburg's excess — the strong, well-grounded exigency of an anthropology of the visual — would therefore be seen to carry the vertiginous possibility of a "montage of attractions" within itself, a possibility that is as dangerous as it is fecund. The horizon of the cinema does not unfold here without a horizon of a *loss of self*: the loss of academic self-referentiality, philosophical risk, the pathos of the thought, in short, the illness of the soul. What distances today's "positivist" art history from this founding moment is that Warburg was not content to discover the return of a *pathos in motion* in the works in question; he surrendered himself to the pathos of movement he invented. We can certainly preserve — and with good reason — this man's archive. But what to make of the *vertigo* of the archive? In the midst of all this "confused erudition," as Warburg called his own writing, how are we to find a path, to recover the "timbre of those unheard voices" (*Klangfarben*) that have been silent for so long?[17] And how not to lose ourselves in this quest?

Thus before Panofsky reassured his readers of the status of "art history as a humanist discipline" — a status illustrated by the figure of a Kant capable of transcending his own physical decrepitude by his ethos — Warburg surrendered himself to the risk of a

complete loss of self, to the image of Nietzsche throwing himself around a horse's neck.[18] The question, it becomes clear, is one of *pathos* and even, if one dares, of *pathology*: Is art history prepared to recognize the *founding* position of someone who spent almost five years in a mental institution between "paranoid fantasies" and "psychomotor agitations"? Someone who "spoke to butterflies" for long hours on end and whom the doctor — none other than Ludwig Binswanger — had no hope of curing?[19]

Must one therefore speak of Warburg's art history as a "pathological discipline"? Let us admit that Warburg produced the cursed part from the start — the Nietzschean, symptomatic part of this "humanist discipline" he contributed to founding — leaving his disciple Panofsky the more commendable, and in a way more efficacious, task of producing the triumphant, positive, neo-Kantian part, dispensing answers (and perhaps thereby forgetting a few principal questions along the way).[20] Warburg, for his part, never ceased to rethink the questions, and this caused him to rework the whole body of his thought each time, reorganizing it, opening it up to new fields. The positivists, the lovers of the closed corpus, derisively called this "flitting about." One might say that Warburg never managed — or wanted — to cure himself of his images. Was not speaking to butterflies for hours on end the definitive way of questioning the image as such, the living image, the *image-fluttering* that a naturalist's pin would only kill? Was it not to recover, through the survival of an ancient symbol for Psyche, the *psychic* knot of the nymph, her dance, her flight, her desire, her *aura*?[21] And how not to recognize, in this fascination with butterflies, the complicity of the metaphoric insect with the notion of the image itself?[22]

Is Warburg's art history a "pathological discipline"? We shouldn't dwell on the controversial aspect of this idea. Instead, we should

try to understand the lessons offered by the word "pathology" itself, above and beyond its usual meaning, which is clinical and medical, disdainful and pitying. In "pathology," one finds first of all the word "pathos." Warburg entered art history through the door of the "renaissance — or survival — of Antiquity," just as Nietzsche entered philosophy through the door of the "birth — and survival — of tragedy." In both cases, one finds Dionysus confronting Apollo, pathos confronting ethos. In this respect, Warburg's art history, from the early studies on Botticelli onward, was a *pathology* understood as *an archaeological science of the pathos of Antiquity* and its fate in the Italian and Flemish Renaissance.[23]

This is why the concept of the *Pathosformel* — the "pathos formula" — appeared so crucial in this art history in the process of re-creating itself. On the one hand, the *Pathosformel* gave the fifteenth-century Renaissance back its original pathetic violence (one has only to think of the Christian "maenads" of Donatello, for example[24]), as well as its essentially hybrid character (Donatello again, then Mantegna, Pollaiuolo...), in such a way that the chronological and almost "degenerative" notions of Mannerism or the Baroque could be seriously reconsidered.[25] Meanwhile, in symmetrical fashion, the notion of classicism was suddenly deprived of the "tranquil grandeur" that had reassured so many aesthetes since Winckelmann.[26] It was precisely its *impurity* that allowed Warburg to consider the "pathos formula" at work in Dürer as *classical*, or as "archaeologically faithful" to Antiquity.[27]

On the other hand, the *Pathosformel* gave art history access to a fundamental anthropological dimension — that of the *symptom*. Here the *symptom* is understood as *movement in bodies*, a movement that fascinated Warburg not only because he considered it "passionate agitation" but also because he judged it an "external prompting."[28] Gertrud Bing rendered the meaning of Warburg's quest perfectly when she stated that the *Pathosformeln* are meant

15

to be considered as visible expressions of *psychic* states that had become fossilized, so to speak, in the images.[29] Here it is possible to think of the iconography of hysteria as Charcot might have re-created it by following the same threads of a history of styles.[30] But Warburg went beyond the "iconographic" notion of the symptom found in nineteenth-century mental hospitals. He understood that symptoms are not "signs" (the *sēmeia* of classical medicine) and that their temporalities, their clusters of instants and dura-tions, their mysterious survivals, presuppose something like an *unconscious memory*.[31]

Therefore, one must look — beyond Eduard von Hartmann's *Philosophie des Unbewussten* of 1869 or Samuel Butler's *Unconscious Memory* of 1880 — to Freud to understand the metaphysical foun-dations of the "psychohistory" asserted by Warburg. Most likely the Freudian concept of the symptom as a *moving fossil* accounts for Warburg's pathos formula and its distinct temporality of ob-livion and returns from oblivion, its whirlwinds and anachro-nisms.[32] Warburg's nymph, it seems to me, crosses the threshold from Charcot's simple "passionate attitude" to the archaeological density carried in the gossamer folds of Gradiva's dress (figure 2).

In *The Image in Motion*, which Michaud presents as a royal path to understanding Warburg's *Pathosformeln* — via Etienne-Jules Marey and William Kennedy Laurie Dickson — the "motion" is not a simple conveyance or narration from one point to another.[33] It includes jumps, cuts, montages, harrowing connections. Repeti-tions and differences: moments when the work of memory be-comes corporeal, becomes a symptom in the continuity of events. Warburg's thought sets art history in motion because the move-ment it opens up comprises things that are *at once* archaeological (fossils, survivals) and current (gestures, experiences).

This fundamental *anachronism* is thus what we must consider in Warburg today. Michaud is quite right to place the "aphasic"

Figure 2. Freud's study, Vienna, 1938.
On the right, plaster cast of Gradiva, Greek or
Roman bas-relief. Photographed by Edmund
Engelman.

and anachronistic montage of *Mnemosyne* — in which postage stamps are found next to classical bas-reliefs — on the same epistemological plane as Warburg's initiatory journey to New Mexico. In both cases, it is a matter not only of *incarnating the survivals* but also of creating a "living" reciprocity between the act of knowing and the object of knowledge. Michaud cites the unpublished text Warburg devoted to the relationship between the "spectator" and "movement."[34] Even though the art historian did not complete this work, one understands that he is content to describe, and even to explain, the facts. Producing new documents by recopying the Florentine archives is not enough to restore the "timbre of those unheard voices" coming from the images. For this the scholar must set himself in motion, displace his body and his point of view, proceed to a sort of transfer by which the "timbre of those unheard voices" — and, one might also say, paraphrasing Walter Benjamin, the *unconscious vision* — would be suddenly revealed.

It is perhaps for this reason that Warburg spoke to butterflies. It is perhaps in this sense that he *listened* to them. Art history as "pathological discipline" is nothing other than a history of art capable of assuming the disturbing paradox that comes over the subject of knowledge when confronted with phenomena indicative of the symptom. One cannot *know* the symptom — the pathos of Antiquity, the unconscious gesture of the nymph — without *comprehending* it. Comprehending it? "To comprehend" means *to take with*. Henri Maldiney, after Freud and Binswanger, relates this sort of knowledge to the *patheï mathos*, the "pathic dimension" of understanding, once sung in Greek tragedies.[35] Isn't there a tragic dimension, or at least a trial dimension — *patheï mathos*: to immerse oneself in a trial and to draw therefrom a grounded understanding — in the "parentheses" that Warburg's travels to New Mexico seem to have constituted? One must not forget that

beyond the pleasures of exoticism, it was through similar paren-
theses or experiments with otherness that certain modern prac-
tices were created and re-created in the twentieth century. It
seems to me significant that Antonin Artaud could write, about
the same Indian New Mexico, a phrase that Warburg would cer-
tainly not have disavowed in 1895: "In chaos I take my first step
toward designating all the larval possibilities that once made up
culture."[36]

Georges Didi-Huberman

Acknowledgments

The idea for this work originated in 1992 during a seminar on the Ghirlandaio frescoes at Santa Trinita given by Georges Didi-Huberman at the Ecole des Hautes Etudes. Nicholas Mann, director of the Warburg Institute, generously allowed me to consult Warburg's personal archives. Without his assent, this research could not have been properly carried out. Also at the Warburg Institute, Anne Marie Meyer kindly deciphered Warburg's manuscript notes for me. Elizabeth McGrath oriented me in my iconographic research, and Benedetta Cestelli Guidi provided me with a lot of precious information on the photographs Warburg took in New Mexico and Arizona. Philippe Morel gave me the documents on the Intermedi of 1589, while Jean-Claude Lebensztejn played me the music from them. Laurent Mannoni lit my lantern on several points in the history of pre-cinema, while Jeff Guess printed most of the photographs for this book.

Many thanks as well to Jacques Aumont, Michel Frizot, Jean Lacoste, Michel Jullien, Ginette Morel, Matthias Waschek, Dorothea McEwan, Giovanni Careri, Philippe Sénéchal, and Nicole Brenez.

I would like to express my profound gratitude to all those in New York and Toronto who worked on the American version of

this book: Jeanine Herman for her research; Amy Griffin for indexing; Nancy Evans for proofreading; Ingrid Sterner for copyediting; Meighan Gale, the managing editor; Julie Fry and Sarah Dorkenwald at Bruce Mau Design; Richard Hunt at Archetype; Jeff Fort for translating Warburg's texts from German; Sophie Hawkes for translating this book from French; and Jonathan Crary, whose research has illuminated many of the ideas in this book and to whom I am indebted for the book's publication in English.

Finally, I would like to dedicate this book to Jean Clay.

Chronology

1866 Birth of Aby Warburg in Hamburg into a powerful family of bankers living in the Hanseatic capital since the seventeenth century. Aby is the oldest of seven children.

1879 According to family legend, Aby cedes his birthright as the eldest to his younger brother Max for the promise that for the rest of Aby's life, Max will buy him all the books he wants.

1886 Aby studies history, art history, and psychology at the University of Bonn with Carl Justi, Hermann Usener, and Karl Lamprecht.

1888 Spends time in Florence. August Schmarsow initiates him to the analysis of figures in motion.

1889 Warburg follows the teachings of Hubert Janitschek and comes into contact with the Viennese School of art history.

1891 Briefly studies medicine in Berlin.

1892 Military service in the cavalry in Karlsruhe.

1893 Publishes "Sandro Botticelli's *Birth of Venus* and *Spring*: An Examination of the Concepts of Antiquity in the Italian Early Renaissance."

1893–1895 Lives in Florence.

1895 Publishes "The Theatrical Costumes for the Intermedi of 1589: Bernardo Buontalenti's Designs and the Ledger of Emilio de' Cavalieri" (in Italian).

1895–1896 Travels to America, visits New Mexico and Arizona, and studies Hopi Indian ritual.

1897–1899 Studies in London and Paris.

1897 Marries Mary Hertz, painter and sculptor from a powerful Protestant bourgeois family of Hamburg.

1898 They move to Florence.

1902 Publishes "The Art of Portraiture and the Florentine Bourgeoisie" and "Flemish Art and the Florentine Early Renaissance."

1904 Return to Hamburg.

1908 Warburg studies the history of astronomy and astrology in Rome in the Vatican Library.

1908–1909 Research in Greek and Arab history of astronomy, under the influence of Franz Boll.

1909 Warburg moves to 116 Heilwigstrasse in Hamburg. He would live there for the rest of his life. His library includes nine thousand books.

1911 The library expands to fifteen thousand books.

1912 Lectures on "Italian Art and International Astrology in the Palazzo Schifanoia, Ferrara," at the International Art History Congress in Rome.

1913 Fritz Saxl becomes Warburg's assistant.

1914–1918 During the war, Warburg abandons his historical research in order to focus on current news, seeking to amass in his library all information on the progress of the conflict. He works on his essay "Pagan-Antique Prophecy in Words and Images in the Age of Luther."

1918–1924 Suffering from serious mental disorders, Warburg spends time in several clinics before being institutionalized in Kreuzlingen, in Switzerland, where he is treated by Ludwig Binswanger.

1919 At the request of the Warburg family, Saxl takes over direction of the library, which he turns into a research institute.

1920 Saxl inaugurates the publication of *Vorträge der Bibliothek Warburg* (nine volumes published between 1921 and 1931) and *Studien der Bibliothek Warburg* (twenty-one volumes published between 1922 and 1932), which includes contributions by Ernst Gombrich (philosophy), Gustav Pauli and Erwin Panofsky (art history), Karl Reinhardt (classical philology), Richard Salomon (Byzantinology), and Helmut Richter (Eastern languages). The library includes twenty thousand books.

1921 Panofsky's first seminar at the Warburg Library.

1923 Lecture at Kreuzlingen on the serpent ritual (*Schlangenritual*), in which Warburg recapitulates his journey to New Mexico twenty-seven years earlier, making it a fundamental wellspring for his development as an art historian.

1924 Warburg returns to Hamburg.

1925 The architect Gerhard Langmaack constructs, according to plans drawn up by Fritz Schumacher, a new library adjoined to the family house, at 116 Heilwigstrasse. The library contains more than forty-five thousand books.

1925–1929 Warburg holds a seminar on art history at the University of Hamburg, in the new building of the Kunstwissenschaftliche Bibliothek Warburg (K.B.W.).

1926 Seminar on Jacob Burckhardt.

1928–1929 Trip to Italy. Presentation at the Biblioteca Hertziana in Rome of an art history project without a text, an atlas of images that Warburg names *Mnemosyne*.

1929 Warburg dies of a heart attack in Hamburg.

1932 Teubner publishes the first two volumes of *Gesammelte Schriften*, in Leipzig, edited by Fritz Saxl and Gertrud Bing.

1933 The Warburg Library, now boasting sixty thousand books, moves to London.

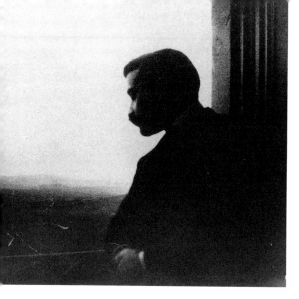

Figure 3. Portrait of Aby Warburg,
Florence, around 1893.

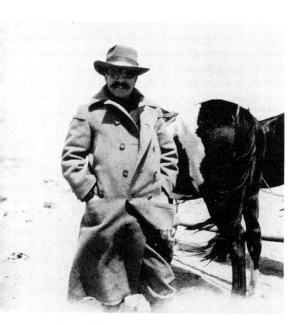

Figure 4. Portrait of Aby Warburg,
New Mexico, winter 1895–1896.
Aby Warburg collection.

Introduction

all squeaking
as bats will in a cavern underworld,
all flitting, flitting criss-cross in the dark
if one falls and the rock-hung chain is broken.
So with faint cries the shades trailed.
— *Odyssey* 24.5–9

During the last decade of the nineteenth century, with the work of Aby Warburg, a discrete, solitary, and profound revolution took place in Renaissance studies. Its nature and meaning opened up previously unknown or overlooked categories of thought to art history.

In 1893, in his first published text, "Sandro Botticelli's *Birth of Venus* and *Spring:* An Examination of Concepts of Antiquity in the Italian Early Renaissance," Warburg tackled the age-old question of the Renaissance artists' return to and interpretation of Antiquity, giving it a paradoxical twist.[1] In treating the presence of mythological figures in Florentine painting, he focused on how these artists represented movement. He argued that it was not the motionless, well-balanced body that served as the model for the imitation of Antiquity, as in Winckelmann's view of art history,

27

but rather the body caught up in a play of overwhelming forces, limbs twisting in struggle or in the grips of pain, hair flowing, and garments blown back through exertion or by the wind. In his *Reflections on the Imitation of Greek Works in Painting and Sculpture*, Winckelmann had formulated an idea in 1755 that was still canonical in art history at the time of Warburg's first endeavors:

> The general and most distinctive characteristics of the Greek masterpieces are, finally, a noble simplicity and quiet grandeur, both in posture and expression. Just as the depths of the sea always remain calm however much the surface may rage, so does the expression of the figures of the Greeks reveal a great and composed soul even in the midst of passion.[2]

By placing the emphasis on the phenomena of transition over the treatment of bodies at rest, on what divides the figure over what pulls it together, and on becoming over the motionless form, Warburg reversed the principles of Winckelmann's aesthetics and the artistic hierarchy that grew out of it. He replaced the model of sculpture with that of dance, accentuating the dramatic, temporal aspect of the works. According to Warburg, what Renaissance artists derived from ancient forms was not an association between substance and immobility, a privilege granted the being over the becoming; on the contrary, they recognized in these forms a tension, a questioning of the ideal appearance of bodies in the visible world (figure 5). Their works bear the stamp of a force that is not harmonious but contradictory, a force destabilizing the figure more than pulling it together. In the light of Warburg's interpretation of Renaissance artists, the divine serenity that served as a model of ideal beauty was transformed into bacchantes with convulsive gestures and violent outbursts. In a text published in 1905 devoted to Florentine engraving of the Quattrocento, Warburg wrote:

28

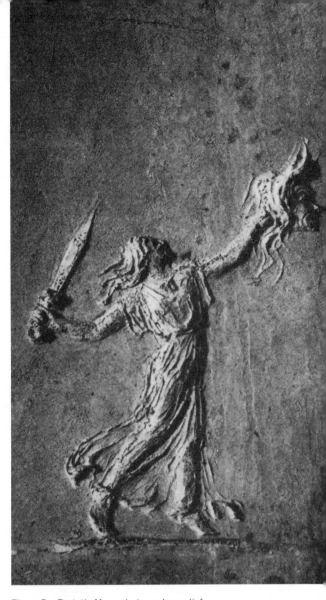

Figure 5. *Ecstatic Maenad*, stucco bas-relief,
first century B.C.E. Underground basilica of
Porta Maggiore, Rome.

It is like ... those dancing maenads, consciously imitated from the antique, who first appeared in the works of Donatello and of Filippo Lippi. Those figures revived the loftier antique style of life in motion, as we find it in the homeward-bound Judith, or in the angelic companion of Tobias, or in the dancing Salome, who emerged on biblical pretexts from the workshops of Pollaiuolo, Verrocchio, Botticelli, and Ghirlandaio.[3]

Nietzsche had formulated the idea of this mutation twenty years earlier when he described the irruption of Dionysian forces within Apollonian equilibrium and symmetry as an ecstatic power within the contemplative conception of the world: from this manifest contradiction was born Attic tragedy, the most complete realization of Greek culture. In fact, *The Birth of Tragedy* opens with the following words:

We shall have gained much for the science of aesthetics, once we perceive not merely by logical inference, but with the immediate certainty of vision, that the continuous development of art is bound up with the *Apollonian* and *Dionysian* duality — just as procreation depends on the duality of the two sexes, involving perpetual strife with only periodically intervening reconciliations.[4]

Warburg intended to make this tension the principle that linked Renaissance artists to the past: beneath the limpid appearance of works of classical Antiquity, these artists laid bare the conflict between two antagonistic powers, at once the source and the condition of these works. Between 1888 and 1905, the art historian began to draft "Grundlegende Bruchstücke zu einer pragmatischen Ausdruckskunde" (Ground-laying fragments for a pragmatic study of expression), in which he proposed to explore how the expressiveness of works is constituted, imagining their

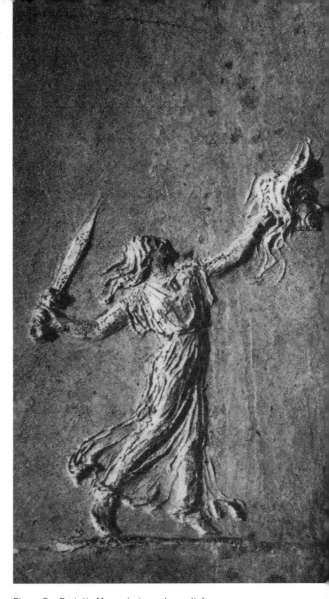

Figure 5. *Ecstatic Maenad*, stucco bas-relief,
first century B.C.E. Underground basilica of
Porta Maggiore, Rome.

It is like ... those dancing maenads, consciously imitated from the antique, who first appeared in the works of Donatello and of Filippo Lippi. Those figures revived the loftier antique style of life in motion, as we find it in the homeward-bound Judith, or in the angelic companion of Tobias, or in the dancing Salome, who emerged on biblical pretexts from the workshops of Pollaiuolo, Verrocchio, Botticelli, and Ghirlandaio.[3]

Nietzsche had formulated the idea of this mutation twenty years earlier when he described the irruption of Dionysian forces within Apollonian equilibrium and symmetry as an ecstatic power within the contemplative conception of the world: from this manifest contradiction was born Attic tragedy, the most complete realization of Greek culture. In fact, *The Birth of Tragedy* opens with the following words:

We shall have gained much for the science of aesthetics, once we perceive not merely by logical inference, but with the immediate certainty of vision, that the continuous development of art is bound up with the *Apollonian* and *Dionysian* duality — just as procreation depends on the duality of the two sexes, involving perpetual strife with only periodically intervening reconciliations.[4]

Warburg intended to make this tension the principle that linked Renaissance artists to the past: beneath the limpid appearance of works of classical Antiquity, these artists laid bare the conflict between two antagonistic powers, at once the source and the condition of these works. Between 1888 and 1905, the art historian began to draft "Grundlegende Bruchstücke zu einer pragmatischen Ausdruckskunde" (Ground-laying fragments for a pragmatic study of expression), in which he proposed to explore how the expressiveness of works is constituted, imagining their

production and reception as an autonomous process, in order to isolate general categories that condition the creative act within any particular determination, be it social, religious, stylistic, or cultural.[5] In this series of notes, one finds, in conceptual form, all the intuitions at work in the published texts, where they remain buried, as if concealed beneath the concerted tangle of historiographical information.[6]

A note drafted on June 2, 1889, when his research on Botticelli was just getting under way, shows that Warburg, a young student, already saw in Renaissance artists' pictorial representation of human features not a univocal manifestation of the sameness of one model but a meeting of more complex forces, more difficult to name, momentarily taking on the guise of the figures themselves: "Artistic activity, when it represents the human figure, is often first of all the pressure of causality reproducing once again the surface of things themselves."[7] The figure is only a veil of illusion cast over reality: in conformity with Nietzsche's lesson, Warburg interpreted Renaissance artists' focus on movement in the works of Antiquity, and the way it compromised a figure's definition, as a questioning of the principle of identity and its representation.

Less than ten years after his first publications on Botticelli, Warburg's research took a different direction, no longer reducible to the categories elaborated by Nietzsche. In 1902, two texts were published simultaneously, one devoted to Ghirlandaio's frescoes in the Sassetti Chapel of Santa Trinita Church in Florence and the other to a series of portraits from the fifteenth-century Flemish school.[8] In these works, the figures were no longer captured at the moment of their modification but depicted in rigorously static poses. The question of movement did not, however, disappear. It became internalized, designating not a body's displacement in space but its transfer into the universe of representation, where it

31

acquired a lasting visibility. Henceforth, for Warburg the question of movement became associated with the subject's entrance into the image, with rites of passage, and with the dramatizations affecting his or her appearance. In his studies on Botticelli, Warburg was trying to elucidate the devices — independently of their significations — by which the artist, by inserting a figure into the picture plane, indicated a change of place. In 1902, the emphasis fell on the process of representation, the ensemble of procedures — no longer technical or formal, but symbolic — by which the subject depicted came to inhabit an image. The analysis of movement in 1893 turned into a study of the animist belief that carried the work of art.

In *The Civilization of the Renaissance in Italy*, Jacob Burckhardt saw the aesthetic transposition of the will to power embodied in unusual individuals as the driving force of Renaissance Florence. He viewed the flowering of the arts in the Quattrocento as the expression of a vital energy seeking to perpetuate itself — outside the dialectical schema of the struggle-to-the-death and domination in images of art — in a more discreet, softer form transfigured by the ideals of a rising humanism. Warburg reworked Burckhardt's intuition, giving it a more radical expression: he aimed not simply to observe and understand the demiurgic fictions, with their magico-religious colorings, that unfolded in the art, but also to *reproduce* them. Warburg replaced the principle of detachment governing the understanding of works with a principle of invention. Research did not simply reflect a theoretical attitude; it had to be imagined as a practice aiming to reactivate its object and experiencing its attraction in turn. Burckhardt considered the Renaissance a repetition of Antiquity, a historical accomplishment of the eternal return. Warburg, going one step further, conceived of the art historian's work as a recurrence of this phenomenon of repetition in the area of knowledge.

Between the studies of 1893 and 1902, a twofold episode took place that sheds light on the strange orientation Warburg gave his work at the turn of the century. In 1895, the historian published a detailed analysis of the Intermedi performed at the Medici court in Florence in 1589, on the occasion of the marriage between the archduke Ferdinand I and Christine of Lorraine, spectacles combining dance, theater, music, and singing (figure 6).[9] Transported a century later in the history of Florentine art, Warburg did not forsake his study of Quattrocento painting. In these ostentatious spectacles, which marked an apogee of Mannerist culture and were of greater methodological than historical interest to him, Warburg recognized a scenographic model for the transformation of the world into representation that he would test in painting in his 1902 studies. The same year his study on the Intermedi appeared, Warburg traveled to America on a trip that was to take him as far as the pueblos of New Mexico and the mesas of Arizona. He witnessed ritual dances in the Indian villages, in which he saw costumed figures acting as intermediaries between men and the powers of nature, seeking to conjure or tame the forces at work in the world through mimetic representation (figure 7). To his eyes, the phenomena he had studied in the Florentine Intermedi reappeared in effective form in the Native American performances as representations of enigmatic forces that borrowed the human form to find expression.

While the Amerindian episode, having been superimposed on the memory of the Mannerist festivities to the point of becoming confused with them, had an immediate effect on his work, it was not until twenty-seven years later that he gave definitive expression to the perceptions proceeding from it. In 1923, in Ludwig Binswanger's clinic in Kreuzlingen, Switzerland, where he was staying, prey to severe mental problems that had kept him confined since the end of the First World War, Warburg summed up

33

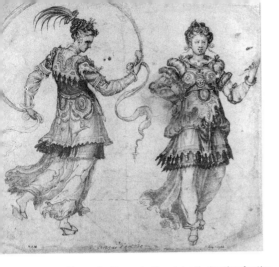

Figure 6. Bernardo Buontalenti, drawing for the Intermedi of 1589. Victoria and Albert Museum, London.

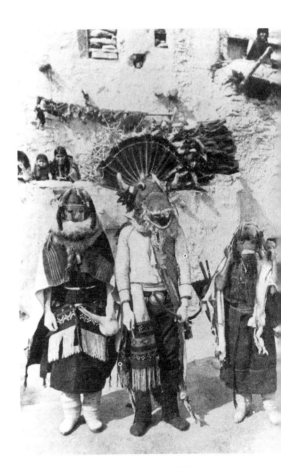

Figure 7. Kachina dancers, around 1897, Arizona. Museum of New Mexico, Santa Fe.

his ethnographic experience in a lecture accompanied by a projection of photographs (some of which he had taken himself during the 1895–1896 trip). In this lecture, he wanted to demonstrate the soundness of his mental faculties; if he chose to return to a trip he had made twenty-seven years earlier, it was because he saw the Native American world as a model for his research and perhaps for the organization of his own thought:

> Their masked dances are not child's play, but rather the primary pagan mode of answering the largest and most pressing questions of the Why of things. In this way the Indian confronts the incomprehensibility of natural processes with his will to comprehension, transforming himself personally into a prime causal agent in the order of things. For the unexplained effect, he instinctively substitutes the cause in its most tangible and visible form.[10]

Warburg's ethnographic research, in light of the Kreuzlingen lecture, seemed like a journey back in time, an exploration of the past by which the Florentine Renaissance could come forth in a clearer light. But this study was also one of introspection, a turning of the subject in upon itself and upon the methods of understanding set into play. "Man is a distant being": Nietzsche's words are not merely a moral precept but also a methodological principle. Warburg understood in 1923 that the experience of otherness is necessary to interpret the familiar, that geographical distance is a metaphor of the past — one that is intimate and personal as much as historical and collective — and that traveling is a technique of anamnesis. The exotic motif, allowing the historian to understand and control the operations he set into play, ceased to be simply the object of research and became its reflection, opening knowledge up to the consciousness of otherness.

At the time of Warburg's trip to New Mexico and Arizona, Native North American cultures were the object of growing attention for researchers (archaeologists, ethnologists, and linguists), as witnessed by the creation of the first ethno-archaeological collections in museums in the United States, and later Europe, and the research and analysis undertaken by anthropologists of the Smithsonian Institution in Washington, DC, and the Field Columbian Museum in Chicago. The transformation of these cultures into objects of knowledge and the desire to preserve their traces were irrefutable signs of their actual disappearance. With the extermination of the last great herds of bison and the colonization of the territories in the West, the "pacification" of Native North Americans had entered its final phase.

During his stay at the Smithsonian Institution, in his conversations with ethnologists and his readings of the *Annual Report of the Bureau of American Ethnology*, Warburg recognized phenomena that would come to shed light on his own field: art history, in becoming aware of time understood as negativity, revealed itself as a means of preservation. Creating an archive conceived as a place for conserving images and for lecturing thus became Warburg's primary activity, while other means of transmission — such as publication and teaching — were relegated to a secondary position.[11]

The theme of preservation overlapped with a formal preoccupation, likewise inspired by an anthropological theme. During his trip to New Mexico and Arizona, while witnessing the ritual performances, Warburg had experienced the profundity of the exchange taking place between a representation and its object. When entering the representation by becoming a figure, the masked dancer charged it with an animistic power, and the art historian understood that the universe of knowledge could avail itself of the same effects. The 1895 trip thus marked his research in a way that was both insistent and subterranean. We find its mark in the

organization of the library that, as of 1902, he began to create systematically. It would be conceived as a place where the researcher would not just preserve traces of the past but resuscitate them artificially by means of the collection and the relationship created between texts and images. The effect of this trip is also felt in the project to which the art historian devoted the last years of his life, after his return from Kreuzlingen, which he called *Mnemosyne* (Memory). In this great montage of photographic reproductions, Warburg substituted the question of the transmission of knowledge with that of its exposition, and organized a network of tensions and anachronisms among the images, thereby indicating the function of otherness and distance in understanding the past (see figures 1, 25, 28, 44, 52, and 91 and appendices 1 and 2).

In 1929, at the time of the signing of the Lateran Treaty, which reconciled the Vatican with the Italian state, a few months before his death, Warburg was in Rome. Struck by the archaic iconographic resonance of the meeting between the pope and Mussolini, he carefully studied, we are told, a newsreel made on this occasion, tirelessly seeking to decode the words coming from the mouth of *Il Duce*, attempting to give voice to this silent effigy. On February 17 he wrote to his wife, Mary, "I was astounded by the pretty Caesarean malice of the play of his lips."[12]

Aside from the Roman anecdote, Warburg's work contains few allusions to cinema. In a late study devoted to Manet's *Déjeuner sur l'herbe*, he referred to the ancient sarcophagi affixed to the gardenside facade of the Villa Medici in Rome "as a film in motion," finding their display to be an important testimony, left by the early Renaissance, of the way in which the world of the pagan gods had been physically preserved.[13] The famous lecture Warburg devoted to the astrological fresco cycle in Ferrara's Palazzo Schifanoia, delivered in Rome in 1912, ended with a strange turn of phrase:

"My fellow students: I need hardly say that this lecture has not been about solving a pictorial riddle for its own sake — especially since it cannot here be illuminated at leisure [*ruhig beleuchten*], but only caught in a cinematographic spotlight [*kinematographisch Scheinwerfen*]."[14] The 1912 lecture was accompanied by a projection of autochromes; since the use of color slides did not come into general use until the 1930s, this gesture demonstrates a very precocious attention to the techniques of artwork reproduction.[15] But the use of slides is not enough to explain the term *kinematographisch*, which seems to designate not a material apparatus of projection but a mental apparatus, a dynamic manner in which to apprehend the works.[16]

The earliest mention of cinema in Warburg's work is in the correspondence, from January through March 1905, between Warburg and Emil Bibo, of the Catero Trading Company, a ceramics specialist from Acoma (a Pueblo site in New Mexico) who sent him films of Native American dances (the matachin dances).[17] In one of these two letters, now in London at the Warburg Institute, Bibo asked Warburg to return the films he had lent him, after selecting the photographs he wanted; he added that his correspondent was welcome to keep the four photographs attached to the reels. It is clear from this letter that Bibo and Warburg saw the reels of film as rolls of photographs before seeing them as objects intended for projection, that is, as spectacle. This hieroglyphic conception of the photograph, according to which the documentary value of the images was not compromised by their indefinite segmentation, is very close to that expressed, more than a half century later, in a theoretical fiction by Hollis Frampton, "A Stipulation of Terms from Maternal Hopi."[18] In this text, the line leading from art history to the cinema via anthropology seems unbroken: the filmmaker and photographer constructed a parable on the invention of cinema by the ancient Hopi, giving the appearance of

scientific reason to his reverie. He imagined the rediscovery of rolls of dried dog intestines divided into regular squares upon which drawings were made, and these projected through a system of multiple refractions on mirrors and bowls filled with water.

Although the question of motion runs through all of his research, Warburg's interest in its mechanical reproduction seems quite marginal. The new Kunstwissenschaftliche Bibliothek, built during the 1920s in Hamburg, next to his family home, was, despite its sophistication, structurally equipped only for the projection of fixed images, not for films. It is nonetheless true that Warburg's method — the application of which ranged progressively from the analysis of static figures in 1893 to the generalized montage in *Mnemosyne*, to which he devoted himself from 1923 — was entirely based on an aesthetic of movement that was expressed at the end of the nineteenth century by the nascent cinema. Warburg opened art history to the observation of bodies in motion at the very moment the first images capable of representing them became diffused. When William Kennedy Laurie Dickson developed a technical procedure making it possible to record and reproduce moving bodies at the Edison Manufacturing Company in New York between 1889 and 1894, he was also constructing a work that would bear upon the appearance and preservation of bodies in images. In this we witness — as, in a similar fashion, in the discipline of art history — a gradual transition from the observation of figures in motion to the animistic reproduction of the living being.

If we relinquish defining the cinematographic apparatus on the basis of material determinations — film as the conjunction of a supple celluloid medium, perforation, and rapid emulsions — and instead consider it, in a more unusual and larger framework, as a conceptual interrelating of transparency, movement, and impression, we will discover, within the field of cinema, the same

39

categories Warburg used in the history of art. In the last decade of the nineteenth century, the filmmaker and the historian apply identical procedures in separate fields that reveal a common orientation. Under the intersecting light of texts and films, a shift occurs in the order of discourse that will lead us to see cinema less as a spectacle than as a form of thought and to see art history as practiced by Warburg as research directed less toward a knowledge of the past than toward its reproduction.

CHAPTER ONE

New York

The Movie Set

The Photography of Motion

When the first daguerreotypes appeared in 1839, commentators immediately focused on this new process's ability to capture reality in all its infinite details. An English observer, Sir John Robison, wrote in the *Edinburgh New Philosophical Journal*: "A crack in plaster, a withered leaf lying on a projecting cornice, or an accumulation of dust in a hollow molding of a distant building, when they exist in the original, are faithfully copied in these wonderful pictures."[1] Through the dizzying effect of enlargement, photography's analytic capacity seemed to extend to the discrete components of objects: the image produced through photographic impression shared not only the appearance of its model but also its intimate structure, its molecular composition.

The same imperceptible passage from seeming to being is found in sixteenth-century descriptions of the camera obscura. When Daniele Barbaro, in his treatise on perspective, described the spectacle inside the darkened chambers, he detailed a world that was intangible and without depth yet endowed with all the marvels of nature:

Close all the shutters and doors until no light enters the *camera* except through the lens, and opposite hold a sheet of paper, which you move forward and backward until the scene appears in all the sharpest detail. There on the paper you will see the whole view as it really is, with its distances, its colors and shadows and motion, the clouds, the water twinkling, the flying birds.[2]

The camera obscura reproduced appearances of the world even as it separated itself from them: it shut itself off to the outside while creating in an enclosed space the illusion of limitless depth. Not only inanimate objects but also living beings were transformed into images in this universe that had been lifted from nature through a cosmological fiction asserting the animistic power of the images, a fiction that seemed to stand the prohibition proclaimed in Deuteronomy on its head:

Take thee therefore good heed unto yourselves ... lest ye corrupt yourselves, and make you a graven image, the similitude of any figure, the likeness of any male or female, the likeness of any beast that is on the earth, the likeness of any fowl that flieth in the air, the likeness of any thing that creepeth on the ground, the likeness of any fish that is in the waters beneath the earth; and lest thou lift up thine eyes unto heaven, and when thou seest the sun, and the moon, and the stars, even all the host of heaven, shouldest be driven to worship them and serve them.[3]

Although the images produced in the camera obscura restored movement and limitlessly expanded the totality of the visible, they were fleeting: without substance, they remained suspended in the manifestation of their model, whose disappearance irrevocably signaled that of the reflection that artificially reconstructed its appearance. The image frozen on the photographic plate, on

42

the other hand, persisted after the disappearance of the object. In this respect, it was condemned to fixity. The chronicler in the *Edinburgh New Philosophical Journal* insisted on the immobility the reproduction imparted to objects, making them appear as though asleep: a crack in the plaster, a dead leaf blown by no wind, accumulated dust. Because the emulsions' low sensitivity required long exposures, one sees a world bereft of movement portrayed in the first photographic attempts, a world abandoned by the living. The shoe shiner and his client on a deserted Parisian boulevard who appear at the bottom left of the frame in a famous 1839 daguerreotype remained immobile long enough for their silhouettes to become imprinted on the plate, long after they had disappeared into the flow of the crowd. The time of the posing suspends and replaces the course of events, as if the impression of the forms were exerted against objective temporality. Photographic hyperaesthesia chased from the scene all that was not made to last (figure 8).

Samuel Morse was in Paris when Daguerre's process was presented to the Academy of Sciences. After participating in a demonstration of the electric telegraph, Daguerre invited Morse to see his photographic plates. In a long letter to his brother, a writer for the *New-York Observer*, which published the letter in 1839, Morse wrote:

> The day before yesterday, the 7th [of March 1839], I called on M. Daguerre, at his room in the Diorama, to see these admirable results. They are produced on a metallic surface, the printed pieces about 7 inches by 5, and they resemble aquatint engravings; for they are in simple chiaro oscuro, and not in colors. But the exquisite minuteness of the delineation cannot be conceived. No painting or engraving ever approached it. For example: In a view up the street, a distant

sign would be perceived, and the eye could just discern that there were lines of letters upon it, but so minute as not to be read with the naked eye. By the assistance of a powerful lens, which magnified fifty times, applied to the delineation, every letter was clearly and distinctly legible, and so also were the minutest breaks and lines in the walls of the buildings; and the pavements of the streets. The effect of the lens upon the picture was in a great degree like that of the telescope in nature.

Objects moving are not impressed. The Boulevard, so constantly filled with a moving throng of pedestrians and carriages, was perfectly solitary, except an individual who was having his boots brushed. His feet were compelled, of course, to be stationary for some time, one being on the box of the boot black, and the other on the ground. Consequently his boots and legs were well defined, but he is without body or head, because these were in motion.[4]

The intensity of the 1839 daguerreotype stemmed not only from its pictorial aspect but also from its composition. The moment he stood still on the boulevard, the man having his shoes shined became divided in two: while the upper part of his body was dissolving, his foot, which has remained in the tangible world, appeared to enter the representation, as if the black cube of the shoe-shine box on which it rested were the *mise-en-abyme* in which the image of the camera obscura was preserved.

Commenting on Daguerre's experiments, the French correspondent for the *Foreign Quarterly Review* also described the phenomenon of blurring produced by motion in the image: "In foliage, he is less successful, the constant motion in the leaves rendering his landscapes confused and unmeaning.... [T]he same objection necessarily applies to all moving objects, which can never be properly delineated *without the aid of memory*."[5] Only after it had fallen to the ground was a leaf available for impression,

when it rejoined the world of inert things. Windblown trees came out blurry on Daguerre's plates because the impression inevitably made their swayings seem simultaneous. Every instant was represented, but they were all represented together: the disappearance of figures was the direct result of the non-disappearance of transitory states. At the same time that its dominion over the world of inorganic objects was revealed, photography revealed its limits: it could give but a frozen section of the curve of a gesture or a displacement, because the gesture or the displacement fell outside the bounds of fixity. Photography, inasmuch as it can render sequences or transitions, remains implicitly subject to the substantialist principle of ancient metaphysics, which presupposes that the object, inclining naturally to rest, appears such as it is when not in motion.[6]

In 1858, William Lake Price announced the imminent unveiling of a process capable of repopulating the desolate perspectives of photographic plates: "Views in distant and picturesque cities will not seem plague-stricken by the deserted aspect of their streets and squares, but will appear alive with the busy throng of their motley population."[7] In 1859, in the first "snapshots" published by Edward Anthony in New York, one really can see living urban scenes, although they are frozen. *Broadway on a Rainy Day* shows Manhattan clogged by automobile and pedestrian traffic: the congestion of the artery extends to the picture plane (figure 9). Between the images of deserted cities taken in 1839 and the urban images of 1859, made possible by a reduction in the time necessary for exposure, thanks to the replacement of collodion bromide with a gelatin emulsion that was ten times more sensitive, moving bodies entered photographs, becoming suspended there. The depiction of movement seemed like an objective contradiction to the first observers of photography: its re-creation on a single surface, where all the successive states of bodies in action were made

45

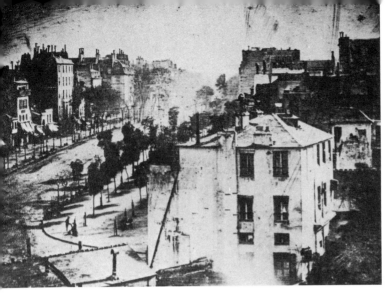

Figure 8. L.-J.-M. Daguerre, *Parisian Street*, around 1839. Bayerische Nationalmuseum, Munich.

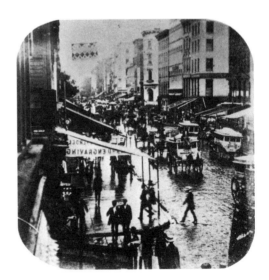

Figure 9. Edward Anthony, *Broadway on a Rainy Day*, 1859. George Eastman House, Rochester.

simultaneous, assumed the ineluctable aspect of a dissolution of the substance photographed, the mass and the contour of the model becoming confused with an amalgam of luminous particles. With the reduced time necessary for the pose, photography fixed the image of a body displacing itself in space by highlighting a finite segment of the curve of its displacement; in capturing the appearance of mobility, not motion, photography had pushed movement out of the medium and gotten rid of it.[8]

The urban landscapes and *vedute* of the first photographs seem as though captured inside an untouchable crystal: their clarity, directly perceived as the counterpart of the disappearance of the human figure, engenders a feeling of morbidity that the acceleration of the process of photographic impression could not begin to combat. With the beginnings of cinematography, the combination of threading and perforated film with the photographic impression, in restituting motion, was perceived figuratively as a symbolic victory over death — flooding both the spectator and the cameraman with very ancient animist reflexes.

"Black Mask and White Eyes Exp Against White Screen": W.K.L. Dickson's Filmed Effigies

> Try to reproduce in copying camera smaller picture
> from larger kinetoscope on collodo albumenized celluloid.
> Make up a stereoscopic illustration of fight to be separate
> from phonograph. Try this
> Get black mask and white eyes Exp against
> white screen.[9]

On June 15, 1889, a press release from the Eastman Company announced the perfection of a procedure of manufacturing film "as thin, light, and flexible as paper, and as transparent as glass,"[10] a technological advance that made the medium of the photographic

47

impression both imponderable and invisible, or a little more unreal. On October 6 of the same year in a suburb of New York, a scene was filmed that its protagonist, William Kennedy Laurie Dickson, Edison's assistant in charge of cinematographic research in the Manufacturing Company, was to describe as the crowning achievement of his first experiments. When Edison, returning from a stay in Europe, entered the Kinetograph Department of the laboratories in West Orange, New Jersey, in room 5 he discovered, on a screen the size of a drawing board, a strange spectacle: "The crowning point of realism was attained on the occasion of Mr Edison's return from the Paris Exposition of 1889, when Mr Dickson himself stepped out on the screen, raised his hat and smiled, while uttering the words of greeting: 'Good morning, Mr Edison, glad to see you back. I hope you are satisfied with the kineto-photograph.'"[11] In fact, it is impossible for a projection to have taken place in 1889, as Dickson suggests, even on a surface as small as a drawing board. In reality, the film must have been running in a small pine box the size of a shoe box, in the upper part of which was a 1-inch hole, fitted with a lens. In 1890, mention was made of a public projection at the Lenox Lyceum in New York, on the corner of Madison Avenue and Fifty-ninth Street, whose "stupefying effects" the correspondent for the *Western Electrician* described in the April 1 edition. But here it was a case of fixed scenes projected by a magic lantern of "almost unimaginable" power, capable of producing figures of such quality that they appeared to be living, active people.

The episode in room 5 was repeated magically on May 20, 1891, when Edison lent "his" invention to the 147 members of the National Federation of Women's Clubs: "As they looked through [the] hole they saw the picture of a man. It was a most marvelous picture. It bowed and smiled and waved its hands and took off its hat with the most perfect naturalness and grace.[12] The small ele-

gantly gesticulating figure was, of course, Dickson, Edison's assistant and paronym.

In a posthumous text devoted to the portrait, published in 1898, the art historian Jacob Burckhardt discovered an indication of the advent of individual portraiture in Florentine painting between the Trecento and the Quattrocento in the painter's newfound desire to represent himself among the figures in his work. According to Filippo Villani, Giotto, who practiced self-portraiture by using a mirror, sprinkled his frescoes in the basilica of Assisi and the church of the Annunciation in Florence, which included effigies of the famous men of his time, with his own likeness.[13] In 1889, the first film created by Dickson in turn took the form of self-portraiture, or self-reflection, according to a phenomenon identical to the one that Burckhardt — and Aby Warburg after him — diagnosed in pre-Renaissance Italian painting as a consequence of the arrival of an individual subject in painting.

Dickson's effigy, presented to Edison's isolated gaze, and later to 147 women at the New York club, is both the model and the agent of a doubling produced between the body and its reflection, of a simultaneous appearance and reduction — a reduction without any loss of definition or compromise of detail in the figure (which was also the case with the effigies of the donors represented at the feet of saints at the dawning of the Renaissance).[14] The cameraman *merges with the object*, as if the true function of the filming were less to reproduce the appearance of bodies than to preserve a trace of them, less to offer it to the gaze of the audience than to sequester it from time. In this light, the restitution of the image in motion would appear as the indefinite repetition of the original event during which the appearances of a subject were captured. By 1889, the supple medium of celluloid, the perforation of the film, and the replacing of dry emulsion with wet collodion had together

made possible transparency, the decomposition of movement, and instantaneous impression. Kodak film proved capable of retaining not only the appearance but also the energy of a moving body concentrated in the unfolding of a simple action taking place in a limited time frame. In this way, cinema produced effects comparable to those that art historians were beginning to notice in painting thanks to the use of photographic reproductions of works and the conclusions drawn from juxtaposing and sequencing them on a single plane.

In its most primitive form, the apparatus for projecting images developed by Dickson (the kinetoscope) was simply a modification of the apparatus used for recording them (the kinetograph): just as the phonograph, through a successive inversion of functions, captured and then gave back sounds, the projection of figures was conceived as a conversion of their recording.[15] The projection room in the Photographic Department of the Edison Manufacturing Company, as described by Dickson, retained traces of this circular process between recording and reproduction, which presupposed that the figures would reemerge from the camera obscura identical to themselves, in the same form in which they were captured. The room was a space covered with black panels to prevent any refraction of the light emanating from the screen, a non-illusionist, unspecified space dedicated not to the imitation of appearances but to the restoration of presence:

> The effect of these sombre draperies and the weird accompanying monotone of the electric motor, attached to the projector, are horribly impressive, and one's sense of the supernatural is heightened when a figure suddenly springs into his path, acting and talking with a vigor which leaves him totally unprepared for its mysterious vanishing.[16]

The instant their images were projected, the figures appeared to emerge from the screen, repeating, inversely, their entrance into the universe of representation. Returning to the episode of 1889, Dickson declared, "The crowning point of realism was attained on the occasion of Mr Edison's return." In Dickson's description, the apparatus in room 5 created, on the contrary, a feeling of unreality; superimposed on a monochrome background devoid of any references, the cameraman's effigy seemed to detach itself from the screen from which he emerged ("Mr Dickson *himself* stepped out *on the screen*"). When the figure steps out of his surroundings, the emphasis is no longer on his displacement in space but on the double event of his manifestation and vanishing. Appearance and disappearance are inextricably intertwined: they are two sides of the same phenomenon. By bursting into the image, the figure demonstrates his exclusion from any context.

In *The Interpretation of Dreams*, published in 1899, Freud, to underscore the strange, unrecognizable aspect of dreams, used the term "hypnagogic hallucination," the quick, changing, and fantastic visual apparitions that present themselves to consciousness when the subject falls asleep. The original film set was not one in which diurnal sensations unfolded; it was more closely related to the oneiric stage in which the figure liberates himself from temporal and spatial determinations.[17]

Before a syncretic style combining different types of representation (mimetic, symbolic, diagrammatic) came to the fore in cinema in 1895, films were based on a system of relationships that proceeded from the figures alone, independently of the place in which they were filmed, as if the latter were purely and simply annulled. The description of the space remained schematic, the field of vision was not clearly delineated, and the black cloth hung at the back of the set manifested not the creation of place but its absence. Similarly, in painting, a monochromatic background

brought out the process of figuration itself rather than the mimetic moment of representation. The appearance of narrative ellipses (which might be called condensations of action), the rejection of figurative amalgams between heterogeneous elements (such as a painted motif and the real object), and the use of illusionistic backgrounds and trompe l'oeil perspectives would mark, before the beginning of the twentieth century, a decisive stage in a unitary and naturalistic conception of the space of representation and in the passage from an unorganized spatiality to a spatiality organized by perspective.[18] Dickson's first films, on the other hand, dealt with the very fact of appearing, the figural properties of filmed bodies, as a moment of initial elucidation that would brutally disappear from the world of commercial cinema but that would leave a lasting mark on the combined fields of scientific and experimental cinematography.

In 1894, the requirements of natural lighting and the lack of a usable set in the Edison Manufacturing Company's Photographic Department made it necessary to construct a building specifically designed for cinematographic experimentation. Dickson filmed for a year in this studio, called the "Black Maria" because its sinister silhouette vaguely suggested that of a police wagon (figure 10). He described the building in which he carried out his experiments as eluding all architectural or functional categorization:

> [The Black Maria] stands in the center of that cluster of auxiliary houses which forms the suburbs of the laboratory, and which is of so peculiar an appearance as to challenge the attention of the most superficial observer. It obeys no architectural rules, it embraces no conventional materials and follows no accepted scheme of color. Its shape, if anything so eccentric can be entitled to that appellation, is an irregular oblong, rising abruptly in the centre, at which point a

movable roof is attached, which can easily be raised or lowered at the will of a single manipulator. Its color is a grim and forbidding black, enlivened by the dull lustre of myriads of metallic points; its materials are paper, covered with pitch and profusely studded with tin nails. With its great sail-like roof and ebon complexion, it has a weird and semi-nautical appearance, like the unwieldy hulk of a medieval pirate-craft or the air-ship of some swart Afrite, and the uncanny effect is not lessened when, at an imperceptible signal, the great building swings slowly around upon a graphited centre, presenting any given angle to the rays of the sun and rendering the apparatus independent of diurnal variations.[19]

When Dickson described the rotation mechanism with which the Black Maria's platform was outfitted, he evoked Nero's Domus Aurea, in which complex and ingenious devices made it possible to domesticate daylight by counterbalancing the sun's course, creating the illusion of suspended time:

> We have been sensible for some time of a disturbance of the ground beneath our feet, and are now aware that the building is slowly and noiselessly rotating on its axis, bringing into our range of vision the glory of the sun-rays westering to their close. Again we are reminded of that indissoluble chain of ideas which links the past with the present, and into the commonplace of existing facts come memories of that chamber in the golden house of Nero so arranged that "by means of skillfully planned machinery it moved on its axis, thus following the motions of the heavens, so that the sun did not appear to change in position, but only to descend and ascend perpendicularly."[20]

Dickson noted the sense of presence, the sensation of relief and proximity produced by the animated images he obtained in this space isolated from the laws of physics. He observed the effect

of three-dimensionality produced by the rotation of the bodies and the familiarity of breathing figures that made their voices heard and that gestured most naturally. The smoothness with which the photographs followed one another and the perfect synchronization of the accompanying phonograph erased any trace of automatism and made the illusion perfect. But this illusion was not that of reality returning to reality through a simple mimetic transposition. Just as he had invented the stage on which they moved, Dickson fashioned, through the use of performers, the filmic beings through which he reproduced the spectacle of the living, starting with a black mask with white eyes against a white background. This, in the early phases of his research, had appeared to him as the first figure of the budding cinema.

The *Edison Kinetoscopic Record of a Sneeze* was one of the first films created in the Black Maria, on January 7, 1894; it has long been considered the first film to be deposited in the Library of Congress as a paper print.[21] It had been commissioned by a journalist named Barnet Phillips to illustrate an article devoted to the kinetoscope that appeared in *Harper's Weekly* on March 24, 1894. The film was published in the magazine as nine strips made up of nine photographs — with each group forming an approximate square, read from top to bottom and from left to right. After numbering the vertical columns and lettering the horizontal columns, the journalist precisely described the modifications on the face of the actor, Fred Ott, during the sneeze, which was provoked by a pinch of snuff breathed up his nostrils (he must have repeated the process several times). The film lasted about two seconds. Phillips divided the recorded photographs into unequal sections: the "priming," the "nascent sensation" and the "first distortion," "expectancy," "pre-meditation," "preparation," "beatitude," "oblivion," "explosion," "recovery" (figure 11).[22]

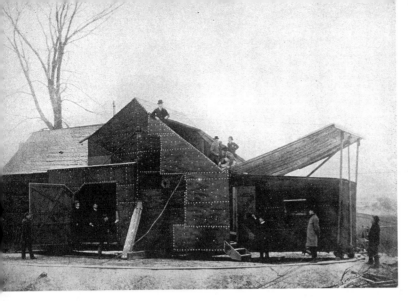

Figure 10. The Black Maria, W.K.L. Dickson's studio, around 1894. From William Kennedy Laurie Dickson and Antonia Dickson, *History of the Kinetograph, Kinetoscope, and Kinetophonograph* (New York, 1895).

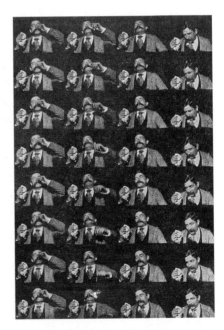

Figure 11. *Edison Kinetoscopic Record of a Sneeze*. From Dickson and Antonia Dickson, *History of the Kinetograph, Kinetoscope, and Kinetophonograph*.

The breakdown and reconstruction of the sneeze in its successive phases show Ott with distorted features, racked by an external force he cannot master: through the expulsion of the breath, the *pneuma*, *Record of a Sneeze* exhibits, in the mythico-trivial register of the nascent cinema, the deployment of vital energy in an ecstatic convulsion.[23] When Dickson, reworking the motif of Ott's sneeze, filmed entwined wrestlers in which one can see "the quick flash of the eye, the tension of the mouth, the dilated nostril and the strong, deep breathing," the point, this time, was to demonstrate that life had been in fact captured in the images, that vital energy was being unleashed through the body and beyond it.[24]

Dickson described the way in which, in his 1894 films, "against the nether gloom" the figures "stand out with the sharp contrast of alabaster basso-relievos on an ebony ground" and the way they animate themselves in a heroic-burlesque pantomime.[25] He conjures the motley procession of wrestlers, mimes, dancers, jugglers, and animals filing across the stage of the Black Maria like a reminder of a mythic time when the species were not yet divided:

> No earthly stage has ever gathered within its precincts a more incongruous crew of actors, since the days when gods and men and animals were on terms of social intimacy; when Orpheus poured his melting lays into the ears of the brute creation, and gentle Anthony of Padua lured the suffering beasts to the mouth of his desert cave.... Bucking bronchos, terriers and rats, accomplished dogs who turn somersaults and describe serpentine dances, trained lions, bears and monkeys are among the stars of this unique company. On one occasion, the platform was occupied by a wire cage, the sometime arena for certain gallinaceous conflicts. A dual between two aspiring roosters took place and the films have registered the strut, the swagger and the general bravado of the feathered knights.[26]

Natural causalities were forsaken for the effects produced by oneiric montages, epic-tragic scenes alternating with burlesque or satyric counterparts. In a minuscule ring, a cat fight takes place beneath the gaze of a referee, whose colossal face takes up the entire background; a troupe of bears accompanied by their Hungarian trainer climbs onto the kinetographic stage set, prompting, according to Dickson, "the inextinguishable laughter of the blessed gods":

> One furry monster waddled up to a telegraph pole, to the soliloquy of his own indignant growls; another settled himself comfortably on a deep armchair, with the air of a post-graduate in social science; a third rose solemnly on his hind legs and described the measures of some unclassifiable dance, to the weird strains of his keeper's music.[27]

Each subject filmed on the Black Maria's set told the tale of a body appearing and becoming a form, a body in search of its own modifications whose contortionistic performance represented the purest expression. Anabella imitating Loïe Fuller (figures 12 and 13), in turn imitated by trained dogs; Caicedo balancing on a tightrope; Bertoldi with knotted limbs, as if he had no bones; Sheik Hadj Tahar, bright arabesque crossing the dark field and turning in upon itself (figure 14) — all the actors appearing before the camera's lens present an emancipation of the bodies of the physical universe in a purified image of movement where the representation of a serpentine line unfolds fleetingly, the same line that, in similar fashion, ceaselessly haunted Renaissance artists as they sought to represent the living being.

When Julius von Schlosser began a historical survey of wax portraiture in 1911, outlining a theory of the history of culture as

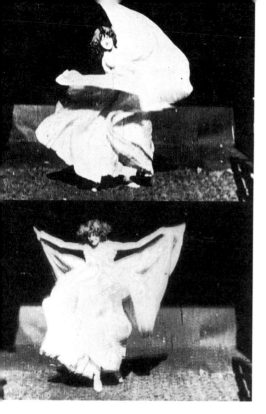

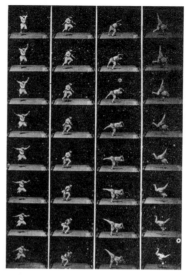

Figure 14. W.K.L. Dickson, *Sheik Hadj Tahar* (printed version; the film is lost). From William Kennedy Laurie Dickson and Antonia Dickson, *History of the Kinetograph, Kinetoscope, and Kinetophonograph* (New York, 1895).

Figures 12 and 13. W.K.L. Dickson, *Anabella Serpentine Dance* (I and II), New York, 1894. British Film Institute, London.

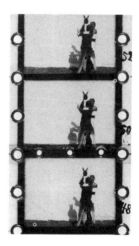

Figure 15. Max Skladanowsky, kangaroo boxer (from the back). Berlin, 1895. George Eastman House, Rochester.

sedimentation, he formulated a hypothesis according to which archaic practices were seen to survive in the most prosaic manifestations of contemporary popular culture in a more or less decomposed form.[28] Thus waxworks in popular museums and at fairs, or dummy heads in the display windows of Viennese hairdressers, appeared to him in the early twentieth century as distant avatars of *boti*, wax effigies suspended from the vault of the Santissima Annunziata in Florence in the Quattrocento, a practice that, having become secularized in European courts in the classical era, slowly declined to the point of finding a debased and discreet perenniality in modern times.[29]

Schlosser's analysis can also be applied to early cinema: borrowing its iconography and staging from the circus, film reactivated ancient forms of representation deposited in contemporary popular spectacles. But this resurgence would be ephemeral, condemned from the moment it appeared by the combined logic of realism and narration. In the Berlin Wintergarten in 1895, in front of a white sheet rather than the black decor of the Black Maria, the same oneiric and farcical population circulated one last time before the camera of the Skladanowsky brothers: wrestlers, kangaroo boxers, acrobats, and dancers — as in the New York kinetographic theater one year earlier — performed acts that referred to themselves alone, miming the transformation of bodies into representation in a euphoric encounter (figure 15).

Ghost Performances: Native Americans in the Black Maria

On September 24, 1894, Dickson filmed two kinetographic strips in the Black Maria, *Indian War Council* and *Sioux Ghost Dance*, when the Buffalo Bill Show was passing through Brooklyn.[30] The troupe had moved to West Orange around the eponymous star of the show, and apparently it was almost inadvertently that Dickson

shot these documents. A remark in his *History of the Kinetograph, Kinetoscope, and Kinetophonograph* nonetheless underscores the importance he granted them: "Unique in interest also is the Omaha war dance, the Sioux ghost dance and the Indian war council, features of aboriginal life which may be historically valuable long after our polished continent has parted with the last traces of her romantic past."[31] In many respects, *Indian War Council* and *Sioux Ghost Dance*, both documents and spectacles, were an extension of the pavilions one could visit in 1893 at the World's Columbian Exposition in Chicago, where, beside a reconstruction of Battle Rock and McElmo Canyon, one found a Kwakiutl village studied by Franz Boas, a Samoan village, a street in Cairo.[32]

Indian War Council shows three Native Americans in ritual costume performing a war dance to the sound of a drum beaten by a musician seated on a white ground cloth: the bodies stand out against the set's black background, legs slightly bent, pressed against each other in a semicircular, undulating motion (figures 16 and 17). Two of the dancers, concentrated on the movement, look into the circle; the other looks straight at the lens, as if this single look cast at the camera sufficed for all three. These dancers, with no space between them, are not entirely individuated: they form the organic totality that Hegel describes in *The Phenomenology of Mind* with regard to the flower religions, that brief moment of harmony in the history of primitive humanity when bodies were linked through a chain of empathy, a moment rapidly swept away by the brutal cult of animals, a hostile individuation that suppressed otherness.[33] The three men form a garland with feathers for flowers, white against their dark skin. To put it in Hegel's terms, in the feathered headdresses of the Native Americans in the Black Maria man had found a garment that was not in conflict with organic life but harmonized with it. The unindividuated character of the bodies is the representation of an *Urwelt* preceding

negativity. The "flower-man" found himself in a non-conflictual relationship of identity with exteriority. The immediate intuition of the world, in which the differentiation between interiority and exteriority had not yet taken place, also constitutes a knowledge of nature:

> [I]t has not yet separated its own being-for-self from that of things; it sees into the heart of things. It is only when the two are separated, when I am for myself and things are outside me, that things become enveloped in the bark of sense that separates me from them, and nature erects a screen before me, as it were. [S]pirit is immediately in the concept, knowing the universal, true nature of things immediately, understanding them intuitively, precisely because its intuition is not an external one. It is a grasping of what is inward to the concept, a form of clairvoyance, comparable to the sleepwalking state, which is a return of the soul to its inner unity with its world.[34]

The Native American performers' somnambulistic circling against the monochrome "partition" of the Black Maria recalls the immediacy of the Hegelian "flower-man's" relationship to the world; their dance, however, expresses not an original state of nature but a primitive state of representation in which Native American folklore serves as a pretext.

In a strictly formal light, the movement of the three *Indian War Council* dancers can be seen as that of a single body, simultaneously broken down and put back together in the picture plane: the film reproduces the dynamic momentum of a single being without suppressing intermediate states, whereas photography could only have given a frozen image of the whole. *Indian War Council* demonstrates that cinema did not mechanically constitute itself as a succession of images, but began by situating itself within

the exposure time that photography, with the acceleration of emulsions, had abandoned.

The dancers started to move only after a slight delay, when the filming had already begun. But while the film had a beginning, its end was left to chance: the image sequence was interrupted before the performance had been completed. In the Black Maria's reference-less shadows, the Native American performers "created a space," to borrow the expression Mallarmé used with regard to Loie Fuller,[35] and disappeared once this space was created: from the mere registration of the performance, they took us back to the pure pulsation of appearance and disappearance.[36]

In *Sioux Ghost Dance*, seventeen Native Americans stand in two lines (children in front) in ceremonial dress with painted faces. There is no division, no centering in the composition, which is reduced to the juxtaposition and superposition of the bodies in a strict frontal pose, in a double, depthless row. Captured in the violent contrast of white ground and black walls, and lit without shadows, the Native Americans are at first small inert figures somewhere between objects and bodies, like kachina dolls, before they become animated and transform themselves into dancers. The picture plane then suddenly becomes saturated with movement, an undulation of limbs and whirling bodies, which jumbles the composition and dissolves the contours. Dickson's film shows us an action more than it shows us the bodies interpreting it, and this action is made up of two simultaneous conversions: that of the Sioux warriors into theatrical performers and, more mysteriously, that of the performers into filmed images emerging from the film against the alabaster background, like the bas-reliefs on which the director based his animated effigies (figures 18 and 19).

In 1680, Native Americans rose up for the first time to shake off the yoke of the Spanish settlers, whom they had at first welcomed

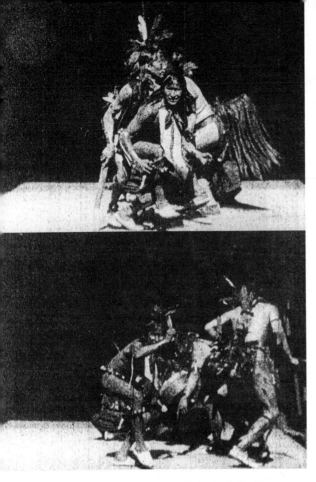

Figures 16 and 17. W.K.L. Dickson, *Indian War Council (Buffalo Dance)*, New York, 1894.

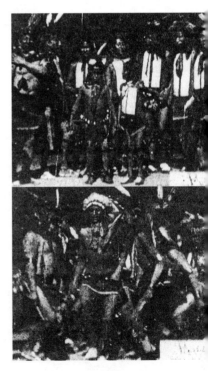

Figures 18 and 19. W.K.L. Dickson, *Sioux Ghost Dance*, New York, 1894.

as protectors. This revolt, which was brutally suppressed, is con-
sidered the impetus for the doctrine of the Sioux Ghost Dance, a
soteriological doctrine with political and bellicose undercurrents,
according to which Native Americans, the living and the dead
alike, would be reunited at a certain moment and freed from
white domination. The eschatological myth of the Sioux Ghost
Dance, which lent its name to Dickson's film, had circulated in
various guises since the seventeenth century and the beginnings
of the colonization of all the Sioux tribes of North America. It
intensified at the end of the nineteenth century until the great
insurrection of 1890, whose crushing defeat at Wounded Knee
meant death for Native American autonomy and the irreversible
disappearance of their vernacular cultures. Neither the producer
of the film (Edison), nor the cameraman (Dickson), nor even the
person who had commissioned the film (Cody), could have been
conscious of the meaning of the dance performed by the Native
Americans. But a journalist from the *New York Herald Tribune* pre-
sent at the September 24 filming spontaneously described their
performance as a commemoration of their defeat, to the extent
that in the Black Maria the Native American warriors were sub-
jected no longer to bullets shot from guns but to the turning of
the film in the camera:

> It was probably more effective in demonstrating to the red men the
> power and supremacy of the white man, for savagery and the most
> advanced science stood face to face, and there was an absolute tri-
> umph for one without the spilling of a single drop of blood.
>
> Holy Bear will, more than any of the visitors, bear the lesson to
> heart, for in endeavoring to grasp the situation, he included a live
> wire as one of the details, and perforce executed a war dance which
> threatened to dismember himself. He was a very meek, docile and
> fearful Indian when at last rescued from the current.[37]

In the journalist's sarcastic narration, the cinematographic opera-
tion appears as a means to domesticate energy and alienate bod-
ies, with the filmic document as the modern version of circus
spectacles. Now it was no longer men or animals but their images
that were exhibited.

One year before the Buffalo Bill Show came to West Orange, in
1892–1893, the ethnologist James Mooney traveled to Arizona to
re-create the history of the Sioux Ghost Dance and to study it in
its latest manifestations.[38] He witnessed the ceremonies held by
the Cheyenne and Apache tribes and photographed their dances.
At the beginning of the account of his mission, published in 1896,
Mooney wrote:

> It soon became evident that there was more in the Ghost dance than
> had been suspected, with the result that the investigation, to which it
> had been intended to devote only a few weeks, has extended over a
> period of more than three years, and might be continued indefi-
> nitely, as the dance still exists and is developing new features at every
> performance.[39]

In an elegiac mode, Mooney evoked a golden age "when women
were nymphs and dryads and men were gods and heroes," a
time of which the Ghost Dance manifests both the irretrievable
loss and the indefinite return.[40] One year later, when Dickson
witnessed the Sioux Ghost Dance in the stylized space of the
Black Maria and documented its last reflection, this dance was a
vestige of its former self: it ended up as a circus spectacle less
for its exotic character than because it had already become a
relic. Emerging from the retinue of Buffalo Bill, the buffalo
killer, to join that of filmic reproducibility, the spectral baccha-
ntes of the Sioux Ghost Dance ("spirit dance," or "dance *for*

spirits") ceaselessly recall the reality of the Native American genocide.

Indian War Council and *Sioux Ghost Dance* describe this subterranean process fleetingly at work in primitive cinematography, which changes the body into an image and gives it an unlimited power of repetition. The kinetographic strip, conceived as the medium for a picturesque spectacle, preserves *de facto* a morbid dimension. The performers in the two photo-printed strips escape from the circus world employing them and recall, in their spectral apparition, the reality of their disappearance. And while they enter the film in borrowed guise, they appear there for their own sakes, since, in fact, the set depicts nothing except the event of their vanishing and the litany of their return.

Once separated from the conditions of their production, the Native American dances, produced as folkloric spectacles and summoned to return to popular culture in the kinetoscopes, ceased to reflect their origins and began to transmit a meaning for which they were not intended. Something in them exceeds simple documentary or anecdotal reference, something related to the functioning of the model in the economy of the image, a function that Warburg would identify during his trip to New Mexico and whose characteristics he would exploit with regard to the works of the Florentine and Flemish Renaissance. The scene filmed *is* the image of the filmic operation, just as the painted scene *is* the image of representability: each is the expression of the process creating it. The *exoticon*, the unfamiliar subject, places the cameraman, like the art historian, in a situation of discovery: an experience of remoteness was necessary to reveal this idea to itself, this thought seeking, through a sort of motionless act, to capture the visibility of a being in an image.

66

CHAPTER TWO

Florence I

Bodies in Motion

Sandro Botticelli and the Nymph with the Billowing Veil

In 1893, in his first published study, the budding art historian Aby
Warburg analyzed two famous paintings by Sandro Botticelli,
Birth of Venus and *Spring*, in a rather conventional attempt to trace
a comparison between literary and pictorial treatments of a group
of visual themes emerging at the end of the fifteenth century and
borrowed from Antiquity. When comparing Botticelli's paintings
with their corresponding representations in the aesthetic theory
and poetry of the time, Warburg did not try to catalog a lexicon
of classical iconographic traits preserved in the visual and literary
culture of the Quattrocento. He was not trying to document sim-
ilarities between the works of the Renaissance and their models,
but rather to understand how Florentine painters and poets ex-
pressed their originality by borrowing various forms of identifica-
tion with the past. What questions did the artists ask themselves
in interpreting the ancient forms? Warburg posited that the phe-
nomena of transmission, assimilation, and transposition that make
up the historicity of artistic forms are the objectified expression
of personal research, possessing, in the final analysis, an intro-
spective meaning. Limiting his analysis to a series of details iso-
lated from the mythological figures, he focused on a series of

secondary motifs in which the representation of movement is concentrated.

In *Birth of Venus*, he studied the affinities between Botticelli's painting and Angelo Poliziano's description, in *La giostra* (The tournament), of a series of imaginary sculptural reliefs of the goddess emerging from the ocean, a scene inspired by a Homeric hymn.[1] Poliziano, a broadly educated humanist, a philologist, jurist, historian, philosopher, and poet, versed in Greek and Latin, and a prominent figure in Italian culture, was the model of Renaissance erudition. As Eugenio Garin has noted, his poetics, dominated by interpretations of Antiquity, was based on an idea according to which "to imitate ... is to become aware of one's own originality in the relationship that links it to the other, to find in oneself the means of creation with an example before one's eyes, to assume its intimate nature through a sort of looking into oneself."[2]

In *La giostra*, Poliziano adapted the quick movements of figures drawn from direct observation to a literary model provided by the epic poetry of Antiquity. The mutual influence between the intuition of bodies immediately present to the poet's sensibility and the reminiscences of the figures in the fable produced a compromise between the mythological figure and the real character. Warburg would identify this composite entity as the universal type of the figure in motion, which found visual expression in Botticelli's *Birth of Venus* and *Spring* and which abounded everywhere in the Quattrocento in the guise of the nymph with flowing hair and windblown veil: in Ghirlandaio's frescoes in Santa Maria Novella, in Agostino di Duccio's reliefs in Rimini.[3] This became so much the case that the reworking of Antiquity in this light ceased to appear in its Apollonian aspect and revealed instead its ecstatic, Dionysian nature.

As Warburg surveyed the ideas in which Poliziano's personality manifested itself through his reworking of "The Homeric Hymn

to Aphrodite," he noted that they all modified the economy of fig-
ures at rest by giving them over to the effects of an external force
and by underscoring their reality. Whereas "The Homeric Hymn"
described Zephyrus bearing the goddess "on the waves of the tur-
bulent sea, in soft, flocculent foam," Poliziano noted how "real the
breezes' breath."[4] To the neat description of the Horae welcoming
the goddess Poliziano added an empirical notation that blurred the
static Homeric figures: "The wind plays with their loose and flow-
ing hair." And when the Florentine poet described the imaginary
relief in which he found — or thought he found — the sequence
from "The Homeric Hymn," imagining he saw the stone figures
coming to life ("On the hard rock, you seem to see the air / shim-
mer"), he played with a conventional formula of ekphrasis to
attribute the impression of life not to the demiurgic talent of the
sculptor but to his scrupulous depiction of naturalistic detail.

Similarly, an imperious sense of motion courses through the
figures in Botticelli's painting, tearing them from the immobility
in which Winckelmann sought to keep their ancient references.
Describing the goddess of Spring in the Birth of Venus (figure 20),
Warburg mentioned only her garments billowing against her
body, her loosened hair, and her off-centered gesturing:

> She stands at the water's edge, turned to face leftward in strict pro-
> file, and holds out to Venus the wind-blown mantle that she grasps
> in her outstretched right hand above and in her left hand below....
> Her gown ... clings to her body, clearly revealing the outlines of her
> legs. A fold curves gently downward to the right from the back of
> her left knee, fanning out in smaller folds below. Her narrow sleeves,
> puffed at the shoulders, are worn over a white undergarment of soft
> material. Most of her fair hair wafts back from her temples in long
> waves, but some has been made into a stiff braid that ends in a bunch
> of loose hair.[5]

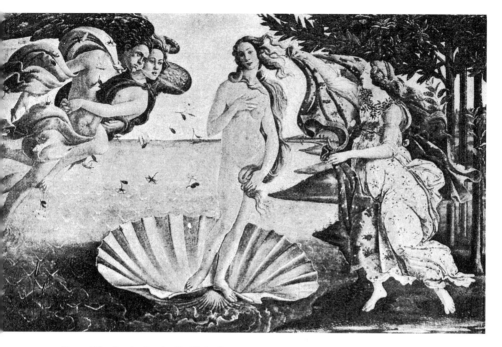

Figure 20. Sandro Botticelli, *Birth of Venus*.
Florence, Uffizi. Illustration in Aby Warburg,
Sandro Botticellis "Geburt der Venus" (Verlag
von Leopold Voss, 1893).

The figure does not appear as a stable entity, but seems to be born from a play of contradictory forces converging at the limit of the body's exterior, to use Aristotle's terms, and not in the self-manifestation of its immobile presence. The movement is described as an active dissociation between the fluttering contours of the figure and its mass, which seems to dissolve at the extremities, like a dance introducing disorder to its symmetry, shattering the measured equilibrium of the static apparition. In Warburg's analysis, by an inversion of the categories of ancient metaphysics, the attributes define the substance, and not the substance the attributes. The Renaissance artist, using models from Antiquity, sought artificially to produce the illusion of motion. If he turned toward Antiquity to the point of identifying with it, it was not to find a repertory of figures but to rediscover the expressive formulas according to which life was represented therein.

The goddess of Spring, described in this way, resembles Kleist's marionettes, whose movements, which are entirely reconstructed, constitute in themselves a critique of the ideality of forms. Human dancers could not reproduce these movements without producing "dissonance":

> Take for example the dancer P. . . . When she dances Daphne and is pursued by Apollo, she looks back at him — her soul is located in the vertebrae of the small of her back; she bends as if she were about to break in half, like a naiad from the school of Bernini. And look at the young dancer F. When he dances Paris and stands among the three goddesses and hands the apple to Venus, his soul is located precisely in his elbow, and it is a frightful thing to behold.[6]

Unlike the dancer, who can never suppress all affectation from his or her gestures ("for affectation appears, as you know, when the soul [*vis motrix*] locates itself at any point other than the center of

gravity of the movement"), the marionette disappears in its own action: it does not execute the character, but the character manifests itself through the marionette, stripped of any interiority. The dancer effaces himself imperfectly in the movements he executes; the puppeteer, on the other hand, gives the sense of effacement by means of a simple string and merely by moving his hands. Where the dancer seeks to produce the character, the puppeteer animates effigies, and the sinuous forms he traces in space are in the end nothing more, wrote Kleist, than the reconstituted "path to the soul of the dancer" — and he added that one can discover this path only through identification (or empathy), "if the puppeteer place[s] himself in the center of gravity of the marionette; that is to say, in other words, [if] the puppeteer dance[s]."[7]

Analyzing a pen-and-ink drawing made by one of Botticelli's students at the end of the Quattrocento, *Study for a Composition of Venus Emerging from the Waves,* Warburg examined the way in which the Florentine artist staged the process of a moving body's appearance by drawing from a series of elements found on the bas-relief of an ancient sarcophagus the artist used as a model (figures 21 and 22).[8] Since the relief was missing areas, the artist copied it as it was. In so doing, he changed even the meaning of the copy. Botticelli's student — like a whole series of Renaissance artists and poets — seems to have used a work of Antiquity, *including its deterioration,* to express the phenomena of appearance and disappearance, seeking to reproduce not so much the figure depicted as the fact of figuration itself, and the pulsing of presence and absence conditioning it. Far from being a sketch, the student's drawing demonstrates that motifs from Antiquity were used by Renaissance artists as a means to analyze the mechanism of representation and the way in which figures resurface, in a mixture of persistence and effacement in which the secret work of visibility unfolds.

Figure 21. Student of Botticelli, *Study for a Composition of Venus Emerging from the Waves.* Musée Condé, Chantilly.

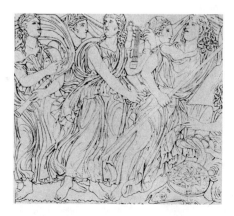

Figure 22. *Achilles in Skyros*, diagram of a bas-relief from Antiquity. Woburn Abbey, England.

There are five figures in the drawing, in varying degrees of completion. The first from the left is depicted as a torso, seen in three-quarters view from behind. Warburg noted that she is a girl corresponding to the nymph type: she is draped in clearly marked folds of cloth, hair gathered in a braid hanging between her bared shoulders (with a few strands curling across her back). Her face is turned to the right, while her lower body is not shown. A second young girl stands beside her; she is also the nymph type, but wears her hair and garment differently. This figure, suspended in the space of the picture plane yet depicted in her entirety, seems to move forward, diagonally to the right, in a prolongation of the figure preceding her. She is off balance, legs crossed, feet quite spread, in a posture that appears to be an effect of the displacement of the body in space, a displacement indicated by the treatment of two peripheral accessory elements (*Beiwerke*), a lock of loose hair and a looped veil: "Her hair is parted in the center, then gathered in a braid and wound around her head, ending in a loose, fluttering tress. The imaginary breeze swells a scarflike garment that is looped over her shoulder."[9] A third figure, seen three-quarters from the front, seems to recede in the picture plane and progressively disappear in the two figures behind her, one of which is cut by the right-hand edge of the paper. The play of alternating superimpositions between the figures' outstretched arms and the garments blown to the left by the wind, and the hatching that introduces a vibration in the contours and modeling of the bodies, all suggest the swirling motion of a single figure moving to the right.

The point of this study was therefore not merely to indicate a series of poses adopted by a figure displacing herself in space as in an animated frieze, but rather to show her decomposition and simultaneous reconstruction in the picture plane. As with the goddess of Spring in the *Birth of Venus*, from this drawing — from the central female figure with twisted hair and fluttering garment,

who leaves in her wake the unstable trace of her doubles — arises the most enigmatic question that could be posed to the plastic arts as they sought to capture what Warburg called "the body striding in motion."[10]

Similarly, in a Botticelli drawing of Minerva — with the usual nymph typology — now in the Uffizi, the goddess's features seem doubled, due to a correction (figure 23). Perhaps this correction indicates not the artist's hesitation at the moment of execution but the documentation of a trembling motion in the composition of the figure, a motion that frees the figure from its typology, allowing it to return to the event of its singular appearance.

In a collection of studies published in London in 1958, *Pagan Mysteries in the Renaissance*, Edgar Wind reworked the studies his predecessor had devoted to Botticelli fifty years earlier, undertaking an in-depth investigation of the sources of *Spring* and *Birth of Venus* in Antiquity.[11] Wind analyzed the Neoplatonic ideas expressed in Botticelli's works in detail; in so doing, he examined the images from a conceptual standpoint that obscured their purely visual tenor, once again covering the Florentine artist with the veil of exegesis that Warburg had deliberately wished to shred (even though his discourse preserved appearances and respected the most traditional laws of art history).

Wind first attempted to uncover the meaning of the group occupying the right-hand side of *Spring*. Chloris, nymph of the meadows, flees before Zephyrus, the personification of the spring wind. At the moment she is caught, flowers spring from her mouth: she is transformed into Flora, the herald of spring (figure 24a). In the *Fasti* Ovid recounted the pursuit, and has the nymph say: "I once was Chloris who am now called Flora [Chloris eram quae Flora vocor]."[12] He reduced the metamorphosis to a simple etymological game, the flowers emerging from the nymph's mouth

becoming but the hieroglyphic expression of her name. Now, according to Wind, in this mutation — which assumes a visual guise at once disturbing and unusual — something deeper than a simple change of name is at work:

> When we see how Chloris, at the touch of the spring breeze, produces flowers from her breath..., how her hands reach behind the flowers that decorate the garment of the new Flora, and how the two figures converge in their rapid motion so that they seem to collide, we can hardly doubt that the metamorphosis was represented by Botticelli as a change of nature.[13]

In a note, he pointed out that other flowers appear between the thumb and forefinger in Chloris's left hand and that the tip of the third finger of her right hand is overlapped by the end of a twig or leaf, "which might be mistaken for a slip of the brush, did not the other hand show the same motif."[14] Wind paid close attention to the most minute local movement and the changes staged in the painting, but always to find meanings, or constants. At the end of his analysis, he concluded with the presence of an erotic theme idealized in the triad Zephyrus-Chloris-Flora, a triad repeated locally in each element of the composition:

> In the guise of an Ovidian fable, the progression Zephyr-Chloris-Flora spells out the familiar dialectic of love: Pulchritudo arises from a *discordia concors* between Castitas and Amor; the fleeing nymph and the amorous Zephyr unite in the beauty of Flora. But this episode, *dinotando la primavera*, is only the initial phase in the Metamorphoses of Love that unfold in the garden of Venus.[15]

Symmetrically, to the left of the goddess of love, the three Graces form a ring, opposing a circular movement to the first group's

linearity (figure 24b). As in the preceding analysis, Wind associated the transparent garments enfolding the three Graces and the intertwining of their arms with literary or philosophical traits, identifying the three dancing figures with the abstract triad of youth, beauty, and sensuality (*castitas-pulchritudo-voluptas*):

> That the Graces are not represented naked, but wearing loose, transparent garments, shows how much the painter was inspired by literature....
>
> In so far as dialectic can be danced, it has been accomplished in this group. "Opposition," "concord," and "concord in opposition," all three are expressed in the postures and steps and in the articulate style of joining the hands. Placed palm against palm to suggest an encounter but quietly interlocked in the absence of conflict, they rise up high to form a significant knot when they illustrate the Beauty of Passion.[16]

Although the stamp of Warburg's thought (which manifests itself both in the attention to details and in the sensitivity to movement) is clearly recognizable in this analysis, Wind persisted in subordinating visual expression to verbal expression, whereas Warburg sought an image's significance in its difference from the original narration that inspired it. In so doing, Wind merely gave the old principle "ut pictura poesis" a philosophical dimension: hence everywhere in Botticelli's painting he found a multiplication, in truth quite fastidious, of signs of the Neoplatonic doctrine of love, as if all the elements in the work posited a unique and coherent meaning. Applying Warburg's iconographism to the letter, Wind leads the theme of metamorphosis back to an original discourse, whereas his predecessor's discourse consisted, beneath the cover of erudition, in pulverizing the mechanisms of iconographic transmission from within, in order to bring out the enigmatic function

Figure 23. Sandro Botticelli (?),
Sketch for Minerva. Uffizi, Florence.

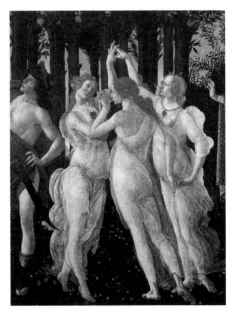

Figures 24a and b. Botticelli, *Spring*,
two details. Uffizi, Florence.

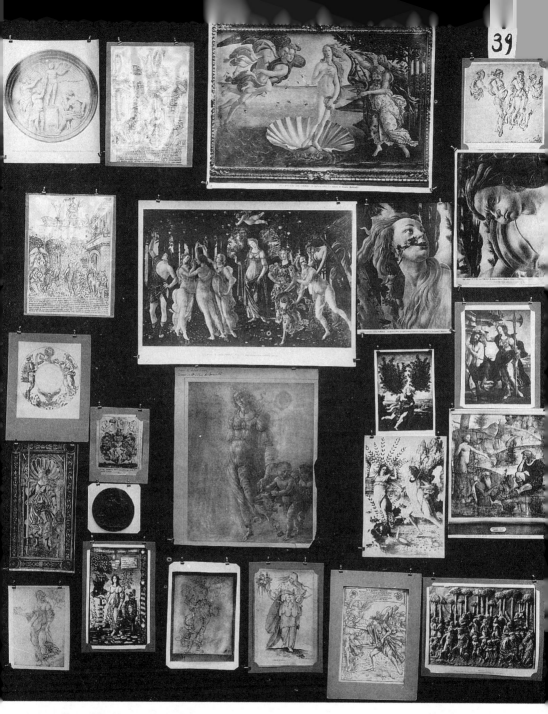

Figure 25. *Mnemosyne*, pl. 39: the nymph
in motion.

of the representation of motion: the manifestation of a body irreducible to meaning.

Beneath the jumble of texts Wind brought together, the strictly visual aspect of Botticelli's painting disappears: perhaps literary interpretation is in fact intended to mask this dimension? But once freed from textual reference, Chloris's metamorphosis into Flora and the circling of the Graces appear to us as the displacement of a single body whose successive positions are represented simultaneously, once in the guise of translation, next in the guise of rotation.[17] The plurality of figures yields to a series of modulations affecting single bodies, and one notices that, as Warburg propounded, the mythographic subject was merely a pretext for the Renaissance artist to explore the movements of which a figure is capable.

Warburg thought that Botticelli made his studies of movement look like mythological scenes, because in Antiquity he found a repertory with which to represent active energy. The artist sought to represent first and foremost not the narrative contents or legendary tales but the immediately visible form in which the existence of individuals appeared to him, and this required empirical observation.

In seeking to grasp from within the conflictual relationships binding the external reality of the world, the ideals of the times, and the artist's personal intuition, Warburg favored displacements and ruptures over the transmission of forms. "God is in the details": Warburg's motto is primarily a methodological prescription signifying that the work is not a closed totality but a juxtaposition of elements in tension, which interpretation should not blur and might even presume to reveal. Botticelli's art, like that of the painters it inspired, combines different levels of high and low culture, weaving mythological elements into the fabric of daily life in such a way that in the eyes of the modern viewer the documents

and the works teem with Florentine life in a transfigured guise. Thus from Quattrocento painting emanates a confined atmosphere "of dry goods and theatrical wardrobes," a netherworld of commerce and artifice that was to the city what the wings were to the stage and that the researcher, through the analysis of works, manages to reconstruct:

> It was not then the practice to visit the artist, remote and abstracted in his studio, and to strike an aesthetic pose beneath his northern light while feeling most profoundly the malaise of world-weary, civilized men. Then, people used to drag their gold-smith painter out of his workshop into the real world whenever the cycle of life itself demanded a new form: a building, a jewel, a utensil, a festive procession.[18]

The comparative analysis of paintings and texts no longer posits transhistorical constants limiting Renaissance culture to a simple tapestry of imitations and paraphrases of Antiquity but demonstrates how artists of the time used the past to convey a reality affecting them directly. The issue was to understand not how the Italian artists, poets, and painters identified with Antiquity but how they appropriated motifs in order to create figures fully participating in Florentine reality. In this appropriation, we find the singular form of style to which we gain access through what Warburg called "empathy" (*Einfühlung*).[19] It conditions the spirit of the times, the moment of universality that the artist either resists or submits to — and according to Warburg, Botticelli was in fact a bit too docile an artist. In 1908, Warburg would write:

> Sandro Botticelli's eye and hand are the equipment of an early Renaissance Florentine artist, in all their natural freshness and keen precision; but in Sandro, the sense of reality that distinguishes his contemporary mentors — Fra Filippo, Verrocchio, Pollaiuolo —

81

becomes no more than a means to an end, that of expressing the whole cycle of human emotional life, from melancholy stillness to vehement agitation.[20]

On the Influence of External Causes on the Displacement of Figures

A series of notes for the "Bruchstücke" (Fragments), drafted in September 1890 and regrouped under the title *Zuschauer und Bewegung* (Spectator and movement), puts Warburg's question of moving bodies and its genesis in an unusual light.[21] In it we already find, in a very condensed form, the outlines of his later studies on Botticelli:

> Sept. 7, 1890. The art of the early Renaissance begins to lose its "scientific" character by introducing figures in forward motion. And artists went in this direction because they believed they were following the "ancients."
>
> With the introduction of the forward-moving figure, the spectator was constrained to exchange comparative for anthropomorphic observation. The question was no longer "What does this expression mean?" but "Where is it moving to?"
>
> The eye executes an imitative movement vis-à-vis the figure, in order to maintain the illusion that the object is moving.
>
> Figures whose clothing or hair is moved can receive this movement from their own bodily movements, or else from the wind, or from both together. They move on a plane parallel to the spectator, so that the spectator can believe in forward movement only when he moves his eyes.[22]

With their forays into the past, Renaissance artists uncovered in art a profound tendency to refuse all conceptual dimension, to deny the status of *cosa mentale* in turning toward life's appear-

ances. The mythological figures they depicted were not the simple incarnation of an idea. As they began to move, the figures became the source of a strange tension, the product no longer of a single will but of independent and multiple forces exercising contradictory influences — that of the artist, but also those of the model and of natural conditions, as well as that of the viewer looking at them. Thus, in the last part of his September 7 note, Warburg demonstrated that through a particular exercise of attention, the spectator can substitute himself for the external cause setting the figures in motion. In a note dated the next day (September 8), titled "Movement and Spectator," and not anymore "Spectator and Movement," Warburg insisted on the anthropomorphic and animist consequences of this activation:

> Sept. 8, 1890. Movements of hair and clothing are signs of the person's heightened movement or — of a strong wind. Hence one can rightly infer the heightened activity of the person represented, while wrongly making this movement depend on the will of the person, and therefore inferring something personal when nothing of the sort is there.[23]

The movement in question is henceforth as much that of the subject looking at the work as that of the object regarded. The spectator abandons passive contemplation in order to intervene actively in the representation. Returning to the question of movement in a note from September 29, Warburg wrote:

> Attribution of motion. To attribute motion to a figure that is not moving, it is necessary to reawaken in oneself a series of experienced images following one from the other — not a single image: a loss of calm contemplation.
>
> Spectator and clothing. With clothing in motion, every part of

the contour is seen as the trace of a person moving forward whom one is following step-by-step.[24]

In this collection of notes from September 1890, Warburg already imagined the conclusions that would lead him to the analysis of figures in motion, applied to specific works, and this would allow him to uncover, in the work of Renaissance artists, a rejection of idealizing aesthetic categories in favor of ecstatic expressive formulas. This rejection profoundly modified the relationship of these artists with Antiquity, a relationship that Warburg tips from an Apollonian pole toward a Dionysian one. The attention to movement would thus lead him to a radical change in perspective. "Loss of calm contemplation," meaning that the seeker's detachment is replaced with a form of active intervention in the process of understanding and interpreting works; and this is probably the meaning of the last section of the note from September 29, in which Warburg, having seen the nymph depicted on the paper come alive, found himself following behind her.

Warburg defines the recording of motion as a persistence of intermediary states in the displacement of the figure: for the onlooker, its perception requires an identificatory attention — of an almost hypnotic type — through which an exchange takes place between the subject and the object. The discrete, controlled hallucination to which the art historian surrendered in the figure of the nymph (undoubtedly a photographic reproduction) has a precedent — and possibly finds its deeper meaning — in an experiment conducted by Goethe, a century earlier, as he contemplated the *Laocoön* group:

> To seize well the attention of the *Laocoön*, let us place ourselves
> before the groupe with our eyes shut, and at the necessary distance;
> let us open and shut them alternately and we shall see all the marble

in motion; we shall be afraid to find the groupe changed when we open our eyes again. I would readily say, as the groupe is now exposed, it is a flash of lightning fixed, a wave petrified at the instant when it is approaching the shore. We see the same effect when we see the groupe at night, by the light of flambeaux.[25]

Like Warburg with the nymph, Goethe called upon an artificial perceptual stimulus to activate the image unfolding before his eyes as if by a flicker effect. That this image was the *Laocoön* is clearly not insignificant: it is a sign of the intimate collusion, to which Warburg would repeatedly return, between the motif of the snake and the representation of movement.

For Winckelmann, the *Laocoön* was an example of static serenity, the violent contradiction between the calm appearance of the hero's face and the twisting of his limbs compressed by the snakes squeezing them, an image of mastered and transfigured pain:

> The pain is revealed in all the muscles and sinews of his body, and we ourselves can almost feel it as we observe the painful contraction of the abdomen alone without regarding the face and other parts of the body. This pain, however, expresses itself with no sign of rage in his face or in his entire bearing.[26]

Goethe, by blinking at the group representing the hero and his sons being overwhelmed by snakes, causes the undulating movement of the reptiles, which had been arrested, to surge forth. At the moment in which the figures become animated, the spectator witnesses the dislocation of the principle of composition stipulating that the plastic arts and painting depict one action alone, at the very moment this action takes place. Such was Lessing's opinion, likewise using the example of *Laocoön*, as he compared the visual arts (painting and sculpture) with poetry:

The artist can never, in the presence of ever-changing Nature, choose and use more than one single moment, and the painter in particular can use this single moment only from one point of vision.... [I]t is certain that that single moment, and the single viewpoint of that moment, can never be chosen too significantly. The more we see, the more we must be able to add by thinking. The more we add thereto by thinking, so much the more we can believe ourselves to see.[27]

Everything that a painter depicts in his painting, or a sculptor in his sculpture, must conspire to represent a single instant. Anything he might introduce concerning prior or subsequent moments would no longer belong to the true composition and would break the laws of temporal unity.

Based on a premise opposed to this doctrine of the fecund moment, the 1893 study on Botticelli appears in Warburg's work as the first fruits of the analysis of movement, taken to the point where movement yields the formula of its recomposition. Just as for Goethe the plastic arts depicted "pathetic passage in the most elevated sense," and the *Laocoön* represented "a flash of lightning fixed, a wave petrified at the instant when it is approaching the shore," the nymph, suspended in the image, was a potential body in motion.[28] Supported by this intuition, Warburg set himself the task of reconstructing the unfolding of the figure in its duration *within* the representation, a reconstitution he would try to accomplish by exploring, in stages, the passages leading from the world of things to that of images.

Etienne-Jules Marey and the Man with the Silver Button

The way in which Warburg sought to actualize potential motion in images is strangely reminiscent of studies by Etienne-Jules Marey, undertaken at the same time in a different field, at the crossroads of

physiology and photography. In a text published in 1894, soberly titled *Movement*, Marey recorded the results of his attempts to transcribe movement at the Collège de France during the preceding decade. He was trying to resolve the aporia into which photography had been thrust when the perfecting of quick emulsions enabled it to represent bodies in motion: since movement is essentially irreducible to instantaneity, in order to obtain an expression of it that does not simply show a body stopped in its tracks, it is necessary to dissociate it from the body, which bears it but is not identical to it.

Seeking not to *reproduce* the appearance of movement but to *reconstitute* it by analyzing its visual properties, Marey envisaged its discrete texture, which is inaccessible to photographic sampling. A consideration of the stops made by the body in motion was forsaken in favor of the evanescent transitions binding them together, through which visibility itself was expressed. Marey thought it necessary to reconstruct movement by making its physical wrapping abstract, based on a combination of visual formulas that do not presuppose figurability, but on the contrary condition it.

Chronography gives movement an abstract expression by means of an oscillograph attached to the moving body, transcribing its displacements. Marey considered this the most accurate expression of movement because it did not allow the appearance of the body to interfere in the representation. But for the moving body whose displacement was too quick or too prolonged, it was necessary to resort to chronophotography, which did not require any material link between the recording device and the model. Since the visibility of the body presented an obstacle rather than a useful reference, this method was intended to do away with thickness and opacity, conjuring the body's presence by removing it from substantiality. In this way, Marey, turning away from exploring instantaneity, proposed "artificially to reduce the surface of the

body in question," to make it disappear, and to put in its place an ensemble of procedures intended to neutralize the appearance of the moving body in favor of the pure phenomenality of its driving force.[29]

In the text of *Movement*, and in the strictly deductive sequence of its accompanying images, a conception of the image strangely akin to Warburg's appears: the figure is conceived not as a modification or a state but as the manifestation of an energy. In one of his first chronophotographic demonstrations, Marey used a man dressed in a close-fitting black jacket, his face hooded, and with galloons marked by bright spots at his joints (figure 26a). When at rest, the figure appears, in his disappearing outfit, to be endowed with a paradoxical presence that allows only what annuls him to be seen. As he begins to run, a mutation affects his body, and in its place its spectral form appears on the plate — not its structure, but its passage, its vanishing, whose anti-figurative aspect Marey further heightened by tracing proofs made by photographic impression onto his images (figures 26b and 27): instead of representing the body devoid of movement, he represented movement through an eclipse of the body.

When the figure's trajectory takes place in terms of depth, the apparatus gives merely a surface representation. Marey thus found it necessary to use a stereoscopic view in order to re-create the unfolding of movement in perspective: to this end, he used someone dressed in black moving away from the viewer against a black background, with a shiny metal button affixed to the base of his spine (figure 27). While the man walked toward the backdrop, an apparatus with a double lens registered two parallel images of the shining point's trajectory, recording it on the printed plate. As did Warburg in his "Bruchstücke," in a note to his text Marey described an optical exercise intended to activate the effects of stereoscopy through the spectator's intervention in the process of representation:

Figures 26a and b. The man with the galloon,
at rest and moving. From Etienne-Jules Marey,
Le Mouvement (1894).

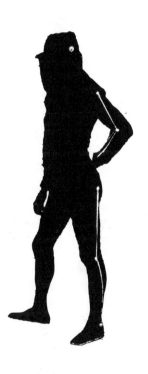

Figure 27. Stereoscopic trajectory of a bright
point placed on the lumbar vertebrae of a man
walking away from the camera. From Etienne-
Jules Marey, *Le Mouvement* (1894).

To obtain the effect of relief without a stereoscope, one must direct one's gaze to a far-off point, then interpose the image between the eye and this point. One sees the page of the book doubled, and consequently one has the sensation of four images of the trajectory. By means of slight movements of the book, and through slight changes in the direction of the eyes, one brings the images most on the inside to superimpose exactly. After that the eye adjusts itself and clearly sees this central image, which appears in relief, between two other images that continue to lack such relief.[30]

The pattern on the plate, with the effect of depth being conveyed by two squiggly lines, is the very image of movement stripped of the moving body sustaining it. This is how Marey avoided the substantialist prejudice that remained implicitly tied to photography in its mechanical association of the being with immobility, and which postulated that a body is only truly identical to itself when at rest. Marey's idea is reminiscent of Warburg's intuition about how Renaissance artists became interested in Antiquity in order to isolate not stable entities, fixed by iconographic parameters, but movements that, in fact, questioned the very idea of stability (figures 1 and 28). The undulating figure that Goethe saw in the *Laocoön* by rapidly blinking his eyes is related to the experiences of both Warburg and Marey: the man's body with the shining button disappeared on the photographic plate, just as the nymph disappeared from the study sheet to yield another figure, that of energy in motion, which draws in its wake, in the guise of a persistent trail of light, the silhouette of a snake.

Figure 28. *Mnemosyne*, pl. 6. Around the
Laocoön: ritual scenes and serpentine shapes.

Florence II

The Painted Space

Animism and Representation

In 1893, in his exploration of the way Italian Renaissance artists represented movement, Warburg asserted that they were ineluctably drawn to describing appearance: the signs of mobility are concentrated on the periphery of the figures, in the deformation of outlines or features, windblown clothing or hair, without affecting their structure. The movement's origin is associated with an external factor that temporarily modifies the body but does not affect it deeply. Considering that in some cases the artist reproduced the sequence of a model's poses, one must admit that he succeeds in merely juxtaposing the successive stages of the development of the sequence on the study sheet or in the painting without recreating its continuity (see figure 21).

Nine years later, in 1902, Warburg published two studies, "The Art of Portraiture and the Florentine Bourgeoisie" and "Flemish Art and the Florentine Early Renaissance," devoted to what he calls the "living art of portraiture." In these studies, he treated rigorously static figures, ones stripped of any gestural expression. Yet the question of movement had not disappeared; it had become interiorized. Warburg sought to understand no longer how Italian Quattrocento artists and Flemish painters

93

represented bodies agitated by an external force but how they represented bodies animated by an inner principle — which is to say, living beings. The representation of movement entailed suggesting not the circulation of moving bodies in space but their presence in the image, not their displacement but their appearance. As an indication of the new direction of his research, Warburg cited the words of the Tuscan poet-philosopher Cesare Guasti as epigraph to his "Art of Portraiture and the Florentine Bourgeoisie": "the living words of men who have slept for four centuries and more in the tomb, but whom love can awaken and usefully consult."[1]

Art history has the power to draw men whose traces are transmitted in art and archives out of the obscurity of the past. By using written and visual sources not simply to understand but to reproduce the past, the scholar changes the nature of historical research itself. Such was the case in the last works of Jacob Burckhardt who — through a posthumous text published in 1898, *Beiträge zur Kunstgeschichte von Italien* (Contribution to the history of art in Italy) — served as a lightning rod for the development of Warburg's ideas in 1902.[2] "Even after his death," wrote Warburg, commenting on Burckhardt's text in light of Guasti's comment, "this connoisseur and scholar of genius presented himself to us as a tireless seeker."[3] Warburg presents *Beiträge* as a synthesis of Burckhardt's *Civilization of the Renaissance in Italy* (1860), which treats the individual in society, independently of visual art, and *Der Cicerone* (1855), which analyzes visual art independently of the artists.[4] In *Beiträge*, Burckhardt studies works of art in their relationship to the historical and spatial environment in order to grasp the "causal factors" figuring in the practical and intellectual determinations of real life. Superimposing the plan of *The Civilization of the Renaissance in Italy* with that of *Der Cicerone*, Burckhardt sought to reconstitute the singular reality of the individual

within the works themselves, by comparing the images to the chronicles of their existence in archival documents.

Warburg focused on two short passages from Burckhardt's text, one devoted to Giotto, the other to Ghirlandaio. Burckhardt diagnoses a mutation in the history of portrait painting between these two artists. With Giotto, faces and attitudes still express an idealized concept of corporeality, but in the execution of secondary figures by the Tuscan painters of the Trecento who followed him, one can already identify the individual features of figures depicted in their day-to-day activities. These characteristics would become progressively accentuated at the dawn of the Quattrocento, eventually invading the representation as a whole, in such a way that the history of portraiture during this period merges with that of the individualization of the figures.[5] In the features of the monks depicted in the frescoes in the great Spanish Chapel at Santa Maria Novella, Burckhardt already saw "many Dominicans" who really existed, adding that in this chapel as elsewhere, photographic documentation should be used to preserve traces of these figures while it was still possible (figure 29).[6] The art of the portrait painter assumed the task of transmitting information that faithfully expressed the individual's belonging to his epoch while capturing his likeness, including the ailments and effects of age. As one gets closer to the Renaissance after Giotto, individual characteristics begin to stand out, and the representations become secularized, invaded by a profane crowd emerging from the anonymous procession of religious orders that the erudite historian, through a process Warburg describes as a mediumistic task, becomes capable of identifying more and more precisely.

This procession irresistibly calls to mind the rows arranged inside the Capuchin catacombs in Palermo, where the dried bodies of parishioners are kept, hung along the walls and dating far

back in time. The simple juxtaposition of the bodies constitutes, by itself, a spatial representation of time: returning from the depths of the catacombs, the visitor — or the religious person — sees the clothing covering the bodies resume its texture and color and the faces their individual features (figure 30).

In "The Art of Portraiture and the Florentine Bourgeoisie," Warburg gives an overtly animist inflection to Burckhardt's study, which remained a sort of historiographic exercise: Warburg describes the simultaneous use of written and visual documents, archives and paintings, as a means to bring the individuals whose traces they preserve back to life through a comparison of the image with the written word:

> Florence, the birthplace of modern, confident, urban, mercantile civilization, has not only preserved the images of its dead [*Abgeschiedene*] in unique abundance and with striking vitality: in the hundreds of archival documents that have been read — and in the thousands that have not — the voices of the dead live on.[7]

The dead are *Abgeschiedene*, those who are separated from us, but also separated from themselves, "those who are split" between their images fixed in paintings and their traces preserved in archival documents. Warburg describes this rift as a real separation of body and voice, which the historian has the power or the task to eliminate. He sees the work of scholarship trying to reestablish the synchrony between image and discourse as both demiurge and montage: "The tone and timbre [*Klangfarbe*, 'sonorous color'] of those unheard voices can be recreated by the historian who does not shrink from the pious task of restoring the natural connection between word and image."[8]

Figure 29. Andrea di Bonaiuto, *The Church Militant and Triumphant*, detail, fresco, around 1365. Santa Maria Novella, Spanish Chapel, Florence.

Figure 30. Catacomb of the Capuchins, Palermo.

To join an image with a sound, a figure with a voice, such was the way the precursors of cinema envisaged the recording and mechanical reproduction of movement before it was thought materially possible. In 1887, Nadar foresaw the realization of the total spectacle "by envelopment," something that cinema would create by combining with an apparatus for reproducing sound: "My dream is to see photography record the attitudes and changes in the physiognomy of a speaker while at the same time a phonograph records his words."[9] At the time the first ideas of cinema were being developed, recording moving images was perceived less as an extension of photography than as a complement to recording the voice, with this association making possible the fantastical realization of a total body combining all the properties of a living being. The apparatus for recording sounds even served as a model for the first attempts to reproduce moving figures, as if the visual and sonorous traces of bodies were two manifestations of a single active energy, which an identical procedure might be capable of capturing.

In the preface to *Animals in Motion* written in 1898, Eadweard Muybridge describes visiting the inventor of the phonograph in West Orange, New Jersey, to present him with his zoopraxiscope:

> It may here be parenthetically remarked that on the 27th of February, 1888, the author, having contemplated some improvements of the zoöpraxiscope, consulted with Mr. Thomas A. Edison as to the practicability of using that instrument in association with the phonograph, so as to combine, and reproduce simultaneously, in the presence of an audience, visible actions and audible words. At that time the phonograph had not been adapted to reach the ears of a large audience, so the scheme was temporarily abandoned.[10]

Eight months later, in October 1888, Edison in turn applied for a patent for a viewing apparatus in which the recording of moving images was openly described as the transposition of that of sounds: "I am experimenting upon an instrument which does for the Eye what the phonograph does for the Ear, which is the recording and reproduction of things in motion, and in such a form as to be both cheap, practical and convenient.... This apparatus I call a kinetoscope 'Moving view.'"[11] Shortly thereafter and under Edison's direction, William Kennedy Laurie Dickson began exploring the possibility of an "optical phonograph," based on the 1877 phonograph. In his prototype, the hand-turned cylinder was coated with photographic emulsion, while the needle, horn, and sound box were replaced by a lens. The operator pointed the instrument at the object he wanted to reproduce, turning the crank handle so that a succession of images would become im-printed in a spiral on the cylinder, which had been rolled with a supple gelatin strip of paper or celluloid. The adaptation of the phonograph to the conditions of visibility remained, of course, an experimental fiction, but this fiction yielded profound indications as to the meaning and purpose of the future instrument for cap-turing movement. In 1891, in a still imaginary register, Edison gave a detailed description of the total spectacle he wanted to cre-ate by combining image and sound:

> If it is desired to reproduce an opera or a play I will get the company to give a dress rehearsal for me. I place back of the orchestra on a table a compound machine consisting of a phonograph and a kinetograph, with a capacity of thirty minutes continuous work. The orchestra plays, the curtain rises, and the opera begins. Both machines work simultaneously, one recording sound and the other taking pho-tographs, recording motion at the rate of forty-six photographs per second. Afterward the photographic strip is developed and replaced

in the machine, a projecting lens is substituted for the photographic lens, and the reproducing part of the phonograph is adjusted. Then by means of a calcium light, the effect is reproduced life-size on a white curtain, reproducing to the audience the original scene with all the sounds and all the motions of the actors exactly as in the original scene.[12]

In the spectacle imagined by Edison, the image-projection and sound-diffusion phase would merely reverse that of their recording: this circular arrangement, closed off from the outside world, tears the event from the linearity of time. When in 1894 Edison returned to his filmed opera project, in an article in the *Century Magazine*, he declared it a means of documentation, which demonstrates that the first models of cinema were less concerned with the reproduction of movement than with preserving a simulacrum of the living: "I believe that in coming years ... grand opera can be given at the Metropolitan Opera House at New York ... with artists and musicians long since dead."[13] Cinema did not, as one might expect, seek at first to imitate reality and give this imitation a reproducible form; it was based on an animist belief concerning the survival of bodies. Edison speaks not just of preserving the appearance of those who have disappeared but of creating an artificial being in a total spectacle combining image and sound.

The device imagined by Edison is comparable to Warburg's conception of subjects from the past as "separate beings" (*Abgeschiedene*), split between images and texts, preserved in documents and works of art, and to which the art historian could give a quasi-organic consistency if he "does not shrink from the pious task of restoring the natural connection between word and image."

This demiurgic aspect was coupled with a formal aspect, though it is unclear which served as vehicle for the other: in the projection of the first cinematographic images, one not only saw

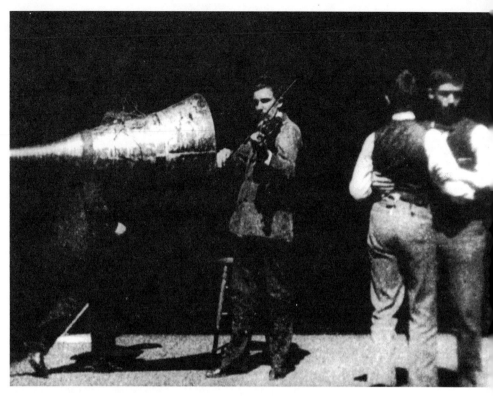

Figure 31. W.K.L. Dickson, *Film Experimenting with Sound*, 1894. Library of Congress, Washington, DC.

bodies appear in the dual form of visual and sonorous reflections; one witnessed the very operation of their recording (figure 31). In this sense, the projection of images on a screen reproduced the passage of bodies into representation. Similarly, in Warburg's analysis the inscription of figures onto the picture plane seems to translate the transferal of individuals into images and the transformation of bodies into pictorial entities.

Francesco Sassetti in Santa Trinita

Warburg felt that what he calls a "living art of portraiture" did not derive unilaterally from the creative power of the artist inspired by the ideals and techniques of his time and cultural reminiscences of Antiquity. The sitter plays a part in the formation of the work, and there exists "an intimate contact between the portrayer and the portrayed."[14] In the history of portraiture between the beginning of the Trecento and the end of the Quattrocento, Warburg recognized, following the Burckhardt of *Beiträge zur Kunstgeschichte von Italien*, an affirmation of the patron's desire for power as he came to occupy the field of representation. Warburg sought to reconstruct the patron's personality based on a montage of texts and images.

At the end of the nineteenth century, the photographic reproduction of works of art gave art historians new instruments of research: by making it possible to bring together images of objects separated in space and time and compare them, photography illuminated phenomena inaccessible to the spectator limited to direct experience. In a text published in 1901, "Flemish and Florentine Art in Lorenzo de' Medici's Circle Around 1480," Warburg writes: "With the aid of photographs, the comparative study of paintings can now be carried further, and the use of hitherto untapped archival resources can clarify those issues that relate to individual

lives."[15] Burckhardt was the first, according to Warburg, to under-
stand the importance of the photographic reproduction of works
of art to interpretation. When Burckhardt discovered, in his *Bei-
träge*, a progressive enlarging of the donor figure in the field of
representation between the beginning of the thirteenth century
and the end of the fourteenth century, he produced a comparative
analysis based — at least apparently — on the use of reproduction.
By using this technique of "active" comparison, one can reconsti-
tute, based on a series of photographs, and better than one could
do so by looking at the paintings themselves, the growing ascen-
dancy of the donor over the course of two centuries in the tradi-
tional economy of the picture plane.

In *Christ on the Mount of Olives* by Lorenzo Monaco (c. 1370–c.
1425), a 43- by 25-inch panel, which Burckhardt still attributed to
Giotto, the figures are represented one-half life-size, except for
the donor, at the bottom left, kneeling with hands in prayer, who
is about one-third the size of the others (figure 32). This frail fig-
ure with perfectly individualized features is at the bottom of the
mountain on which the sleeping apostles are leaning and contem-
plates the scene from below, without intervening in the composi-
tion of the image. In an altarpiece by the Florentine Fra Filippo
Lippi (1406–1469) executed around 1440, the donor, Alessandro
Alessandri, and his two sons, Jacopo and Antonio, have grown in
size and now occupy half of the space granted to the bodies of the
saints; the same proportion is found in the *Madonna del Ceppo*,
commissioned from the artist by the merchant Francesco Datini
(figure 33). And in the Ghirlandaio fresco in Santa Trinita (1480–
1486), a work Warburg focused on in 1902, the donor now has
the same importance as the saint and shares his world inside the
sacred narration (figures 34a and b).[16]

In image after image, by following the size and placement
of the patron in the picture plane, one sees the appearance and

Figure 32. Lorenzo Monaco, *Christ on the Mount of Olives*. On the lower left, the donor. Uffizi, Florence.

Figure 33. Fra Filippo Lippi, *Madonna del Ceppo*. Municipal Gallery, Prato.

Figure 34a. Domenico Ghirlandaio, *The Confirmation of the Rule of the Order of Saint Francis*, Santa Trinita, Florence. 34b. Detail.

development of a new type of man, the *uomo singolare* seeking to ward off finitude not through the transfiguration of his features (which were individualized as of the Trecento) but through his progressive intrusion into the field of representation. In the desire physically to appear in an image, Warburg sees an aesthetic translation of the will to power of a new class of merchants and materialist entrepreneurs whom Burckhardt, in *The Civilization of the Renaissance in Italy*, had made into the agents of the Italian Renaissance. Nonetheless, even in the imminent spatiality of Ghirlandaio or Hugo van der Goes, whatever the relationship among the figures, the patron is always depicted in a hieratic attitude, in profile and with hands in prayer, immobile or kneeling, in such a way that it is not the donor himself who appears to be represented but his identifiable, almost descriptive effigy, which suggests the presence of an intermediate entity between the physical body and its pictorial representation, an entity whose identification would seem necessary to Warburg for elucidating the mechanics of figuration.

In the fresco in the Sassetti Chapel at Santa Trinita, where Ghirlandaio depicts an episode from the legend of Saint Francis, the elements of the sacred scene are concentrated in the foreground, inserted in front of the open scenery of the city. The fresco, writes Warburg, offers a successful example of "portraits of individuals who may be identified as members of a highly specific circle." On close inspection of this work, given all the resources in the archives and literature found in Florence, "the contemporary background emerges as a participant force with great immediacy and in entirely personal terms."[17] Whereas in the Bardi Chapel at Santa Croce the cycle of Saint Francis was depicted by Giotto in its historico-legendary form (figure 35), in Santa Trinita the story is now that of the Florentine city, where the saint's appearance emerges simply as illustration or fable: "Ghirlandaio and his

Figure 35. Giotto, *The Confirmation of the Rule
of the Order of Saint Francis*. Santa Croce,
Florence.

patron extend the donor's traditional modest prerogative of being devoutly present in some corner of the painting, and coolly assume the privilege of free access to the sacred narrative, as onlookers or even as participants in the action."[18]

The fresco was commissioned by Francesco Sassetti. He combined, writes Warburg, two contradictory ways of conceiving of the world: the idealism of the medieval Christian and the pragmatism of the pagan Etruscan merchant, a combination that produced an "enigmatic creature" who was "elemental yet harmonious in his vitality."[19] The ambiguity of Sassetti's person is echoed throughout the cycle devoted to him, where, beneath the surface of Renaissance humanism and beyond the celebration of profane values, one feels a growing sense of uneasiness permeating the representation.

If one considers the identificatory, almost hypnotic links Warburg maintained with the subjects of his study, his description of Sassetti's personality cannot fail to resound with autobiographical elements. Francesco Sassetti (1421–1490), the "type of honest and thoughtful bourgeois living in an age of transition," whom Ghirlandaio depicted in his fresco with the features of a patron and a merchant, was employed by the Medici bank in Avignon, Geneva, and Lyons before becoming the private banker of Piero de' Medici and Lorenzo the Great.[20] Like Aby turning his back on the family bank, which, as the eldest, he was destined to head, in order to devote himself to art history, Francesco Sassetti, a man of refined culture, showed a pronounced taste for erudite and intellectual endeavors: he performed important administrative functions in the universities of Florence and Pisa, collected ancient coins, possessed a vast library, and was an ardent promoter of humanist studies, to the point of neglecting his duties as a businessman. On May 10, 1485, he wrote to Lorenzo: "I want to help all talented men as much as I can, especially those working in the humanities."[21]

The Sassetti family was traditionally associated with the Dominicans of Santa Maria Novella. After quarreling with the Dominicans, Francesco transferred the commission he wanted from Ghirlandaio, for a fresco cycle representing the life of Saint Francis, to the less opulent Santa Trinita. According to Warburg's theory, which seems quite unlikely, the prospect of seeing the life of the founder of a rival order depicted shocked the Dominicans and drove Sassetti to transfer his commission to Santa Trinita.[22] The decoration of the chapel, in the northern part of the transept of the Franciscan church near the sacristy entrance, began in 1479, the year of the death of Francesco's eldest son, Teodoro, and the birth of another son of the same name. It was completed in 1485.

The custom of outfitting chapels inside a church and having Masses said for the family's dead first appeared in Tuscany at the end of the thirteenth century. The task assigned to Ghirlandaio, as one learns from a preparatory drawing preserved in the print collection in Rome, still shows a traditional Franciscan subject.[23] It was clearly altered during its execution in the Santa Trinita chapel, in a composition organized around the tombs of Francesco Sassetti and his wife, a descendant of a family of Etruscan lineage, Nera Corsi, whom Francesco had married in 1459. Deviating from the cycle of Saint Francis as one finds it represented at Santa Croce — in Giotto's Bardi Chapel or in the marble reliefs for the pulpit in the nave, sculpted in the 1470s by Benedetto da Maiano — Ghirlandaio transposed episodes of the saint's life into a contemporary context and represented sites of the donor's activities in the background: the *fabbriche* of Assisi have been replaced by contemporary views of Geneva and Florence.[24] The tombs of Francesco and his wife were inserted in semicircular niches, called *arcosòli*, or recesses, on the level of the frescoes and situated on the sides of the chapel at exactly the same height as the empty sarcophagus in the center of the painted Nativity on the panel above

the altar (figures 36 and 37). The deceased are depicted in full-length portrait, quite reduced — they measure about 3.9 feet — between the real tombs and the image of the empty tomb, making the scenography of the chapel suggest the assumption of the deceased bodies in the representation (figures 38 and 39).[25] On the right-hand wall of the chapel, beneath the niche housing Sassetti's tomb, a relief sculpted by Giuliano da Sangallo, inspired by a sarcophagus representing the death of Meleager, shows a corpse partially enveloped in a shroud and stretched out on a catafalque with torso half raised. To the left, a seated woman weeps, while two others, with hair in disarray, throw arms heavenward: together they express the two sides of grief, one melancholic, the other convulsive (figure 40). The bas-relief, like a commentary, brings out the double continuity between Sassetti's tomb and the full-length portrait of him: it demonstrates the passage from physical death to survival in an image (the corpse rises, accompanied in its resurrection by the ecstatic transformation of the weeping woman into a maenad), giving Ghirlandaio's frescoes over these funeral reliefs and the tombs of Sassetti and his wife what Panofsky would call in 1964 the quality of an "exorcism."[26]

Proceeding from the panel representing the Nativity to the fresco immediately over it, one finds the depiction of the miracle of Saint Francis resurrecting a child (see figure 43, center). The background of this scene has a profane setting: the Santa Trinita square and bridge, the extension of which opens onto Via Maggio, and, on either side of the square, the Spini and Gianfigliazzi palaces. On the right: the facade of Santa Trinita as it appeared before its rebuilding by the architect Bernardo Buontalenti in the sixteenth century.[27] According to Ludovico Zorzi, this fresco constitutes one of the first speculative and self-contemplative scenographic documents in Italian painting.[28] The painted space opens onto the area surrounding the church — as it appeared at the time

of its execution — in such a way that the space of the Sassetti Chapel seems to turn inside out, like a glove: the fresco's surface functions as an inverse window, a window that opens not onto a distant space, an imaginary or far-off landscape, but onto the exterior of Santa Trinita itself, in a fashion strangely anticipating the camera obscura. Entering the church and approaching the Ghirlandaio frescoes, the spectator proceeds smoothly from the sight of the real city to that of its representation: he returns to the world by means of images.

If one now considers *The Confirmation of the Rule of the Order of Saint Francis* in the chapel's lunette (figures 34a and 42), which opens onto another Florentine setting (the Piazza della Signoria), one understands that the empty tomb painted on the lower panel and the resurrected child on the middle fresco develop a common theme: they prepare and justify Sassetti's intrusion into the historico-legendary space of the upper fresco as a middle realm between the sarcophagus containing the patron's real body and his effigy. The tomb at the right of the chapel, which contains — or is thought to contain — Sassetti's real body, becomes the empty tomb of the *Nativity*, and the empty tomb in turn prefigures the resurrection of the child and Francesco's reappearance, above, in the real setting of the Florentine city.

Francesco's entrance into the image echoes, in transfigured form, his body's entrance into the chapel. He takes his place in the painting with his entourage — his *Umwelt* — intruding into the sacred narration as well as into the city's history, creating the conditions for his fictive appearance: "Neither loggia nor choir stalls, not even the balustrade behind the bench of Cardinals, can shield the pope and Saint Francis from the intrusion of the donor's family and their friends."[29] The patron appears to bear witness, through his gesture of devotion, to a religious concept of existence, yet his effigy is first and foremost profane: he participates in the

Figure 36. Giuliano da Sangallo, tomb of
Francesco Sassetti. Santa Trinita, Florence.

Figure 37. Domenico Ghirlandaio, *Portrait of Nera Corsi*. Santa Trinita, Florence.

Figure 38. Domenico Ghirlandaio, *Portrait of Francesco Sassetti*. Santa Trinita, Florence.

Figure 39. Giuliano da Sangallo, bas-relief under the tomb of Francesco Sassetti, detail. Santa Trinita, Florence.

commemoration of the saint in order to give a lasting testimony of his person and his power. In making the commission, Sassetti sought not to incorporate himself into the narration but to use to his advantage the field of representation in both its dimensions: the historico-referential (the city of Florence) and the sacred (the legend of Saint Francis). Warburg removes Sassetti's mask of piety when he writes: "The portraits on the wall of his chapel reflect his own, indomitable will to live [*Daseinswillen*], which the painter's hand obeys by manifesting to the eye the miracle of an ephemeral human face, captured and held fast for its own sake."[30]

The donor's image parasitizes the hagiographic sequence evoked by the saint's presence, reducing it to a secondary action and rendering it nothing more than the guarantee of the votive efficacy and legitimacy of the image (see figure 34b). Sassetti, in having himself represented in the legend of Saint Francis and commissioning two tombs in a pagan style from Giuliano da Sangallo, responds to a very ancient survival rite running through the figurative apparatus of Christian belief.

In 1907, in "Francesco Sassetti's Last Injunctions to His Sons," a text written in light of documents unknown to him in 1902, Warburg tempered his very Burckhardtian interpretation of the frescoes in Santa Trinita as a symptom of the will to power of a patron governed by profane ideals. The presence of the Sassetti *consorteria* in *The Confirmation of the Rule of the Order of Saint Francis* and the *Resurrection of the Boy by Saint Francis* henceforth seemed to represent signs of real devotion to him. Fra Modesto Biliotti's chronicle, recently discovered, documented Sassetti's transfer from Santa Maria Novella to Santa Trinita; in a newly discovered letter to Sassetti, Marsilio Ficino refers to the two chapels in Sassetti's home as an indication of authentic piety; and in particular a testament left to his two sons on the eve of a trip to Lyons in 1488 had

been exhumed — all these led Warburg, in 1907, to reevaluate the Christian component in Sassetti's culture and to underscore its archaizing side.[31] The general design of the images in the Santa Trinita chapel, where, without organic unity, pagan naturalism and medieval religious fervor lie side by side, bears witness to a contradiction that would later be resolved in Ghirlandaio's work on the Tornabuoni Chapel in Santa Maria Novella. In a letter to his Dutch friend the philosopher André Jolles, Warburg asserts that he no longer sees any trace of Christian devotion in the frescoes of the Tornabuoni Chapel, and considers them a domestic art made for a Renaissance banker:

> Would you immediately recognize the biblical events as the main subject? Certainly not; you would hardly suspect at all that this is an illustration of the New Testament. One would rather think that this is an official family party; an old butler stands in a Renaissance loggia and busies himself at a genuine antique buffet to get the punch ready. A young servant hurriedly brings the lemon he has been waiting for so long.[32]

The banker who commissioned the frescoes, Giovanni Tornabuoni, is to Francesco Sassetti as a comic figure is to a tragic actor. Warburg caricatures him as follows:

> Saturated sponge of prosperity ... well-fed and well-padded ... the nicely rounded Giovanni Tornabuoni with his imposing bulk and his large tired eyes whose broad back had been so comfortably warmed by the sun of good fortune ...[33]

Frozen Between Bodies and Images

In the third part of the 1893 text devoted to Botticelli's painting, "How the Works Came to Be Painted: Botticelli and Leonardo,"

Warburg noted that *Spring* and the *Birth of Venus* and an entire series of works of the Florentine Renaissance depicted in the face of the nymph Flora an identical, slight peculiarity: "The lower lip droops very slightly."[34] In Warburg's eyes, this constituted an identifying mark contradicting the idealization of the young goddess's features. From this he deduced that in the features of the nymph the painters sought to depict a real woman, whom he identified as the beautiful Simonetta Cattaneo. Born in Genoa, Simonetta married the Florentine Marco Vespucci and died of consumption at the age of twenty-three. Angelo Poliziano had depicted her in *La giostra*.[35] She may have sat for a portrait, now in the Chantilly museum, executed by Piero di Cosimo between 1485 and 1490, an asp around her neck.[36] By 1893, the softening of the faces, progressively dissociating the bony structure from its exterior flesh, had come to seem an irrefutable sign to Warburg of the presence of an individual portrait in the image, and the study of movement had begun to yield to an unease with regard to time.

Resuming the same type of analysis for the Ghirlandaio fresco in 1902, Warburg uncovered signs of the physical presence of subjects in certain alterations of features, in signs of aging — at times almost invisible — irrefutably inscribed on the models over time and contradicting the idealizing function of the images. Lorenzo de' Medici appears with "a flattened nose" that has "a bulbous, *drooping* tip" and with "the shrunken features of a man in pain." His face contrasts with that of Angelo Poliziano, sensuously swollen, full, and pink, in which a slight sagging still recalls the laws of fate: Poliziano "of the unmistakable — and much mocked — aquiline nose, with its *pendulous*, Epicurean tip; the shallow upper lip; and the full-lipped gourmet's mouth" (figure 40).[37]

Warburg spends more time on the figure of the court singer Luigi Pulci, also depicted in the fresco. He describes his "gaunt, pale, joyless face, looking up trustfully, if gloomily, at Lorenzo; a

prominent nose with heavy nostrils, a thin upper lip, resting on the prominent lower lip with a hint of embitterment" (figure 41). He then compares it with another portrait, found on Filippino Lippi's fresco at Santa Maria del Carmine in Florence, a portrait made from a death mask in 1484, after Luigi's death (figure 42). He notes Luigi's lugubrious appearance, "suggested by its lifeless look, which contrasts with all the lively-looking heads that surround it, by the hollowness of the eye socket despite the superimposed half-open eye, by the absence of hair, and by the awkwardly positioned neck." It is difficult to recognize the same person in the frescoes of Ghirlandaio and Filippino Lippi without performing a veritable figurative autopsy, as does Warburg, in order to settle the identity of the two heads: "The whole lower half of the face, including the relative positions of nose, lips, and chin, together with the highly individual expression of weary resignation, is entirely the same in both heads."[38] If one slips the figure from Santa Trinita over the one from the Carmine, it appears in all its morbidity: beneath the exterior flesh (the thick nostrils, the fleshy lower lip), another face comes through, drawn and pale, ectoplasmic, without expression or padding. Given that Luigi died before Ghirlandaio's fresco was completed, one understands the sadness overwhelming the face in the Santa Trinita cycle: the bitterness, the melancholic gaze Warburg believes he detects, become translated in his eyes to Luigi's consciousness of his untimely demise.

In Warburg's analysis, Ghirlandaio's fresco becomes a composite space peopled with figures copied from the living and the dead alike, whose images are slowly transformed into intermediaries between the living and the dead. The impression produced by these enigmatic beings should be seen in light of Warburg's interpreting, in the study on Ghirlandaio, the appearance of the individual portrait as being derived from the ancient pagan custom

Figure 40. Domenico Ghirlandaio, *The Confirmation of the Rule of the Order of Saint Francis*, detail: portraits of Angelo Poliziano and Giuliano de' Medici. Santa Trinita, Florence.

Figures 41 and 42. Above: Domenico
Ghirlandaio, *The Confirmation of the Rule of
the Order of Saint Francis*, detail: portrait of
Luigi Pulci. Santa Trinita, Florence.
Right: Filippo Lippi, portrait of Luigi Pulci,
detail from *Raising of the Son of Theophilus*.
Florence, Brancacci Chapel, Santa Maria del
Carmine (the fresco, begun in the 1420s
by Masaccio, was completed by Lippi in the
1480s).

Figure 43. Sassetti Chapel, view of the whole.

adopted by the Church of allowing wax replicas of donors into the sacred space as votive offerings: "By associating votive offerings with sacred images, the Catholic Church, in its wisdom, had left its formerly pagan flock a legitimate outlet for the inveterate impulse to associate oneself, or one's own effigy, with the Divine as expressed in the palpable form of a human image."[39]

In "Francesco Sassetti's Last Injunctions to His Sons," his 1907 appendix to "The Art of Portraiture and the Florentine Bourgeoisie," Warburg compares the art of portraiture as Ghirlandaio practiced it in Santa Trinita to the Florentine bourgeoisie's custom of suspending their life-size wax effigies from the vault of the Santissima Annunziata as an offering or as thanks:

> [The painted portraits] are there to commend themselves to the saint's protection. To those whose susceptibilities, as far as the Renaissance is concerned, are purely artistic, such devout ostentation may seem merely crass; but to the Florentines of the day, accustomed as they were to gazing reverently at the throng of fashionably dressed, internationally endowed life-size waxworks in SS. Annunziata, it could never remotely have seemed excessive or profane.[40]

As Georges Didi-Huberman has shown, the *boti* are the missing link in the history of the fifteenth-century portrait: Florentine art of the Quattrocento retained, in the individual portrait, a trace of a very ancient culture while at the same time making it a symbol of Renaissance humanism.[41] The art of portraiture thus rests on a fundamental ambiguity: while it reveals a community's harmony with itself, with the city, and with the city's institutions, it favors the resurgence of archaic rituals related to an uneasiness about the survival of the body. Warburg stresses this ambiguity when he writes:

This lawful and persistent survival of barbarism, with wax effigies set up in church in their moldering fashionable dress, begins to cast a truer and a more favorable light on the inclusion of portrait likenesses on a church fresco of sacred scenes. By comparison with the magical fetishism of the waxwork cult, this was a comparatively discreet attempt to come closer to the Divine through a painted simulacrum.[42]

As in the Giotto cycle in Santa Croce (see figure 35), the figures in the Santa Trinita frescoes are life-size; their clothing falls almost without folds, in somewhat rough volumes. But the detail on the faces, stamped with the appearance of life, individualizes the figures and refers to their models in the heart of Florence. Ghirlandaio, in individualizing the features and sharpening the contours, seems to have depicted less the real figures than their effigies found analogously or as prototypes in the wax ex-votos hanging from the Santissima Annunziata. Within the fresco, the transformation of the body into representation is completed, which the *boti* prefigure and help to explain.

During the first decade of the twentieth century in Vienna, Julius von Schlosser undertook to trace the history of wax modeling, and continued Warburg's study beyond the moment when the superstitious practice of exhibiting the *boti* died out, making way for the cultivation of the portrait among the Florentine bourgeoisie.[43] This history, conceived as one of the survival of a custom, is the reverse side of that of the painted portrait, whose secret meaning it reveals: it shows that the portrait should be defined not only on the basis of its mimetic ability (its conformity to the person it represents) but also by the dramatic values of its appearance *in effigy*. The hyperrealist and superindividuated wax portrait carries the deep trace of the myths of safekeeping that

one finds throughout the history of the representation of bodies in images. As Thomas Medicus has shown, Schlosser's research into wax modeling feeds on both the morbid and the animist sentiment that continued, at the threshold of the twentieth century, to give rise to the photographic reproduction of bodies.[44] The molded figures are analogous to the frozen models whose features became imprinted on photosensitive plates during prolonged poses, models brought into representation along with every single detail of their exteriors, definitively removed from organic time and entering documentary time. The wax portrait found in photography a last, fleeting manifestation of itself before being relegated, as Schlosser wrote in 1911, to wax museums, fair booths, and barbershop windows.

The practice of wax portraiture imperceptibly tips the question of the reproduction of appearances toward that of the physical occupation of the picture plane. Reference to the *boti* thus makes it possible, in Ghirlandaio's frescoes, to open up an intermediate theatrical space between the universe of the city and that of ritual. Perhaps this is the real meaning of the stairway that opens onto the foreground in the upper fresco in Santa Trinita (see figure 34a): it requalifies the space of the representation as a stage on which the spectacle of Sassetti's transfiguration unfolds. Warburg recapitulates the list of all the figures included in his study (some of whom had appeared as early as 1893), as if it were a matter of assigning roles to actors:

[Standing in front of the Santa Trinita fresco.] It is time for a scene change: the contemporary backdrop, painted with the Palazzo Vecchio and the Loggia de'Lanzi, has already been lowered into place; in the wings, the Sassetti stock company awaits its cue. Enter, through a trap, three little princes [Giuliano, Piero, and Giovanni de' Medici] and their professor — learned in all matters pagan, privy dancing

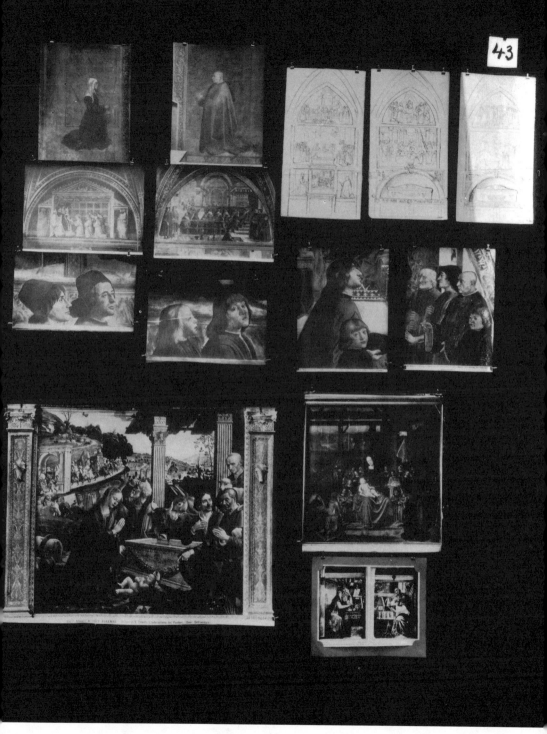

Figure 44. *Mnemosyne*, pl. 43: the Sassetti
Chapel deconstructed.

master to the nymphs of Tuscany [Angelo Poliziano] — together with a witty domestic chaplain [Matteo Franco] and a court balladeer [Luigi Pulci], all ready to launch the intermezzo. As soon as they reach the top step, even the cramped space still occupied by Saint Francis, the pope, and the consistory will be taken over as a playground for secular diversions.[45]

Three Portraits of Maria

> Marotte (1468), Mary's "doll." 1. Hand puppet (as opposed
> to a marionette) mounted on a stick, draped with a cloth
> body. By extension, a woman's head made out of wood,
> cardboard, or wax used by hatmakers and hairdressers to
> dress their shopwindows. 2. *Idée fixe*, mania.

In his 1893 study, Warburg turned a conventional art-historical question on the reworking of figurative types from Antiquity into a question on the representation of bodies in movement. Nine years later — in 1902 — he broadened this shift, giving it a clearly animist meaning in both his text devoted to the Ghirlandaio cycle in Santa Trinita and a simultaneous study on the interactions between Italian visual culture and Flemish art at the end of the fifteenth century, "Flemish Art and the Florentine Early Renaissance." In the second essay, Warburg described in succession three paintings of the same model, executed over many years, by two painters, Hugo van der Goes and Hans Memling: taken together, these three portraits of Maria Portinari, wife of a Medici representative in Bruges, Tommaso Portinari, show us what Warburg calls "the three successive ages of woman . . . seen with remorseless, almost symbolic clarity."[46]

In Ghirlandaio's fresco in Santa Trinita, Warburg described a figure and his retinue entering the representation as a psychopompic ritual: Sassetti leaves the world in order to be reincar-

nated in an image. The successive portraits of Maria allow for a glimpse at how an individual, after entering the universe of representation, continues to be transformed there. The point is no longer, as in the Santa Trinita fresco, to scrutinize the moment a figure appears in a painting but, rather, to observe the phenomena of corruption — the dark side of the generation of forms — affecting the figure in the space of representation itself.

The first portrait, now in Turin, is by Hans Memling, the favored painter of the rich colony of Italian merchants set up in Bruges. Max Friedländer describes, in a paradoxical manner, how Memling's preoccupation with individuality was part of his quest for the ideal:

> A searching examination reveals his portraits as more individual than a superficial inspection would suggest.... The main lines are selected and defined with flexible, pure and subtle draftsmanship. The chance play of light is eliminated, abrupt and striking contrasts avoided. A gentle, slow, even and full projection of form is achieved more by wise manipulation of the line than by strong shadows."[47]

For Warburg, by contrast, Memling's portrait of Maria proceeds from the individual history of the sitter, translating her physical as well as psychological peculiarities. "In the Turin portrait," he writes, "Maria has yet to outgrow the diffidence of extreme youth; her childlike face seems ill-at-ease beneath the heavy Burgundian hennin with its long veils" (figure 45).[48] Significantly, the portrait is referred to not by the name of its painter, as one might expect, but by the place where it now resides, Turin. Warburg suggests that there is a direct relationship between the model and the painting, which is not mediated by the artist, whose function thus becomes slightly blurred.[49] In other words, the painting is qualified not simply by its site but also *as* a site in which the figure comes forth

in its transformation into a painted being. And this being in turn is no longer entirely a fabricated image related to its model merely by bonds of likeness; it is a being of flesh changed into representation that conjures up the fate of the body in portraying the simple fact of its existence. The neat shapes of Ghirlandaio's effigies rework the thick, heavy silhouettes of the *boti*; Maria's long, transparent veil falling the length of her body is, by contrast, like an aura, the enigmatic agent of the de-realization removing her from the universe of bodies in order to transport her into that of figures. Barely emerged from childhood, Maria trails this gauzy fabric behind her, giving her frail body a spectral appearance. Archetype of the Flemish Renaissance portrait, Maria, covered by a veil stirred by no wind, stands in contrast to Botticelli's Venus, whose hair and garment billow freely. Her image is one of immobility, but also of introspection. Maria is "ill-at-ease" in this veil, which haloes her body in an unreal haze, and beneath the headdress shackling the free expansion of her energy: they foretell the fate of her flesh and her appearance, the inescapable law of nature and the force tearing her from childhood.[50]

The expression of this unease, this *Unbehagligkeit*, coupled with a kind of shyness in the Turin portrait, yields to a "ghost of a smile" in the second portrait, also by Memling (figure 46):

> In the Paris painting, she wears the hennin as the natural emblem of woman's estate; and in keeping with her standing in life she has learned to carry off a resplendent necklace — cinquefoils of massive gemstones on a web of gold — with a sophisticated ghost of a smile that does not quite suit the praying posture of her hands.[51]

In the work referred to as "the Paris painting," Maria seems to have integrated the laws of time and rank; henceforth she easily carries the woman's robes that floated around her as she emerged

from childhood. As in his 1893 study, Warburg is interested in the figure's attributes and the details concealing the work's latent meanings. He notes that, to the headdress, which Maria also wears in her first portrait, Memling has added a heavy necklace of jewels and gold to decorate her neck, a common feature in the female portrait in the Flemish tradition. This necklace conveys a particular meaning here: the mixture of timidity and malaise has given way to the smile Warburg notices, which he interprets as bearing witness to a lucidity and harmony with the profane world, in contrast to the devotion implied by the hands in prayer. Just as Sassetti had his person replicated in the fresco "for its own sake," as Warburg wrote in 1902, Maria's smile seemed to indicate an accord with existence and a confidence in the powers of representation, suggesting that the process of converting the body into an image had already begun. Unless one sees on her lips not a smile half drawn but a smile half erased ... This smile would then be caught as it was disappearing, as rigidity began to take over Maria's limbs, frozen in the ritual position of the orants.

A third work is summoned to back up this theory, Hugo van der Goes's famous triptych (around 1475) now in the Uffizi, the right-hand panel of which shows Maria (her husband, Tommaso, is depicted symmetrically on the panel to the left). Warburg describes the overwhelming presence of accessories and finery in this painting as symptoms of petrifaction (figure 47):

> The third portrait reflects an even greater degree of luxury, for the hennin is now strewn with pearls; but all this magnificence is no longer an occasion for joyous self-congratulation. Maria kneels, with a look of resignation, under the protection of Saint Margaret and Saint Mary Magdalene, and her finery is now a purely external attribute, the churchgoing dress that was expected of ladies of rank at the Burgundian court. Her haggard look in this Uffizi triptych is

127

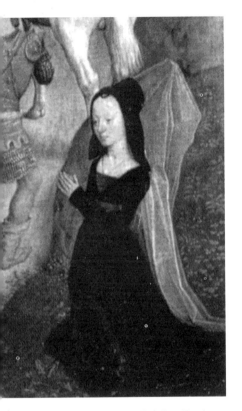

Figure 45. Hans Memling, *Passion*, detail: portrait of Maria Portinari. Galleria Sabauda, Turin.

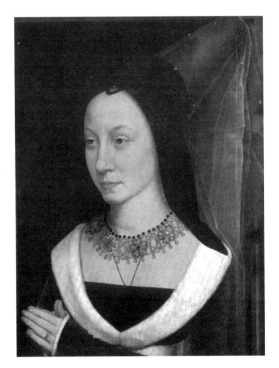

Figure 46. Hans Memling, *Portrait of Maria Portinari*. Metropolitan Museum of Art, New York.

Figure 47. Hugo van der Goes, *Adoration of the Shepherds*, right-hand panel: portrait of Maria Portinari. Uffizi, Florence.

perhaps a little exaggerated, as seen through the astringent tempera-
ment of Hugo van der Goes; but his tendency to "pare down" alone
does not explain the profound alteration of Maria's features. The
years 1470–1477, in the course of which she had given birth to her
children Maria, Antonio, Pigello and perhaps Margherita as well, had
left their mark.[52]

In the triptych, which he recognized as a major contribution to
anti-rhetorical, static painting, at odds with the idealized style
practiced by Renaissance artists influenced by the models of
Antiquity, Warburg saw Maria, only twenty years old at the time
of the painting's execution, as exhausted by the successive births
of her children (five had already been born, five more were to
come).[53] In Memling's second portrait (figure 46), and in the
work by van der Goes (figure 47), Maria is depicted in a similar
posture, hands in prayer, and she wears the same clothes and jew-
els. The dress edged with ermine at the collar and cuffs, the neck-
lace, the ring, the hair in a headdress, and the faint eyebrows are
identical, except that the hennin is studded with pearls in the van
der Goes painting, as an indication of a mineralization echoed in
the background of rocks. The three works were executed by two
artists at different times, but the same figure appears to go from
one to the other, with a slight pivoting progressively uncovering
her profile while her appearance is imperceptibly altered. In the
van der Goes triptych, Maria has lost her bloom of youth and her
slight smile, her skin is more yellow, her limbs stiffened in an atti-
tude of morose piety, while her angular features come to reflect
the rocky scenery around her (figure 47).

In examining the signs of Maria's physical alteration over the
course of the three portraits, Warburg applies the ancient medical
technique of prognostics. Pliny, in his *Natural History*, indicates
its use in painting with regard to the portraits of Apelles, which

were so perfect, he said, that they re-created faces not simply as they were but as they would become:

> [O]ne of those persons called "physiognomists" who prophesy people's future by their countenance, pronounced from their portraits either the year of the subjects' death hereafter or the number of years they had already lived.[54]

The painted surface appears to be but a transparent screen between the model and the historian looking at him or her, a screen revealing not immobile figures but figures delivered to the grips of time. Thus the stages of Maria's entry into the universe of representation reveal the spectacle of her physical deterioration. She is depicted in several stages of her existence, and her maturation takes on the double, contradictory aspect of hardening and desiccation, or *marasmus*, which Galen's theory of the humors interpreted as the complete — and irreversible — consumption of all humidity in hardened organs and an emaciation comparable to a gradual melting.[55] "What is old age but a path that leads to death? Death is the extinction of natural heat and *marasmus* resembles old age." Maria's features harden, her bones show through her emaciated flesh, while her jewels, her clothing, and their clasps envelop her body as foreshadowings of funerary dress. According to Warburg, the Portinari triptych transforms Maria into a votive effigy, a transformation whose completion coincides with her disappearance from the world of the living.

If one examines the links between the two studies Warburg published in 1902 beyond the similarity of the themes and compositions, one notices that the votive nature of Ghirlandaio's and van der Goes's works caught his attention at the same moment. Warburg went so far as to see a causal relationship between the two works. The Portinari triptych's arrival in Florence in 1483, two

years before the Santa Trinita cycle was completed, might indicate a direct influence of the van der Goes painting on Ghirlandaio, an influence immediately sensed in the similarity of the central panel of the Portinari triptych and the altarpiece of the Santa Trinita cycle, both of which depict a Nativity.[56] The interiorization of movement in the treatment of the figures would thus indicate a northern presence in the culture of the Italian Renaissance. In 1901, Warburg attributed the transition from the representation of movement to that of interiority in Italian art at the end of the Quattrocento to Flemish influence. In his opinion, "What they learned from Flemish artists was not the embodiment of life in motion but the psychology of the interior."[57]

During a lecture given on January 19, 1929, at the Biblioteca Hertziana in Rome, before the reproductions from *Mnemosyne*, Warburg once again returned to the relationship uniting the two painters, giving it a symbolic signification that was supposed to underlie and accompany any stylistic analysis.[58] Here again he suggested an active intervention on the part of the protagonist (Sassetti) in the formation of the work:

> In the tomb-chapel of Francesco Sassetti the army of *revenants* which bewails his death with uninhibited passion as though he were Meleager finds Northern allies in the rites for his soul. While Ghirlandaio …recounts the legend of St. Francis, the *avvocato speciale* at the Last Judgment, in the style of Flemish characterization, Francesco himself expresses his shepherd-like devotion on the panel in the manner of Hugo van der Goes.[59]

In the studies Warburg published in 1902, connections are at work not only among the images but also between the images and the texts, and inside the texts. Given the importance granted to the photographic reproduction of works, their placement on the

page itself takes on meaning with regard to traditional laws of scholarly communication. Through analogy with the painting, the printed page seems to have been imagined as a map. The text is no longer a nebulous medium for transmitting meaning; it is considered from every vantage point, including its spatial configuration. In a note on Maria's descendants, in which he discusses the young girl depicted beside and slightly behind her mother in the van der Goes triptych (she seems a smaller replica of Maria, whose name she also bears), Warburg establishes the date of her birth:

> The daughter kneeling next to Maria Portinari is the eldest, also a Maria, whose exact age is not given in the 1480 *catasto*; nor is that of her sister Margherita, although the order of listing shows that Maria was the elder. As seen in the triptych, she is clearly older than Antonio, who was born in 1472.

The notes develop an underlying interpretation of the text, according to which the Uffizi triptych might represent a propitiatory rite:

> If Margherita had been born by the time the painting was commissioned, she would surely have been included, as the saint shown is her patroness, Saint Margaret, who was also the saint most invoked by women in childbirth....
>
> Perhaps Margherita was born while van der Goes was working on the painting; in any case, in Florence the Portinari lived in the parish of S. Margherita and owned a chapel in the parish church.[60]

The execution of the painting would not, then, follow but *precede* Margarita's birth. In van der Goes's work, the Portinari are depicted beside the saint not to thank her but to supplicate her as

the patroness of childbirth. A sign in the painting furthermore recalls the name of Margarita as a visual incantation: Maria, whose pregnancies followed one after the other and sapped her energy, wears pearls in her hennin. They are a sign of her desiccation, as we have seen, but are also put there as amulets: the sewn marguerites (daisies) on her headdress refer in their very name to the protective saint who will give her name to the child-to-be-born.[61]

Thus Warburg enumerates the list of Maria's children in a note, and this archival document, in its dryness, coupled with the image of Maria, assumes incantatory accents foreign to the conventions of art history (figure 48). In the layout of the *Jahrbuch* article, the text of the note forms a column running the length of the reproduction of her portrait. The names of Maria's children accompany her image in the form of a scroll, as a litany of her fecundity:

> The children's names were as follows: (1) Maria, 1471–?, became a nun in 1482; (2) Antonio, 1472–?; (3) Pigello, 1474–?; (4) Guido, 1476–after 1554; (5) Margherita, 1475(?)–?, married Lorenzo Martelli in 1495(?); (6) Dianora, 1479–?, married Cornelio Altoviti; (7) Francesco, before 1487–after 1556, a cleric; (8) Giovanni Batista; (9) Gherardo (?); (10) Folco (?). The two last-named are recorded only in an unverifiable source in Biblioteca Riccardiana, Florence, Ms. 2009.[62]

A shredded cloth is all that remains of the story of these individuals. If the memory of Maria's children is lost to the night of time — their deaths are indicated only by a question mark — Maria, beyond disappearance, seems to continue her journey. In the following note, as if the thread of a buried thought were unwinding, Warburg indicates that he believes to have found her in a work created in the same Florentine milieu as the Portinari altarpiece: the Memling triptych of the *Last Judgment*, painted for Angelo

Tani and stolen by a Hanseatic pirate before ending up in Danzig.[63] Warburg identifies Maria, lost in the middle of a crowd (figure 49): "Might not the woman who is being resurrected in the foreground, and she clutches her brow in terror, be Maria Portinari?"[64]

Maria, prey to the malaise already gripping her in Memling's Turin portrait, seems to go from painting to painting, taking her place as a footnote on the page. The first three portraits trace the curve of her existence from adolescence to maturity. The last image shows her at the moment of resurrection. But Warburg dates the Danzig *Last Judgment* to 1473, before the Uffizi triptych: this resurrection, therefore, has nothing to do with Christian belief. Maria drifts through history irrespective of the chronology of the works: she appears here and there, found through chance discoveries, given over to the historians' searches, which Warburg treats both as a game and as a demiurgic task.

The analysis of Maria's portraits was based on a comparison of the three paintings, which was facilitated by photographic reproductions. Elsewhere, in the preface to "The Art of Portraiture and the Florentine Bourgeoisie," Warburg stressed the importance of such reproductions, underlining the great change undergone by art history after Burckhardt. Yet the type of analysis developed in the 1902 studies is not merely the result of new analytic tools provided by photography. Something now exceeded the purview of static comparison: the sweep of the three portraits of Maria reproduced, in an elliptical foreshadowing, the movement of a single body through a succession of juxtaposed images. It was now a matter of comparing or contrasting not two images, in conformity with the method of double projection elaborated by Wölfflin, but three — a succession of planes representing the same subject at different moments of her development. It is no longer

Figure 48. Hugo van der Goes, *Adoration of the Shepherds*, detail: Maria Portinari, in Aby Warburg, "Flandrische Kunst und florentinische frührenaissance Studien" (1902).

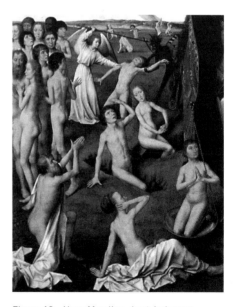

Figure 49. Hans Memling, *Last Judgment*, detail. Gdansk, Marienkirche. In the foreground, according to Warburg, Maria Portinari.

as if one painter after another treated the same model, but as if the model herself travels from painting to painting and gathers, in her being as image, the modifications of her fleshly being. The same phenomenon is found in a note to "The Art of Portraiture and the Florentine Bourgeoisie" devoted to Giuliano de' Medici, whose vital principle seemed to have been exhausted in the successive works depicting him: "By a strange irony of fate, Giuliano, the carefree child whom Ghirlandaio leads by the hand into Florentine art, makes his departure from it as an ideal type of prematurely spent vital power: as the duke of Nemours, on the tomb by Michelangelo in S. Lorenzo" (figures 40 and 50).[65]

Decoding the three successive portraits makes it possible to reconstruct, four centuries later, the life of a Florentine bourgeois woman, her brutal emergence from childhood, her pregnancies, her decline. Warburg is not contented merely to look at the juxtaposed portraits as a string of images; he manipulates them, following the protocol of the "*Bruchstücke*" (Fragments) of 1890, in order to produce his own study material.[66] The wooden panel painted in oil or the wall covered in fresco, once photographed and rearranged according to the exigencies of analysis, does not, like a window, refer merely to the scenes depicted, but communicates laterally, through the effects of sequencing, with the images immediately juxtaposed with it.

In his monumental *Early Netherlandish Painting* of 1953, based on a series of lectures given at Harvard in 1947–1948, Erwin Panofsky devotes a fine analysis to the Portinari triptych and returns specifically to Warburg's note on the dating of the painting.[67] Taking up the list of Maria's children, he endeavors to show that Warburg confused the oldest, also named Maria, with the youngest, Margarita, remaining — apparently — untouched by the symbolic arrangement of Warburg's analysis, depicting it as a banal historiographical excursus. But Panofsky, in turn, as if unconsciously

Figure 50. Michelangelo, *Tomb of Giuliano de'
Medici*. Medici Chapel, Florence.

influenced by his predecessor, produces an analysis of the painting that goes beyond any law of iconological discourse. He begins by stressing the unusual impression created by the presence of the triptych in the Uffizi, surrounded by Italian paintings, and sees this impression originating in the Flemish work's reflecting the emergence of a complete man (*totus homo*) escaping from the medieval dichotomy between the soul and the body. Van der Goes's figures have acquired, he says, a sort of "stage presence," and the stage on which they are performing is none other than that of melancholy. When Panofsky describes the triptych, he gives a strange twist to its development, resorting to the lexicon of contemporary physics. Van der Goes's painting fully remains, in his opinion, a site of the expression of an interior energy. Contrary to the "'stable' substances" painted by Jan van Eyck, which emit no energy, whatever the arrangement of their atoms or their molecules, or the "'metastable' substances" of Rogier van der Weyden, which emit an energy under the impetus of an external cause (the metastable substances would correspond to the Botticellian moment in Warburg's analysis), van der Goes's figures are, Panofsky writes, unstable substances that emit energy in the absence of any exterior stimulus, "but in emitting rays they gradually destroy themselves":

> While this *totus homo*, "self-determining sculptor and molder of his own self," laid claim to an entirely new dignity he also found himself surrounded by entirely new dangers. Even in Italy, where his birth was preceded by a continuous development extending over nearly two centuries, his baptism was attended by that ominous godmother, Melancholy. And van der Goes, unsupported by what we call the humanistic movement, had to create him in his own image — the image of a man whose nature may be likened to that of radioactive elements. From "stable" substances no energy can be obtained by

139

any possible rearrangement of atoms or molecules. "Metastable" substances will yield energy when activated by an initial stimulus from without. Only "unstable" substances give off energy in the absence of any exterior stimulus; but in emitting rays they gradually destroy themselves.[68]

Within a profoundly naturalistic representation, the painter has revived the convention of reducing the size of the donors with respect to that of the saints protecting them, creating a contrast of "almost frightening" intensity (see figure 47). Towering like giants over their protégés, surrounded by a landscape of dry hills and skeletal trees, they appear less tutelary than menacing. Van der Goes adopted this now-obsolete convention in the panels of the triptych surrounding the central panel's scene of the adoration not out of backwardness but because he wanted to represent the figures as if caught "in a circle of solitude," creating a space that is rigorously defined by the laws of perspective but that does not correspond to the human scale.

The chromatic and formal analysis of the triptych allows Panofsky to demonstrate that the painter was trying to combine spatial depth with the multiplication of details (figures 51a and b). The result is a "vertiginous" and "terrific" tension between the lines and the surfaces that one and the same energy seems to raise up and destroy: the folds, the wrinkles in the skin, all the details of the objects and the bodies are stamped with such clarity that they appear *to be made of glass*, whereas the colors cast over the painting what Panofsky calls, quoting Paul Valéry, "a strange contradictory sheen [*une étrange lueur contradictoire*]":

> Hugo's attempt to combine a maximum of spatial depth and plastic energy with a maximum of surface detail resulted in a terrific tension not only between three-dimensional and two-dimensional

Figures 51a and b. Hugo van der Goes,
Adoration of the Shepherds, central panel and
detail. Uffizi, Florence.

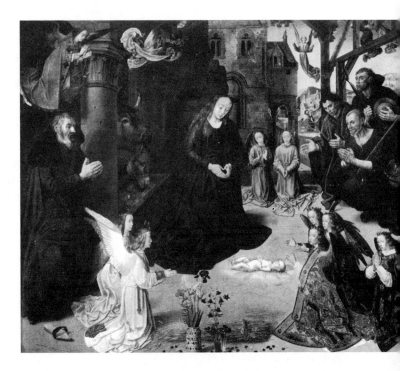

form but also between surface and line. And it is in the very preci-
sion of his design, in those *tretz netz* admired by his contemporaries
and noticeably more prominent in the Portinari altarpiece than in
his other works, that this tension can be felt. The outer contours
seem to be bent and tightened by the same internal pressures which
make the surfaces bulge and recede; the wrinkles and creases of the
skin, the strands of hair, the weave of a straw hat are etched into
these surfaces with an incisiveness which at times all but destroys
their continuity.... In the wings, the somber depth of claret, dark
olive-green, warm brown, and velvety black contrasts with pale tan
and glaring white. In the central panel, the brilliant gold-and-
vermillion of the coped angels clashes with the dark blue of the
Madonna and the dusky red of the St. Joseph, and this again with
the white, the cool aquamarine and the chatoyant green of the
other angels. The color of the soil is a dry, loamy yellow, and the
flesh tones, modeled with whitish lights, give an impression ap-
proaching lividity.[69]

On one level, Panofsky seems to echo Warburg on an icono-
graphic point regarding a secondary figure in the van der Goes
triptych. But this issue is merely a pretext for formulating a ques-
tion on the influences the immediate context exercises over the
reception and interpretation of works from the past. Now, the
strange description Panofsky developed between 1947 and 1948
remains profoundly Warburgian, but in a sense that the American
Panofsky could not deliberately assume unless it was to question
the consistency of iconological doctrine.[70]

 In 1929, after the signing of the Lateran Treaty and a few months
before his death, Warburg was in Rome. Arnaldo Momigliano,
recounting a memory of Gertrud Bing's, gives a sense of the fasci-
nation this episode held for the art historian:

Bing happened to be in Rome with Warburg, the founder and patron saint of the Warburg Institute, on that day, February 11, 1929, on which Mussolini and the Pope proclaimed the reconciliation between Italy and the Catholic Church and signed the concordat, the first bilateral agreement to be reached between post-Risorgimento Italy and the Church of Rome. There were in Rome tremendous popular demonstrations, whether orchestrated from above or below. Mussolini became overnight the "man of providence," and in such an inconvenient position he remained for many years. Circulation in the streets of Rome was not very easy on that day, and it so happened that Warburg disappeared from the sight of his companions. They anxiously waited for him back in the Hotel Eden, but there was no sign of him for dinner. Bing and the others even telephoned the police. But Warburg reappeared in the hotel before midnight, and when he was reproached he soberly replied something like this in his picturesque German: "You know that throughout my life I have been interested in the revival of paganism and pagan festivals. Today I had the chance of my life to be present at the re-paganisation of Rome, and you complain that I remained to watch it."[71]

In a controlled anachronism, Warburg was reformulating Burck-hardt's idea of the Italian Renaissance as an alliance between a religious conception of existence and the desire for power of the *condottieri* and adventurers.[72] But it is hard to say whether he was trying to understand the past in light of the present or the present in light of the past (figure 52).

Under the positivist varnish that Panofsky, in his American period, gives to his analysis of northern painting, Warburg's influence is still felt: in turn using an "anachronistic" and a reflexive method, he analyzes the Portinari triptych in light of his own epoch. At the end of the Second World War, the scene of melancholy shifted: Hugo van der Goes's work appeared to him, right

after the first nuclear explosions, as though covered by a veil of radioactivity, as if the memory of Hiroshima had become, for the time being, an insurmountable horizon of the aesthetic experience, and the art historian, in his understanding of works of art, could no longer overcome the consciousness of his own historicity.

Figure 52. *Mnemosyne*, pl. 78: the Concordat
and the resurrection of paganism.

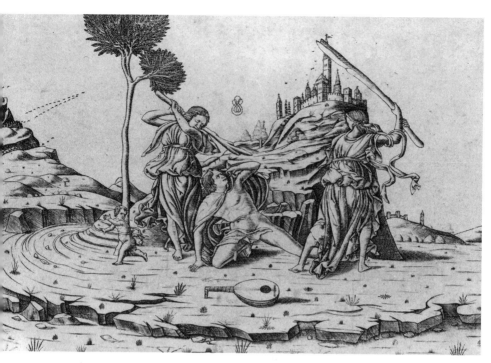

Figure 53. *Death of Orpheus*, engraving from
northern Italy (school of Andrea Mantegna).
Kunsthalle, Hamburg.

Florence III

The Theatrical Stage

The Construction of the Stage

In a text on the theme of the death of Orpheus in the art of the Italian Renaissance, published in 1906, Warburg set about demonstrating that Renaissance artists drew inspiration from Antiquity less to borrow a concept of ideal beauty than to find models of pathetic expression. He based his argument on two graphic works, a drawing by Dürer and an engraving by an anonymous northern Italian painter (probably from the school of Andrea Mantegna) (figure 53). The drawing and the engraving depict maenads — Dionysian counterparts to the Apollonian nymphs — about to engage in a violent act, that of clubbing Orpheus, who cowers on the ground.[1] In the engraving, the two enraged women and their victim, caught in a circular movement, are depicted on a plateau neatly hewn in the rocky earth like a rotating prism, with a mountain rising up behind it. The scene seems to take place in an intermediate space between reality and drawing, in a theater whose decor features a precipitous, cutout landscape, as opposed to a landscape in the natural world. In 1902, Warburg had already noted that the anonymous engraving seemed copied not from a work of Antiquity but from the final act of Poliziano's *Orfeo*, "the first Italian tragedy," which was staged in Mantua in 1472 and was,

according to Warburg, "the first attempt to confront an Italian audience with flesh and blood characters from classical antiquity," that is, the first staging of Antiquity.[2] But there is an intermediate stage between the models from Antiquity and their actualization, in which the process of imitation assumes an identificatory aspect: the encounter between the body and its image in a living spectacle. The engraving at the Kunsthalle bears a trace of this detour, and in it lies, according to Warburg, the profound mechanism behind the imitation of Antiquity by artists of the Italian Renaissance.

At the bottom of this discovery, which presupposes an underlying relationship between the surface arts (painting, engraving, drawing) and the theatrical arts, one finds Burckhardt's keen intuition on the nature of Renaissance festivities — which constitute, in his opinion, a transitional form between reality and representation. In his studies on Botticelli, Warburg mentioned this intuition and commented on it:

> Once we assume that festive performances set the characters before the artist's eyes as living, moving beings, then the creative process becomes easier to follow.... As Jacob Burckhardt — anticipating future discoveries in one of his unerring intuitive generalizations — once said: "Italian festive pageantry, in its higher form, is a true transition from life into art."[3]

When Warburg analyzed the relationship between Angelo Poliziano's poetry and Botticelli's work in 1893, and discovered a scenic dimension in the latter's paintings and drawings, he gave unusual depth to traditional iconographic discourse, showing that it need not be reduced to the simple transposition of literary and visual elements but should open itself up to the idea of the transformation of bodies into images and images into bodies.[4] In 1895, the historian published a study devoted to the Intermedi created

in Florence in 1589 on the occasion of the marriage of the arch-
duke Ferdinand I of Tuscany to Christine of Lorraine, the grand-
daughter of Catherine de Médicis.[5] Jumping one century forward
in Florentine history for purely methodological reasons, he leaves
behind the pictorial universe of the Quattrocento. Warburg con-
siders these spectacles, for which there was an exceptional amount
of documentation in the Florentine archives, an experimental
model that would allow him to uncover and comprehensively ana-
lyze the mechanisms he had already detected in the painting.

That same year, shortly after the publication of his text, War-
burg traveled to America, going as far as the Hopi villages in New
Mexico and Arizona. Attending the Pueblo Indians' ritual dances,
he believed he saw enacted before his own eyes the festivities he
had just been studying in the Florentine archives. These two
episodes, which mirrored each other, together constitute the ori-
gin of the "activist" conception of art history that Warburg would
develop in his 1902 studies, then in the creation of his library, and
last in the formulation of *Mnemosyne*. It was a matter not simply
of observing phenomena and understanding them but of repro-
ducing or resuscitating them in such a way as to erase the bound-
aries between the representation and its interpretation.

The historical leap that led to the analysis of the Intermedi,
followed by the geographical leap that led to New Mexico, brought
Warburg models of interpretation destined to enrich his studies
of late-fifteenth-century painting. The art historian followed a
path that deviated from his discipline's usual expectations regard-
ing influences and chronologies: he obeyed subterranean associa-
tions, seeming at times to be guided by chance encounters. In this
way, within the city of Florence he traced a complex trajectory,
both temporal and spatial, leading from Santa Croce to Santa
Trinita via the Uffizi, Santissima Annunziata, and Santa Maria
Novella, finding among the works in these buildings a network of

increasingly subjective correspondences. We see the same type of circulation reproduced on an intercontinental scale among Hamburg, Florence, and the Native American town of Oraibi, and we see it resurface again later, purely artificially, in the closed universe of his library.

During the whole month of May 1589, with the festivities organized for the princely marriage, Florence was transformed into a veritable *theatrum mundi*. In the city, where painted scenery was set up next to real architecture, a cosmological spectacle combining music, dance, and performance took place, mixing the registers of the profane and the sacred, the aristocratic and the popular — religious processions, masquerades, and combats between men and animals, as well as plays, ballets, and symphonies.[6]

On May 1, 1589, peasants from Peretola brought the princely couple a fountain and a maypole mounted on two chariots as symbols of fecundity. The evening of the second, Gli Intronati Senesi (The fools from Siena) performed a comedy called *La pellegrina* (The female pilgrim) by Girolamo Bargagli at the theater in the Uffizi, with Intermedi created by Giovanni de' Bardi.[7] On the third, the festival of the discovery of the True Cross was celebrated; a miraculous image of the Virgin was unveiled in the church of Santissima Annunziata. On the fourth, a game of *calcio a livrea* (football in livery) was played by nobles in the Piazza Santa Croce.[8] The Intermedi were repeated on the sixth (with this repetition indicating their reproducible nature), along with another comedy, *La zingana* (The gypsy). May 7, Easter Sunday, a high Mass took place in San Lorenzo, during which knights were dubbed. A *caccia* was held on the eighth in Piazza Santa Croce: lions tore apart a mule, dogs devoured rabbits, and fifteen horsemen killed several bulls, a bear, and many other animals. A satiric takeoff followed this hunt: a battle between rats and dogs in

which the rats prevailed, "to the great laughter of all [*con gran riso di tutti*]." On the ninth, the relics of Saint Anthony were transferred to a chapel in the Church of San Marco, after having been paraded throughout the city. On the eleventh was a parade (*sfila*), jousts (*sbarre*), and a naumachia in the courtyard of the Palazzo Pitti, which had been transformed through a complex feat of engineering into a body of water, on which ships were maneuvered by galley slaves brought in from Leghorn. The Intermedi were repeated on the thirteenth for the Venetian ambassadors, with a comedy titled *La pazzia* (Madness), performed by a famous Milanese troupe, the Gelosi (Jealous ones), with the great actress Isabella Andreini in the leading role (figure 54). Her performance made quite an impression on the audience when, feigning madness and in the tradition of the commedia dell'arte, she spoke "in Spanish, then in Greek, then in Italian, and in many other languages at random."[9] A *corso saracino* (horse race) took place on May 23, an allegorical performance on the twenty-eighth, and on June 8, for the last time, a repetition of the Intermedi.

In all the contemporary accounts, the Intermedi, complex spectacles combining dance, music, and theater, are recalled as the most splendid aspect of the 1589 festivities.[10] Between 1576 and 1582, the foreman, Giovanni de' Bardi (1534–1612), a poet and musician, had been the driving force behind the Florentine Camerata, gathering together Florentine scholars and artists who wanted to promote a reform of melodrama inspired by Antiquity, removing it from the rigid conventions imposed by court spectacles and reinforcing its clarity and dramatic unity.[11] The spectacles of May 1589 gave Bardi the opportunity to test his ideas by producing an "archaeological" image of Antiquity in harmony with the criteria of realistic imitation.[12]

Warburg based his reconstruction on three sets of documents:

Figure 54. Isabella Andreini, scene from the
Commedia dell'arte. Musée Carnavalet, Paris.

the detailed description of the unfolding of the Intermedi left by Bastiano de' Rossi;[13] the account books left by Emilio de' Cavalieri, director of the troupe of dancers and singers, which contain detailed notes on the making of accessories, costumes, and decorations; and the preparatory drawings made by the engineer Bernardo Buontalenti now in the Biblioteca Nazionale of Florence. These documents made it possible to trace the genesis of the spectacles and showed that they were, as Warburg argued, an attempt to revive artificially the mythic universe of Antiquity as the artists and poets imagined it: "The deviser, the composer, the superintendent, the designer, the machinist, and — not least — the costumer, worked together to create in every detail the contemporary idea of an authentic antique spectacle."[14]

Since the beginning of the sixteenth century, court spectacle had been losing its ephemeral aspect. It took place inside the palace, in a permanent theater designed with such performances in mind.[15] For the spectacles of 1589, Buontalenti redesigned the old theater of the Uffizi, a rectangular building of Vitruvian inspiration, where the seats were arranged in a horseshoe around three sides of the room and faced the stage.[16] He installed machines, adapted the infrastructure to the production of unusual special effects, and added a framed proscenium to the original decor, a proscenium one can actually see — as it was installed in 1589 — in an engraving by Jacques Callot depicting the Palazzo Pitti theater during the performance of *The Giant of Mount Ischia*, a play staged at Carnival in 1616 (figure 55). This separation between the floor of the stage and the room marked a step in the history of theater decoration: based on Alberti's "intersecting," it enabled one to construct, starting with the fictive surface suggested by the framing, an illusionistic space by manipulating perspective effects.[17] In a 1947 article on cinematic relief, Eisenstein still saw the invention of the

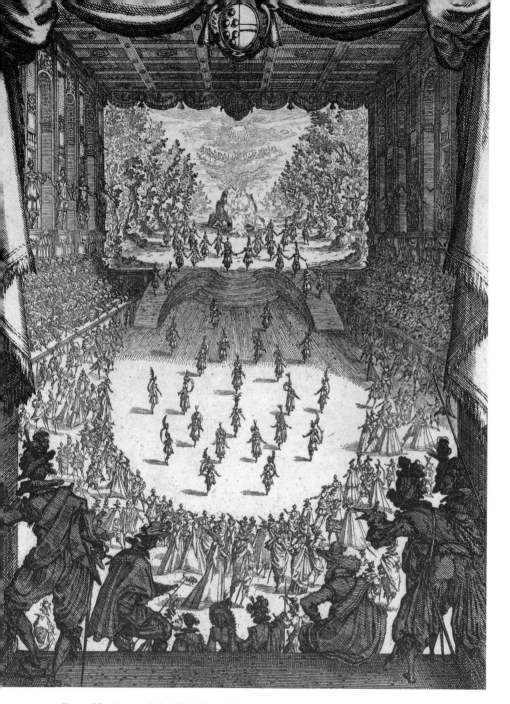

Figure 55. Jacques Callot, *The Giant of Mount Ischia*, engraving, 1616.

proscenium as one of the first manifestations of cinematographic space. It forced one to rethink the link between the spectator and the stage, starting with the structural rupture created by the framing, a rupture seeking to disrupt the tiered composition of the planes and the depth of field.[18]

The central character in Warburg's study is the engineer Buontalenti. It was he who took on the task of *animating* Bardi's concepts by creating the illusion of space and movement through decorations, stage arrangements, and machines. Bernardo Buontalenti (1536–1608) entered the service of the Medici in 1547, at the age of eleven. An anecdote reported by Filippo Baldinucci shows his precocious interest in moving bodies and animated figures:

> At a tender age [fifteen], he designed a crèche for the young prince [Francesco, the son of Cosimo de' Medici], which was considered very unusual and marvelous. For not only did the skies open and the clouds drop, and here and there a group of angels flew about while other figures walked on earth, but the many figurines proceeding toward the crèche, with such varied movements, seemed quite real.[19]

Buontalenti is also credited with perfecting a toy that prefigured the zootrope and created the illusion of movement, and with mastering the ephemeral displays of pyrotechnics:

> In the same circumstances, he invented a game made up of silhouettes cut out and arranged in a circle, then placed inside a large paper cylinder. Turning from the effect created by the smoke of a candle, they projected their shadows on the paper placed between them and the viewer. The object was called a girandole. This is how he came to be known as the girandole man, then Bernard of the Girandoles.

This was a nickname that stuck all the more when he put on the most marvelous fireworks display people had ever seen, and in between, those clever girandoles which have become so common today in public festivals.[20]

For more than a half century, Buontalenti supervised the duchy's ceremonies, building machines and designing costumes and decorations for the theater, overseeing festivals and funerals alike.[21] He was the creator of "accessories" (*skeuopoios*), whose art of "the getting-up of the spectacle is more a matter for the designer than the poet."[22]

Buontalenti's machines brought important improvements to the concept of the stage.[23] His creations for the Medici court festivities can be considered the intermediate link that led from the perspectival arrangement applied by Sebastiano Serlio to the theater of Vicenza (1539) and Serlio's "Trattato sopra la scena" (Treatment of the stage) in his *Secondo libro di prospetiva* (Second book of perspective; 1545), to Nicola Sabbatini's *Pratica di fabricar scene e macchine ne' teatri* (The creation of stage sets and machines in the theater; 1638) — a text that codified the Baroque stage.[24] Buontalenti replaced the old system of periaktoi, or revolving scenery (*scaena versatilis*), which were used to change sets and for effects of apparition, with a stage with painted sliding wings (*scaena ductilis*) where opening perspectives, mounted on slide bars, created sequential effects of spatial depth. This system would become widespread in seventeenth-century European theater.[25]

For the Intermedi of 1589, Buontalenti conceived a scenography that responded analogically to the new requirements of the *stile rappresentativo*: the spectacle of a fairylike Antiquity creating a sense of the resurrection of the fable must include a combination of spatial illusion and archaeological reconstruction, tangible

verisimilitude and erudite rationality (*verosimiglianza . . . congiunta col ragionevole*).[26]

Buontalenti's preparatory drawings and a series of engravings made after them by Agostino Carracci and Epifanio d'Alfiano give a precise idea of the Intermedi's stage and sets.[27] On the sides, a series of wings followed the contours of the stage to a backdrop, which closed the perspective. Thus, the height of the wings diminished toward the back, while the actors, either on the stage or placed in the clouds, were arranged in a triangle that opened up toward the *frons scaenae* to accentuate the impression of depth.

The Unfolding of the Intermedi

The Intermedi, six in number, represented the harmony of the celestial spheres, the contest between the Muses and the daughters of Pierus, Apollo's combat with the serpent Python, the realm of spirits, the song of Arion, and the descent of Apollo and Dionysus accompanied by Rhythm and Harmony. Each Intermedio alternated with a comedic act, which served as its support. Aside from the rather loose cosmological theme indicated by representations of the heavens, earth, ocean, and underworld, the spectacle imagined by Bardi had no real dramatic unity. Subject to the demands of the court audience, and produced collectively, it must have constituted a sort of compromise between mythological pantomime and pastoral drama. Narrative transitions, which were nonexistent, were replaced by associations and displacements reminiscent of dream logic. Judging from Rossi's text, it would appear that the spectators of 1589 were less sensitive to the meaning of the moving images unfolding before their eyes than to the changes of scene, the moving of sets, and the appearance and disappearance of figures orchestrated by Buontalenti's machines, which must have contributed to the oneiric aspect of the Intermedi.

As the curtain rose on the first Intermedio, the audience saw

an allegory inspired by Plato, composed by Ottavio Rinuccini, and set to music by Emilio de' Cavalieri and the choirmaster Cristofano Malvezzi.[28] On the ground there appeared a rustic temple and in the sky a cloud on which a few female figures played musical instruments and sang (figure 56).[29]

The cloud disappeared into the temple, and then the temple disappeared into the ground. In its place there appeared a starry sky, in which shone a light "like that of the moon on a clear night," wrote Rossi. At this point, concealing the perspective, a parade of clouds ridden by sirens passed by. Little by little the low clouds rose into the sky, the light intensified, and the clouds seemed to be lit up by the sun's rays.

By means of a set change, the city of Pisa appeared before the audience, with its buildings (*fabbriche*) along the Arno, its bridges, cathedral and bell tower, and the palace of the knights of Saint Stephen, for the first act of *La pellegrina*.[30] Seven scene changes ensued "with such smoothness and speed," wrote Baldinucci, "that the eye barely had time to grasp the movement."[31] The singing contest between Pierus's daughters and the Muses, the judgment of the nymphs, and the metamorphosis of the sisters into magpies provided the subject for the second Intermedio.[32] A garden appeared, in the middle of which a mountain rose up.[33] Two moss-covered grottoes were contrived there, with water flowing out of them.[34] The spectacles involved not only sight and sound but also smell: the smoke rising from the perfume pans and fountains was so pleasant, Rossi recalled, "that one had never smelled anything so subtle, so sweet, nor in such great quantity, and which would never be smelled anywhere else, if not in happy Arabia."[35] Then the set of Pisa reappeared.

At the beginning of the third Intermedio, the urban scene turned into a wilderness, with the houses becoming covered with leaves and the whole set changing into an underwood, in which a

deep cave opened up, where the combat between Apollo and Python would take place (figure 57). From the left two groups entered, twice nine couples, representing the throng from Delphi, dressed in Greek robes. Their task was to stir up the audience's emotions with words, gestures, and song, each actor differing from the rest by a color, ornament, or costume detail. While participating in the narration, the chorus and the coryphaeus also commented on it; they occupied an intermediate position between the spectators and the spectacle and were entrusted with the process of identification.[36]

The chorus first expressed on the audience's behalf the fear arising from the presence of the monster:

> Here is the spot where, drunk with human blood,
> The monster lay within this gloomy grove,
> Clouding and blackening the air
> With its foul breath and malignant venom.[37]

The coryphaeus responded:

> This is the place where, craving flesh
> The fearful worm stands; in this place
> It spews out fire and flames, hisses, and roars
> Destroying grass and flowers.
> But where's the monster now?
> Can Jove at last have heard our pleas?

Suddenly the dragon appeared at the cave's entrance, spitting out swirls of smoke, flames, and a repulsive mixture that included his poisoned breath. In the *Ricordi e memorie* of the administrator Girolamo Serjacopi — an important testimony of the preparation of the festivities and the mounting of the spectacles of which he

Figure 56. Bernardo Buontalenti, *The Harmony of the Spheres*, drawing for the first Intermedio. Uffizi, Florence.

Figure 57. Bernardo Buontalenti, *Apollo and the Serpent Python*, drawing for the third Intermedio. Biblioteca Nazionale, Florence.

kept records — one finds a firsthand account of the fabrication of
the dragon:[38]

> Signor Giovanni da Vernio has asked for work to begin on the ser-
> pent for the third Intermedio [Apollo's dragon]. Its head and feet are
> to be made of papier-mâché; the body and the rest are included in
> the carpenter's contract. Below is the estimate for the head and feet.
> The head is to be br. 1¾ long and 1⅛ high [1 *braccio* = 23 inches]. A
> design has been prepared on canvas by M. Bernardo. The feet about
> br. 1½ high, as shown in the book for the third Intermedio.
>
> Piero Pagolino says he will construct
>
> | the head (clay) for fl. | 30.– |
> | the feet (clay) | 10.– |
> | | 40.– |
>
> Michele di Antonio, sculptor,
>
> | the head fl. | 56.– |
> | the feet (clay) | 14.– |
> | | 70.–[39] |

Seeing the papier-mâché monster, the Delphic chorus, worried,
addressed the god with sad and plaintive songs:

> O miserable we!
> We were then born to slake
> The hunger of this loathsome beast?
> O Father, King of Heaven,
> Look mercifully down
> On miserable Delos
> Imploring you on bended knee,
> Pleading for help with bitter tears.
> Send your lightning and your bolt

To avenge poor Delos
On the ferocious monster that devours her.

The dragon emerged from its lair, uncoiling its terrifying length, showed its claws and its terrible teeth, whose grindings the flute imitated, and pursued the unhappy Greeks into the forest. The action then followed, as Warburg noted, the unfolding of the *Nomos Pythicos* (the Pythic law) as described by Pollux in *Onomasticon*:

1. The god examines the terrain and determines if it is suitable for combat.
2. He challenges the dragon.
3. The combat begins. The soloist imitates the fanfare of the trumpets and pauses for the grinding of the monster's teeth by the flute (the *odontismos*, the *azzannamento*).
4. The dragon dies; the god's victory is celebrated.
5. Apollo sings a triumphal song and begins to dance.[40]

Thus the audience saw the vengeful god of Latona come down from the heavens on the stage of the Palazzo Pitti to the sound of viols, flutes, and trombones while the chorus anxiously awaited the outcome of the battle, then broke out joyously at the moment of the final victory:

See the foul dragon
Slain by your unconquered hand.
Dead is the loathsome beast;
Come, rank after rank,
Come lovely nymphs, and with your song,
Exalt Apollo and his Delos to the skies.
A thousand times, a thousand,
O joyous, happy day!

O blessed homes,
O blessed hills, allowed to see
The fearful serpent
Drained of its life and blood —
Which with malignant venom
Did rob the fields of bloom, the woods of leaves.[41]

The fourth Intermedio transported the spectators into the infernal realm (figure 58).[42] A desolate landscape appeared, made up of rocks and caves filled with flames snaking (*serpeggiando*) into the air and hurling their smoke heavenward. The ground opened onto a hell, where groups of figures rose. Among these diabolical figures, two furies, dressed in a stocking that gave the impression of nudity, especially impressed Rossi. Their skin seemed dry and covered with ash. Their hands and faces were stained with blood, their breasts pendulous. Snakes coiled in their hair and around their breasts and waists. Each fury was accompanied by four demons with eagle talons for hands and feet, their backs covered with scales and great black wings.[43] There was also a sorceress riding in a golden chariot drawn by two polychrome dragons covered with mirrors and spewing fire.

The fifth Intermedio was based on the fable of Arion, the zither player in Plutarch. Arion from Methymna, thrown overboard by the ship's crew, was carried to dry land by a dolphin. Just as he was about to be hurled into the waves, he appeared on the poop deck, singing the *Nomos Pythicos*.[44] The theater regaled the audience's eyes with a sea sprinkled with waves, and rocks gurgling with real water; small boats sailed at the foot of the mountains marking the perspective. Amphitrite, like the Venus of Botticelli's painting, appeared on a half shell the color of mother-of-pearl hitched to two dolphins, followed by a retinue of fourteen naiads (figure 59).[45]

Figure 58. Bernardo Buontalenti, *The World of the Demons*, drawing for the fourth Intermedio. Louvre, Drawing Collection, Paris.

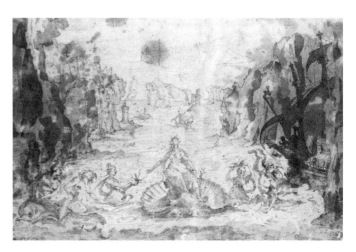

Figure 59. Bernardo Buontalenti, *Amphitrite*, drawing for the fifth Intermedio. Louvre, Drawing Collection, Paris.

During the sixth Intermedio, without a change of scene all the instruments began to play together: organs, cymbals, harps, viols, zithers, lyres, Spanish and Neapolitan guitars, lutes, theorbos, trombones, flutes. The sky from which this harmony sounded then opened, and the set was flooded with such bright rays that, according to Rossi, if not for the vapors rising from the earth, human eyes could not long bear its intensity.

Seven clouds appeared, carrying Apollo and Dionysus, as well as Harmony, Rhythm, and the procession of the Graces and Muses. They stepped onto the stage singing, and when they all began to dance together, accompanied by forty men and women in rustic costume, Warburg could not resist interpreting the union of these two gods marking the end of the representation as the resurrection of Greek tragedy as Nietzsche had conceived of it. "When [the sixth Intermedio] ended, long before the spectators would have wished, the sky closed, and those who were on the ground left, dancing and singing, by various routes, and left the splendid set empty; and their departure marked the end of this noble representation," Rossi wrote.[46]

After the spectacle, which lasted about seven hours, a banquet was served for the spectators in Palazzo Vecchio, and on the buffet tables set up amid ephemeral sculptures made of spun sugar, painted and gilded food was mixed in with edible things.[47]

Costumes, Accessories, and Body Language in the Intermedi

In his discourse "Sopra la musica e il cantar bene," Giovanni de' Bardi identified three types of rhythm: the rhythm of bodies, which is seen; and the rhythm of harmony and of words, which are heard. In his opinion, meaning is born in the combination of these types of rhythm.[48] As much as through the words and song, the meaning of the Intermedi was therefore supposed to be transmitted through

dance and pantomime. In the spectacles of 1589, the sets, the scenography, the accessories, the choreography, and the costumes had a figurative function, whose importance Warburg had already recognized in painting in his 1893 study of Botticelli. With regard to the second Intermedio, the art historian downplayed the meanings conveyed by speech in favor of the expressiveness of the bodies and gestures, and his thesis applies to all the spectacles conceived by Bardi and staged by Buontalenti:

> [T]he true origins of the Intermedio . . . did not lie in the spoken drama so much as in the mythological pageant; and this, being an essentially mute and gestural art, naturally relies on accessories and adornments. All those now extinct transitional forms between real life and dramatic art, which the fifteenth, sixteenth and seventeenth centuries produced in such abundance — as, for example, in the carnival mascherate, for the *sbarre*, the *giostre*, and the *buffole* — afforded a unique opportunity for members of the public to see the revered figures of antiquity standing before them in flesh and blood.[49]

Two hundred eighty-six costumes were made for the Intermedi.[50] They were sewn by two tailors, Oreto Belardi and Nicolò Serlori, assisted by fifty people, who began the work in October 1588. On November 17, a first siren's costume was completed for the actor Giovanni Lapi, whose measurements Warburg carefully recorded from the amounts in Emilio de' Cavalieri's account book, as if wanting to write down the *formula* of its fabrication:

> Note of the materials required for a costume, for no. 6, Giovanni Lapi: 17 November 1588.
> Red satin for the bands, skirt, and underskirt <ca. 6.5 m>. — Deep blue taffeta for lining of the bands <ca. 1.3 m.>. — Yellow voile for

the overskirts and for patterns that will not be used <ca. 4.6 m.>. —
White voile for ruffs, footwear, and overskirts <ca. 8.7 m>. Gold
voile for trimming and front <ca. 2.5 m>. Calendared cloth for the
bodice, sleeves, bands etc. <ca. 4.4 m>. — Canvas painted with
feathers <ca. 4.6 m>. — Green cloth cut unevenly <?> for the skirt
and underskirt <ca. 8 m>. — Small masks, 4, and large shoulder
masks, 2, total 6. — <?> fabric for the bodice <ca. 0.45 m>.[51]

When Rossi described a lunar siren (Giovanni Lapi?) at the
moment she appeared in the first Intermedio, he noted the effect
produced by the arrival onstage of the actor decked out and in the
process of becoming a figure (figure 60). Rossi's description is a
sort of visible takeoff, a "dress-up"of Cavalieri's arid and elliptical
formula:

> After Harmony came the Sirens. The first of these, who turned the
> Moon's heaven, was covered like the other Sirens in feathers from
> neck to knee, and on the back the feathers overlapped just as natu-
> rally as they do on the back of a bird; the feathers were made of soft,
> sky-blue silk, heightened with silver, which made the Siren look the
> same color as her planet when it is seen in the night sky. At the end
> of the feathers a beautiful gold decoration, and below the feathers
> she wore a charming white satin gown to her knees, with some gold
> embroidery on it. Her little, pale blue shoes were covered in jewels,
> cameos, little masks, and with gold and silver ribbons. In contrast
> to the wicked Sirens, who have ugly and misshapen lower parts,
> the poet had taken care to make these admirable in their perfection.
> Her hair was blonde, and her headdress shaped like the rays of the
> moon; to her headdress were attached, in pretty disarray, several
> gaily fluttering pale blue veils; and on top of her headdress was a
> Moon. To make her more cheerful and lovely she wore a red cloak;
> when this caught the light (I shall have more to say later about the

lights, artfully concealed in the clouds) it glittered so brightly that the eye could not rest on it.[52]

On November 19, the costumes of the other performers were cut out and adorned with "shoulder pieces, masks, half-masks and paper roses." For the female roles, all played by men, the contours of the bodies were softened by fake breasts: "Breasts and bosoms made of paper of all kinds; to deliver on 3 December, 24 painted paper busts from Francesco Gorini."[53]

As demonstrated in Warburg's study on Maria Portinari and that on the *Imprese amorose*, as well as in his taste for costumes and fancy dresses, the clothing — but also the masks and hairstyles, the jewels and makeup — is charged with symbolic properties: it takes the body to the threshold of its own appearance (figure 61).[54] For Warburg, reading about the preparation of the actors did not merely provide information on the nomenclature of the theatrical costumes. In the fantastic appearance created by the superimpositions of flowing cloth and the many ornaments on the actors' clothing, Warburg saw an active resurgence of the phenomena he had discovered in the painting of the Quattrocento. The costumes worn by the sirens, the hamadryads, and the women of Delphi in the Intermedi of 1589 were identical to those covering the bodies of the nymphs whom Florentine artists had made the embodiment of their feelings toward the past. While the actors differed in their accessories or their attributes (bark and oak leaves mixed with precious stones for the hamadryads, who were wood nymphs, colored feathers for the Muses), they assumed the fictive appearance of slender young girls, with hair undone, dressed in Greek styles with flowing veils, revealing once again the serpentine shape that, from the time of Alberti, had seduced Renaissance artists as an expressive form of vital energy.[55]

Figure 60. Bernardo Buontalenti, preparatory drawing for a siren's mask. Uffizi, Florence.

Figure 61. Bernardo Buontalenti, preparatory drawing for the Intermedi. Biblioteca Nazionale, Florence.

Just as he had perceived a Dionysian component in the way in which Quattrocento artists interpreted the works of Antiquity, Warburg uncovered a tragic element beneath the Neoplatonic appearance of the Florentine Intermedi. He saw them not as representing a harmonious vision of the organization of the world but as the transfigured staging of an original chaos. While he noted the tragic dimension of the spectacles of 1589, he grasped their entirely constructible character and discovered the pieces of this construction — and the laws of their assembly — in the archives of the Florence libraries. During his trip to New Mexico and Arizona, which he undertook a few months after the publication of his text devoted to the *costumi teatrali*, Warburg would discover the phenomena of apparition he had observed in the history of court spectacles, in an intersection of proximity (*Annäherung*) and strangeness (*Unheimlichkeit*). Through the Native American dances he witnessed in the pueblos of the Black Mesa, he saw the resurgence, in an active form, of the Intermedi of 1589, the reality of which he had sought to reconstruct to the extent permitted him by the archives. That an identification between the Florentine festivities and these rituals had developed in his research appears to be borne out by a simple consideration of dates, where we find a coincidence that, according to Warburg's views on the unconscious determinations of language, would not have seemed entirely fortuitous: one need only rearrange the numbers in 1589 to get 1895, the year Warburg published his study and began his trip across the Atlantic.[56]

Among the Hopi

Melancholic Scene: Aby in America

> One or several people setting off to drift, for a more or less long
> period of time, forsake generally accepted reasons to
> displace oneself and to act, as well as their personal relation-
> ships, work and hobbies, randomly to follow the pull of the
> land and its corresponding encounters.
>
> — Guy Debord, "Theory of Drifting,"
> *Internationale situationniste* (June 1958)

On April 21, 1923, Warburg delivered a lecture on the Pueblo
Indians' serpent ritual at the Bellevue clinic in the Kreuzlingen
sanatorium, where he had been since 1921, going through a peri-
od of melancholic depression that had torn him away from his
studies at the end of the First World War.[1] The Binswanger archives
at Tübingen contain an account of the crisis the art historian faced
at the beginning of the 1920s that made his institutionalization
necessary:

He practices a cult with the moths and butterflies that fly into his
room at night. He speaks to them for hours. He calls them his little

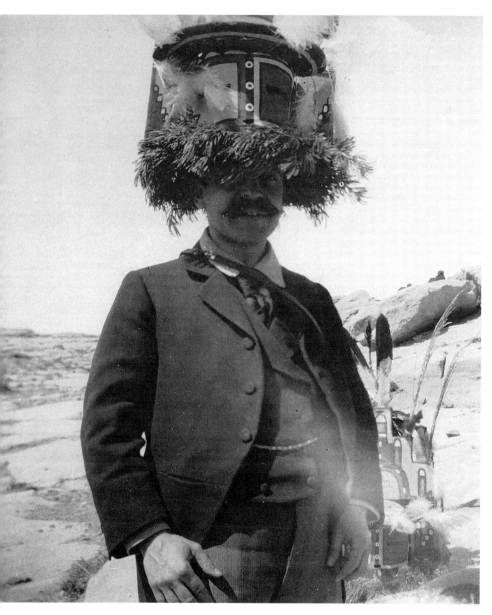

Figure 62. Aby Warburg wearing a kachina
dancer's mask.

soul animals [*Seelentierchen*] and tells them about his suffering. He recounts the outbreak of his illness to a moth:

"On November 18, 1918, I became very afraid for my family. So I took out a pistol and wanted to kill myself and my family. You know, it's because bolshevism was coming.[2] Then my daughter Detta said to me, 'But, Father, what are you doing?' Then my wife struggled with me and tried to take the weapon away from me. And then Frede, my younger daughter, called Malice (Max and Alice, my brother and his wife). They came immediately with the car and brought Senator Petersen and Dr. Franke with them. Petersen said to me: 'Warburg, I have never asked anything from you. Now I am asking you please to come to the clinic with me, for you are ill.'"[3]

Perhaps the butterflies to whom Warburg confided his distress represented a new manifestation of the nymph, which, in 1918, continued to haunt him. In his biography of Warburg, Ernst Gombrich cited a draft of a letter addressed to his Dutch friend the philosopher André Jolles at the beginning of the century in which Aby evoked the nymph as a beautiful butterfly escaping him:

The most beautiful butterfly I have ever pinned down suddenly bursts through the glass and dances mockingly upwards into the blue air.... Now I should catch it again, but I am not equipped for this kind of locomotion. Or to be exact, I should like to, but my intellectual training does not permit me to do so.... I should like, at the approach of our lightfooted girl, joyfully to whirl away with her. But such soaring movements are not for me.[4]

In a text on Florentine engraving published in 1905, the identification of the butterfly with the nymph once again defined the process of figuration as a metamorphosis — which, according to Warburg, found its purest expression in the work of Botticelli.

About the dancing female figure depicted in a wood engraving attributed to Baccio Baldini, Warburg wrote:

[T]he antique butterfly has emerged from the Burgundian chrysalis: the dress flows free . . . ; and a Medusa-winged headdress . . . has banished the empty ostentation of the hennin. This is the native idealism of grace in motion that Botticelli made into the noblest expressive resource of early Renaissance art.[5]

On November 8, 1921, Binswanger, responding to Freud's inquiring after his patient, wrote pessimistically:

Already in his childhood Prof. V. [that is, Aby Warburg] showed signs of anxiety and obsession; as a student, he had already expressed delusional ideas; he was never free from obsessional fears, etc.; and his literary productivity greatly suffered from this. On this basis, a very serious psychosis set in, probably set off by a pre-senile state, and the material, which until then had been elaborated neurotically, was expressed in a psychotic form. Combined with this was an intense psychomotor excitation, which is also persistently present, although it is subject to extreme fluctuations. Here he has been placed in the locked ward, but in the afternoon he is usually calm enough so that he can receive visitors, have tea with us, go out on excursions, etc.

He is now still quite dominated by his fears and defensive maneuvers, which remain on the border between obsession and delusion, such that, despite his capacities for formal logic being completely intact, there is no more place for any activity in the scientific domain. He is interested in everything, possesses excellent judgment concerning people and the world, his memory is outstanding; but it is possible to focus his attention on scientific themes only for very brief moments.

I believe that his psychomotor excitation will again slowly sub-

side, but I do not believe that a restoration of the situation *quo ante* of the acute psychosis or a resumption of his scientific activity will be possible. I ask you of course to communicate this information only in such a way that I remain anonymous. Have you read his *Luther?* It is a terrible pity that he will most likely never be able to draw from his enormous treasure of learning or from his immense library.[6]

Contradicting his doctor's prognosis — or demonstrating the effectiveness of the care he was receiving — Warburg, in 1923, seems to be once again in full possession of his mental faculties. In his lecture "Images from the Region of the Pueblo Indians of North America," he returned in a sustained and coherent manner to the journey he had made twenty-seven years earlier, in the winter of 1895–1896, through Colorado, Arizona, and New Mexico, concerning which he had since maintained an almost complete silence.[7]

In 1893, one of the five Warburg brothers, Felix, married in New York the daughter of the financier Jacob Schiff, Frieda, and thereby entered into the powerful circle of Kuhn, Loeb & Co. Two years later, Paul, another of Aby's brothers, married Nina Loeb, a daughter of the banker Solomon Loeb. Paul's move to New York marked the transatlantic extension, from Hamburg, of the activities of M.M. Warburg & Co., with which he would continue to be associated until 1907, alongside his father, Moritz, and his brother Max. It was on the occasion of this second marriage, which was like the reproduction of the royal wedding of 1589, that Aby undertook his trip to America in late 1895.

The story, reported by Max in the funeral oration he delivered upon Aby's death in 1929, is well known: the oldest of the seven Warburg children (five boys and two girls), Aby had ceded his

birthright as the eldest to Max when still a child, in exchange for
the promise that Max would buy him as many books as he wanted
for the rest of his life. While Paul Warburg financed the Loeb
Classical Library founded by his brother-in-law James, Max gave
unflagging support to Aby's undertaking: the growth of the Kul-
turwissenschaftliche Bibliothek followed that of the family bank,
whose turnover increased sixfold between 1890 and 1910.[8] But
Aby always maintained an ambiguous position toward the activi-
ties of his banking family, from which he had voluntarily dis-
tanced himself. On the one hand, he depended more and more on
it for the functioning of his library. In a letter to Max in 1900,
Aby wrote: "We must demonstrate by our example that capital-
ism is also capable of intellectual achievements of a scope which
would not be possible otherwise."[9] On the other hand, the library
was set up as a counterpoint to the values on which its material
existence depended, as a haven of thought in the midst of a world
devoted to the pragmatism of the marketplace.

An amusing anecdote cited by Ron Chernow recounts the sort
of exchange that had developed between the two brothers. In
March 1903, when Alice and Max were celebrating their fifth
wedding anniversary, Aby put on a skit in which he played the
role of Max twenty-five years later, communicating with Paul in
New York from Hamburg by an apparatus that transmitted their
voices and images at the same time. Max in turn imitated his old-
er brother and depicted him seated at his desk, writing a study on
the Medici habit of wearing white socks with blue dots and ex-
plaining it through Flemish influence. In conclusion, the pseudo
Aby declared that his text would be so dense and so complex that
no one would ever be able to understand it.[10]

Quickly tiring of the New York social scene, Warburg, after pass-
ing through Cambridge, Massachusetts, where he visited the Pea-

body Museum and its collection of Native American archaeology, went to Washington, to the Smithsonian Institution, founded in 1846. Since 1879, the Smithsonian had housed a very active Bureau of American Ethnology, whose publications would become for Warburg an inexhaustible source of information on Native American culture.

In a note drafted in Kreuzlingen on March 17, 1923, at the time he was preparing his lecture on the serpent ritual,[11] Aby returned to the intricacies of the theoretical and biographical motifs that led him, after Washington, to prolong his stay in the United States for a few months and that took him west, all the way to New Mexico:

> Outwardly, in the forefront of my consciousness, the reason I would give is that the emptiness of the civilization of eastern America was so repellent to me that, somewhat on a whim, I undertook to flee toward natural objects and science, so I traveled to Washington to visit the Smithsonian Institution. This is the brain and scientific conscience of eastern America, and indeed in Cyrus Adler, Mr. Hodge, Frank Hamilton Cushing, and above all James Mooney (as well as Franz Boas in New York), I immediately found pioneers in the research on the indigenous people; they opened my eyes to the universal significance of prehistoric and "savage" America. So much so that I resolved to visit western America, both as a modern creation and in its Hispano-Indian substrata.
>
> A desire for the romantic was compounded with a desire to occupy myself in a more manly way than had yet been granted to me. I was still feeling anger and shame over the fact that, during the time of the cholera, I did not hold out in Hamburg as my brother and my dear wife's family did.
>
> Aside from this, I had developed a downright disgust with aestheticizing art history. The formal contemplation of images — not

conceived as a biologically necessary product situated between the practices of religion and art (which I understood only later) — seemed to me to give rise to such a sterile trafficking in words that after my trip to Berlin in the summer of 1896 I tried to switch over to medicine.[12]

Warburg had already studied medicine but, after his journey, the topic of medicine took on new and shamanic meaning. Thinking perhaps of Bernard Berenson, whose volume on Florence in his *Italian Painters of the Renaissance* dates from 1896, Warburg termed the discipline that considers works independent of their function and religious origins "aestheticizing art history." In the Smithsonian Institution, he discovered that it was possible to revitalize art history by opening it up to anthropology.

Among the people cited by Warburg, Franz Boas, one of the founders of modern ethnology, is particularly significant. In the second half of the 1880s, after a trip among the North American Kwakiutl, Boas, who was originally from Berlin, settled in New York. Warburg initially came into contact with him either through Frederic Ward Putnam, the curator of Harvard University's Peabody Museum, or through Jacob Schiff, whom Boas had asked to finance his research. The art historian and the anthropologist were to begin a correspondence after Warburg returned to Europe, and in 1927 Warburg still imagined founding a science that would combine their respective disciplines.[13] Boas promoted a pluralistic and far-reaching concept of anthropology that included research into different races, languages, and cultures, requiring excursions into the related disciplines of geography and archaeology. He also proposed opening up the discipline of anthropology to the techniques of the modern spectacle, to the point that one can recognize, in his museological projects, pre-cinematic forms of exhibition. Concerning the installation of ethnographic rooms

at the American Museum of Natural History in New York, Boas
wrote to Putnam, in 1896:

> In order to set off such a group to advantage it must be seen from
> one side only, the view must be through a kind of frame which shuts
> out the line where the scene ends, the visitor must be in a compara-
> tively dark place while there must be light on the objects and on the
> background. The only place where such an effect can be had is in a
> Panorama building where plastic art and painting are made to blend
> into each other and where everything not germane to the subject is
> removed from view.[14]

Each display case functioned as an autonomous scene while as a
group they produced a sense of a sequence, opening the museum
space up to the plastic and syntactic resources of scripting and
montage well before the cinema began to codify them.

In 1904, Boas defined anthropology very broadly as a disci-
pline that addressed questions about the physical and mental exis-
tence of humanity as encountered in different forms of societies,
from the most ancient times to the present and in all parts of the
world. Against the evolutionist interpretation dominant in Amer-
ican anthropology, he argued that only when the relationship be-
tween distant cultures and our own world is established can the
rudiments of modern anthropology be posited.[15] Warburg granted
the theme of distance the same methodological value as Boas, but
he gave it a historical rather than a geographical significance.

In Warburg's eyes, the trip to New Mexico and Arizona was
not only a displacement of knowledge; it was also a parable of
loosening the grips of melancholy. In seeking to replace the study
of works and texts with "a more physical activity," Warburg mod-
ified his discipline itself, giving his research a practical significa-
tion unheard of in art history. Warburg discovered Native America

through archives, and a book and a certain image, even more than his meeting other researchers, revealed the object of his quest to him. In the library of the Smithsonian Institution, he consulted the large folio edition by the Swedish archaeologist Gustaf Norden-skiöld of *Cliff-Dwellers of the Mesa Verde, Southwestern Colorado*, published in Stockholm in 1893, and a poor-quality photograph (or print) in this text took on an initiatory meaning for him:

> A book and an image gave me the scientific grounding for my trip and a certain vision of its goal. The book, which I found at the Smith-sonian Institution, was the work by Nordenskiöld on the Mesa Verde, the region in northern Colorado where the remains of the enigmatic cliff dwellings are found — a work of very high quality, ani-mated by a scientific spirit, which alone I have to thank for the solid foundation of my efforts.[16]

Thus the association of an image and a text inspired Warburg's trip. According to the rough draft of the 1923 lecture, it was liter-ally by immersing himself in the documents that Warburg made it to the mesas of Arizona, just as it was on the basis of documents in the Florentine archives that he sought to revive the Intermedi and the festivals of 1589, whose memory exists only as a testimonial of the past:

> Nowadays, the last thing that anyone thinks of on May 1 is a may-pole. Lions, foxes, and wolves no longer do battle on the Piazza di S. Croce; and the traditional game of *calcio* is no longer played there. Nothing remains of the *sbarra* and the *corso al saracino* but weapons and caparisons in museum showcases; and today we go to the theater to see something quite different from the "*macchini quasi sopranna-turali*" (almost supernatural machinery) of Bernardo Buontalenti.[17]

In 1902, looking at Ghirlandaio's frescoes, Warburg noted the same process as he tried to reconstruct the atmosphere of Renaissance Florence based on the city's archives and the Santa Trinita paintings. Perhaps while looking at the fresco in the Sassetti Chapel as it opened fictively, in reverse angle, onto the space outside the church, he remembered the discovery he had made in Washington about the ability of images to lead the seeker toward exteriority.[18] The almost fortuitous combination of text and image that prompted Warburg's trip to New Mexico led to his transforming the experience into a document and, inversely, his making the document a place of experience — or adventure. This was accomplished by taking paths from the circumscribed space of knowledge in order to return to the real world.

Gustaf Nordenskiöld, the son of a famous Swedish explorer who contributed to the discovery of the Arctic, traveled across the United States in 1891. Like Burckhardt, he was a ferryman for Warburg, granting him access not to Florentine culture but to the universe of the Native American (figure 63).

In Denver, Warburg viewed the Native American archaeological collection that had been sold to the Denver Historical Society by a family of pioneers of the Mesa Verde, the Wetherills. He decided to explore the region once he had assured himself of the family's assistance. The Wetherills had been one of the first families to move to the site. For more than thirty years, John Wetherill and his brother Richard systematically excavated the sites in the Mesa Verde and emptied them of their relics in order to sell them to institutions or private collections. In September 1894, the Mancos newspaper ran an advertisement that was to appear in each edition of the paper for a year: "Mancos Canyon & the Aztec Cliff Dwelling. Indian Curios, Aztec Relics, Photographs for Sale. Address: Richard Wetherill, Alamo Ranch, Mancos, Colo."

The Wetherills' activities in the late nineteenth century

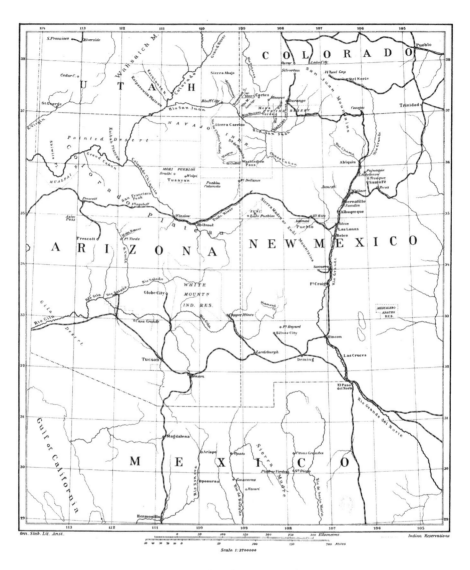

Figure 63. Map of the Pueblo region. From Gustaf
Nordenskiöld, *Cliff-Dwellers of the Mesa Verde,
Southwestern Colorado* (1893).

reflected both the intellectual and the popular craze for the pre-
colonial history of the American continent. In 1893 at the World's
Columbian Exhibition in Chicago, one pavilion was built to imi-
tate a Native American site — the representation of Battle Rock
and McElmo Canyon — a pavilion in which a cliff house was re-
created and where a collection of objects discovered by Wetherill
was exhibited. At the end of the exhibition, the whole collection
was donated to the University of Pennsylvania.[19]

During the summer of 1891, Nordenskiöld, with the help of the
Wetherills, dug up more than six hundred objects from the cliff
dwellings, which he brought back to Europe and deposited in the
museum of Stockholm before dying at the age of twenty-six, in
1895 — the same year Warburg (who was not yet thirty years old)
took his trip.

Aby decided to follow Nordenskiöld's itinerary step-by-step:
after having passed through Chicago and Denver, he arrived at the
Anasazi sites in the beginning of December and stopped near the
village of Mancos, at the ranch of Richard Wetherill, whom he
hoped would be his guide, as he had been for the Swedish scholar.
By the time Warburg arrived, Wetherill had already left with a
student from Harvard, George Bowles, for an excavation from
which he would not return until the spring. Thus freed from Nor-
denskiöld's text, Warburg left Colorado, went to New Mexico,
and during the next few months visited the Pueblos of San Juan,
Laguna, Acoma, Cochiti, and San Ildefonso, from Santa Fe to
Albuquerque. In a December 14, 1895, letter to his family, he
wrote from Santa Fe:

> The meaning of my journey is this: to get to know not only the
> American West in general but in particular the area that is of greatest
> importance for the history of the original inhabitants of America,

and this is the region where Utah, Colorado, New Mexico, and Arizona come together; this region is bordered roughly from 111°–106° west of Greenwich and 38°–35° north.

What one finds here is twofold: in the north, there are a great many abandoned structures dug into the high sandstone cliffs of the Rocky Mountains, containing remnants of pottery, mummies, tools, etc., most of which have ended up in American museums; second, in the south are the "Pueblo Indians" themselves, who, having retained in part their old forms of life, still live today in small villages around Santa Fe and, farther west, on their reservation. There is some connection between the abandoned ruins and the Pueblo Indians of today (so-called in contrast to the savage, nomadic Indian tribes; pueblo = village, that is, sedentary), and part of the task of any scientific or scholarly investigation into the primal history of America is to determine this connection. [...] I do not believe I am wrong to consider that gaining a vivid representation of the life and art of a primitive people is a valuable corrective to the study of any art.[20]

Retracing the route that had led to the creation of collections of Indian arts and crafts in East Coast museums, and the birth of Native American ethnology, Warburg reached the ruins of the Pueblo civilization and saw them as Nordenskiöld had (figure 64). From there he changed course and visited some abandoned sites, destined for archaeological investigation, in the villages of the plains, where, not far from the cities, there were deteriorated manifestations of Native American culture. Thus, not far from Santa Fe, in the village of San Ildefonso, Warburg witnessed the antelope dance. During this ceremony, which echoes the mythological spectacle in the second Intermedio representing the metamorphoses of Pierus's daughters into magpies, he saw dancers leaning on sticks as on front legs, imitating the gait of antelopes in order to identify with them (figure 65).[21] In this ritual, which

Figure 64. Ruins of a Pueblo village. From
Gustaf Nordenskiöld, *Cliff-Dwellers of the Mesa
Verde, Southwestern Colorado* (1893).

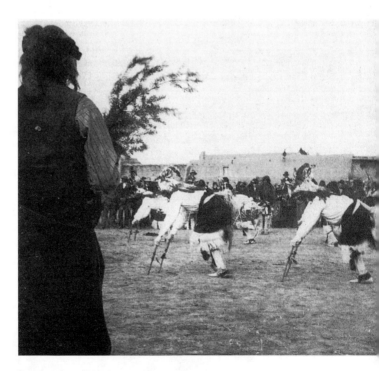

Figure 65. Antelope dance at San Ildefonso.
Aby Warburg collection.

endured more than three generations after the disappearance of the antelope herds and was therefore deprived of its practical aims, the mimetic incorporation of the man into the animal was produced only as a survival of the past.

Shortly after seeing the antelope dance, Warburg suddenly left New Mexico. After staying a while in northern California, visiting San Francisco, and planning to leave for Japan, he returned to Arizona at the end of March and stopped in Hopi territory, beyond the Atchison-Topeka-Santa Fe railroad line, as he would put it, in Nietzschean terms, in one of the last "reserves" of American space not yet sectioned off by train tracks and telegraph. In the Black Mesa, Warburg visited the villages of Walpi and Oraibi, where he witnessed the Hemis kachina, or corn-growing, dance: during this ceremony, masked dancers, charged with a magical, not simply a mimetic, function, addressed the dead along with the clouds and the rain, acting as intermediaries between the community and the forces of nature.

When he returned to Europe, Warburg brought with him a collection of notes, ritual objects, and decorated utensils, which he gave to Hamburg's Völkerkunde Museum, in addition to dozens of photographs, many of which he had taken himself. He gave three lectures at photography and anthropology societies in Hamburg and Berlin — before returning abruptly to his Italian studies, seeming to have definitively concluded his American experience.[22] Nevertheless, in a May 17, 1907, letter addressed to James Mooney, Warburg demonstrated that his trip had had an unforeseen and profound influence on his research:

> I have continually felt indebted to your Indians. Without the study of their primitive culture, I would never have been in a position to find a broader foundation for the psychology of the Renaissance. Sometime I will give you a sample of my methods, which, I may say,

are quite new and possibly for that reason not as widely recognized as I might have in fact expected.[23]

In the notes to the lecture he gave on February 10, 1897, to the members of the Amerika-Club in Hamburg, one finds an article Warburg cut out of the *St. Louis Globe-Democrat* on December 14, 1895, titled "Miracle in New Mexico." His keeping this clipping shows the extent to which his trip into Native American territories was linked to the themes of survival that would strongly mark his analyses of Florentine painting after he returned to Europe:

Coffin Entombed for Centuries Throws Off
Its Earthly Covering
Floors of the Church Beneath Which It Was Buried Cracked
and Broken — Skeleton of the Patron Saint of Isleta Indians
Again Appears

ALBUQUERQUE, N.M. DECEMBER 13 —

The strangest and most supernatural occurrence that had been brought to public attention in this land of wonderment is the cause of extraordinary excitement just now at Isleta. Marianó Armijo and Hon. A.C. Debaca, of this city, spent yesterday at the quaint town investigating the miracle for themselves, and can offer no reasonable theory in explanation of it. The circumstances are these:

About two months ago the old men of the tribe held an all-night session in their underground council chamber, and in accordance with instructions, the oldest chief made a formal call next day on Father Deuche, the Catholic priest, who was in charge of the parish. He told the man of God that according to the tradition of the Isleta, it was about time for Padre Paddilla to again rise from his grave, as he had done at the end of every cycle of twenty-five years since the body was translated from Gran Quivera and buried near

187

the altar of the Isleta church. The clergyman was at first inclined to scout the idea as the records of that historic edifice threw no light on the matter, but was finally induced to make an investigation. The old chief outlined the spot on the one side of the altar where he claimed the remains were entombed. Although there was no indication of the rising of the body at that time, the old chief informed the priest that the phenomenon would certainly occur the next turn of the moon.

Father Paddilla, from whom the Paddilla takes its name, is a sort of patron saint with the Isleta Indians, and many of their prayers are directed to him. He is supposed to have given up his life in their cause in the sacking of Gran Quivera, several centuries ago and when the Isleta church was erected the body sacredly removed there.

The priest became sufficiently impressed with the story to communicate it to the authorities at Santa Fe, and the story even went to Rome. He was instructed to make a thorough investigation and keep a close watch. Shortly afterwards Archbishop Chapelle visited the Isleta Church and heard the whole story from first sources.

Now for the marvelous part of the story, which has just taken place. All at once there were indications of the floor cracking over the place designated by the old chief, as if the earth were being pushed up from below, as is reported to have occurred. The displacement of earth became larger every day, until finally the coffin came to the surface from a depth of 12 feet, the void being filled by the displaced earth falling in. The coffin is a rude trough-like structure, hewn out of cottonwood logs, and, strange to say, in a good state of preservation. It was difficult to remove the clumsy, hand-wrought nails. The interior revealed the complete skeleton of a man, whose teeth indicate that he had not reached advanced years. A cowl, such as is worn by monks, was in place at the head of the coffin, and a silk stole, the priestly insignia of office, surrounded the body portion of the skeleton. Both the cowl and stole are in good condition and have not

rotted in the least. The stole shows great antiquity, both in design, make and ornamentation. The priest removed one of the teeth, which he preserved. The coffin and its contents were inspected by the awe-stricken people, and the shrine will be visited by hundreds tomorrow.

Messrs. Armijo and Debaca made a close investigation and carefully observed the disturbed portion of the church floor. They talked freely with the Indians about the occurrence and tried to reach some reasonable explanation of it. Mr. Armijo thought some strange peculiarity of the earth might account for the resurrection of the coffin, but he is at a loss how to explain the preservation of the cottonwood box and the garments mentioned. The Indians believe it is a genuine visitation from their sainted padre. It certainly is a strange affair and merits investigation.

Might one not imagine that in the Ghirlandaio fresco in Santa Trinita, with its staircase leading up from below in the foreground (see figure 34a), Warburg saw a phenomenon of elevation comparable to the one in the church at Isleta, with the saint's body resurfacing from the depths of the ground? Although the trip to the Southwest left a persistent mark on Warburg's research, it did not resurface explicitly until twenty-seven years later, in Kreuzlingen: it then clearly appeared as a stage in the exploration of the early Renaissance that Warburg had begun in the 1880s, which led him to his analysis of the works of Botticelli (1893) and Ghirlandaio (1902). The 1923 lecture was the recollection of this experience.[24] At this date, New Mexico was not only, in Warburg's eyes, an analogy for Renaissance Florence in which the process of figurability was reproduced *in vivo*; it had become the geographical metaphor of his own personality.

"In the Land of the Painted Panel"

> It is a wonderful region viewed from any standpoint. Scenic!
> — George Wharton James, *The Indians of the*
> *Painted Desert Region* (1903)

In his 1923 lecture, Warburg stated that he wanted to give a summary impression of "the inner life" of Indians (*das Seelenpeben des Indianer*), but his account is first and foremost a description of his own universe of knowledge and the laws governing it. Thus in an April 12, 1924, draft of a letter he described his lecture as the moment when the thread of his thought had become coherent once again:

> I was able to speak freely for an hour and a half, without losing my train of thought, and I was able to make a series of claims relating to the psychology of culture in close connection with my earlier research. I insist on this because it seems to me that my doctors saw in this lecture a very encouraging sign that my faculties of communication had been restored, but not what I see in it, with gratitude and surprise: namely, the direct continuation and development of the research I had undertaken when I was in good health.[25]

The account of the trip to the Indian territories was not simply a formal exercise through which Warburg intended to demonstrate the integrity of his mental faculties. It should be understood, even in its contents, as the recapitulation, if not the result, of his work.

Fritz Saxl was the first to emphasize the importance of Warburg's receptivity to historical anthropology. He rightly remarked that Warburg was a student not only of Carl Justi and Hubert Janitschek (or the heir to an art history based on the principles of general aesthetics) but also of Hermann Usener, whose course on mythology he had taken in Bonn. Warburg's research must be

seen in connection with the trend in the history of religions that endeavored to understand ancient texts and the origin of Greek religion through contemporary pagan cultures.[26]

Now, the lecture, which Warburg had been granted by Binswanger and which he delivered to the clinic's patients and physicians, was not intended merely to illuminate his analysis of the Italian Renaissance. It had a deeper meaning. Although Warburg presented it as a sign of his own recovery, it in fact demonstrated that his thinking — including its most paradoxical manifestations — had certain similarities with the Native American concept of the world and could be explained through them. In the preparatory notes for his lecture, Warburg remarked:

> I ... do not want the slightest trace of blasphemous pseudoscience to be found in this comparative search for the eternally constant Indianness within the helpless human soul. The images and words ought to be a help to those who come after us, in their attempt to reflect on themselves in order to defend themselves from the tragic aspect of the tension between *magical* instinct and discursive logic. The confession of an incurable schizoid, deposited into the archive of the doctors of the soul.[27]

Warburg intended to demonstrate that Pueblo culture seemed "divided" by the effects of the ambivalence in which the Native American found himself, an ambivalence that made him pass freely from pragmatic activity to a symbolic interpretation of natural phenomena:

> To us, this synchrony of fantastic magic and sober purposiveness appears as a symptom of a cleavage [*Zerspaltung*]; for the Indian this is not schizoid but, rather, a liberating experience of the boundless communicability between man and environment [*Umwelt*].[28]

The two modes of understanding that govern the existence of the Pueblos also condition the researcher's experience, his at once laborious and intuitive circulation within the universe of discourse and representations. The methodological link Saxl noted between Warburg's art history and anthropology is superimposed by a more secret relationship of identification. In this way, Native American thought became not only the experimental model of a historical formation but also, and more profoundly, through its very ambivalence, the double of the historian, who reconstituted it through a constant oscillation between pragmatism and symbolism. The analogy was no longer between two cultures viewed in the same light but between the scholar and the object of his knowledge.

Just as the 1895 trip had proceeded from a book, the 1923 lecture opened by quoting the description of a mesa by the German archaeologist Emil Schmidt, who had visited the Pueblo sites a few years before Warburg:

> All in all it is a piece of earth only barely equipped by nature, which the prehistoric and historic inhabitants of the region have chosen to call their home. Apart from the narrow, furrowing valley in the northeast, through which the Rio Grande del Norte flows to the Gulf of Mexico, the landscape here consists essentially of plateaus [*Plateaulandschaffen*]: extensive, horizontally situated masses of limestone and tertiary rock, which soon form higher plateaus with steep edges and smooth surfaces. (The term *mesa* compares them with tables.) These are often pierced by flowing waters, . . . by ravines and canyons sometimes a thousand feet deep and more, with walls that from their highest points plummet almost vertically, as if they had been sliced with a saw. . . . For the greater part of the year the plateau landscape remains entirely without precipitation and the vast majority of the canyons are completely dried up; only at the time that

snow melts and during the brief rainy periods do powerful water masses roar through the bald ravines.[29]

Thus in the lecture, an almost imperceptible displacement occurs. In a paraphrased reference to Schmidt's description, Warburg replaced the term "plateau," with which Schmidt translated "mesa," with "Tafel," which belongs to the vocabulary of geology but also designates a painted panel or painting on wood. The expression "In diesem Gebiet des Colorado Tafellandes" thus could also be read "In the land of the painted panel," a painting the size of a landscape.[30]

Carl Georg Heise, future director of the Kunsthalle in Hamburg, recounted in his memoirs that the talks by Warburg, his teacher and friend, were punctuated with witty remarks that served a specific purpose: "This wit was not used as a form of tempered humor, but helped him express his thoughts precisely."[31] In 1923, Warburg seemed to describe the deserted mesas, furrowed by torrents, as a concrete representation of what would become in his eyes, during the winter of 1896, a field of experimentation for the analysis of Florentine painting.

Crossing the Mesa Verde, Nordenskiöld noted in his 1893 book, "[W]e meet at every step with ancient remains showing that these regions, now deserted, were once inhabited by a large population."[32] Penetrating in turn the Anasazi sites, Warburg crossed the threshold where Nordenskiöld had stopped, transforming archaeology's field of investigation into a field of study open to art history understood as a reconstruction of the past. Just as Norbert Hanold sets the mechanism of hypotyposis into motion while wandering through the ruins of Pompeii, and sees the city surge forth before his eyes as it was on the eve of the disaster, Warburg used the cliff dwellings of Mesa Verde as places of anamnesis — leading him to a different past.[33] Thus the memory of

Bernardo Buontalenti and the Florentine festivals of 1589 came to light in Warburg's vision of the mesas. There is a photograph taken in New Mexico, now in the Warburg Institute, in which it is hard to imagine, given its framing and subject, who other than he could have taken it at the time. It shows a cluster of stalactites in a sinuous rock formation. Beyond the reptilian-phallic theme, which is a little too obvious not to be ironic, it recalls the grotto created by Buontalenti in the Boboli Gardens (figures 66 and 67).[34] On the upper part of the facade, between garlands of stone, a semicircular opening is visible, through which one can make out the inside of a grotto, an intermediate place between nature and representation. Warburg found an echo of this image in the cliff dwellings, the villages in the rocks whose ruins he contemplated.

In his lecture, Warburg recounted that in January 1896 in Santa Fe, he received an unusual visit at the Palace Hotel from two Indians, Cleo Jurino and his son Anacleto, who, among other drawings, made a colored sketch of their vision of the cosmos right before his eyes (figure 68). Cleo, the father, was a priest-painter of the Cochiti sanctuary (kiva).[35] The drawing shows a snake with an arrow-shaped tongue as a rain god (figure 69).[36] In a vertical column in the margin of the drawing, Warburg added annotations in an arrangement that prefigures the placement on the page of the note devoted to Maria's progeny in the 1902 study (see figure 48):

> The serpent (Ttzitz Chu'i) and the cosmological drawing with the weather fetish were sketched for me on 10 January 1896 in my room, no. 59, in the Palace Hotel in Santa Fe, by Cleo Jurino, the guardian of the Estufa at Cochita.[37] C.J. is also the painter of the wall-paintings in the Estufa. The priest of Chipeo Nanutsch.
> 1. Aitschin, house of Yaya, the fetish.
> 2. Kashtiarts, the rainbow.

Figure 66. Stalactites, New Mexico.
Aby Warburg collection.

Figure 67. Bernardo Buontalenti, facade of the
grotto in the Boboli Gardens (upper part),
Florence. Photographed by Philippe Morel.

3. Yerrick, the fetish (or Yaya).

4. Nematje, the white cloud.

5. Neaesh, the raincloud.

6. Kaash, rain.

7. Purtunschtschj, lightning.

10. Ttzitz-chui, the water serpent.

11. the 4 rings signify that whoever approaches the serpent and does not tell the truth, drops dead before one can count to 4.

In the lecture, the drawing was followed by an account of what happened in the church in Acoma. Surrounded by Native Americans, Warburg participated in a Mass celebrated by a Catholic priest on a Baroque altar dating back to the Spanish occupation (figure 70). Since the priest did not speak the Indian language, an interpreter translated his words; for Warburg, the ceremony must have seemed like an asynchronous montage of visual and sonorous elements, whose combination produced a complex representation, combining spectacle and ritual. Wrapped in colorful woolen clothing decorated with white, red, or blue motifs, the Indians, as actor-effigies, made "a most picturesque impression [höchst malerischen Eindruck]" (figure 71).[38] It was not a logical chain of events, in his account, that led Warburg from the hotel in Santa Fe to the church in Acoma, but rather a purely analogical association of images obeying the mechanism of memory and following the order of the projected photographs that illustrated his remarks.[39] On the walls of the church, Warburg explained, paintings that looked like enlargements of the Santa Fe drawings slowly appeared to him: "It occurred to me during the service that the wall was covered with pagan cosmological symbols, exactly in the style drawn for me by Cleo Jurino."[40] In a photograph taken by Warburg, to the left of an Indian standing near a door, there appears, like a shadow, a jagged orna-

ment in which one recognizes the shape of a staircase; "in the rep-
resentation of the evolution, ascents, and descents of nature, steps
and ladders," whose irregular profile symbolizes the cosmos, "em-
body the primal experiences of humanity" (figure 72).[41] Undoubt-
edly the ghostly shape Warburg captured in his snapshot appeared
to him once his eyes had become accustomed to the half-light, but
he suggests that the shape of the staircase manifested itself under
the effects of the ritual taking place before him. The moment the
walls became covered with cosmological motifs, nothing distin-
guished the space in the church from that of the representation,
and the art historian surely remembered this phenomenon of iso-
morphism in his analysis of the Santa Trinita frescoes when de-
scribing the process of a body's appearance as an image.[42]

Through a new textual sleight of hand, the walls of the church
covered with paintings (did the shadow of the staircase serve as
transition?) became the space of the sacred kiva, and the circle of
images closed in on the presence of the serpent, "the strangest of
animals" (*das unheimlichste Tier*). The serpent, "symbol for the
rhythm of time," reigned in the darkness of the kiva as if born
from the drawing that Cleo Jurino created for Warburg in his
room at the Palace Hotel and through which he indicated not only
the direction but also the vector of the art historian's research.

Kachina Dance

> He asked me if indeed I hadn't found some of the move-
> ments of the puppets, particularly the smaller ones, to be
> exceedingly graceful in the dances.
>
> —Heinrich von Kleist, "On the Marionette Theater"

The kachina dance, which Warburg witnessed in the villages of the
Black Mesa when he returned from California, survived only in the
most remote regions of the Pueblo country, far from civilization,

197

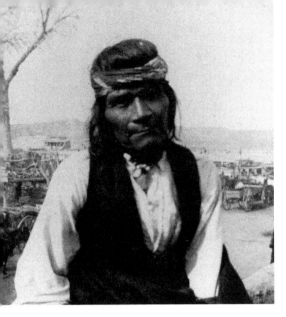

Figure 68. Cleo Jurino.
Photographed by Aby Warburg.

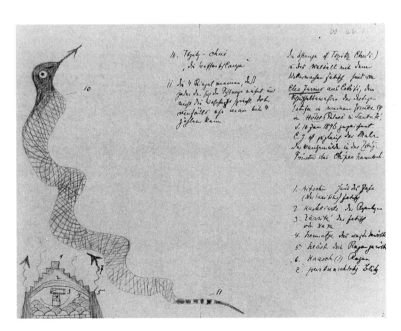

Figure 69. Cleo Jurino, drawing of a serpent in
the shape of the rain-bearing lightning bolt. Aby
Warburg collection.

Figure 70. Interior of the church at Acoma.
Photographed by Aby Warburg.

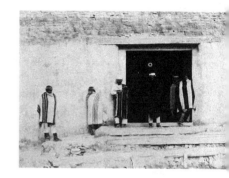

Figure 71. Indians at the door of the Acoma
church. Photographed by Aby Warburg.

Figure 72. Church at Acoma. To the left of the
image is a motif in the shape of a staircase.
Photographed by Aby Warburg.

as a last expression of the Indian peasants' contemplative culture.[43] From the train station in Flagstaff, Warburg and his guide reached the foothills of the Black Mesa in two days, crossing the desert in a small carriage. A sandstorm, he said, swept over their tracks, delivering the art historian to himself and transforming the spatial distancing into a return to times past. In the 1923 lecture, Warburg mentioned the moment when, during his stay in New Mexico, the village of Acoma appeared to him in the middle of the stretch of desert: he was positioned, he wrote, "like a Helgoland in a sea of sand."[44] In a spectral contrast, the steep slopes of the North Sea where Aby walked as a child surged up again from the rocky promontory on which Walpi was erected, above the desert, transforming the real landscape into an image of the past (figures 73 and 74).

On May 27, 1896, the night before the kachina dance, Warburg was in an Oraibi kiva, the Pueblos' underground prayer space carved below the houses. The Indians were seated together and smoking, and there was neither altar nor fetish. From time to time, Warburg noted, a pair of brown legs would appear at the top of the ladder leading into the sanctuary. Perhaps he mentioned this detail in 1923 because these wax-colored legs, suspended for a moment in the kiva, henceforth evoked the floating *boti* beneath the vault of the Annunziata for him.[45] The dancers were preparing themselves, he wrote, in a house nearby. Taking water into their mouths, they sprayed it onto the leather masks as the colors were rubbed in; the sprayed water evoked and summoned the rains to flow forth from the bottom of the canyons.[46]

During the 1923 lecture, Warburg projected a photograph taken by Adam Clark Vroman in 1895 depicting kachina dolls suspended from the wall of a house "like the figures of saints that hang in Catholic farmhouses." These dolls were not ordinary toys,

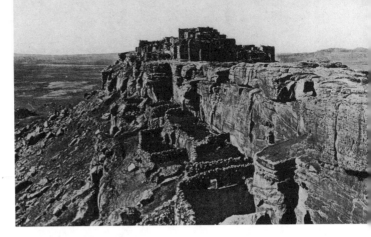

Figure 73. Overview of Walpi. From the *Eighth Annual Report of the Smithsonian Institution*, pl. 21 (the photograph is reproduced in Nordenskiöld's work).

Figure 74. Helgoland, in the North Sea, postcard. Aby Warburg collection.

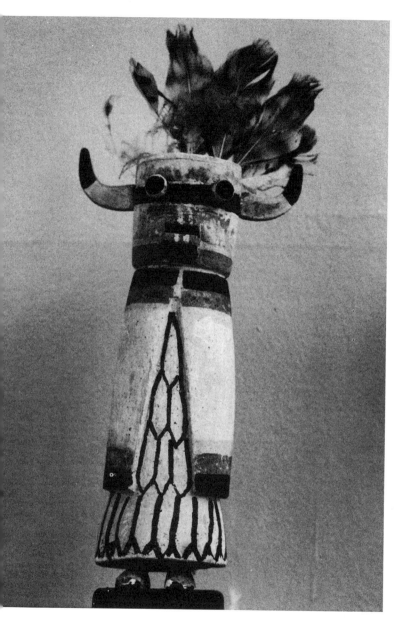

Figure 75. Kachina doll. Völkerkunde Museum,
Hamburg (gift of Aby Warburg).

he wrote, but replicas of masked dancers acting as "demoniac mediators between man and nature at the periodic festivals that accompany the annual harvests" (figure 75).[47] In dressing like the doll representing him, the dancer produced an intermediate being between the body and the image and transformed himself into a representation (see figure 7). This intuition, directly inspired by Burckhardt, who discovered in Renaissance festivities a path leading from life to art, was reversed by Warburg, who saw in the Oraibi ceremony the opening of a path leading from art to life.[48]

Performed by forty dancers, with the female characters played by men dressed in women's clothing, as in the Intermedi of 1589, the dance took place on the square at sunrise. The dancers' masks were green and red, traversed diagonally by white stripes, with three dots representing raindrops. These symbols were echoed in the wraps wound (*geschlungen*, literally "snaking") around their bodies, red and green decorations on a finely woven white ground.

A similar chromatic symbolism is found in the way Rossi, in 1589, described the costumes of the dancers, for example the hamadryads who appeared during the second Intermedio:

> [They were] all dressed in different colors, each in some way different from the others: one was dressed in dark blue and red, another in violet and white; one in green and yellow, another in blue and orange, yet another in stripes; and all were dressed in satin.... They wore belts like Diana, with the quivers at their sides filled with arrows: their bows were slung back over their shoulders, for, in their hands, they carried musical instruments.[49]

Like the figures who carried musical instruments in 1589, the Indian dancers carried rattles made from hollow gourds filled with pebbles. Around their knees they wore tortoise shells hung

with pebbles, creating a rattling sound as their legs moved, the equivalent of the trimmings and decorations — "shoulder pieces, masks, half-masks and paper roses" — worn by the Florentine dancers.[50] The "female dancers" in the Native American rituals, faces covered by a cloth, had masks decorated on top with anemone-like hairstyles similar to those worn by young Pueblo girls. Painted horse tails hung from the masks symbolized rain; dots scattered over their wraps and accessories represented drops of water.[51]

The dance lasted all day, with the dancers stopping from time to time to rest. When the masked men drew aside, no one was to follow them: anyone who saw them without a mask was believed to die, for their action prohibited any apparition that was not un-real. After each break, they returned to the troupe and resumed their monotonous movements (figures 76a and b).[52]

When the sun began to set, something happened that clearly revealed the parodic and disturbing undercurrent from which the kachina dance drew its meaning and its power for Warburg:

> Six figures appeared. Three almost completely naked men smeared with yellow clay, their hair wound into horn shapes, were dressed only in loincloths. Then came three men in women's clothes. And while the chorus and its priests proceeded with their dance movements, undisturbed and with unbroken devotion, these figures launched into a thoroughly vulgar and disrespectful parody of the chorus movements. And no one laughed. The vulgar parody was regarded not as comic mockery but, rather, as a kind of peripheral contribution by the revellers, in the effort to ensure a fruitful corn year.[53]

Like the characters of the commedia dell'arte in Renaissance the-ater, the clown dancers of the Pueblo ceremonies corresponded

to precise characters acting in a definite manner. The most common group were the mud heads, of which one can see examples in the photographs by Henry R. Voth that Warburg kept (figures 77a, b, and c). They would appear in the comic, burlesque, and often obscene interludes presented to the spectators watching from the roofs of their houses. They wore masks of cotton smeared with mud (hence their name) that had protruding circular orifices stuffed with raw cotton, seeds, and dirt taken from the footprints left by the Indians around the pueblo. In using this dirt, the mud heads acquired a magical ascendancy over other men, from whom they could demand respect and veneration.[54]

A few years before Warburg, Jesse Walter Fewkes, one of the foremost experts on Pueblo rituals, described the intervention of the masked clowns during the kachina dances, emphasizing their orgiastic and disturbing character:

1. Inordinate eating and begging, urine drinking, gluttony and obscenity.
2. Flogging of one another, stripping off breechcloths, drenching with foul water, ribald remarks to spectators, and comical episodes with donkeys and dogs.
3. Story telling for pieces of corn even under severe flogging by masked persons, races, smearing one another with blood, urinating upon one another, tormenting with cactus branches.[55]

At the beginning of 1896, while watching the antelope dance in San Ildefonso, Warburg was struck by its naive, almost comical aspect, immediately adding that no impression was more dangerous than this: "To laugh at the comical element in ethnology is wrong, because it instantly shuts off insight into the tragic element."[56] More imperatively than the clumping parade of the

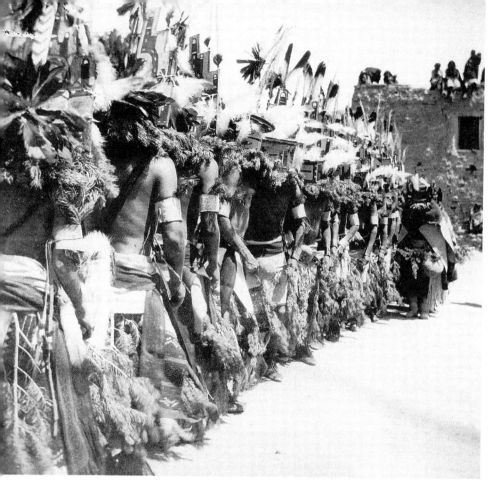

Figures 76a and b. Kachina dancers.
Photographed by Aby Warburg.

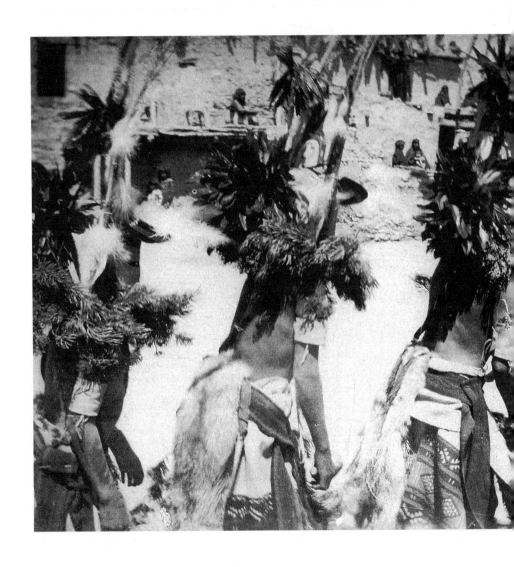

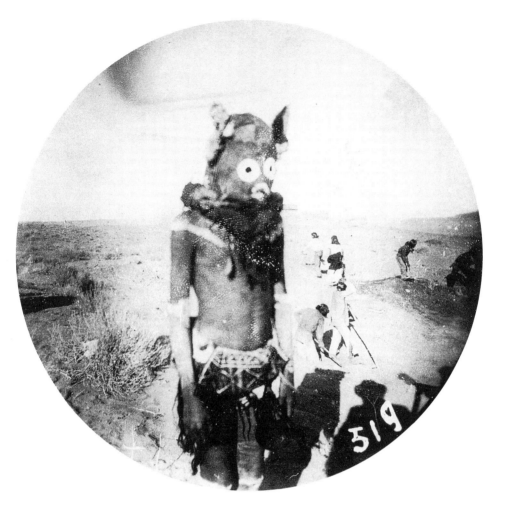

Figures 77a, b, and c. Clown dancer (above),
kachina dancer and runner (right).
Photographed by Henry R. Voth. Aby Warburg
collection.

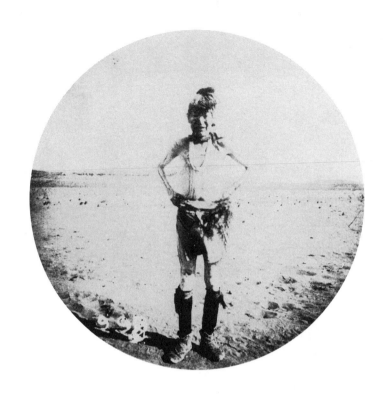

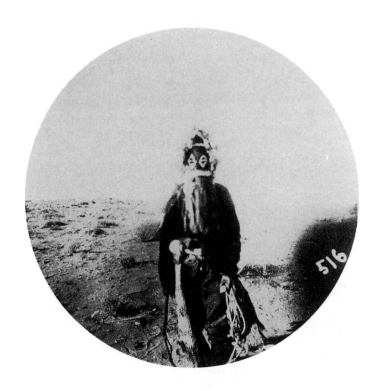

antelopes, the absurd irruption of the clown dancers, at once obscene and violent, prohibits laughter and brings to mind Nietzsche's words at the beginning of *The Birth of Tragedy*:

> The symbolism of the satyr chorus proclaims this primordial relationship between the thing-in-itself and appearance. The idyllic shepherd of modern man is merely a counterfeit of the sum of cultural illusions that are allegedly nature; the Dionysian Greek wants truth and nature in their most forceful form — and sees himself changed, as by magic, into a satyr.[57]

When the satyr appeared on the tragic stage, he momentarily unveiled to the spectator the nothingness from which being proceeds in the world of man; he showed that the individual is but a dream, that appearances are mere illusion. Tragedy was born from this experience, which Nietzsche defined as the expansion of the Dionysian chorus, projecting from itself a world of Apollonian images, which he described, curiously enough, as a projection:

> But suppose we disregard the character of the hero as it comes to the surface, visibly — after all, it is in the last analysis nothing but a bright image projected on a dark wall, which means appearance through and through; suppose we penetrate into the myth that projects itself in these lucid reflections: then we suddenly experience a phenomenon that is just the opposite of a familiar optical phenomenon. When after a forceful attempt to gaze on the sun we turn away blinded, we see dark-colored spots before our eyes, as a cure, as it were. Conversely, the bright image projections of the Sophoclean hero — in short, the Apollonian aspect of the mask — are necessary effects of a glance into the inside and terrors of nature; as it were, luminous spots to cure eyes damaged by gruesome night.[58]

Like the satyr drama, the clown dancers' performance was not simple parody; its enigmatic brutality revealed something about the origins of figuration in a spectacle that was both comic and painful. The world of aesthetic representation came to cover this brutality with the veil of appearances, but received its meaning and its intensity from it.

In a 1938 article titled "A Category of the Human Mind: The Notion of Person, the Notion of Self," Marcel Mauss notes several theories on the origin of the notion of personhood.[59] These include Latin etymologists' explanations, which claim that *persona*, deriving from *per/sonare*, designates the mask through (*per*) which the voice of the actor resonated — an explanation invented after the fact. It would appear that the word derives in fact from the Etruscan *farsu* or *phersu*, the strange character who appeared in the sixth century B.C.E., found many times in Etrurian frescoes. This is the masked figure, dressed in a striped multicolored helmet, who appears in the tomb of Pulcinella, in the so-called tomb of the Augurs, and in the tomb of the Olympiads, where he is running in profile and setting a dog upon a chained slave, his head hooded by a sack, in a cruel game (figure 78).[60] Now, Emile Benveniste claims (according to Mauss) that the word *phersu* derived from the Greek *prosopon* (which means the face, the mask, and the person). The *phersu*, who comes from the world of both the game and the ritual, would thus be a stage character appearing in a spectacle governed by a disturbing and comic dramaturgy not as an officiant but as an actor simulating a sacrifice. In a marginal note to his juridical and moral definition of the term, Mauss demonstrates the persistence of this "theatrical" concept of the notion of person as it was constituted during classical Antiquity and as it became stabilized in the system of Roman law: "The word *persona*, an artificial personage, mask, and role in comedy

and tragedy, in deceit and hypocrisy — as opposed to the word "me" — continued along its way. But the personal character of law was founded, and *persona* also became synonymous with the true nature of the individual."[61]

Beyond the formation of the identity of self, *persona* continued to designate the artificial persona, the comic or tragic mask — a stranger to the "ego" — which has no self-consciousness or interiority and retains its sense as a superimposed image. Like the multicolored actor in the Etruscan tombs, the clowns who appeared to Warburg in the Indian mesas in the middle of the kachina dances force the ambiguous categories defining the modern subject as a person to go back to the persona, to the mask, to the simple act of masquerading.

The Serpent Ritual

> These two were then the snake people, the man being the
> Snake chief. The woman by and by gave birth to young
> rattlesnakes. They laid them on the sand to dry. The
> grandfather often took them in his blanket and carried
> them around, showing them to the people in the houses
> and kivas, because he loved them.
>
> — "Legend of the Serpent," recounted by Voth
> in *The Oraibi Summer Snake Ceremony*

In 1488, Andrea Lotti, an agent of Lorenzo de' Medici's, informed his employer of the discovery of a small group of marble statues in the cloister of Rome's San Pietro in Vincoli. They were the three *Faunetti* caught in the coils of a large serpent, which Lotti deemed to be of exceptional beauty, with a marvelous execution of lifelike gesture. They gave the impression of life, he said, and they lacked only a voice; the central figure was depicted at the moment it

succumbed to death.[62] The small sculpture in San Pietro in Vincoli was in fact a copy of the *Laocoön*, which would be excavated a few years later, in 1506, in the Belvedere gardens. In 1755, Winckelmann would see in the ancient sculptural group a triumph of calm and static grandeur over the convulsions of suffering that deformed their features. Warburg offered an entirely different interpretation. In a 1905 study titled "Dürer and Italian Antiquity," he described the interest shown in the *Laocoön* at the moment of its discovery as a testimonial and a result — a symptom — of an artistic search for a "gestural pathos" that found its primordial, sorrowful form in the writhing of serpents (figure 79).[63] In devoting his 1923 lecture to the serpent ritual among the Pueblo Indians, Warburg resumed his study of the *Pathosformeln* undertaken in 1893, giving them a new dimension: in the performance of the dancers who manipulated live snakes, the serpentine line through which Renaissance artists translated the figure in motion resurfaced, as did the memory of the third Intermedio of 1589, which portrayed the struggle between Apollo and the serpents Python, and the transformation of the bloody sacrifice into representation.[64]

The antelope and kachina dances remained mimetic representations: in them, the dancers appeared as substitutions for animal or natural powers to which their masks connected them. Here, the death-bearing serpent intervened as a living actor in the ritual and was associated with the dancer without mediation. The serpent ritual took place every year in August, over nine days, alternating between Walpi and Oraibi; thus Warburg could not see it during his trip. In his lecture, he was inspired by a description published in 1894 by Jesse Walter Fewkes in the fourth volume of the *Journal of American Ethnology and Archaeology* and by the Reverend Henry R. Voth's *The Oraibi Summer Snake Ceremony*.[65] Warburg certainly consulted these works at the Smithsonian Institution in Washington — works that, after all, he had in his library. The Kreuzlingen

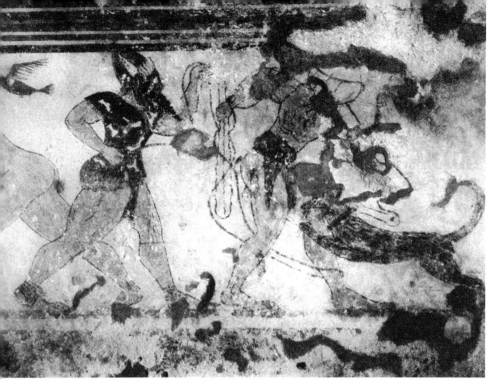

Figure 78. *Phersu Setting a Dog on a Chained
Slave*, fresco of the tomb of the Olympiads,
detail, around 530 B.C.E., Tarquinia.

Figure 79. Jean de Gourmont, *Laocoön*,
engraving, around 1540.

lecture was thus born of the universe of documents, not from direct experience, and, strictly speaking, is lacking in ethnographic value. Taken out of its context and meaning and envisioned analogically and formally, ritual is not an object of study but an instrument of analysis for the art historian; such is the way it appeared in the texts Warburg consulted, without reference to direct experience, as I shall outline broadly below.

The snakes were captured in the middle of the desert in August, at the time when the rains were due. The first three days of the ritual were devoted to finding the snakes, which alternated with periods of prayer in the kivas. The snake hunters were dressed in kilts and wore moccasins; they were marked with pinkish spots on the upper and lower arms and legs, and on each side of the sternum and spine.[66] In 1891, sixty snakes were used, two-thirds of which were rattlesnakes (*Crotalus confluentus*). They were kept in jars, in the darkness of the kiva, until the time of the ceremony. The snakes were not fed while they were confined, nor was their poison extracted. They were treated with the greatest care and gentleness; sudden movements were avoided, and voices were not raised around them. The Reverend Voth recounted seeing a snake escape from the sack in which it was held. The hunter who had captured it the day before called it "my animal," picked it up without any fuss, and put it back into a sack.[67]

The active phase of the ritual began on the fifth day. A sand painting representing the Hopi world was traced on the floor of the kiva. Fewkes carefully described the painting that the chief of the Antelope priests created in 1891: Inside a border made up of many geometrical color lines, and on a background of brown sand, four symbols of lightning appeared in the shape of snakes (figures 80a and b). Their bodies formed a quadruple zigzag between the half-moon shapes representing the clouds; their triangular heads

215

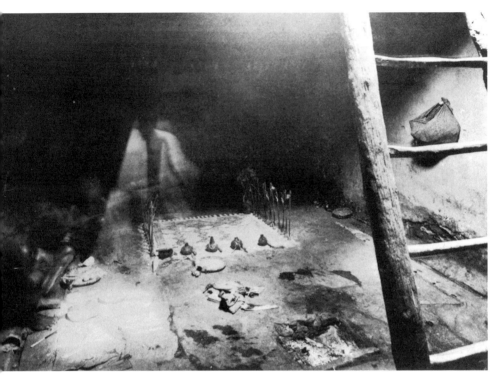

Figures 80a and b. Above: Sand painting in a
kiva depicting four lightning-bolt serpents. From
Henry R. Voth, *The Oraibi Summer Snake
Ceremony* (1903). Below: The motif.

pointed to the east. Forty parallel lines, made with black sand, represented rain. The priest-painter made no preliminary sketch in order to determine the size of his figures, and at no time did he touch the earth directly, content to let the sand slip between his fingers. He used no ruler, no string, no other measuring instrument.

The execution of the image was followed by an initiation ritual for which the novices, the priests, and the spectators, men and women, gathered in the snake kiva. Fewkes described the episode as follows: A cloth was stretched from wall to wall, concealing the jars where the snakes had been placed and creating a corridor for the dancers. The serpent chief sat in one corner of the room, wrapped in a blanket. On signal, while the priests began to murmur incantatory songs, an actor-dancer, his legs stiff, jumped out backward from behind the cloth stretched across the middle of the space. He wore a feathered headdress, and his face was painted. He first approached the lit hearth, took up a pipe, and began to dance while smoking. Then he disappeared behind the screen dividing the room and reappeared a moment later, still dancing. Legs still stiff, he approached the head priest and drew a dead branch from beneath the blanket; then he went over to the novices and shook it in front of their faces. Then he went back behind the cloth, and in his place another actor, the "puma-man," appeared. Twice, while the priests sprinkled cornmeal on the sand painting, he slipped his head under the chief's blanket and pulled out, successively, through a game of hide-and-seek for which Fewkes gives no explanation, a lit pipe and a serpent writhing in his mouth. Approaching the novices in turn, he bent forward and let the animal hang down, touching their knees with it. After bringing the reptile back to the chief, the dancer disappeared behind the cloth. Other dancers executed the same moves, alternately taking corncobs and live snakes from under the blanket.[68]

On the ninth day, the ceremony of the washing, or baptism, of the snakes took place. At one in the afternoon, the priests gathered at the back of the kiva, near the jars where the serpents were kept. An earthenware bowl was brought, into which a liquid was solemnly poured. The serpent priest began to grasp the snakes, two by two, holding them by the neck. The snakes' heads, despite their resistance, were immersed several times in the receptacle; then they were thrown violently onto the floor of the kiva in the middle of the painting. While the snakes contracted, the priests, using a stick decorated with feathers (nakwakwoci), rolled them in the sand. The operation was repeated until all the snakes had been thrown: "They are living rain-serpents — saints in animal form," wrote Warburg. The snakes then erased the painting in which they were depicted and appeared, in place of their images, with bodies coated in sand the colors of the universe (and then they were captured again, and put back into the jars) (figure 81).

Why didn't the snakes bite? First, according to Voth, because of the repeated handlings to which the Indians subjected them: Before the ritual of initiation, they did not brutalize the serpents, in order to accustom them to the presence of men. Frequently touched by the ends of whips, they were no longer afraid of contact and became used to seeing shapes moving above them. But the main explanation, according to Voth, has to do with the way in which they were handled: they were never seized with a quick, jerky, or hesitant grasp; the movement of the hand had to be slow and smooth, and the grip had to be made when the snake was not coiled, ready to strike. The photographer-ethnographer reported in 1896 that he saw an old Indian named Nuvakwahu, who was almost blind, trying to catch snakes undulating on the ground before him. Guided by his companions' voices, he stretched his hand out slowly, without hesitation, creating a path in the middle of the snakes, without seeing their shapes.[69]

218

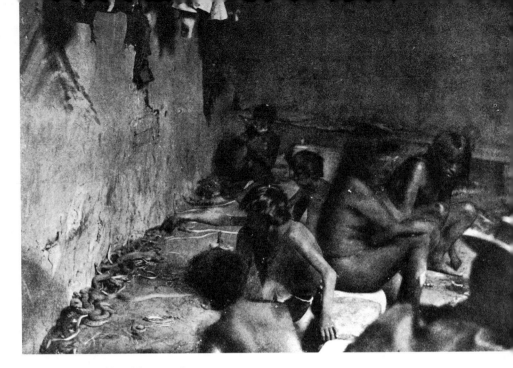

Figure 81. The washing of the serpents.
From Henry R. Voth, *The Oraibi Summer Snake Ceremony* (1903).

A priest told Voth that during the washing of the snakes, the officiants were not to spit outside the kiva and were supposed to swallow their saliva. Anyone who walked on spittle or touched it was thought to become enchanted by the snake, and part of his body would swell and burst if the spell was not broken.[70]

On the ninth day, the serpent dance, which took place in public, with both Indians and white men present, marked the last phase of the ritual. In 1891, the roofs of the houses surrounding the Walpi square were occupied by Navajo from the neighboring villages, Americans from the cities, and most of the inhabitants of Walpi. An unwritten law dictated that the dance take place at dusk, "As the plaza is situated on the south side of the village over which the shadows of the buildings fall at that time, it was impossible to get a good photograph of the observance" — which a few years later, in 1896, Voth succeeded in doing in the village of Oraibi, probably using more sensitive film and a snapshot.[71]

The dancers spent most of the afternoon preceding the performance in their kiva, brushing their accessories and dressing for the ceremony. The snakes were brought to the square at six o'clock. The snake priests were grouped in threes: the bearer, the "cajoler," and the retriever. The trios lined up near the *kisi*, the sacred rock around which the movements were organized; the snake bearer would kneel and thrust his hand into the jar while his helper held him by the foxtail covering his back. When the bearer stood up, he was holding the poisonous snake between his fingers. Without hesitating, he placed the animal in his mouth, grasping it by the neck with his teeth or lips.[72] His eyes were closed. Placing his left arm around the bearer's neck, the man supporting him shook a stick decorated with feathers the length of the snake to appease it and protect the bearer. The two men circled the place, progressing to the left, followed by a third, charged with picking the snake back up if it fell (figure 82).

After each group executed the course, the bearers threw their snakes into a large circle created near the sacred rock, and the women sprinkled cornmeal on the writhing mass. On cue, the officiants jumped into the circle and seized as many snakes as they could to carry them away from the village, to the four cardinal points, where they set them free. The snakes, wrote Warburg, inspired by Fewkes, were released by the dancers "with lightning speed" (*Blitzschnell*). Transformed by the consecration and the danced imitation, they were released alive, as lightning bolts, messengers for the storms and rain. A series of purifications (vomiting, aspersion with ash) marked the end of the ceremony.[73]

Apollo's fictive battle with Python on the stage of the Intermedi was reproduced during the Native American ritual, but in a real form (see figure 57). We might turn to Nietzsche to uncover the deeper meaning of this episode and its repetition, to the transfiguration of the shepherd who is delivered of the snake lodged in his throat, which the philosopher describes as an irruption of satyr drama in the universe of the pastoral:

And verily, what I saw, I had never seen the like. A young shepherd I saw, writhing, gagging, in spasms, his face distorted, and a heavy black snake hung out of his mouth. Had I ever seen so much nausea and pale dread on one face? He seemed to have been asleep when the snake crawled into his throat and bit itself fast. My hand tore at the snake and tore in vain; it did not tear the snake out of his throat. Then it cried out of me: "Bite! Bite its head off! Bite!" Thus it cried out of me — my dread, my hatred, my nausea, my pity, all that is good and wicked in me cried out of me with a single cry....

But the shepherd, however, bit as my cry counseled him; he bit with a good bite. Far away he spewed the head of the snake —

221

and he jumped up. No longer shepherd, no longer human — one changed, radiant, laughing![74]

The snakes' appearance on the scene during the ritual Warburg described in the 1923 lecture marks the resolution and, to some degree, the path to the end of his long research into figures in motion. The representation of the transitory state that he noted, as early as 1893, in the art of the Florentine Renaissance continuously led him back to the motif of the snake. It appeared in the nymphs with billowing hair and veils drawn by Botticelli, and reappeared in the Intermedi figures, whose silhouettes Rossi insistently described as interlacing serpentine forms.

In 1435, in *On Painting*, when Alberti suggested how to animate figures by using various accessories and attributes, he compared the representation of hair to that of snakes: "The seven movements are especially pleasing in hair where part of it turns in spirals as if wishing to knot itself, waves in the air like flames, twines around itself like a serpent, while part rises here, part there."[75] Warburg did not cite this passage, but he noted that in Alberti's Tempio Malatestiano, Agostino di Duccio, on his sculpted panels, "filled the hair and drapery of the figures ... with ... liveliness of movement." His undulating reliefs are found in the twenty-fifth plate of *Mnemosyne* as a variation on the serpentine form, which Warburg, over the course of his research, would recognize more and more clearly as the "universal pathetic form" of the representation of movement.

In 1893, Warburg sought to review the questions that Florentine artists had asked themselves in interpreting the forms of Antiquity. It seemed to him that they had turned toward Antiquity not to preserve the Apollonian dimension but to discover pathetic formulas. The attention to movement shifts the interpretation of the works toward their Dionysian aspect: such is the deepest

sense of Warburg's research, which led to a profound reevaluation of Renaissance art. In the eyes of the art historian guided by the question of motion in the works of Renaissance artists, the pastoral shepherd was replaced by the tragic satyr, the nymphs by the ecstatic maenads, whose transformation and entrance into Dionysus's retinue were described by Nietzsche before him:

> The young girls and older women rise up, letting their long hair fall onto their shoulders, arranging the unlaced and unadorned deerskin, and tying around the multicolored fleece a belt of serpents which affectionately kiss their cheeks....[76]

The Death of the Serpent

> O my brothers, I heard a laughter that was no human laughter; and now a thirst gnaws at me, a longing that never grows still. My longing for this laughter gnaws at me; oh, how do I bear to go on living! And how could I bear to die now!
>
> — Nietzsche, *Thus Spoke Zarathustra*

Fewkes noted that in Oraibi, which was farther away and less accessible to outside influences, the serpent ritual continued in an austere and incomprehensible form free from all theatricality. The ceremony he had witnessed in Walpi already contained signs of alteration, in his opinion, in its slightly decorative and demonstrative emphasis. During the first decades of the twentieth century, when the last vernacular Indian cultures were entering into a process of irreversible decomposition, the serpent ritual, in spreading outside the protected space of the mesas, became an attraction prized by tourists and a moneymaking subject for tour operators. In 1924, at the Ingleside Inn in Phoenix, Arizona, one could photograph authentic Indians, with live snakes in their mouths (figure

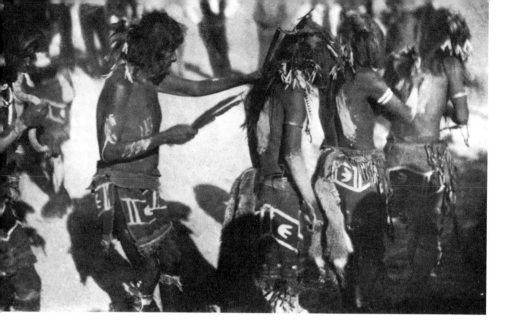

Figure 82. Snake dance. Photographed
by George Wharton James. From Henry R. Voth,
The Oraibi Summer Snake Ceremony (1903). To
the left: a dancer with a snake in his mouth.

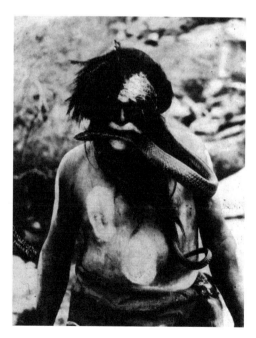

Figure 83. Hopi Indian Study #28, 1924.
Photographer unknown. Library of Congress,
Washington, DC. The ritual transformed into a
tourist attraction.

83).[77] The demystification of the ritual, hereafter performed with its photographic reproduction in mind, was the unquestionable sign of its definitive disappearance under the effect of an acculturation more efficacious than any sacrifice. The contemplativeness of the Native American ceremony was replaced by the false violence of images recycled in a folkloric spectacle. The ceremonies photographed at the end of the nineteenth century by Voth and George Wharton James show the dancers enveloped in the aura made by their movements, which make them even less clearly visible: the clarity of the snapshots taken in the 1920s, and the frontal pose of the models, mark the irreparable disappearance of the very thing they claimed to preserve.

In 1891, Fewkes recorded, with the help of a phonograph rented from the Pacific Phonograph Company, the sixteen songs that the Antelopes sang during the consecration of the serpent. A Native American named Ha-Ha-We repeated them for him a few days after the dance, outside Walpi, in the calm of his hotel room. The dancer let down his hair and rubbed his body and face with iron oxide and kaolin in order to prepare himself for the ceremony. He repeated the songs one by one, and each time the recording was completed, he wanted to hear it. Ha-Ha-We smoked after each song and blew smoke rings on the phonographic cylinders. In one or two cases, the cylinders were not long enough, but the Indian did not want to interrupt his song in order to allow Fewkes to record the whole melody. When all the songs were recorded and the cylinders wrapped in paper, he spit on them and declared himself satisfied. Ha-Ha-We had lent his services to the recording session as if to a ritual of preservation; but the phonograph and the wax rolls that allowed the songs to be reproduced were also the instruments of their destruction.

At the end of his 1923 lecture, Warburg declared that in 1896

in San Francisco, during his excursion to the Pacific Coast, he photographed the man responsible for this disappearance and, in him, the human conqueror of the serpent cult: the man appeared to him in the guise of a passerby, wearing a black top hat (*Zylinder*), against the background of a classical dome (figure 84). The hieroglyph of fecundity had been replaced by a silhouette topped with a shiny black cylinder; the canephore, symbol of domestic energy and acculturation, by a grotesque and disturbing counterfeit of the basket carriers from ancient tradition. Behind the man in the top hat, in the telegraph wires striating the sky and destroying space, Edison, the "electrical sorcerer" who allowed Fewkes to record the songs of Ha-Ha-We, had captured lightning.

Modern technology has released man from the symbolic relationships he used to have with nature, bringing with it a series of rational substitutions for the ritual behavior with which he once confronted the impenetrability of phenomena and the instinctive terrors born of incomprehension. "The replacement of mythological causation by the technological removes the fears felt by primitive humanity."[78] If Warburg repeated the progressive clichés of positivism, it was to turn them on their heads, and not, as Gombrich tried to demonstrate, to prolong them. The "fears felt by primitive humanity" are opposed not to knowledge but to the world's demystification, which the art historian would diagnose as the definitive sign of the instrumentalization of nature, seen in the disappearance of spatial relationships and the domestication of energy.[79] Electrical circuits and water pipes would henceforth imprison not only electricity and water but also the original myths of lightning and irrigation:

> The lightning imprisoned in wire — captured electricity — has produced a culture with no use for paganism. What has replaced it? Natural forces are no longer seen in anthropomorphic or biomorphic

Figure 84. A passerby in San Francisco.
Photographed by Aby Warburg.

guise, but rather as infinite waves obedient to the human touch. With these waves, the culture of the machine age destroys what the natural sciences, born of myth, so arduously achieved: the space for devotion [*Andachtsraum*], which evolved in turn into the space required for reflection [*Denkraum*].

The modern Prometheus and the modern Icarus, Franklin and the Wright brothers, who invented the dirigible airplane, are precisely those ominous destroyers of the sense of distance, who threaten to lead the planet back into chaos. Telegram and telephone destroy the cosmos. Mythical and symbolic thinking strive to form spiritual bonds between humanity and the surrounding world, shaping distance into the space required for devotion and reflection: the distance undone by the instantaneous electric connection.[80]

CHAPTER SIX

Hamburg

The Art History Scene

K.B.W. — Kiva

In 1944, Fritz Saxl recounted that when he visited the Kulturwis-senschaftliche Bibliothek for the first time, early in the second decade of the twentieth century, before he became Warburg's closest collaborator, he was struck by the organization of the books, and understood that it was not a static arrangement but a universe of representations in motion:

> The arrangement of the books was . . . baffling, and any young stu-dent like myself may have found it most peculiar, perhaps, that War-burg never tired of shifting and re-shifting them. Every progress in his system of thought, every new idea about the inter-relation of facts made him re-group the corresponding books. The library changed with every change in his research method and with every variation of his interests. Small as the collection was, it was intensely alive, and Warburg never ceased shaping it so that it might best express his ideas about the history of man.[1]

Saxl added that there were more complete libraries; one under-stood, however, little by little, that Warburg's goal was not simple erudition. His objective was to determine, in his own eyes, the direction of his research and to abolish *de facto* the distinction

229

between accumulation of knowledge and aesthetic production, between research and performance. While recognizing that the library constituted "a collection of questions more than a repository of books," Saxl ultimately and pragmatically made himself the advocate for attaching this strange object of knowledge — as its inventor had wanted — to the university of Hamburg, founded at the end of 1920s.[2]

Like Saxl, Ernst Cassirer, in his funeral oration for Warburg in 1929, described the library as an enigmatic space steeped in the thought of its demiurge:

> This uninterrupted procession of books seemed to me to be surrounded by a kind of magical air, which lay over them like a magic spell. And the more I immersed myself in the rich contents of this library, the more this feeling was confirmed and intensified. From this series of books there emerged ever more clearly a series of images, of determinate and originary spiritual motifs and configurations, and behind the multiplicity of these configurations there stood, clearly and forcefully, the figure of the man who devoted the best part of his life to the foundation and construction of this library. And unexpectedly, something else arose for me out of this collection of books: an impression of the great personality of a researcher whose destiny as such is deeply influential.[3]

Perhaps it is in light of the discovery of the Warburg library that one should read the following lines from Cassirer's great work published in 1927, *The Individual and the Cosmos in Renaissance Philosophy*, devoted to the relationships between the subject and the object in Neoplatonic theories of knowledge:

> As a mere living entity, the Ego is relegated to a state of isolation. The act of thought consists in abandoning and overcoming this isolation

and fusing with the One Absolute Intellect, the *intellectus agens*. The possibility of this fusion is necessary not only to *mysticism*, but to *logic* as well; for this fusion alone seems capable of really explaining the process of thought and of establishing its necessary validity. The true subject of thought is not the individual, the "self." Rather, it is a non-personal, substantial being common to all thinking beings; one whose connection with the individual Ego is external and accidental.[4]

In the 1923 lecture, Warburg underscored that the Pueblo Indians got their name from the place in which they lived, which he interpreted as a sign of fusion between man and his environment ("Schrankenlose Beziehungsmöglichkeit zwischen Mensch und Umwelt"). He saw the contemplative, sedentary life of the Pueblos, which distinguished them from Navajo hunters and warriors, their hereditary enemies, as analogous to the researcher's mode of being. In giving his name to his library, Warburg definitively linked his existence to that of a place and entered, with his disciples and his powerful family of bankers and arts patrons, into the space of knowledge, just as the Florentine bourgeois had entered, along with their kin, into the space of representation. He wrote: "What interested me as a cultural historian was that in the midst of a country that had made technological culture into an admirable precision weapon in the hands of intellectual man, an enclave of primitive pagan humanity was able to maintain itself."[5] Based on the model of the Pueblos' surviving in the middle of the American territory cut into sections by railroad and telegraph lines, the library rose up in Hamburg, one of the most active centers of European mercantile civilization, as much as an instrument of historical research as an "observatory," to use Warburg's own term, of the survival and decomposition of cultures.

The Pueblo Indians had invented an analogical circulation among house, cosmos, and sacred site whose origins reach back to time immemorial. The kiva, sacred underground devotional chamber (*interiorisches Andachtsraum*), was integrated into the living space, of which it constituted a lower floor, as in the house on the Heilwigstrasse where, until 1926, the rooms inhabited by Aby and his family were on the upper floors, while the rooms on the ground floor were entirely given over to the configuration and consultation of books. The library was organized according to the symbolic relationships that governed the individual in the Indians' world: the space of contemplation (*Andachtsraum*) and the space of thought (*Denkraum*).

In his observations of Native American rituals, Warburg had discovered the possibility of abolishing the boundary between the world and representations: such was the experience he wished to reiterate and perpetuate within the walls of his library, elaborating a type of thought that espoused the movements of intuition, allowing itself to be decoded according to its rhythms, a thought inseparable from the body and the encounters affecting it. In a note drafted in the Palace Hotel in Santa Fe on January 27, 1896, Warburg analyzed this principle of identification between the subject and its *Umwelt*, which would thereafter determine the orientation of his research:

 I. Incorporation (medical magic)
 II. Corporeal introjection (animal, imitation)
 III. Corporeal annexation (symbolism of tools)
 IV. Corporeal addition (ornamented pottery) (Really belongs to III.)
 I believe I have found the formula for my psychological law at last, for which I have been searching since 1888.[6]

And in a letter addressed to his brother Paul on January 4, 1904, Aby described the organic link binding him to his library, putting his discovery in a humorous light: "I bought 516 books last year.... I have also grown at least 516 grey hairs in that year, and if things go on at that speed, which, I fear, will certainly be the case as far as book purchases go, I shall acquire at least another 500 grey hairs (i.e., books)."[7]

Carl Georg Heise recounts that in his peregrinations, Warburg was inseparable from his traveling library and re-created, in hotel rooms, the configuration of his workspace in Hamburg (see figure 111). In 1889, Warburg wrote something from Florence to his mother that is rather banal but takes on more meaning in retrospect: "I must now have all the aids (books, photographs) close at hand."[8] He insisted, as a necessity, on having at hand the visual and written documents in which his universe of knowledge was gathered. In a 1925 letter to Max, a letter written before the installation of the library in the new building at 116 Heilwigstrasse (figure 85), Warburg explained his reasons for needing this proximity:

> The novelty of my method consists in the fact that, in studying the psychology of artistic creation, I bring together documents from the domain of language as well as from the plastic arts or from the world of religious and secular drama. To be able to do this, I and my young assistants or research companions must use large tables on which to lay out the documents, i.e., the books and images, so that we can compare them, and these books and images must be easily and instantly within reach. I therefore need a veritable *arena* [P.-A. Michaud's emphasis] with tables, so that I can have at hand both the ordinary books and the iconographic material.[9]

When Warburg describes the elliptical reading room he wanted for the new library, one sees again a resurgence of the Oraibi site

Figure 85. The facade of the K.B.W.
(Kunstwissenschaftliche Bibliothek Warburg),
116 Heilwigstrasse, Hamburg.

where the dances observed by the spectators assembled on roof-
tops took place (figure 86):

> By introducing an oval wall of books, as is shown on the plan, we
> will obtain two things: *first*, from the arena the books will be closer
> and easier to consult, and, *second*, above this elliptical wall of books
> we can install a row of chairs from which the audience, when it is
> somewhat larger, can see and hear everything.[10]

During his work sessions, Warburg was constantly in motion,
handling books, comparing photographs, and writing and classify-
ing reports. According to Saxl, "Often one saw Warburg standing
tired and distressed bent over his boxes with a packet of index
cards, trying to find for each one the best place within the system;
it looked like a waste of energy and one felt sorry."[11] As in the
antelope, kachina, and serpent dances, Warburg's movements
within his library were "danced causalities," and the collection of
books as a whole was both the objectification of his thought and
an allegory of the world and the bodies moving in it.[12] The class-
ing of the entries, and the constant shifting of the books on the
shelves, were rites of orientation for which Warburg had con-
ceived the model during his trip to the Indian country, and he tire-
lessly reproduced this model in the confined world of his library.
In his study, imaginary threads bound him to each group of works,
and at any given moment one could guess, depending on the dis-
tance between them, his interest in the material they covered.

Heise recalled that on Warburg's worktable there were piles
of works whose superimposition itself had meaning: catalogs of
ancient works; small objects that, he said, he considered fetishes;
and, in particular, "a pile of office accessories he always wanted
close at hand, and in large quantities, from paper clips and thumb-
tacks to paperweights, from adhesive strips to sealing wax, to

which one must add a few personal idiosyncrasies such as packets of thin strips of paper to be used as bookmarks." Heise added that Warburg flew into violent rages when an object was moved on this table, as if "on an astrological plane the constellations had been modified" in this artificial cosmology whose model he had constructed (figure 87).[13]

The rituals of knowledge are a response to the enigma of the individual in the world of man. They are not the explanation (there is no explanation) but the emphatic repetition of the place where the paths of knowledge and of identification merge. Like the doll dancers in the kachina ritual, the researcher gives meaning to something that has no meaning — not in *understanding* but in *reproducing* the world in the closed universe of representations.

Beyond the Railroad Line

> Parmenides said, "One cannot think of what is not"; — we are
> at the other extreme, and say, "What can be thought of must
> certainly be a fiction."
>
> — Nietzsche, *The Will to Power*

In a note written for the last session of the course he taught in Hamburg in 1926–1927, Warburg tried to illuminate the thought of Burckhardt and Nietzsche: like "seismographs," both recorded, he said, a succession of "mnestic waves" (*mnemische Wellen*) transmitted to them from the past.[14] Faced with an experience of this sort, which threatened the rational exercise of his research, Burckhardt walled himself up in the university: "Burckhardt was a fully conscious necromancer: hence the powers that seriously threatened him appeared clearly to him, from which he escaped by building a watchman's tower. His clairvoyance was like that of Lynceus." In his teaching, Burckhardt did not stray from the oracular aspect of his thought. Acting as a lucid and rational clairvoyant,

Figure 86. Elliptical reading room in the library.

Figure 87. Aby Warburg's worktable.

he simply gave it the form of didactic knowledge. Faced with the powers that he came up against, Nietzsche succumbed "in the limpid atmosphere of Turin," which had produced a simulacrum of a cure in him during the famous crisis marking the final break-down of his never-to-be-regained thought. When he lost con-sciousness in the middle of the street after witnessing the mal-treatment of a horse, he was brought home. At the time, he was living in the house of a bookseller named Davide Fino, whom, in a sublime slip, Warburg calls Delfino, leading Nietzsche back into the mythological procession of the Intermedi of 1589: "He is a type of nabi, the ancient prophet running through the streets, tearing his clothes, screaming in pain, who, perhaps, succeeds in seducing the people."[15] At the time of the Turin crisis, Nietzsche had called on Burckhardt for assistance. But, walled up in his tower, the latter watched him, as Warburg wrote, slip away, "like a hierosolymitan watched a dervish spin," in a tension he himself felt as the rending of his own thought. On April 3, 1929, a few weeks before his death, Warburg noted in his journal: "Sometimes it looks to me as if, in my role as psycho-historian, I tried to diag-nose the schizophrenia of Western civilization from its images in an autobiographical reflex. The ecstatic 'Nympha' (maniac) on the one side and the mourning river-god (depressive) on the other."[16]

After the years spent in Binswanger's clinic, Warburg saw the forces he had identified in his research (the tension between Apollo and Dionysus as expressed, historically, in aesthetic forms) as the manifestation of an internal conflict affecting the very conditions of knowledge. He had understood that mania is melan-cholia, to use Freud's terms, and that it also expresses a renuncia-tion of the conditions of experience, a violent separation from the sphere of temporality.[17] Warburg reread *The Civilization of the Renaissance in Italy* many times and was filled with the pagan vision of Quattrocento Florence that Burckhardt had explored

before him. But after his return from Indian country, he saw Florentine civilization in a different light: "He saw the masquerades with their chariots and Lorenzo de' Medici's *Canti Carnascialeschi* as avatars of the dances he had seen on the mesa."[18] Burckhardt conceived of the Renaissance as the moment at which two epochs became intertwined and played out simultaneously, as a historical realization of the eternal return. Warburg reworked his lesson in reverse: in the history of civilization he saw no longer the accomplishment of the will to power but a process of decomposition whose extent the Indian rituals had allowed him to measure.

Warburg knew long before he left that in the mesas of Arizona and the plains of New Mexico he would find not the original state of Native American culture but an acculturation at work since the beginnings of the Spanish conquest, of which the birth of Amerindian ethnology at the end of the nineteenth century merely marked the final stage. It was not a world transmitted whole in its primitive form that he undertook to explore in his trip, but a culture in the process of being eradicated, where all symbolic activity was slowly transformed into a ritual of preservation. According to Nietzsche, "To understand historically is to revive. There is no path leading from the concept to the essence of things." In identifying his thought with the Native Americans, Warburg exposed it to the consequences of their disappearance. He anticipated this outcome in 1889, in a note in the form of a theory for a philosophy of history:

Antiquity: Attempt to find satisfaction in life, pleasure, or self-destruction.

Middle Ages: Self-destruction for the sake of a future personal life....

Modern Times: Restriction of enjoyment; self-destruction for the sake of an impersonal life.[19]

When he returned from Kreuzlingen in 1924, Warburg gave this schema a nondiscursive form in his last project of an "art history without a text," *Mnemosyne*.[20] As with the texts in his library, he gave expression, but with images this time, to the unresolved conflicts that had given meaning to his history of forms, as well as his own thought. "I can no longer stand the sound of my old expressions, stencilled from high-quality tinfoil."[21]

Warburg had penetrated into the mesas as into a space closed off from recognition, where each object was posited as an enigma, and the Pueblo villages appeared to him as a set of questions, demanding that their interpretation renounce the illumination of meaning in order to concentrate on relationships and structures. Thus he commented on the photographs he projected during his 1923 lecture less as ethnographic documents than as compositions. In other words, in the final stage of a critical reversal, he described less the object on which he had focused his camera than the photographs themselves, a reversal that was to lead to a true methodology of montage.

In the village of Laguna, Warburg had photographed a young girl carrying a clay pot full of water on her head (figure 88). This Indian figure recalled the canephore of the Western tradition, as Ghirlandaio had depicted her in the frescoes of Santa Maria Novella (figure 89), or Botticelli in the Sistine Chapel, and who appeared in a number of works by Renaissance painters, from Fra Filippo Lippi to Raphael, as an allegory of fecundity. But all movement has disappeared from the body of the young Native American, who, in silhouette, seems closer to the caryatids than to the supple and loose-limbed Florentine nymphs. The schematic figure of the bird traced on the earthenware pot is like the vital principle, the *anima*, of the figure holding it up. Through a symbolic montage, the photograph associates a sign and a figure and gives them a common meaning. Thus, during his lecture, Warburg noted:

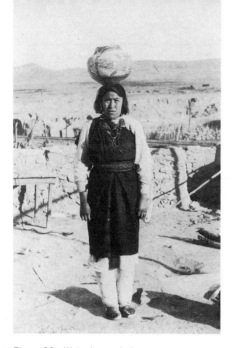

Figure 88. Water bearer in Laguna.
Aby Warburg collection.

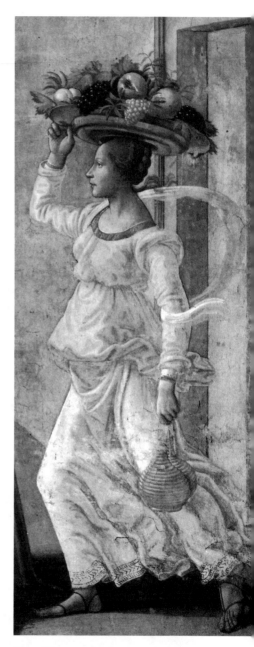

Figure 89. Domenico Ghirlandaio, *The Birth of Saint John the Baptist*, detail: canephore. Santa Maria Novella, Florence.

The characteristic style for the drawings on these pots is a skeletal heraldic image. A bird, for example, may be dissected into its essential component parts to form a heraldic abstraction: it becomes a hieroglyph, not simply to be looked at but, rather, to be read. We have here an intermediary stage between a naturalistic image and a sign, between a realistic mirror image and writing.[22]

Inspired by her otherness itself, Warburg saw the Laguna girl (aus Laguna: who comes from Laguna, but also "who comes from the lagoon") as a resurgence of the nymph, whose movement is expressed, this time, no longer in an external, dramatic form but in an internal, symbolic form.[23] Movement is manifested in her no longer by external attributes — folds in the clothing, hair — but in the combination of two heterogeneous, visual elements and by the picture's use of montage.

In *Mnemosyne*, these symbolic procedures became generalized. On the preliminary panel of his atlas of images, Warburg combined a map of the heavens, a map of the West, and, slightly separated from the first two images by a black band, the family tree of the Tornabuoni, one of the great families in the Florentine colony in Flanders (figure 90).[24] The three images represent the circular movement of the stars, the sublunar universe in which the fifteenth-century Florentine bourgeoisie lived, and the process of generation and corruption, creating a strange diagram of the organization of the cosmos. For the panels of *Mnemosyne*, which he called "a ghost story for adults," Warburg collected all the themes of his prior research and organized their visual juxtaposition in a complex network of anachronisms and analogies he modified ceaselessly — as he did the ordering of the books in his library.[25] It is possible to trace the circulation of one motif through Warburg's work as a whole, as through the history of culture itself, according to its recurrent and protean appearance in the panels of his atlas:

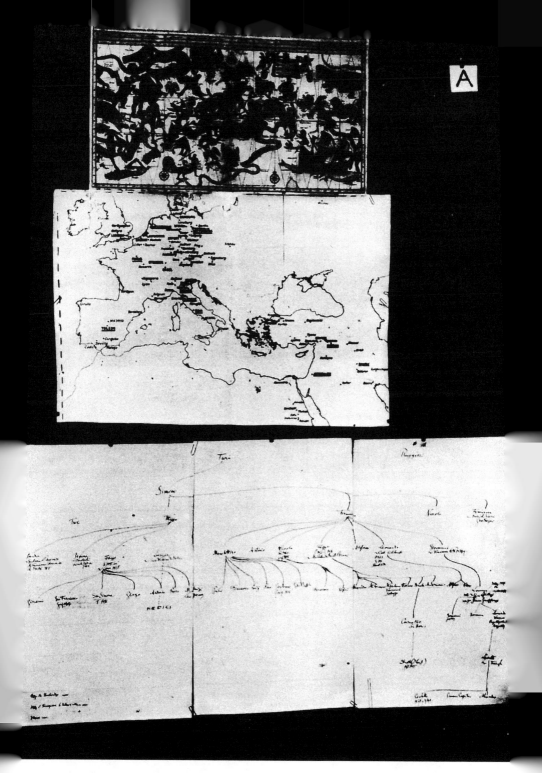

Figure 90. *Mnemosyne*, pl. A: the diagram of
space and time.

the basket-carrying nymph thus reappears in *Mnemosyne* as Fortuna, the Hour of autumn (panel 46), and in the guise of a model posing for an advertisement for Hamburg-America ocean liners (panel 77).[26]

The panels covered with black cloth on which Warburg mounted his images were made not to be exhibited as such but to be photographed in order to form a new, complex entity (figures 91a and b). They were not meant simply to be apprehended, in their contents, as a collection of the *Pathosformeln*, the pathetic formulas that Warburg had repeatedly examined more and more aphoristically in the works of Renaissance artists since the end of the 1880s.[27] One must also see them in their material configuration, being attentive to the spaces between the images, their variations and their repetitions, the way in which the reproductions are concentrated in certain areas of the panels, and all the phenomena of *inscription* that ended up leading Warburg's research into the description and analysis of forms. With *Mnemosyne*, Warburg established "an iconology of intervals" (*eine Ikonologie des Zwischenraumes*[28]) involving not objects but the tensions, analogies, contrasts, or contradictions among them.

Even if nothing in *Mnemosyne* is related to film technique per se, it is a cinematic arrangement. The black backgrounds on which the play of the sequencing and displacement of images is organized serve the same function as the space described by Dickson in his first films created against the backdrop of the Black Maria: an isolating function concentrating on the representation of movement and apparition. Warburg's construction also reflects the process of projection in which the sequencing, fusion, and contradiction among the images take place; it has simply lost its diachronic aspect and demands active intervention from the viewer. Confronted with the tabular deconstruction of the panels, the viewer must re-create the trajectories of meaning, the highlights, by

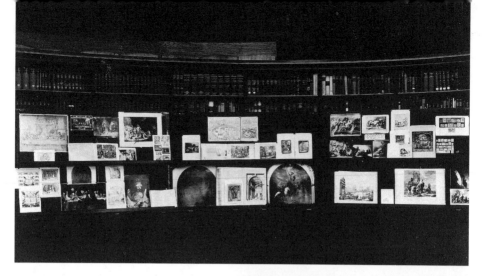

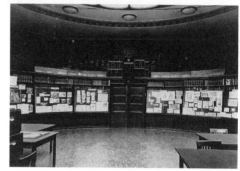

Figures 91a and b. Before *Mnemosyne*:
exhibitions on Rembrandt and Ovid in K.B.W.'s
reading room, 1926 and 1927.

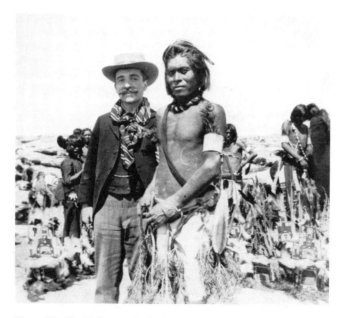

Figure 92. Aby Warburg and a Native
American. Aby Warburg collection.

focusing on the spacing of the photographs and on the differences in size among the printed images that correspond to variations of emphasis.

Warburg's correspondence with Binswanger demonstrates that the genesis of *Mnemosyne* is to be found in the American universe. On May 25, 1928, Binswanger wrote to Warburg: "I am very sorry to tell you of my opposition to your planned trip to America. I can easily understand what this trip means to you. " On July 12, 1928, Warburg answered him: "My work is nearly complete. *Ca.* 900 reproductions are already arranged on the tables: the question of presentation is for the most part likewise resolved. I would have brought the book back from America complete. It would have been a thousand times better if I had been allowed to leave."[29] The conception of the images in *Mnemosyne*, the silent conception based in pure dynamic relationships and phenomena of visual attraction and repulsion, originated in the 1895 trip and in the anachronistic and unlikely comparison of Native American rituals with sixteenth-century Florentine culture. The sailor with the flowing scarf one sees on panel 77 in the advertisement for the HAPAG liners is the transformation of both the nymph with the billowing veil and the kachina of Native American rituals, tirelessly turning her head from east to west, like a ferryman between the exploration of far-off lands and an understanding of the past.[30]

The Last Metamorphosis

In early 1896, when participating in the kachina ceremony in Oraibi, Warburg had noted that a small temple was the true center of the dance:

> The little temple is the actual focal point of the dance configuration. It is a little tree, adorned with feathers. These are the so-called

Nakwakwocis. I was struck by the fact that the tree was so small. I went to the old chief, who was sitting at the edge of the square, and asked him why the tree was so small. He answered: we once had a large tree, but now we have chosen a small one, because the soul of a child is small.[31]

Some time later, Warburg asked a group of Native American children to illustrate a poem by Heinrich Heine in which lightning is mentioned: inverting the relationships between positive knowledge and its object, he exposed a fragment of German culture to the wisdom of children. In the archives of the Warburg Institute, one finds the transcription of the story that the instructor, F.M. Neel, had them draw, following Warburg's suggestion:

It was a dark, cloudy day with much lightning. A mother told her little boy not to go out, but he went out into the storm. The storm became so terrible that he turned back, fell over a dog that he did not see and stumbled into a pond where his father found him and got him out with a long pole.[32]

On November 4, 1896, Neel wrote to Warburg, who had returned to Hamburg, about the results of the experiment:

Dear Sir:
I was agreeably surprised to get your letter of the 19th ult. I will gladly answer your questions. I feel highly flattered by the attention you have given to the sketches drawn by the Moquis.
It took the boys from twenty to forty minutes to do the sketching. I gave them no points as to what scene or scenes they were to sketch other than what the story suggested to their imaginations. However, I referred them to a story in one of their reading books, discussed the pictures of that story and led their imaginations out

somewhat by telling them of other pictures that could have been drawn so as to tell other salient parts of the story under discussion. But this was not done of the story from which they made the sketches.

The boys did not copy.

I made no drawing of the scene whatever.

The Indians, like most peoples of excellent memories, have fertile imagination. It is very little trouble as soon as they comprehend English, to get them to write stories from pictures, in which they will weave in scene after scene, all being built up by imagination. I have been greatly astonished very many times at the length of a yarn spun by some boy from a very simple picture. Now, your story I had repeated to them in Moqui and then written on the board and their imagination did the rest.

It gives me pleasure to write you, and would gladly help you further if in my power. I am anxiously waiting to hear who is the president elected on the 3d inst.

I am, with kindest regards,
Very truly yours,
F. M. Neel
U.S. Indian Service

Under the influence of the dominant American culture, twelve of these drawings depicting a storm were realistic. But two of them depicted the symbol of the serpent as it had appeared to the art historian in the underground space of the kiva. Destroying the implicit link between knowledge and mastery, the children who made the drawings revealed something to Warburg about his own thought.[33]

It was not merely a form of understanding that was revealed to Warburg in the old Oraibi man's words or the Indian schoolchild-

ren's drawings; it was the deepest, most hidden wellspring of his search. Heise recounts in his memoirs that the reading room of the library was always decorated with a few images unexpectedly arranged: postcards, newspaper clippings, and in particular children's drawings.[34]

As the mute presence of Anacleto beside his father, Cleo, in the scene at the Palace Hotel in Santa Fe demonstrates, Warburg peopled the tale of his trip with children, and perhaps the whole trip should be understood as the intimate memory of a far-off past.[35] In a preparatory note for the 1923 lecture, Aby, in recalling an illness his mother suffered during the summer of 1874, remembered having explored, as a diversion from the impending death he had — mistakenly — foreseen, a library full of books on the Indians: "I devoured entire piles of these Indian novels at the time, and this was obviously the way I found to escape from an unsettling present that left me helpless."[36]

This episode seems to have repeated itself when, in 1895, Warburg experienced an intense feeling of guilt for having gone to America at a time when a cholera epidemic had reached Hamburg, exposing his family to the disease. When he returned from Kreuzlingen in 1927, he declared he was a "ghost" and had crossed the threshold of death backward.[37] The lecture was a rite of return through which the course of time was reversed, and this explains why he took as his subject the trip to the Indian territories, from twenty-seven years before. The paths of his research became confused with those of remembrance. And the most moving record of all is perhaps the portrait of Warburg smiling (the photos from America are the only ones, to my knowledge, in which one sees him smiling), posing in cowboy getup, standing next to an Indian (figure 92).

New York Engraving & Printing Co.

1. Navajo going to the Snake Dance. 2. Moqui grave-hunter. 3. Eastern Visitor. 4. Moqui girls. 5. A view on the first mesa. 6. Moqui man.
7. Moqui girl. 8. A spectator. 9. Walpi from the North. 10. Waiting for the Snake Dance. 11. Moqui women, filling Ollas at a spring.
12. Walpi, showing sacred rock. 13 and 14. Moqui racers from the springs after leaving ba-hoos in the morning.
15 and 16. Moqui Dancers in the evening returning from placing the snakes back in the desert.

Figure 93. "Going to the Snake Dance at
Walpi," August 1891. From Thomas Donaldson,
*Moqui Pueblo Indians of Arizona and Pueblo
Indians of New Mexico* (Washington, DC, 1893).

Zwischenreich

Mnemosyne, *or Expressivity*
Without a Subject

> Our realm is that of the intervals [*Zwischenreich*].
> — Sigmund Freud to Wilhelm Fliess, April 16, 1896

Mnemosyne, the atlas in images Warburg was working on before his untimely death in 1929, remains one of the most fascinating and enigmatic objects in the history of contemporary art (see figure 90). Its reconstitution was shown for the first time in Vienna in 1994, although the accompanying exhibition catalog represents but a working hypothesis, omitting variants and unpublished material.[1] Nonetheless, until a critical edition of the atlas is published, this attempt at reconstruction allows us to begin to find our way through this strange landscape imagined by Warburg, in which a new style of apprehending aesthetic phenomena is elaborated — where knowledge is transformed into a cosmological configuration and the rift between the production of the works and their interpretation is abolished.

Mnemosyne, *"Iconology of the Interval"*
That Warburg conceived of *Mnemosyne* topographically, beyond the montage of maps on the preliminary panel of the atlas, appears to be suggested in the enigmatic phrase "iconology of the

intervals," which he used in his journal of 1929.[2] This iconology is based not on the meaning of the figures — the foundation of interpretation for Warburg's disciples, beginning with Panofsky — but on the interrelationships between the figures in their complex, autonomous arrangement, which cannot be reduced to discourse.

Although Ernst Gombrich claimed that Fritz Saxl played an important role in the genesis of the project, one notes that *Mnemosyne* recapitulates, in images, Warburg's research into the survival of Antiquity throughout his career — from the depiction of the gods of Antiquity in Renaissance art to the representation of the nymph in motion; from the history of the heavens and the correspondences between the microcosm and the macrocosm to court festivals.[3] One episode, however, is strangely absent from this thematic catalog: Warburg's trip to New Mexico and Arizona during the winter of 1895–1896, despite the important photographic documentation he had available and that he had in part assembled firsthand.[4] The trip remains nonetheless a likely, though deleted, origin of the atlas Warburg undertook right after leaving the Kreuzlingen clinic — after having delivered his lecture on the serpent ritual, which broke his long silence and marked his return to the Indian question, in which he had seemingly lost interest for more than twenty-five years.[5]

In the margin of his draft of the 1923 lecture, Warburg noted, "missing Freud *Totem and Taboo*."[6] In the first lines of that essay, Freud declared that he sought to establish a parallel between "the psychology of primitive peoples, as it is taught by social anthropology, and the psychology of neurotics, as it has been revealed by psycho-analysis."[7] In light of Freud's remarks, the Kreuzlingen lecture takes an openly introspective turn.

But the trip to the American West also has a heuristic value. In 1930, Saxl noted that it was in New Mexico that Warburg discovered the principle for a renewal of his interpretation of the

Florentine Renaissance.[8] In the images of the rituals Warburg photographed or assembled after the fact, one does notice that he sought to interpret the past in the light of the faraway, producing a collision between two levels of reality unknown to each other: Native (and to some extent acculturated) America on the one hand, and the Florentine Renaissance, on the other (figures 94a and b). These violent associations, which over time would lose their intuitiveness and become structural, arise not from simple comparisons but from rifts, detonations, and deflagrations. They seek not to find constants in the order of heterogeneous things but to introduce differences within the identical. In *Mnemosyne*, in keeping with the model Warburg formulated during his trip, the distance between the images, which tends to invert the parameters of time and space, produces tensions between the objects depicted and, inductively, between the levels of reality from which these objects proceed.

To grasp what Warburg meant by the "iconology of the intervals," one must try to understand, in terms of introspection and montage, what binds, or, inversely, separates, the motifs on the irregular black fields that isolate the images on the surface of the panels and bear witness to an enigmatic prediscursive purpose. Each panel of *Mnemosyne* is the cartographic relief of an area of art history imagined simultaneously as an objective sequence and as a chain of thought in which the network of the intervals indicates the fault lines that distribute or organize the representations into archipelagoes or, in other words, as Werner Hofmann has put it, into "constellations."[9]

In arranging the images on the black cloth of the panels of his atlas, Warburg was attempting to activate dynamic properties that would be latent if considered individually. His inspiration for this technique of activating visual data was a concept formulated in 1904 by Richard Semon, a German psychologist who was a

Figures 94a and b. Masked dancers,
Hopi country, Arizona, 1895. Photographed
by Henry R. Voth. Aby Warburg Collection.

student of Ewald Hering's. In his *Die Mneme als erhaltendes Prinzip im Wechsel des organischen Geschehens* (Memory as a basic principle of organic becoming), Semon defined memory as the function charged with preserving and transmitting energy temporally, allowing someone to react to something in the past from a distance. Every event affecting a living being leaves a trace in the memory, and Semon called this trace an engram, which he described as the reproduction of an original event.[10]

Warburg's atlas externalizes and redeploys in culture the phenomenon described by Semon within the psyche. The images in *Mnemosyne* are "engrams" capable of re-creating an experience of the past in a spatial configuration. As conceived by Warburg, his album of images represents the place in which original expressive energy can be rekindled in archaic figures deposited in modern culture and in which this resurgence can take shape. Like Semon's engrams, the atlas's images are "reproductions," but they are photographic reproductions, literally, photograms.[11]

One example is on panel 2 of the atlas (figure 95), in the elements arranged on the top and to the right. In this module, one finds, arranged in a circle:

- two representations of the heavens from a ninth-century manuscript, after Ptolemy;
- a globe held by the Farnese Hercules from the Museo Nazionale in Naples, in close-up;
- a detail of the Farnese Hercules;
- a close-up of a detail of the globe held by Hercules, depicting an episode from the legend of Perseus;
- and below, vignettes taken from the *Aratus*, a Latin manuscript in Leiden, carved on two symmetrical columns, depicting the actors in the narrative: Andromeda, the sea monster Cetus, Perseus, Pegasus, Cassiopeia.

Figure 95. Aby Warburg, *Mnemosyne*, pl. 2
(detail): Ptolemy's heavens.

Through the simple juxtaposition of images taken from different sources, Warburg generates something that any one of these images taken alone would not produce. Taken simultaneously, the two drawings of the celestial vault represent the totality of the sky. The close-up of the globe, to the right, appears as the materialization of this double planetary relief, in such a way that one moves unconsciously from a drawing of the heavens to its projection in three dimensions, from a line drawing to a photograph. Next, one moves from the close-up to the general plan, and from the close-up to the extreme close-up that isolates an episode of Perseus's adventures in a syntax entirely cinematic in inspiration. Next, one comes back to a general drawing of the sky through a circular movement, a formal path similar to the spherical object represented, so that the sequence of images organized by Warburg leaves figuration and moves into mimetic reproduction of the sphere of the sky in motion.[12]

Panel 43 involves the cycle of frescoes Sassetti commissioned from Ghirlandaio for the Santa Trinita chapel, to which Warburg devoted his decisive 1902 study (see figure 44).[13] One notes, as in panel 2, a juxtaposition of line drawings (in the upper right, an overview of the three panels) and photographic images, an indication of the basically constructible nature of the representations. Warburg repeatedly used schematic transcriptions of works of art, which he arranged on sheets as on storyboards, organizing their interrelationships with colored lines.[14]

The visual arrangement of the chapel is deconstructed before being rearranged analytically: beneath the *Confirmation of the Rule of Saint Francis*, depicted first by Giotto (to the left) and then by Ghirlandaio (to the right), Warburg shows a detail of the figurative sequence from the foreground of Ghirlandaio's fresco in which a number of people emerge from below on a staircase, entering the pictorial plane. Cutting out the images accentuates

the phenomenon of irruption, which sets Ghirlandaio's work apart from Giotto's, over any elements the two works might have in common. In other words, the art historian uses an iconographic constant (the confirmation of the rule) to show that the conditions of representation have changed between the two painters. It is a matter no longer of depicting an episode from Franciscan legend but of staging a phenomenon of appearance, figures entering into the representation. Warburg is not content to reproduce the two frescoes and compare them: he reconstructs a detail from Ghirlandaio's work based on a series of artificially disjointed plastic elements.[15]

A last example, panel 25, is devoted to the reliefs by Agostino di Duccio in the Tempio Malatestiano in Rimini (figure 96). On the panel, where the images are arranged relatively regularly, the upper part presents the temple as a whole, situating the work of Agostino — whom Warburg considered, along with Alberti (the temple's architect), one of the great instigators of figures in motion in the Renaissance. Panel 25 goes beyond simple registration and should be seen as a composite construction conjoining a physical experience of space and certain mental operations (associations, memories, repetitions, focalizations). The staccato rhythms of the composition, the irregular format, and the close-ups of details of figures reproduced elsewhere on the panel in overview (the muses of the temple, or the relief of the Castello Sforzesco in the center and the lower right) attest to this fact. One suddenly realizes that the panel constitutes in reality a visit to the temple and is developed like an interior monologue; it is the chronicle of thoughts and associations that went through the historian's mind as he worked.

The images assembled by Warburg in this way function as discontinuous sequences that find expressive significance only when considered in an arrangement of complex interconnections.

Figure 96. Aby Warburg, *Mnemosyne*, pl. 25:
Agostino di Duccio's reliefs in the Tempio
Malatestiano, Rimini.

The *Mnemosyne* panels function as screens on which the phenomena produced in succession by the cinema are reproduced simultaneously.

During a seminar he held in his library in Hamburg in 1927, Warburg referred to Burckhardt and Nietzsche (the Apollonian and Dionysian poles of his own thought) as "seismographs."[16] The model of the seismograph goes back to the pre-cinematic work done by Etienne-Jules Marey during the last two decades of the nineteenth century.[17] But Warburg probably imported this image from literary criticism. In a lecture titled "The Poet and the Present Time" (published in *Neue Rundschau* in 1907), treating the relationship between poetry and temporality, Hugo von Hofmannsthal wrote:

> [The poet] is like a seismograph that vibrates from every quake, even if it is thousands of miles away. It's not that he thinks incessantly of all things in the world. But they think of him. They are in him, and thus do they rule over him. Even his dull hours, his depressions, his confusions are impersonal states; they are like the spasms of the seismograph, and a deep enough gaze could read more mysterious things in them than in his poems.[18]

From this passage Warburg's art history seems to have retained two points: the "despecification" of discourse ("indeed, this precise separation between the poet and the non-poet does not seem at all possible to me"[19]), which makes it possible to recharacterize the metadiscursive discourse of the historian or the philosopher as a form of authentic poetic expression; and an implicit critique of the philosophy of the subject: the author is less the master of his words than he is a receptive surface, a photosensitive plate on which texts or images surging up from the past reveal themselves.

Warburg called *Mnemosyne* "a ghost story for adults" [eine

Gespenstergeschichte für ganz Erwachsene]," and, in describing his return from Kreuzlingen, he spoke of a sort of return from the dead. In his library, he stayed, like Hofmannsthal's poet, "beneath the staircase of time":

> Strangely, he lives in the house of time, beneath the staircase, where everyone must pass by and no one pays any attention. . . . There he dwells and sees and hears his wife and brothers and children as they go up and down the stairs, speaking of him as a man who has disappeared, or even as a dead man, and mourning over him. But it is forbidden for him to reveal himself, and so he lives unknown beneath the staircase of his own house.[20]

The disparate objects whose images Warburg collected for the panels of his atlas are like the material from which poetry, according to Hofmannsthal, is made. They are objects taken from different levels of the past, freed from functionality, abandoned to a strange figural floating:

> [The poet] is unable to pass by any thing, however inconspicuous. That there is something like morphine in the world, and that there was ever something like Athens or Rome or Carthage, that there have been human markets and that there are human markets, the existence of Asia and Tahiti, of ultraviolet rays and the skeletons of prehistoric animals, this handful of facts and the myriad of such facts from all orders of things are somehow always there for him, waiting for him somewhere in the dark, and he must reckon with them.[21]

The planar dislocation in the panels of *Mnemosyne* finds a parallel, as Kurt Forster has noted, in the photomontages created by the avant-garde movements of the second and third decades of the twentieth century.[22] This association has the advantage of

removing Warburg from the context of human sciences at the end of the nineteenth century, where Gombrich still tried to confine him.[23] But perhaps one should look for the original inspiration of this idea in illustrated books on Native American ethnography, which Warburg began to collect after his return from America. More radically, one can find the most pertinent analogy to Warburg's endeavor outside the human sciences, in cinema. Jean-Luc Godard, seventy years or so later, sought in his *Histoire(s) du cinéma* (Story (stories) of the cinema) "to bring disparate things together" and work the material of film as Warburg worked that of art history, mixing personal and collective memory, going beyond the limits between the production and the interpretation of works, between language and metalanguage, drawing the meaning of an actualization of images from reciprocal revelations possible only through montage.[24]

Warburg's juxtaposition of an image of Judith holding the head of Holofernes with a female golfer wielding her club (figure 97) is echoed in Godard's flickering superimposition of the silhouette of Lillian Gish passed out in the snow (in *Orphans of the Storm*) and a hysterical woman patient of Charcot's (figures 98 and 99).[25] In *Histoire(s) du cinéma*, the filmmaker describes the history of cinema as a "saturation of magnificent signs that bathe in the light of their absence of explanation."[26] This beautiful phrase, which echoes Mallarmé, also holds true for *Mnemosyne*.

Mnemosyne, "Art History Without a Text"

A few months before undertaking his trip to the land of the Hopi in 1895, Warburg published, in Italian, a study of the Intermedi staged in Florence on the occasion of the marriage of Ferdinand de' Medici and Christine of Lorraine.[27] According to Warburg, the Intermedi were a spectacle that belonged not to dramatic art, properly speaking, which expresses itself through words, but to

Figure 97. Aby Warburg, *Mnemosyne*, pl. 77:
bottom, center: Erica Sellshop, *The Headhunter
as Woman Playing Golf* (Aby Warburg, journal,
July 31, 1929).

Figure 98. D.W. Griffith, *Orphans of the Storm*
(1921), Lillian Gish lying on a bench,
photogram. Bibliothèque du film, Paris.

Figure 99. Jean-Martin Charcot, from
"Photographic Iconography of La Salpêtrière."
Photothèque de l'Assistance Publique, Paris.
"What is the difference between Lillian Gish in
Orphans of the Storm and Augustine in La
Salpêtrière?" (Jean-Luc Godard)

"the mythological pageant; and this, being an essentially mute and gestural art, naturally relies on accessories and ornaments."[28] The language of gestures thus forms a point of convergence between the Native American rituals and the Intermedi interpreted as pantomimes of the ancient world.

Hermann Usener's role in Warburg's decision to undertake his trip to the American West has already been documented.[29] In an article titled "Heilige Handlung" (Sacred action), the German philologist, whose course Warburg took in Bonn, traced a parallel between the Hopi Indians and the peoples of Antiquity, a parallel that Warburg was inspired to adapt to the study of the Italian Renaissance. In addition, there is the less-known influence of the American ethnographer Garrick Mallery, the author of a long study titled *Sign Language Among North American Indians, Compared with That Among Other Peoples and Deaf-Mutes*, published in the accounts of the Smithsonian Institution in 1880, which Warburg alluded to in the draft of his 1923 lecture on the serpent ritual.[30]

Mallery's research was part of a vast series of studies on sign language among North American Indians — from Stephen H. Long's groundbreaking research, published in 1823,[31] to Ernest Thompson Seton's great dictionary, *Sign Talk*, published in 1918, in which seventeen thousand signs were cataloged.[32] Mallery's originality lay in his comparative perspective, according to which sign language is the fundamental expressive mode of humanity, revealing the transcendental formation of the person. Traces of this were found as often in popular Neapolitan culture as in the communities of North American Indians, among the deaf-mutes, or on the margins of modern society (it is the language of the underworld and secret societies). Thus the gesture made by Judas in Leonardo da Vinci's *Last Supper* is, according to Mallery, similar to the sign used in Naples and among certain Native American

communities to designate the thief (figure 100). Through the language of signs, "civilized" man engages in an infradiscursive communication that opens him to the consciousness of otherness.

Mallery tells an amusing story that illustrates the effects of the irruption of pantomime into the arena of art history. During a course on the history of painting, Thomas Hopkins Gallaudet, professor in a school for deaf-mutes, received John Trumbull, who wanted to test Gallaudet's powers of facial expression. Having been invited by Gallaudet to choose any event from the history of Greece, Rome, England, or America, "of a scenic character, which would make a striking picture on canvas," Trumbull challenged the professor to express Brutus's condemning his two sons, who had resisted his authority and disobeyed his orders, to death. In short, he asked him to mime a painting by David. Gallaudet then put himself into a paradoxical state in order to communicate to his students, through pantomime alone, the image the painter had suggested:

> I folded my arms in front of me, and kept them in that position, to preclude the possibility of making any signs or gestures, or of spelling any words on my fingers, and proceeded, as best I could, by the expression of my countenance, and a few motions of my head and attitudes of the body, *to convey the picture in my own mind to the mind of my pupil.*[33]

The main threads of Gallaudet's performance, limbs immobilized by invisible bonds, are the following: according to a convention common among the deaf-mute, he expressed the equivalent of a Roman, aquiline nose, by stretching his facial muscles; his gaze wandered to the east, and he rocked his head, imitating the crossing of the Atlantic Ocean to stress that the event took place not in America but in the Old World (Gallaudet mimicked something faraway); he rolled his eyes from top to bottom and repeatedly looked backward to indicate that the event took place in the remote past

Figure 100. Sign for thief among the Indians.
From Garrick Mallery, *Sign Language Among
North American Indians*, p. 291.

(Gallaudet mimed the past). The second half of the performance
was more conventionally dramatic. Gallaudet showed authority,
punished the wrongdoers, and condemned them to death. He
expressed the passage of days by falling asleep and waking several
times; he expressed the offense by staring at two distant points in
space in order to indicate two offenders; he showed deliberation,
and hesitation accompanied by conflicting emotions; he looked at
the two young people (two arbitrary points in the void) alternately,
then simultaneously, "*as a father would look.*"[34] Then he mimed
emotional conflict once again in order to convey "graphic" power.
Finally, he showed the decision to condemn them to death. Changes
of expression are the most difficult thing to describe but also the
most fascinating, Mallery concluded, for they instill life with "the
skeleton sign." A similar turn of phrase is found in Warburg's 1923
lecture when he describes a young Hopi girl who, like a canephore,
carries on her head an earthenware pot, on which is depicted a
"skeletal heraldic image."[35] At the end of Gallaudet's demonstra-
tion, the deaf-mute students were clearly capable of transcribing
the precise history of Brutus and his sons.

Warburg probably remembered Mallery's didactic-shamanic tale during his trip among the Hopi when, in a Native American school, he reversed Gallaudet's performance and asked the students to illustrate a German poem, "*Hans Guck in die Luft*," that is, to translate an unknown text into familiar images.[36]

Sign language, which allows the *istoria* of painting to be transmitted independently of speech, opens up an access to the past for the modern viewer. Through Mallery's text, it was in fact from Andrea de Jorio that Warburg borrowed the intuition informing the lexical structure of *Mnemosyne*. In *Gesture in Naples and Gesture in Classical Antiquity*, published in Naples in 1832, Jorio sought to interpret the gestures of Antiquity as they appeared in works of art, on vases and reliefs, based on the gestures of his contemporary Neapolitans (figures 101a, b, and c). Mallery, reworking Jorio's theories from an ethnographic angle, commented on a fragment of a vase from Antiquity depicting Dionysus (at right) and the satyr Comus with two nymphs, Galena (Tranquillity) and Eudia (Serenity), in light of Native American sign language.[37] Galena, dressed in a wild beast's skin, beats a tympan while Eudia snaps her fingers — a gesture, according to Mallery, executed during the tarantella, an ecstatic dance practiced in the Italy of his day. But seen as sign language, the nymphs' poses take on a more precise meaning. The two women appear to have had an argument. The one on the left points to her companion, in a gesture of reproach. Galena, while pivoting her torso, raises her arms in a gesture of surprise or denial. According to Mallery, the movement of raising the hand to the shoulder, palm toward the interlocutor, is found among the Dakota Indians. Furthermore, Eudia's left hand is also pointed toward her rival, thumb and index touching, which is the Neapolitan sign of love.

Another fragment depicts Athena surrounded by a war council.[38] The goddess, in a vehement gesture, looks to the right and

Figure 101a. Dispute Between Neapolitan Women, end of the nineteenth century. From Andrea de Jorio, *Gesture in Naples and Gesture in Classical Antiquity* ([1832]; Bloomington: Indiana University Press, 2000).

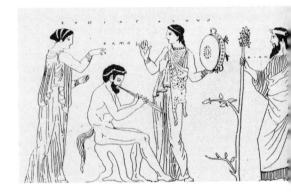

Figure 101b. Comus and Dionysus Between Two Nymphs. From Jorio, *Gesture in Naples and Gesture in Classical Antiquity.*

Figure 101c. Athena in the Middle of a War Council. From Jorio, *Gesture in Naples and Gesture in Classical Antiquity.*

stretches out her left arm to the left; her right hand brandishes a spear to the right, and the position of her feet shows that she is ready to bound forward. She enjoins the people on her right to follow her. The seated warrior holds his right hand flat suspended above his knees. This signifies, in the Neapolitan gestures of Mallery's time, hesitation, an invitation to reflect before undertaking a dangerous enterprise. Native Americans attributed the very same meaning to a hand held in the same position, tilted slightly upward. The warrior seated to the right holds an open hand to Athena, palm facing upward and clearly raised. Here again, Mallery found equivalents in Neapolitan culture and Native American signs, where questioning was expressed by the outstretched hand, palm turned up, and the notion of quantity by an ascending movement of the open hand.

An iconographic study of vases and reliefs from Antiquity thus found operational instruments of analysis in modern anthropology. Conversely, in the light of the gestures sketched out by Mallery, latent archaic traits reappear in modern imagery. Published by Jorio and reproduced by Mallery, a nineteenth-century Neapolitan engraving depicting a quarrel between two women thus echoes the iconography of the maenads in the Dionysian cortege. The woman to the left, shocked to see her former friend, who has become rich, strolling with her fiancé, raises the hem of her skirts derisively to imitate the great lady; the insulted woman makes the sign of horns with both hands to indicate a menacing curse. This gesture, which is executed to conjure up *la jettatura*, the evil eye, also alludes to the sacrifice of horned animals. The fiancé, for his part, bites his finger: this is a sign of passion, like the grinding of teeth and the biting of lips.

Conceived no longer in terms of its arrangements but from the point of view of the images, the atlas presents itself as a collection of the *Pathosformeln*, the pathos formulas, used in art to form a

mute language freed from discursivity. The analysis of expressive gestures opens up an unusual, intuitive path to the figures of the past and allows one to identify their recurrence in contemporary imagery. The trip into Hopi country, during which Warburg endeavored to find traces of the Florentine Renaissance in the Native American universe, thus appears as a verification of Jorio's demonstration in light of Mallery's anthropological analyses.

The Mié, or Frozen Pose

While staying in San Francisco in 1896, Warburg toyed with the idea of going to Japan. Let us imagine he wanted to see Kabuki theater:

> In the past, when the only illumination in Kabuki (and also Occidental) theatre was candles and oil lamps, the actors performed almost in the dark.... And so a stage servant would follow the protagonist around the stage, carrying a long pole with a candle in a little dish at one end. Thus the actor's face, upper torso, and arms were illuminated without the assistant being visible to the spectators. In spite of this contrivance, it was necessary to give the spectators time to take in the actor's expression, at least in the most crucial moments: it was even the more difficult to catch this expression in the twilight given that the spectators were often occupied with other activities: eating, drinking tea, gossiping.
>
> One might suppose that this situation gave birth to the Kabuki actors' custom of stopping, or better, of *cutting* as they describe it, *mie* (literally, to show). Why cut? The actor's pose could be des[c]ribed as stopping the film in that particular frame where the actor is showing a special tension: hence the meaning of cutting the action and of blocking a living immobility.[39]

The Kabuki actor went from one *mié* to another, from the height
of one tension to the next, immobilized at the height of gestural
intensity like the *Laocoön*, which Goethe compared to the move-
ment of a frozen flash of lightning or a petrified wave (figure
102).[40] In *Mnemosyne*, Warburg sought to juxtapose figures caught
at the culminating point of their expressivity by using the black
spaces between them as visual ruptures, disjunctions in which
diminution or slackening energy was annulled. Thus if one were to
express *Pathosformeln* in Japanese, one might translate it as "*mié*,"
a movement frozen in the instant of its greatest intensity.

Corresponding to the project of founding an art history with-
out a text is a critique of the supremacy of language in the genesis
of meaning, a criticism of the aristocratic, tragic theatrical forms
based on the privileging of the text. If the theory according to
which sign language informed the project of *Mnemosyne* through
Warburg's experience of Native American rituals and Italian com-
edy proves true, one must look for the origin of *Mnemosyne* not in
tragedy and the aristocratic theatrical forms articulated in lan-
guage but in pantomime and satyr drama, at the point where the
commedia dell'arte and Native American ritual converge.

In his 1923 lecture, Warburg recounted that during the kachina
dances in Oraibi, he was struck by the sudden appearance of clown
dancers, which he compared to that of the satyr in the tragic cho-
rus. The clown Koyemsi is also related to Harlequin, with whom
he shares the practice of the *lazzi*, obscenity (the bat is originally
a sexual symbol inherited from the phallic games of Antiquity),
gluttony, and in particular the black mask whose use, in both Ital-
ian comedy and Native American rituals, allowed the plastic elo-
quence of the body to develop and an unpsychological repertory
of expression to be produced (figures 103a and b). The mask pre-
serves the uniqueness of the person wearing it and, by hiding his
face, removes him from humanity in order to transform him into

a specter. Displaying emotion without a subject, pantomime replaces the actor's performance from an angle of hallucination and fear — such was Antonin Artaud's conclusion, in 1931, when he was elaborating the doctrine of pure theater, based on Balinese theater, founded on gesture and the rejection of psychological drama: "The hieratic costumes give each actor a kind of dual body, dual limbs — and in his costume, the stiff, stilted artist seems merely his own effigy."[41] The dissociation that Artaud saw enacted on the stage of the Balinese theater was something that Warburg had already seen in the Native American rituals, before making it a pathway into the analysis of figurability in painting. It was to lead Warburg, with *Mnemosyne*, to conceive of art history based on this "secret psychic impulse," an impulse that is "speech before words" and that Artaud saw as the origin of theatrical creation (figures 104 and 105).[42]

In the second century, the Sophist Athenaeus spoke of a famous actor of his time named Memphis, whom they called "the dancing philosopher" because he taught Pythagorean philosophy by gestures alone. In an early note for his "Bruchstücke" (Fragments), drafted on September 29, 1890, one might find the source of Warburg's research into the pure sequences of images that came to replace discourse and that transformed him, in turn, into a dancing philosopher: "To attribute motion to a figure that is not moving, it is necessary to reawaken in oneself a series of experienced images following one from the other — not a single image: a loss of calm contemplation."[43] A series of images following one from the other (*eine aufeinander folgende Reihe von Bildern*), a strip of film, a snake.

273

Figure 102. Toshusai Sharaku, The actor Otani Onjii in *Eitoku* at the moment of the *mié*, detail from the Edobei Roll, 1794, Musée des Arts Asiatique Guimet. Réunion des Musées Nationaux, Paris.

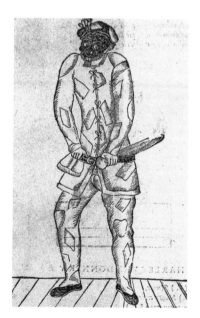

Figure 103b. Tristano Martinelli in the role of Harlequin. From *Compositions de rhétorique de M. Don Arlequin* (Lyons, 1601).

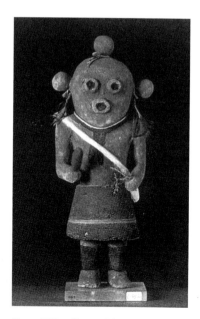

Figure 103a. Koyemsi (mud head) Hopi kachina, painted wood, feathers, fibers. Height: 26 cm. Horst Antes collection.

Figure 104. *Mnemosyne*, working panel.

Figure 105. *Mnemosyne*, pl. 5 (detail): the deconstruction of a group of Niobides (left column).

Crossing the Frontiers

Mnemosyne *Between Art History and Cinema*

The Arrangement

As a history of images aimed at understanding the conception and fate of works, art history must avail itself of something that is not, or not yet, artistic. This intuition inspired all Warburg's research, from his first publications to his last project in *Mnemosyne*.[1] On the large panels stretched with black cloth of his atlas, created between 1924 and 1929, Warburg arranged images of disparate origin: art reproductions, advertisements, newspaper clippings, geographical maps, and personal photographs. He repeatedly rearranged these images, just as he repeatedly rearranged the books in his library and even the order of words and phrases in his written texts. The atlas was an instrument of orientation designed to follow the migration of figures in the history of representation through the different areas of knowledge and in the most prosaic strata of modern culture. Images borrowed from low culture appear here and there throughout *Mnemosyne*, becoming insistent in the last panels (see figures 52 and 97). As early as 1907, however, Warburg's study of Burgundian tapestries bears witness to a rejection of art history's normative hierarchies: "If we refuse to be distracted by the current tendency to regulate art-historical inquiry by posting border guards, then it becomes evident that

monumental pictorial forces are at work within this 'inferior' region of Northern European applied art."[2]

Yet in retracing the fate of images in the history of religion or science up through their modern reworkings in advertising or documentaries, the atlas did not simply attempt an extra-artistic definition of images. It marked, in particular, photography's invasion of art-historical discourse and its installation in the place traditionally reserved for the text. In *Mnemosyne*, photographic reproduction is not merely illustrative but a general plastic medium to which all the figures are reduced before being arranged in the space of the panel. In this way, the viewer participates in two successive transformations of the original material: different types of objects (paintings, reliefs, drawings, architecture, living beings) are unified through photography before being arranged on the panel stretched with black cloth. The panel is in turn rephotographed in order to create a unique image, which will be inserted into a series intended to take the form of a book. The atlas, then, does not limit itself to describing the migrations of images through the history of representations; it reproduces them. In this sense, it is based on a cinematic mode of thought, one that, by using figures, aims not at articulating meanings but at producing effects.

Kracauer and the Question of the Frame

During the 1920s, in his chronicles of modern culture and day-to-day life, published in serial form in *Frankfurter Zeitung*, Siegfried Kracauer, discussing the subject of the photo-cinematic image, developed a form of analysis adapted to the laws of technical reproducibility that echoed Warburg's research.[3] According to Kracauer, the photographic or cinematographic image, like the painted image for Warburg, is essentially documentary. Fiction is but a varnish masking the reflection of material existence.

Kracauer's correspondence with Panofsky, which began in the 1940s after his immigration to the United States and while he was elaborating his *Theory of Film*, illuminates his conception of the cinematographic image and the place for a theory of cinema in the field of modern science.[4] On October 17, 1949, Panofsky wrote to Philip Vaudrin, the editor of Oxford University Press, which would publish Kracauer's book in 1960.[5] In the letter, he praised the project Kracauer was advocating, introduced a nuance, and reproached the film historian for dissociating the image's narrative and documentary functions in basing his theory on the inherent conflict between the cinematic structure and the text (between the shot and the sequence of shots, or between the recording of events and their staging). According to Panofsky, Kracauer would perpetuate a naively realist conception of representation. In reducing the basic cinematic unity (the photograph) to a simple reflection of reality, he tended to erase any subjectivity from the image in favor of its objective content. Wouldn't it be better to situate this tension, this bipolarity, within the photograph itself? As a Kantian art historian, Panofsky posited that the cinematic image reflects not the real but the way in which the cameraman perceives something; thus only auteurist cinema would be accessible to iconological discourse. This explains Panofsky's complete lack of interest in documentary cinema, as seen in the famous article from 1937 "Style and Medium in the Motion Pictures."[6] The history of cinema, like that of art, can present itself as a history of forms and styles only if it has been conceived beforehand as a history of artists.

On November 6, 1949, Kracauer responded briefly, asserting that Panofsky had not completely understood him. If, as his interlocutor had noted, there is no discontinuity between photography and cinema in his concept of the image, the cinema, reduced to the

ultimate component of the photograph, cannot simply reproduce appearances of the world. Photography does not copy nature; it metamorphoses it. Far from being a simple slice of reality, it retains and reveals what Kracauer calls elsewhere "the monogram of history": "The last image of a person is that person's actual *history.*... This history is like a *monogram* that condenses the name into a single graphic figure which is meaningful as an ornament."[7] The critic's task would therefore be to decant the cinematic shot (the basic filmic unity, the cinematic structure) of its narrative function in order to isolate the surfaces with which it is made and produce, by exploring the world of factuality revealed by this break in the filmic continuity, a historical phenomenology of surfaces.[8]

Kracauer conceived of the phenomenology of the photograph (and by extension the phenomenology of cinema) as an experience of the unreal dimension of reality: "in illustrated magazines," he wrote in his articles for *Frankfurter Zeitung*, "people see the very world that the illustrated magazines prevent them from perceiving."[9] This represents the paradoxical mechanism of disenchantment that designates both a state of lucidity in the face of images of modern reality and the loss of the irreducible aura tied to memory of the past. In turning framing into the phenomenological revelation of the "imaginary" contents of reality, Kracauer, carrying on the thought of Béla Balázs, conceives of the frame (*Ausschnitt*) as a "setting at a distance" (*Entfremdung*) of reality and links up directly with Alberti's construction of *istoria*. In *On Painting* (1435), Alberti wrote: "First of all about where I draw. I inscribe a quadrangle of right angles, as large as I wish, which is considered to be an open window through which I see what I want to paint."[10]

Thus on December 17, 1943, in praising Panofsky's *Albrecht Dürer*, published that same year, Kracauer intuitively referred to

the effects of framing produced by the text. "It's as if," he wrote to Panofsky, "one were looking at a distant landscape through a hole in a wall."[11] Considering that his analysis of images needed to find efficacious analytic instruments in the iconological current in art history and that, symmetrically, his research into the images of modern culture and day-to-day life arose, at the crossroads between phenomenology and history, from an iconology of the photographic, Kracauer, during the 1940s and 1950s, sought to ally himself with the Warburg school. But this was to be a story of missed opportunity. The correspondences he began with Gertrud Bing, Edgar Wind, and Ernst Gombrich led nowhere, and his prolonged exchanges with Panofsky always retained a slight tone of incomprehension. Through the problematic of the photographic, Kracauer, in reducing the basic cinematic unit (the photograph) to its documentary dimension, contradicted the neo-Kantian principles of Panofsky's iconology, for which the image, whether photographic or pictorial, always refers in the final analysis to a subject.

What Kracauer sought, however obscurely, through his exchanges with Warburg's followers was contact with Warburg's thoughts about images. In the arrangement of *Mnemosyne*, the last stage of Warburg's iconology, the documentary aspect of the image is indeed revealed through the process of photomechanical reproduction. But the similarities end there. In the panels of his atlas, Warburg intended to activate the images' latent effects by organizing their juxtaposition against the black grounds he used as a conductive medium. In describing his manipulations in a 1927 note, he used the metaphor of electrical conductivity:

> The dynamograms of ancient art are handed down in a state of maximal tension but unpolarized with regard to the passive or active energy charge to the responding, imitating, or remembering artists.

It is only the contact with the new age that results in polarization. This polarization can lead to a radical reversal (inversion) of the meaning they held for classical antiquity.[12]

Warburg's thought diverges from Kracauer's in that the latter conceived of the image as a static phenomenon, based on the notion of the frame (his analysis of the cinema in this regard depends, as Panofsky rightly noted, on the cult of the photographic), whereas Warburg considered the image a cinematic structure, within a problematics of movement, or montage.

Eisenstein and the Theory of Montage

In 1926, in a text titled "Béla Forgets the Scissors," Eisenstein, criticizing the role that the German film theorist granted to the figurative content of the image, asserted, as he would so many times after, the similarities between cinema and montage. In returning cinema to the plastic system of easel painting, Balázs would produce what Eisenstein called the "starism" of the image itself.[13] Now the image is but a fragment among other fragments. The essence of the cinema resides not in images but in the relation among images, and the dynamic impulse, or movement, is born of this relationship.

Four years later, in a chapter from *Der Geist des Films* (The spirit of the cinema) [1930]) titled "No ideograms!," Balázs answered Eisenstein. The Russian cinema, he wrote, was too much like a thought process. To return cinema to ideograms was to bring it back to the most primitive type of written language:

Too often, the Russians succumb to this very evident danger of film hieroglyphs. For example, when, in Eisenstein, the statue of the tsar is knocked off its pedestal, this symbolizes the fall of tsarism. When the shattered fragments come back together, it symbolizes

the restoration of bourgeois power, and so on. These are all symbols that mean something, like, say, the Cross or the paragraph sign or Chinese ideograms:

Now, images ought not to *symbolize* ideas, but rather to fashion or stimulate them. Ideas arise within us as logical consequences and not as symbols or already formulated ideograms in the image. Otherwise montage is no longer productive. It becomes a production of rebuses and riddles.... We're shown ideograms and dissertations in hieroglyphics. Cinematic forms of this sort make film regress to the most primitive forms of the written sign.[14]

We can infer from Balázs's reply what Eisenstein's thought shares with Warburg's: sequences of images are used like ideograms in *Mnemosyne* to produce a new art-historical language that is similar to Eisenstein's visual syntax. The very development of the concept of the interval on which the structure of the atlas rests, which would remain the dominant concept of twentieth-century montage, dates from 1920s Russian film theory.[15] In *Mnemosyne*, the subjective dimension that Panofsky assigned to the contents of the image is displaced among the images. Their contents are photographic or documentary; only their insertion in a sequence of images transforms them into unities of expression. Within the panel, the fragment has no separate existence; it is the specific representation of a general theme running through every element and leading to the formation of an "overall global image effect" comparable to Eisenstein's *Obraznost*:

Unlike "representation" (*izobrazenie*), the "image" (*obraz*) cannot be defined in terms of figurativity. Rather, the image is "meaning" understood as a condition of the work and as its finishing point. The construction of the work (whether literary, cinematic, pictorial, musical) aims at producing an overall "image effect." It is precisely

this quality of the work — in its definition as a semantic saturation obtained through the conversion of meaning into a signifying system on several levels — that Eisenstein was designating with the term *Obraznost* ("imageness" or "imaginicity").[16]

In a 1929 text titled "Beyond the Shot" — written when Warburg was working on *Mnemosyne* and published as an afterword to a book by Naum Kaufman on Japanese film — Eisenstein develops the notion of the "hieroglyph" on which Balázs would base his 1930 critique. The text begins like a syllogism:

Cinema is, first and foremost, montage. [...]
And Japanese cinema is quite unaware of montage.
Nevertheless, the principle of montage
may be considered to be an element
of Japanese representational culture.
The script,
for their script is primarily representational.
The hieroglyph.[17]

Eisenstein goes on to distinguish two types of hieroglyph in Japanese culture: figurative (simple) and copulative (complex). He then puts forward the famous formula whereby the combination of two hieroglyphs is equivalent not to their sum total but to their product. If each of them corresponds to an object, their meeting corresponds to a concept: the combination of two representations produces a third representation of a different nature. For example:

The representation of water and of an eye signifies "to weep,"
the representation of an ear next to a drawing of a door means "to listen,"

284

a dog and a mouth mean "to bark"
a mouth and a baby mean "to scream"
a mouth and a bird mean "to sing"
a knife and a heart mean "sorrow"
and so on.[18]

Through juxtaposition, two independent motifs are transformed into the representation of a reality of another order. In this way, a primitive mode of thought (thinking in figurative hieroglyphs and images) imperceptibly evolves toward conceptual thought. What's more, in Eisenstein's examples the combination of two figures produces not a third figure but an action. In a similar fashion, Warburg discovered among the Pueblo Indians a form of thought that proceeded strictly from images and acted through images. And if his journey to America can be seen as the genesis of *Mnemosyne*, that is because, like Eisenstein interpreting Japanese hieroglyphs, Warburg discovered in the Hopi a concept of montage capable of transforming hieroglyphs into action — capable, that is, of setting them in motion.

To explain his idea of montage, Lev Kuleshov used the brick as a model: "If one has an idea-phrase, a fragment of the story, a link in the entire dramatic chain, then this idea is expressed, laid out in shot-signs, like bricks."[19] According to Eisenstein, this concept of montage as a concatenation of parts, a chain of bricks, is limited to the external aspect of the link between frame and montage, which is conceived as the collage of a shot with another shot. In opposition to this linear conception of montage-rhythm, which he criticized for being mechanical and external, Eisenstein posited the concept of montage-collision. Here we have not a concatenation but a shock between elements, one that presupposes a moment of decomposition prior to the recomposition. And the phenomena of montage are not limited to a general articulation of the shots;

they manifest themselves within the isolated image, in the very continuity of the shot. In its deployment, the image collides with the boundaries of the frame, which it explodes in order to propagate itself through a dynamic impetus: "Just as a zigzag of mimicry," wrote Eisenstein, "flows over, making those same breaks into a zigzag of spatial staging."[20]

For the Native Americans, the zigzag is the graphic form associated with lightning and with the snake, which they attributed to untamed energy. Discussing the snake ritual in his 1923 lecture, Warburg described the dancers as manipulating the reptiles like Eisensteinian hieroglyphs, like montaged images, associating the human form with the symbol of movement embodied in the snake.[21] And it was through the Indian ritual, by a "collision effect," that Warburg would recognize in the serpentine figure a sign of the attention paid by Renaissance artists to the representation of movement, of which the *Laocoön* would become for him the emblematic image (see figure 28). Eisenstein explained that the *Laocoön* is the totem of movement because it's an image produced by montage.[22] The sculptural group is a representation of uninterrupted sequential displacements aimed at juxtaposing expressions that appear only in succession. In the nineteenth century, Duchenne de Boulogne's attempts to compose a coherent image of Laocoön's face through photography — by correcting his expressions and avoiding the anatomic and muscular contradictions — only produced expressionlessness. As a cinematic figure that brings succession to simultaneity, the *Laocoön* is not only a montaged figure but a figure of montage; and the snakes, beyond their pathetic signification, have a formal function in the composition: that is, they hold the group together by outlining the concatenations of the different parts of the "shot."

If the snake is the figure of montage, Dionysus, torn into pieces by the Titans and later resuscitated from his scattered limbs, is its

God: "We are at once reminded of the myths and mysteries of Dionysus, of Dionysus being torn to pieces and the pieces being reconstituted in the transfigured Dionysus. Here we are at the very threshold of the art of theatre which in time was to become the art of cinema."[23] In the light of Eisenstein's parable, *Cretinetti che bello!*, a burlesque story of dismemberment staged by André Deed in 1909, appears as a primitive metaphor of montage. Cretinetti, a clownish dandy, is chased to the country and torn apart by a troupe of love-crazed furies played, in keeping with the codes of popular comedy, by men in women's clothing; he then, through the help of special effects, collects his scattered limbs, dusts off his trousers, and continues on his way, whistling (figure 106).[24] The ritual action has been changed into a figurative motif, the sacrificial knife into a film editor's scissors. The break-up and reassembly of the body of Cretinetti-Dionysus is the mythological dressing of a concept of the image, born with the cinema, that proceeds no longer from immobility but from motion.

Krazy Kat and the Deconstruction of the Surface Plane

When Warburg was developing *Mnemosyne*, George Herriman was publishing in the Hearst newspapers a comic strip imbued with figurative and mythological elements of Hopi culture. In it we find, quite unexpectedly, effects of the breakdown of the frame similar to those in the atlas (figure 107). Krazy Kat's adventures, broad variations around a single scenario, take place in the Painted Desert below the Black (or "enchanted") Mesa, where Warburg had recently witnessed Native American rituals. Ignatz Mouse hurls a brick at Krazy Kat, who takes this aggression as a gesture of love, while Offissa Pupp, the police dog secretly in love with Krazy, tries to prevent the brick throwing by putting Ignatz into prison.[25] In *Krazy Kat*, the brick is not, as in Kuleshovian

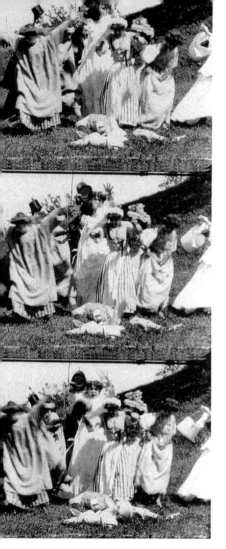

Figure 106. *Cretinetti che bello!*,
André Deed, 1909.

Figure 107. George Herriman, *Krazy Kat*,
Sunday pl. 2, August 1922.

montage, an element of construction: it serves a principle of destruction. As in the atlas panels, the fragmentation of the surface plates in the *Krazy Kat* panels marks the appearance of a montage-like way of thinking. One may therefore infer that the mechanism of *Mnemosyne* was borrowed from the cosmological montages of the Hopi sand paintings: it reproduces the migration of images through art history the way the Indians represented the circulation, encounter, and mutation of the world's inner forces (figure 108).

So much for the origin of *Mnemosyne*. What was its fate?

Jean-Luc Godard and the Destiny of Images

Kurt Forster, one of the first people to underscore the importance of the American Indian episode in Warburg's researches, drew a parallel between *Mnemosyne* and the development of photomontage among the avant-gardes of the 1920s.[26] Benjamin Buchloh placed the *Bilderatlas* in the context of the eruption (through photography) of the archive in contemporary artistic practices, and compared it to Gerhard Richter's *Atlas*.[27] But it is probably in cinema that we would find the deepest resonance with Warburg's undertaking: as in the works of Yervant Gianikian and Angela Ricci Lucchi,[28] and especially in Jean-Luc Godard's *Histoire(s) du cinéma*, in which film, by exiling itself from its place of origin, becomes confused with the exploration of its own past and in which the superimpositions and juxtapositions that video makes possible serve the same purpose as the dislocation of plane in *Mnemosyne*. On six occasions, in *Passion, Grandeur et décadence, King Lear, On s'est tous défilés* (an advertisement for Girbaud), *JLG/JLG, Histoire(s) du cinéma 4B: Les Signes parmi nous*,[29] Godard quotes a text by Pierre Reverdy called "L'Image":

Figure 108. Altar of the Antelope Priests at
Cipaulovi from Jesse Walter Fewkes, *Tusayan
Snake Ceremony* (1897).

The image is a pure creation of the mind.

It cannot arise from a comparison but from the juxtaposition of two more or less distant realities.

The more distant and right the relationship between the two juxta-posed realities, the stronger the image will be — the more emotional power and poetic reality it will have.

Two entirely unrelated realities cannot be usefully juxtaposed. No image will be created.

Two constructed realities cannot be juxtaposed. They are opposed. Rarely is any force obtained from this opposition.

An image is strong not because it is brutal or fantastic — but because the association of ideas is distant and right.[30]

This is how Godard describes cinema, and it could likewise be a description of *Mnemosyne*.

Figure 109. Aby Warburg and a Hopi Indian,
winter 1895–1896. Aby Warburg collection.

Memories of a Journey

Through the Pueblo Region

Aby Warburg

*Unpublished Notes for the Kreuzlingen Lecture on the Serpent Ritual (1923)**

*The original text, 115 typewritten pages with additions in Warburg's hand, is in the author's archive at the Warburg Institute in London under catalog number 93.4. Warburg's handwritten additions are in italics; variants are indicated by slashes. Words in square brackets are the (French) translator's. Question marks in brackets indicate an illegible word. All crossing out and underlining are Warburg's.

R e i s e - E r i n n e r u n g e n

a u s d e m G e b i e t d e r

P u e b l o s

(Fragmente zur Psychologie des primitiven Menschen)

Help! 8 August 923
Done! 11 August 23

Sketches that should never be printed
begun March 16, written while still on opium

Memories of a Journey Through the Pueblo Region
(Fragments / *dusty documents* / on the psychology / *the artistic*
practice / of primitive man / *of the Pueblo Indians of North America*)

The afterlife of primitive humanity in the culture / civilization / of
the Pueblo Indians.

Kreuzlingen

Documents drawn from the culture of primitive man, on the problem of
symbolic connections
10 April 923 *Becoming and decline of the space of thought*
creation destruction *27 Oct. 923*

The lecture given is on linen paper and is contained in a large gray
envelope

It's a lesson from an old book:
the kinship of Athens and Oraibi
28 VII 923

Warburg
[?]
21 [?] IV 923
addition of 26 IV

I do not want my presentation of images from the life of the Pueblo Indians in North America, on April 21, 1923, in Kreuzlingen, Bellevue, to be taken in any way as "results" — I am against this expression here, since Herr Dr. Kurt Binswanger[1] invited Pastor Schlatter to my lecture in these terms *without my being aware of it* — not, then, as the "results" of a supposedly superior knowledge or science, but rather as the desperate confessions of someone seeking redemption from a state in which his attempt at spiritual elevation has been arrested by / *in* / the compulsion to be connected through *a real or imaginary* incorporation. The central problem *should be understood* as the catharsis of the burdensome ontogenetic compulsion toward a sensorial positing of causes. I also do not want the slightest trace of blasphemous pseudoscience to be found in this comparative search for the eternally constant Indianness within the helpless human soul. The images and words ought to be a help to those who come after us, in their attempt to reflect on themselves in order to defend themselves from the tragic aspect of the tension / *the split* / between / *magical* / instinct and inhibition / *discursive logic*. The confession of an incurable schizoid, deposited into the archive of the doctors of the soul.

Plan *I*[2]

Washington
Trip to Chicago
Denver
Colorado Springs
Excursions to the cliff dwellings
Durango
Mancos
Wetherill Ranch *Mancos Canyon*
Santa Fe and Albuquerque
San Ildefonso
Cochiti
Laguna
Cubero
Acoma
Albuquerque
Zuni
California intermezzo
Pasadena
Coronado Beach
San Francisco (universities)
Flagstaff
Grand Canyon
Holbrook
Keams Canyon (Hans Guck in die Luft [Johnny head-in-the-air])
with American schoolchildren
Three villages of the mesa
The Hemis kachina dance in Oraibi (rattlesnake dance, same
location)

Slides II *24 III 1923*

1. Map (1) *Desert steppe*

2.⎱ *Plastic arts*
3.⎰ Cliff dwellings (2, 3) ~~Architecture~~

4. Santa Fe (5)

5.⎱ *Types of houses, flat village images*
6.⎰ Laguna (8, 9)

7. Girl with jug (10) *ceramics and* <u>*ornament*</u>

8.⎱ *symbol of the pottery. Washbasin*
9.⎰ Pottery (79a, 79b) *irrational, mystical el.*

10. Oraibi, interior (44)? *Kachina ? plastic art*
 24?

11.⎱ *Cosmological synthesis*
12.⎰ Cleo Jurino (61 and slide to be made) *Painted image of serpent*

13. Kiva (66) [?] *and painting*

14. Zuni landscape (17) *Cosmic rhythm* [?]

15. Typical Zuni. Photo taken with difficulty (19)

16. Acoma, view (12)

17. Acoma, door of the church (13) *(Wabai)* ⎱[?]

18. Acoma, church interior (14a)

18a. Ladder at the edge of a field

MIMETIC ELEMENT

19.⎱
20.⎰ San Ildefonso, mimetic hunting magic (57–59) *(60–60a)*
21.⎰ *mother of all animals*

Magical totemic Region of absolute paganism, far from the railroad, culture of the
kachina dance three pagan high plateaus
[?]

22. Holbrook, railroad tracks (20)

23. Train car (22)

24. Navajo weaver woman (25 ff.?) } ?

25. Mr. Keam in front of his house (29)

26. Mesa (37)

27. Walpi (38)

28. Street in Walpi (39)

29. Oraibi, old man (41)

30–39. Hemis kachina dance (45–54)

40. Dance spectator

41–43. Walpi, snake dance

44. Uncle Sam (79)

45. Kreuzlingen, church

Laocoön

Asclepius wheel ?

Oraibi [?]

Children from Keams Canyon

 [names?]: [?] *Dale, Fewkes, Harrison, . . . railroad*

Kreuzlingen
14 March 923
Still on opium

The Problem

Why did I go? What attracted me?

Outwardly, in the forefront of my consciousness, the reason I would give is that the emptiness of the civilization of eastern America was so repellent to me that, somewhat on a whim, I undertook to flee toward natural objects and science, so I traveled to Washington to visit the Smithsonian Institution. This is the brain and scientific conscience of eastern America, and indeed in Cyrus Adler, Mr. Hodge, Frank Hamilton Cushing, and above all James Mooney (as well as Franz Boas in New York), I immediately found pioneers in the research on the indigenous people; they opened my eyes to the universal significance of prehistoric and "savage" America. So much so that I resolved to visit western America, both as a modern creation and in its Hispano-Indian substrata.

A will to the Romantic was compounded with a desire to occupy myself in a more manly way than had yet been granted to me. I was still feeling anger and shame over the fact that, during the time of the cholera, I did not hold out in Hamburg as my brother and my dear wife's family did.

Aside from this, I had developed a downright disgust with aestheticizing art history. The formal contemplation of images — not conceived as a biologically necessary product situated between the practices of religion and art (which I understood only later) — seemed to me to give rise to such a sterile trafficking in words that after my trip to Berlin in the summer of 1896 I tried to switch over to medicine.

I did not yet have any notion that this American journey would make so clear to me precisely the organic interconnections between art and religion among primitive man, and that I would so

301

distinctly see the identity, or rather the indestructibility, of primitive man, who remains the same throughout all time, such that I was able to demonstrate that he is an organ in the culture of the Florentine early Renaissance as well as later in the German Reformation.

A book and an image gave me the scientific grounding for my trip and a certain vision of its goal. The book, which I found at the Smithsonian Institution, was the work by Nordenskiöld on the Mesa Verde, the region in northern Colorado where the remains of the enigmatic cliff dwellings are found — a work of very high quality, animated by a scientific spirit, which alone I have to thank for the solid foundation of my efforts.

The romantic vision that aroused the desire for adventure was a very bad large-format color print showing an Indian standing in front of a cliff face in which one of these villages has been built. This gave me a first impression and prompted a number of serious questions, which I put to the gentlemen of the Smithsonian Institution, who immediately drew my attention to Nordenskiöld's book. When I asked whether it might not be possible to visit these cliff dwellings, I was told that in winter there were great difficulties and it was already the end of November: but this only attracted me as something to be overcome. Also because I had just finished my military service, which I had carried out with great enthusiasm but which finally ended in failure, since when I left I was only a noncommissioned officer. I had seen anti-Semitism in its insidious form as a profound danger for Germany, and in this regard I would like to stress that I never felt I had the necessary qualities to make a truly good reserve officer, but that there were others who were even worse but who were promoted on the basis of their more suitable confession, and above all that truly capable German Jews were taken out of the army — which was paid for by the bloodshed in 1914. A couple thousand more Jewish officers and we might have won the Battle of the Marne.

Sassetti, Dürer... Antiquity, Luther

on opium

In any case, I benefited from the fact that the American army and American farmers use the same saddles for their horses as our artillery. And I brought with me a will to endure stress and strain, even if not in a really heroic form.

My observations of modern American civilization also gave rise to another wish, which afforded me the most pleasant impressions: I decided to visit American institutions of learning, the schools and universities in the West. That I was able to make this journey with ever-renewed goodwill is something I owe to the benevolent generosity of the authorities — inconceivable to us Europeans — who were, no doubt, induced to such consideration by two very strong recommendations, namely from the secretary of war and the secretary of the interior of the United States Kuhn, Loeb procured these recommendations for me, two letters of five lines at most, which opened every door in the West to me. And to these was added another very effective recommendation from Seligman to the railroad magnate Robinson in Chicago. I went one afternoon to his office, where I found an old American man who showed a restrained energy beneath a slightly tired face; he read the letter, raised his head for a moment, and asked simply: "What can I do for you, sir?" If I had merely offered a few bland generalities, I would have been lost. But I immediately said to him that I would like to have a recommendation for the governor of New Mexico, as well as one or two other letters to prominent people in the Pueblo Indian region, and that I would very much like to have free travel on the Atchison–Topeka–Santa Fe line. His answer was simply: "All right, sir, you get the letters in the afternoon *at two o'clock.*" After which I received in the Palace Hotel three very valuable letters of introduction and a pass for the railroad. Only with this pass was I able to make my repeated excursions into the Indian villages from Santa Fe.

The Indians' Artistic Culture

The art of the Indians appeared to me in two different domains, which for the Indians themselves, however, are one unified activity: in dance and in ~~ornamentation and figurative representation~~ the plastic arts. Both of these artistic expressions ~~are not~~ must be integrated as implements into their religious representations ~~and practices~~, which are the rudiments of a worldview that has been [???] thought through in an undeniably grandiose manner [illegible correction]. Hand drawings in color made for me by an Indian in Santa Fe, ~~Juan Chata~~ *Cleo Jurino*, revealed beneath the so-called childish execution the auxiliary representations of an ordered imagination, astoundingly identical to what we find ~~in later Hellenism~~ *in ancient periods (of Europe and Athens)*.

And now the question arises: In the works of these brown-skinned dancers, painters, ornamental potters, and figurine carvers, should we see autochthonous creations, the thoughts of primitive peoples, or do we stand before hybrid products assembled from thoughts of South American origin combined with a European supplement? We know that the latter was introduced by the Spanish at the end of the sixteenth century and reached the north of New Mexico, leaving behind a stratum on top of original American representations, over which more recently the puritanical American culture, with its civilizing efforts, is also being spread. From a philological perspective, we find ourselves before the most difficult object imaginable: a palimpsest whose text — even if we bring it out — is contaminated. This situation is complicated by the fact that today the Indian languages are so rich and distinct that neighboring Pueblo villages — there are about thirty or forty — cannot understand each other and must resort to sign language or (before that) to Spanish, and now to English.[3]

This difference of dialects alone makes a reliable historical psychology nearly impossible, and the necessary preliminary lin-

guistic work would require a lifetime to provide a secure foundation. Since I made these little excursions, this work has taken on vast proportions for me, but, with respect to the migrations of the Pueblos, it seems to have led to relative clarity.[4]

What I saw and experienced, then, reflects only the outward appearance of things, and I have a right to speak of it only if I begin by saying that this insoluble problem has weighed so heavily on my soul that during the time when I was healthy, I would not have dared to make any scientific statements about it.

But now, in March 1923, in Kreuzlingen, in a closed institution, where I have the sensation of being a seismograph assembled from the wooden pieces of a plant that has been transplanted from the East into the fertile northern German plains and onto which an Italian branch was grafted, I let the signs that I receive come out of me, because in this epoch of chaotic decline even the weakest has a duty to strengthen the will to cosmic order.

(For primitive man, animals are a fully achieved ~~cosmic~~ *magic* symbol, compared with which human efforts appear fragmentary and inadequate.) 15 III 923

The ~~artistic~~ *primitive* culture *of the Pueblo Indians* reveals to the rationalist and degenerate European a means — which is uncomfortable and painful and therefore not readily used — that can aid in fundamentally destroying his belief in an idyllic, leisurely, and fabulous country as man's common and primal homeland before the original sin of enlightenment. The fabulous, as the ground of the Indians' games and art, is a symptom and proof of a desperate attempt at order over and against chaos, not a smiling and pleasant surrender to the flux of things.

A fabulous animal, apparently the most concrete product of a playful fantasy, is something abstract that has been grasped in statu nascendi with great and difficult effort. It is a determination

of the contours of appearances, which, in their transient ungrasp-ability, do not allow themselves to be grasped otherwise. Example: the snake dance of Oraibi.

It is a region of arid desert. Rain falls only in August, accompa-nied by heavy storms. If it does not come, then a difficult year of arduous agricultural work (corn and peaches) will have been in vain. If lightning appears, hunger will be banished for this year.

A snakelike form, enigmatic movements, which have no clearly determinable beginning or end, and danger: these are what light-ning shares with the snake, which presents a maximum of move-ment and a minimum of graspable surfaces. When one holds a snake in one's hand in its most dangerous form — namely, the rattlesnake — as the Indians in fact do, when one lets oneself be bitten and then, rather than killing it, takes it back out into the desert, in this way human force tries to comprehend, through a sheer grasping with the hands, something that in reality eludes manipulation.

The attempt at magical effects is thus first of all an attempt to appropriate a natural event in the living likeness of its form and contours: lightning is attracted through mimetic appropriation, unlike in modern culture, where it is drawn into the ground by an inorganic instrument and eliminated. What distinguishes such an attitude toward the environment from ours is that the mimetic image is supposed to bring about a relation by force, whereas we strive for spiritual and material distance.

The originary category of causal thought is childbirth. Child-birth links the enigma of a materially determinable intercon-nection with the inconceivable catastrophe of separating one crea-ture from another. The abstract space of thought between subject and object is based on the experience of the severed umbilical cord.

The "savage," at a loss before nature, is orphaned and has no

fatherly protection. His courage for causal thinking is awakened in the selection, through elective affinity, of an animal-father who **totemism** gives him the qualities he needs in his struggle with nature, qualities that, in comparison with the animal, he finds only in a weak and isolated way in himself. This is the primal cause of totemism. **Durkheim**

The feared snake ceases to be fearsome* when it is adopted as a parent. In this regard, it should be recalled that the Pueblos have a matriarchal law; that is, they seek the cause of existence in the irrefutable "Mater certa." The representation of the cause — and this is the scientific achievement of the so-called savage — can shift between animal and human being. The most starkly visible form of this shift and transformation occurs precisely in the dance, through their own music and — as with the rattlesnake dance — even through the appropriation of the living being itself.

Warburg's Memories of Indian Books

16/III 923

In 1875, my mother lay deathly ill in Ischl. We had to leave her in the worst moment of crisis in a mail carriage drawn by a red postilion, in the care of our faithful Franziska Jahns, who actually brought her back home to us, cured and healthy, in late fall — despite having been treated by three Viennese authorities, Widerhofer, Fürstenberg, and one other, and by Catholic sisters, whose smell I still have in my nose today.

I sniffed at my mother's grave illness like a *frightened* animal. In the unusual state of weakness that presaged her illness, she seemed very strange and uncanny to me as she was carried in a litter up to Calvarienberg near Ischl, which we wanted to visit. It was on this occasion that I saw for the first time with my own eyes, in completely degenerated farmhouse images, scenes from the Passion of Christ's life, whose tragic and naked power I mutely sensed.

* inevitable — taboo? horror?

A single visit to my pitiful and distraught-looking mother, in the company of a vulgar Austrian Jewish student who served as a preceptor, created an atmosphere of inner despair that reached its high point when my grandfather arrived and said to us, "Pray for your mother," whereupon we sat down on some trunks with our Jewish prayer books and mumbled over them.

There were two possibilities for dealing with these incomprehensible emotions: a delicatessen downstairs, where for the first time we were given nonkosher sausage to eat, and a lending library, which was full of Indian novels. I devoured entire piles of these Indian novels at the time, and this was obviously my way of escaping from an unsettling present that left me helpless. They were small editions, in the translations by Hoffmann, I think.

The painful sensations were abreacted in the fantasy of romanticized cruelty. I was giving myself a protective vaccination against active cruelty, which apparently belongs to the ontogenetically necessary self-protective actions with which humans are endowed in their struggle for existence and which until further notice lie ready in the attic of the subconscious.

This "évolution régressive" found in the person of Slevogt — within the framework of a technically tranquilized artistic configuration — a fertile soil and a vaccine against the agent that destroys romanticized terror, which the average educated person needs.[5] He is also the illustrator of the *Iliad*, the Leatherstocking Tales, and *Don Juan*.[6]

When I traveled to visit the Indians, I was free from this interest in the Leatherstocking romance, and I saw virtually nothing of that kind in the area where I found myself, for it had indeed been the very scene of those terrifying battles between the Apache and the white men, but after some years the Apache had been deported and transferred into those human zoos called "Indian Reservations" on the Canadian border.

But another piece of this romance had been left in my memory by a book, perhaps without my being clearly aware of it. If I am not mistaken, it is by Browne and is called "A Journey to the West"; translated from English, it contains crude English illustrations,* and when I was probably about sixteen or seventeen, it filled my imagination with the whole grotesque richness of pioneer life in the American West, and this in a peculiarly exciting and graphic way.

When I reread the book about seven or eight years ago, I was appalled by its insipid hypocrisy. This in no way alters the fact that it affected my imagination like a kind of yeast.

(I would like to remark here that no book had such a tumultuous romanticizing effect on my youthful imagination as Balzac's "Petty Annoyances of Married Life," with French illustrations by... Among these illustrations were images of ~~satanism~~ *oddities for example in* [?], which I saw again before falling ill from typhus in 1870 and which played a curious demoniac role in my feverish dreams.)

In mythical thinking (see Tito Vignoli, *Myth and Science*[7]), a stimulus evokes / e.g. / as a defensive measure, the / *always imaginary* / exciting cause in a maximally intensified / *biomorphic* / creaturely form, that is, when / *e.g.* / a door groans on its hinges, one believes one hears — or rather unconsciously wants to hear — the growling of a wolf.

19 III 923 mythical thinking

It is characteristic of mythical thinking (see Tito Vignoli, *Myth and Science*) that a visual or aural stimulus sets up a biomorphic cause in consciousness in place of the real cause, regardless of whether and how the latter is demonstrable in terms of scientific truth — as, for example, sounds coming from far away — and this biomorphic cause, because of its graspable creaturely dimensions,

mythical thinking

* Copy [?], Warburg Library.

makes possible an imaginary defense measure. For example, when a door groans in the wind, this stimulus produces a feeling of fear in a savage or a child: the dog is growling. Or when the Bafiote compares a locomotive to a hippopotamus,* this is for him an enlightening form of rationalism, in the sense that he is enclosing this unknown violent animal that has come storming in on him within the creature that he knows, that he is used to hunting and shooting.[8] If this defensive fantasy is scientifically inadequate — since in the case of the locomotive it overlooks the fact that movement on rails is restricted and that there is no aggressive will, that is, it does not understand that the machine is restricted — this only reveals the difference between machine civilization and primitive culture, whose fundamental presupposition is that between one creature and another, it is the hostile and aggressive human or animal personality that dominates. The more intensely the physis of this will to attack fills the entire creature, the more intense is the defensive impulse in the one attacked. To defend oneself by connecting a subject or an object to a being with the maximum graspable dimensions of strength — this is the fundamental act of one who thinks in terms of the fabulous in his struggle for existence.

Phobic mythic imagination as substitute for the cause

moderately

In primitive man, memory has a biomorphic and comparative substitutive function. This is to be understood as a defensive measure in the struggle for existence against living enemies, which the phobically stimulated brain / *memory* / attempts to grasp, on the one hand, within the most distinct and clearest possible limits and, on the other hand, in all their force, in order then to be able to find the strongest defensive measures. These are tendencies at work beneath the threshold of consciousness.

By means of the substituted image, the stimulus creating the

*Heinz Werner, *Die Ursprünge der Metapher* (The origin of metaphor), p. 17.

impression becomes objectified and fashioned as the object to be defended against. When, for example, the enigmatic locomotive is seen as a hippopotamus, it thus acquires for the savage the character of something that his combat techniques can defend against. He could kill it if it charged toward him. He does not know that there are machines, that is, blind, inorganic moving beings, which — between natural phenomena and the human realm — have been produced by titans. When the first locomotive passed through Mecklenburg and stopped at the station, the peasants waited to see when a fresh horse would be put on the locomotive — an essentially equivalent biomorphism, although less straightforward because of the limited civilization involved.

The hair of Fortune, 26 Oct 923

This is an objective biomorphism. Subjective biomorphism, which voluntarily and imaginatively connects man with other beings, even inorganically, has the same tendency in its wish for an intensified accumulation of force with respect to enemies. In totemism, for example. The elective paternity in totemism is based on the fact that the Indian fighter from the Coyote clan wishes to take on the cunning and strength of this animal. Totemism is a subjective-phobic function of memory. The Moki of the Rattlesnake clan are able to take hold of a rattlesnake in a dance, without wanting to kill it, because they are related to it. But at the same time they believe they are grasping the one who carries the lightning that brings them rain.

false

For the man whose mythic thinking is derived from a biomorphic — that is, an organically defined determination of contours — the relation of the will to events must be explained through the fact that this determination replaces the scientifically "verifiable" cause; it substitutes what is inorganic and unstable with a creature that is biomorphically and animistically familiar and observable as a whole.

Phobic structural biomorphism "differentiation"

When I try to establish an order, I connect images external to

me with each other. This entire biomorphism is a phobic reflex, and the rest is a cosmic act that is merely binary and not refined; that is, the phobic reflex as biomorphic imagination lacks the capacity to set down a numerically ordered cosmic image. This objective setting down of images is present in these harmonical[9] tendencies, as they are found among the Indians and the Hellenists / *Hellenism* / and whose enormous progress in relation to simple biomorphism consists of the fact that simple biomorphism acts on the function of memory through / *with* a / *magical* defensive measure, whereas in the attempts at "structural" thought the hand directs not a weapon but a tool that creates an outline and gives a visual summary of this phobic biomorphism, which in any case cannot be externalized on its own as long as it has not been repeatedly presented to consciousness.}

Only lips
without sound

The point of departure is this: I see man as <u>an animal that handles and manipulates</u> and whose activity consists in putting together and taking apart. That is how he loses his organic egofeeling, specifically because the hand allows him to take hold of material things that have no nerve apparatus, since they are inorganic, but that, despite this, extend his ego inorganically. That is the tragic aspect of man, who, in handling and manipulating things, steps beyond his organic bounds.

Tragedy of
incorporation
phenomenology
fluctuating
limits of
personality
Appropriation
by
incorporation;

The fall of Adam consisted, first, of the ingestion of the apple, which brought a foreign body into him with incalculable effects; and, second — and certainly to the same degree — of the fact that with the hoe, which he had to use to work the earth, he underwent a tragic extension, because this tool did not essentially correspond to him. The tragic aspect of man, as one who eats and manipulates, is a chapter in the tragedy of humanity.

Ingestion

Saturn

Whence come all these questions and enigmas of empathy with respect to inanimate nature? Because for man there is in fact a situation that can unify him with something that belongs to him

passages [?]
toward the
cosmos or the
Tartarus

312

— precisely in the act of manipulating or carrying — but that does not flow through his veins. The tragic aspect of clothing and tools is the history of human tragedy in the largest sense, and the most profound book written on this is <u>Sartor Resartus</u> by <u>Carlyle</u>.[10]

the tragic aspect of clothing as foreign (8 V 923)

Man can therefore extend his own delimited contours through manipulating and carrying things. He does not receive any direct life feeling from what he grasps or carries. This is nothing new to him, since by nature there are already parts of him that belong to him but that have no sensation when they are removed — nails and hair, for example — even though they grow before his eyes. Just as in a normal state he has no feeling for his own organs. From what we call an organ, then, he receives only slight signals of its presence, and every day he experiences the fact that he possesses only a very meager system of signals for processes that belong to nature. He finds himself in his body like a telephone girl during a storm or under artillery fire. Man never possesses the right to say that his vital feeling coincides (through a constantly present system of signals) with the entire delimited sphere of alterations taking place in his personality.

Feeling of the personality in the [?] temporal memory

<u>Memory</u> is but a chosen collection of stimulus phenomena corresponding to sonorous enunciations (loud or soft speech). (That is why I keep in mind a particular notion of my library's purpose, namely as a primary collection for studying the psychology of human expression.)[11]

The question is: What is the genesis of spoken or pictorial expressions, by what feeling or point of view, conscious or unconscious, are they preserved in the archive of memory, and are there laws by which they are set down and force their way out again?

The problem that Hering formulated so well — "memory as organized matter"[12] — should be answered using the means available in my library, as well as, on the one hand, through the psychology of primitive man — that is, man reacting in an immediate,

313

reflexive, and unliterary way — and, on the other hand, through historical and civilized man, who consciously remembers the stratified (historical) formation of his own and his ancestors' past. With primitive man the memory image leads to a religious act / *that binds* /, with civilized man it leads to *incorporation* inscription.

Conceptual differentiation

All humanity is eternally and at all times <u>schizophrenic</u>. And yet an attitude toward memory images may be designated ontogenetically as prior and primitive, while it nevertheless remains secondary. In the later stage, the memory image does not release an immediate practical reflex movement — whether combative or religious — rather, memory images are consciously accumulated in images or signs. Between these two stages stands the treatment undergone by the original impression, which can be designated as a symbolic form of thought.

Totem and Taboo

The T O T E M is a way of connecting heterogeneous objects with the organic, oriented toward the past. The T A B O O is a way of distancing heterogeneous objects from the organic, in relation to the present.

missing Freud, Totem and Taboo

Material for the Lecture [?]
In April 1896, during the second half of my journey through the Pueblo Indian region, after a two-day train ride from Holbrook I arrived at the ranch of Mr. Keam, the Indian trader for the Moki Indians, whose villages lie on three parallel rock plateaus to the east of this settlement. The easternmost of these villages is called Oraibi. A missionary, Mr. Voth, had settled here, at the foot of the cliff on which Oraibi is located; his wife was Swabian by birth,

and she gave me a very friendly welcome. After many years of associating with the Indians, Voth had gained their trust by fulfilling his missionary duty as little as possible. He studied the Indians, bought the items they produced, and did a lively business selling these objects. Because he possessed their trust to an unusual degree, it was possible to photograph them during their dance, which otherwise they never allow because of their aversion to having their images reproduced. That is how I came to observe and to photograph a Hemis kachina dance, that is, a dance meant to promote the sprouting of grain.

It was a mask dance. The dancing Indians fell into two groups. Some knelt and made music in feminine dress — in reality they were men — and in front of them the actual dancers were lined up; their dance, a slow spinning movement, was accompanied by monotone singing and continuous shaking of rattles. The two lines of men converged in the direction of a small stone temple, before which a small tree decorated with feathers was planted in the ground. These feathers, I was told, would be taken into the valley after the dance ceremony was finished. They are called nakwa-kwoci. They are also found on the bahos — instruments made of small wooden sticks used in prayer — to which they are tied.

Hemis kachina dance

During the dance, an Indian with long hair, completely covered in a long garment, wearing no mask, walked around the dancers and sprinkled them with flour.

The mask itself is rectangular, divided by a diagonal line; two adjacent triangles are red and green. Inside the diagonal line is a row of dots that signify rain. At the top, on both sides, are wooden points cut in a zigzag form that probably represent lightning.

The dance lasts, in various formations, from morning to evening. When the overheated dancers want to take off their hot masks, they step away for a moment to a rocky ledge by the village and rest there. The dancing continues until late in the evening.

315

Copy based on
notes from 1896

Hemis kachina
dance
The Indians who take part in the kachina mask dance do not represent gods, but they are not simply priests. As demoniac intermediaries between the people and the heavenly powers, they are inhabited by a magical force when they wear the masks.

Their task is to call down the nourishing rains through their dance and prayer. In the dry steppe of Arizona and New Mexico, the Indians' most ardent prayers are for thunderstorms, for if the rain does not come in August, the only month it can appear, then the corn does not ripen and the evil spirit of famine approaches, bringing care and misery for the long, hard winter months.

In accordance with their agriculture, the kachinas assume a changing task and significance, as revealed in the different types of dance and song and above all in the symbolic decorations, different each time, of the face masks and the dance implements. Study of the kachina masks and of the pictorial dance decorations pertaining to them is facilitated by the Indians' custom of giving to their little girls, until the age of about ten, wooden puppets that precisely reproduce the costume of the kachina dancers. The
Kachina mask
Moki Indians call these dolls tihu; one sees them in every Indian house hanging on the walls or on the ceiling beams. They can be acquired without great difficulty.

Children are instilled with a great religious awe of the kachinas. Every child sees the kachinas as frightful, supernatural beings, and the moment when a child is enlightened as to the nature of the kachinas and is himself taken into the society of the masked dancers represents as the most important turning point in his education.

These kachina dances take place publicly in the open space of the pueblo. They are, as it were, the popular complement to that mysterious and artfully developed idol worship that the closed
Oraibi
religious brotherhood celebrates at night in the underground kiva.

In Indian villages close to the rail line, it is very difficult for a foreign white person to see the real kachina mask dances, but it is

316

.

completely impossible to attend the secret services in the kiva, since the rather base white society that usually made up the front guard of American culture during the building of the railroad abused the Indians' trust and created an atmosphere of suspicion that is only too understandable.

The inhabitants of the Moki or Hopi villages located two or three days' journey from the railway station, and reachable only by wagon through the steppe, raise fewer obstacles to the observation of their religious practices, although admittance to the secret services in the kiva is possible only through the mediation of an American who has befriended the Indians long before.

In the missionary Henry R. Voth, who lived a few kilometers from the Oraibi mesa, I had the good fortune to find a researcher who had gained the complete trust, only too rare in American ethnology, of the Indians in Oraibi. When I stayed with him from April 22 to May 2, 1896, I had his intelligent guidance to thank for a truly living image of the religious life of the Moki. Oraibi

The masked kachina dance that I had the opportunity to observe and from which I will show a few images in what follows was the so-called Hemis kachina dance; it was the first to take place after the corn was sown, and it was dedicated to consecrating the sprouting seeds. We observed this one on May 1, 1896.

1. How are their villages built? Organization
 a) either in cliffs
 b) [or] terraced

2. What activities do they pursue?
 a) hunting
 b) agriculture
 c) pottery, weaving (?)

3. Cultic art practices (cosmological magic in the art practice of the Pueblo Indians).
 a) vases and weaving
 b) wall painting and drawing by hand

Transition: Kachinas. House in Acoma with dolls. Figurative art only a repetition of the art of mimicry.
 a) mimicry of the hunt
 b) mimicry of agriculture
 c) snake dance

It is here a matter of a mimetic culture with a primitive social form, a hunting culture combined with a sedentary farming culture that builds houses, on which a layer of medieval Spanish Catholicism has been spread. One has therefore a contaminated material.

How does Western Christian culture distance the pagan element?
The entire practice of art is embedded in rain and hunt magic and is reflected before the artificial backdrop of Spanish culture.
With the Pueblo Indians, it is still possible to observe an underground magical pagan art practice among living men. If we have been with the Pueblos, we understand above all the underground layers of classical culture.

Psychology of the weak forces in man.
A peaceful state in the struggle for existence.
An encompassing memory.
The snake as a primordial element of the religious representation and practice of humanity.

318

28.III

As village dwellers and farmers, the Pueblo Indians of today, because of the activities forced on them by necessity, have developed a sense and a practice of rhythm (in time) and of symmetry (in space). This is because, on the one hand, as farmers they consciously live the rhythm of the year, with its passing and becoming, and, on the other hand, as artisans, especially in weaving and pottery, they have the principle of harmonical plastic or graphic artistic ability thoroughly in their blood. These technical and agricultural abilities encountered a foreign, and specifically a European, incursion that was undeniably influential; the Jesuits brought sixteenth-century Spanish civilization to the Moki, who later understood the necessity of shaking off this element.

Between mimicry and technique there is plastic art.

I am giving this lecture for another reason. I hope that the material will give you the feeling that it deserves to be elaborated scientifically. And this can happen only if I have the opportunity, with the help of my library in Hamburg, to examine my memories critically. [???]

I observed among the Indians two juxtaposed processes that vividly show the polarity of man in his struggle with nature: first, the will to compel nature with magic, through a transformation into animals; and, second, the capacity to grasp nature, in a vivid abstraction, as a cosmic-architectonic totality that is objectively coherent and tectonically conditioned.

Before setting out on my trip, I received new and personally overwhelming elucidations on the psychology of the will to animal metamorphosis from Frank Hamilton Cushing, the pioneer and veteran of the struggle to gain insight into the Indian psyche. Smoking his cigarettes, this man with a pockmarked face and thinning red hair, whose age no one can guess, told me how an Indian

319

once said to him: Why should man be higher than the animals? Just look at the <u>antelope</u>, which is nothing but running and runs so much better than man, or the bear, whose whole being is strength. Men can only do something, but the animal can do what it is, C O M P L E T E L Y.

29.III

Twenty-eight years ago, the railroad did not yet go near the Moki villages that lie farthest to the northwest. It was necessary to take a three-day wagon ride to reach them.

The fact that civilization has destroyed distance, aside from facilitating the arrival of curious spectators, must have a destructive effect on pagan religious life. The misery of the Indian who struggles for his life in the arid steppe by planting corn is eliminated to the extent that the land is cultivated using easier methods of conducting water, or even irrigation. The infertility of the soil when it is not watered was and is the primitive basis of the Pueblo Indians' religious magic. As they did for the Jews wandering in the desert under the guidance of Moses, the desert and the need for water play a role here as factors in the formation of religion.

See Voth Snake Ceremony ill.[13] The relation to soil and climate must be clearly grasped as a formative force in the Indians' religious practices. The entire year is accompanied by the so-called kachina dances — to which we will return and of which we will see some images — and these are nothing other than parallel actions promoting the ripening corn at particular stages of its development.

The magic involves the apprehension, arising from a wish, of a future event *only* by means of figural mimicry.

With the images from my journey to the Pueblo Indian villages, we enter the region of an original pagan religion that in its mi-

metic and plastic arts has clearly preserved nonecclesiastical primitive elements, over which, admittedly, a stratum of Mexican Catholic culture was spread in the sixteenth century and to which American intellectual education was more recently added.

In the northwest corner of the region where the Indians' cliff dwellings are located, the original elements of the pagan world-view, insofar as it leads to religious practices and representations, can still be grasped relatively intact, because the railroad — at least this was true thirty years ago — did not lead directly to these villages.

Thus did one factor of their magico-religious ceremony remain constant in its plastic force: the lack of water, which at certain times every year threatens their meager agriculture in the middle of the steppe. If the rain does not appear in August, the plants wither in the otherwise fertile, alkaline soil, and famine threatens. This urgent distress in the desert — so familiar to us from the Old Testament — which only the rain god in his grace can relieve, has been a factor in the formation of religion well into modern times, and photography allows us to form an idea of the growth- and rain-promoting magic of this region, in the images of the dances that the Indians execute at certain times, according to the rhythm of the growing corn.

Seen from the outside, this agricultural magic has a peaceful character compared with what we know of the war dances of the savage Indians of earlier times, which always had at their center a real human sacrifice. The Pueblos' dances, as we will see in the Hemis kachina dance, are also connected to a sacrifice, but in a sublimated, spiritualized form: a human is not sacrificed; rather, a small tree is made into an interpreter of the prayers, therefore a true pagan tree cult.

The animal cult and animal sacrifice, however, still clearly resonate in the principal harvest dance involving live rattlesnakes.

321

Conscious and reflective man is situated between systole and diastole. Prehension and comprehension [Greifen und Begreifen]. He moves, as it were, in a semicircular arc up from the earth and back down to the earth.

And when he stands upright, at the vertex of this arc — an advantage he has over the animals — the transitional states between instinctive self-loss and conscious self-affirmation become clear to him.

Although he himself is an object of the processes of polarity, he gains an insight into the transitional phase in which he simultaneously perceives the self-displacing image or sign elements and fixes them as such, in images or in writing.

Such a background representation, which accompanies the alternation from systole to diastole as a transient inhibitory process, is the abstraction of a numerically and harmonically ordered space. A part of this alternation's destructive and dominating power is thereby taken away from it. The law-like — which means the inevitable — aspect of this succession or sedimentation is experienced as redemptive.

Between prehension and comprehension lie the outlining and delimitation of contours.

The artistic process is situated between mimicry and science. It uses the hand, but the hand reverts to its own movement. The hand imitates; that is, it renounces any right to possess the object other than by palpably following its outer contour. It therefore does not completely renounce touching the object, but it does renounce taking possession through comprehension.

The artistic act is, as it were, a neutral grasping that does not concretely alter the relation between object and subject; rather, it registers with the eye and reproduces — in the plastic arts by actually touching, for the painter only by tracing the outline.

25.III

The tropological attitude is a state of mind that allows image exchange to be observed in statu nascendi, and in three parts, where it is a matter neither of a complete trope exchange nor of a metaphor held clearly at a distance. In medieval tropology, it is a matter of simultaneously seeing three objects juxtaposed in a situation of exchange. In its conscious functioning, the moment of exchange is placed simultaneously and directly before the eyes. Indeed, the retina on which the images are projected is, as it were, a triptych in which three successive phases of development are to be illustrated: the situation of man under nature, under the old law, and under the new law of grace. Example: the vine from the land of Canaan, the bronze serpent, and the Crucifixion.

The philosophy of history allows us to observe this process of exchange.

It is always a question of the extent to which the metamorphosis is still conscious. Everything we live through is metamorphosis.

The cosmological-tectonic element in the Pueblos' symbolic and artistic representations corresponds to their characteristics as sedentary, house-dwelling people who farm. The terraced layout of their houses explains the presence of ladders (they climb down into their houses from above) and stairs as a concrete foundation in the schema of their world structure (see the drawing by Jurino [on page 198, figure 69]).

The mimetic element in their dance art, however, corresponds to the culture of nomads and hunters, for they are indeed also hunters, although not as exclusively so as the nomads.

Material for the history of the symbolic attitude in mimicry and in the visual arts.

323

March 26

The snake as a primordial element in the religious representations and practices of humanity.

What qualities does the snake possess such that it would take its place in religion and art as an element of comparison and repression [verdrängender]?

1. In the course of a year, it passes through the entire cycle of life, from the deepest deathly sleep to the most intense life.

2. It sheds its skin and remains the same.

3. It is not capable of walking on foot, and yet it possesses a maximum of self-propelling force in connection with the absolutely deadly weapon of its poisonous fangs.

4. It presents a minimum of visibility to the eye, especially when it changes color to match the desert, according to the laws of adaptive mimicry, or when it darts from the hole in the ground where it lies hidden.

5. Phallus.

These are the qualities that make it a symbol capable of displacing and repressing what is "ambivalent" in nature, dead and living, visible and invisible (its attack, without prior warning and no chance of being saved, is disastrous).

Everything enigmatic and quick.

A complex mixture of maximal mobility and minimal attackable surface.

At the same time, exposed to periodic death-like sleep and subject to the metamorphosis of its skin. That is why, in its repressive function, it is the given comparison for events in which man experiences or sees an organic or inorganic alteration that is causally inexplicable.

Symbol of eternity (Zrwân). The snake as a symbol of change and transformation.

Incorporation as a logical act of primitive culture.

Incorporation is a process that occurs between a human being and a foreign being, animate and inanimate.

The process can be compared to the formation of a simple sentence. We have the simple sentence in statu nascendi, in which subject and object merge into each other if the copula is missing, or annul each other if the accent is different. This situation — an unstable simple sentence made up of three parts — is reflected in the religious artistic practice of primitive peoples to the extent that they tend to incorporate an object as a process parallel to that of syntax. Or else the subject remains and the object disappears; it is incorporated. Example in Vischer.[14] Communion rites.

2.[15] Appropriation through incorporation. Parts of the object remain as associated foreign bodies, thus inorganically extending the ego-feeling. Manipulating and carrying.

3. The subject is lost in the object in an intermediary state between manipulating and carrying, loss and affirmation. The human being is there kinetically but is completely subsumed by an inorganic extension of his ego. The most perfect form of the loss of the subject in the object is manifest in sacrifice, which incorporates some parts into the object. Mimetic and imitative transformation: example: the mask dance cult.

The scientific worldview presupposes that an actual transformation of a human into a plant, animal, or mineral is, by the laws of nature, impossible. The magical worldview, however, is based on the belief in the fluid borders between human, animal, plant, and mineral, such that man can influence becoming by means of a voluntary connection with the organically foreign being.

What is the significance of the symbolic act, within the function of memory, for the metamorphosis of things? The metamorphosis of the inanimate universe is a counterpart of primitive man's own metamorphosis. To a certain extent, he transfers the

causality of the metamorphosis of events into himself. The meta-
morphosis of the plant from seed to fruit is a counterpart to his
personal metamorphosis — as a mask dancer — as a master of this
process of ripening.

Legendary Origins of the Clan with the Totem Serpent [16]

We came out of the earth by the Colorado Grande. After some
wandering, we settled in Tokonabi (Navajo Mountains). But there
were few springs and few clouds there. The chief had two daugh-
ters and two sons, one of whom, Ti-yo, always sat sadly on the
wall, wondering where the water went when it disappeared into
the ground. Ti-yo said he had to solve this riddle.

Together with his father, he builds a boat; his mother gives him
food, and his father gives him five pahos and tells him to whom he
must give them.[17] He also gives him part of an eagle's thigh. Thus
equipped, Ti-yo travels straight down the river of the underworld
until he reaches another land. Someone there calls to him. He is
near the house of Madam Spider, who greets him warmly. There he
enters into a spacious kiva. He gives Madam Spider the large paho
and the eagle's thigh; she is very happy with them, gives him some-
thing to eat, gives him a place to stay for four days, then advises
him to go to the snake house and promises to accompany him.

Then she prepares a magic charm, which she gives him as a
gift, and — invisible to others — accompanies him on his right ear.

He flew on his bundle of eagle feathers until he came into a
kiva close to the great snake, to whom he gave some of the magic
charm. She let him pass. Then he descended into the snake kiva,
where many men, all dressed in snake skins, sat in silence next to
a sand pon-ya.[18]

From there he descended farther into the antelope-snake kiva.
Men dressed in white sat around a sand pon-ya. He handed one of
his blue pahos to the chief, who took it, laid it on the sand pon-ya,

and said: "I was expecting you, and I thank you for coming. I make the clouds come and go, and I make the wind blow that ripens the corn; and I direct the coming and going of the mountain animals. Before you return, you can wish for many things. Request what you will, and it shall be granted."

Now Madam Spider advised him to resume his wandering. The eagle flew to the west, where he saw a great body of water stretching far away, and in the middle of it the long shafts of a ladder jutted from the roof of a kiva. The spider urged him to go there. When he arrived, two pumas were guarding the entrance. But the spider calmed them with her magic.

The kiva was made entirely of turquoise and coral, and in the middle an old woman sat on the floor all alone. "That's the friendly mother; every night, when she takes off her coat, she becomes a charming young girl," said the spider. Then the good old woman prepared a meal for two: "That's for you and for your father when he comes home." As she said this, the spider whispered to him to get ready with the paho for the sun. And like the noise of a thunderbolt, the sun came in. He took out of his coat all the pahos he had received from humans on his travels and put them in order. "These are from humans with good hearts; they shall have what they wish. But these are from the evil ones; my eyes do not want to look upon them."

Ti-yo gave him his paho. "That's good, my friend, my relative, my son, let us smoke," said the sun, and they smoked. The sun then asked Ti-yo to accompany him on his journey through the underworld. Ti-yo held on to his belt, and they flew into the deepest depths of the underworld, to the house of Mu-i-yin-wuh.

A lot of serious people were hurrying about there, and the sun brought Ti-yo into the middle of this hardworking throng, where Ti-yo gave Mu-i-yin-wuh his paho. He said he would always heed the wishes of Ti-yo's people and that it was at his behest that all

the seeds of the living came to be. The crowd he saw there was busy with this work.

Then the sun took him back up and led him eastward to the sunrise. When they stopped, they were next to the sun's house, a kiva just like the one in the west, except that it's red. There were no women here either, only the sun's brother, who takes turns with his brother carrying the sun shield. The brothers change places every four days.

Here the sun taught him to make the sun paho. Then he would be able to see into the hearts of all men. The most important gift he could receive is in the antelope-snake kiva, the gift of the rain cloud. The sun gave him the skins of the gray and the yellow fox, set him on his shoulders, and led him through the sky to the west.

They found the good old woman there again. She gave him many rich gifts. He wrapped everything carefully in his coat, climbed back up the ladder, and flew away on his part of the eagle.

It was the twilight of evening when he arrived at the snake kiva; five days had passed since he had been there the first time. He quickly entered and went to the antelope-snake kiva, where he sat by the sand pon-ya for four days, listening to the teaching of the chief, who said: "Here we have an overabundance of rain and corn. In your land there is little. So you must use magic. Mark well these prayers in your breast, these songs you shall sing, these pahos you shall make; and when you display the white and the black on your bodies, the clouds will come."

He gave to Ti-yo pieces of the two kiva fires and some sand from the pon-ya in the antelope-snake kiva; these, he said, are the colors of the corn that will come forth from Ti-yo's prayers.

He also gave him two girls who knew the magic charm against the rattlesnake's bite. He was to give one of them to his brother.

He also gave him a ti-po-ni from the sand pon-ya and ordered him always to carefully preserve it. "For truly, it is your mother."

Madam Spider then let him come into her house, where he stayed four days and hunted rabbits for her. Then she made a basket for him, and on the fifth morning she set him in it with a girl on each side. Then she disappeared. But a thread appeared and took hold of the basket, which rose through the white clouds and sailed all the way to Tokonabi. Ti-yo took the girls to his mother; they stayed there for four days, and his brothers prepared the wedding presents.

On the fifth day, his mother washed the girls' heads, and from the top of the house it was announced that a foreign tribe had come to them; in sixteen days, their ceremony would be held. And until today the snake ceremony is announced sixteen days in advance.

Ti-yo and one of the girls went into the antelope-snake kiva; his brother went with the other one into the snake kiva. (At this point, the actual ceremony is recounted, except that the brothers do not go off on the snake hunt.)

Beginning on the fifth evening of the ceremony, and then on the next three after that, low clouds gathered over Tokonabi, and the snake people came up out of the underworld. The next morning they were transformed into reptiles of every sort. The morning after that, the snake girls said: "Bring the younger brothers of the snake people here, wash their heads, and let them dance with you." And it was done; at sundown, Ti-yo made a snake house out of flour, and the snakes were brought into it. All the people passed by and threw sacred flour on them. But they took the younger brothers back out into the valleys; they went back to the snake kiva in the underworld and took all the wishes of the people there.

After that, the girls gave birth to many snakes. When the children wanted to play with them, they were bitten. We had to emigrate from Tokonabi; the two snake girls were left behind. After long wanderings, the war god appointed Walpi to them as the place of residence where he wants to be worshiped.

18.4. Slides

1. Zuni landscape
2. Map
3. Santa Fe
4. Laguna I
5. Laguna II
6. Oraibi, interior
7. Billings
8. Pottery I
9. Pottery II
10. Cleo Jurino
11. Cleo Jurino, drawing
12. Kiva
13. Acoma I (on the cliffs)
14. Acoma II (in front of the church)
15. Acoma III (inside the church)
16. Acoma IV (church, ornament)
17. Barn with ladder
18. Antelope dance I
19. Antelope dance II
20. Antelope dance III
21. Antelope dance IV
~~Lt. Bryan~~
22. Holbrook
23. Hotel
24. Weaver woman
25. Keams Canyon
26. Walpi, view of the village
27. Walpi, street
28. Oraibi, old man
29. Hemis kachina I, spectator
30. " II, spectator
31. Hemis kachina dance I
32. II
33.
34. III
35. IV
36. V
37. VI
38. VII
39.
40. Hemis kachina chief
41. Snake dance, Walpi I
42. Snake dance, Walpi II
43. Snake dance, Walpi III
44. Laocoön
45. Asclepius
46. Kreuzlingen
47. Uncle Sam
 Small Hemis kachina tree

[Numerous handwritten additions, to the right of items 30–40 in list, some in shorthand, including: men standing, sitting, dancers stepping, moving, seen frontally, turning, lone woman, sacred flour, pause in the dancing, small tree.]

On Planned American Visit (1927)

Aby Warburg

The presence of Professor <u>Julius Sachs</u> has given me, aside from great personal pleasure in seeing him again, an insight that began to work its way toward us decades ago: namely, that without a knowledge of the humanist tradition and humanist education, the self-observations of the old and the new Europeans — if indeed I may thus designate the Americans — must necessarily remain insufficient.[1]

And since at the same time, thanks to the visit of Miss Gladys Richard, Dr. Boas's outstanding student who was working here this winter at the anthropology museum, I saw how only an extensive knowledge of ancient religious culture would allow us to make any use of the study of the surviving Indian civilization, the field of observation to which this idea commanded me now appears as a closed circle: "It's a lesson from an old book: the kinship of Athens and Oraibi."[2]

Because my present existence stands under the sign "Gathering Hay in a Thunderstorm" (which I do not take sentimentally), I would like to draw some conclusions: ever since we have had such an understanding correspondent as Paul Sachs at the Fogg Museum in Boston, it would almost be a sin of omission if we did

not try to establish — without any obligation on either side — an organic connection.[3]

There it would be possible (as Adolph Goldschmidt is now doing with respect to medieval art[4]) to make the significance of ancient traditions for modern culture persuasively felt as a problem of vital importance. Accordingly, through a very brief series of lectures at Columbia University or in Washington — lectures that in terms of space, time, and material would go far beyond methodological aspects — we could treat the problem of cultural exchange as the structure of social memory in the simplest and soundest way, by using the question of the "influence of Antiquity" on current European intellectual life as our Ariadne's thread — as we have done for ten years now.

When I look back on my life's journey, it seems that my function has been to serve as a seismograph of the soul, to be placed along the dividing lines between different cultural atmospheres and systems. Placed by birth in the middle, between Orient and Occident, and driven by elective affinity into Italy, which itself must attempt to construct its own new personality on the lines dividing pagan Antiquity from the fifteenth-century Christian Renaissance, I was driven toward America [illegible handwriting], the object of a supra-personal duty, in order to experience life there in its polar tension between the instinctive pagan nature cult and organized intelligence. After I had set up in Holland, too — in my studies on Rembrandt, a reliable mirror for capturing the ancient traditions of the region[5] — the following marching orders were given to my institute: the entire officers' corps must — if the turret of the observation tank is to function — undergo the most extensive and fundamental education in relation to, <u>first</u>, a knowledge [?] of Italy, especially in its relation to Antiquity, and, second, the antiquity of America; that is, the religious and artistic practice that lives on among the Indians, transmitted by Mexican

332

priests, to which primordial indigenous elements were added, [????] must be as present for all of us as the ancient tradition is to the <u>modern</u> American frame of mind.

On this point, the United States is in danger of failing to recognize the essence of the cultural tradition, since no one is there to show where the indestructible values of the spiritual and intellectual tradition are to be found — even for practical life, which at its deepest level can only be applied science.

Since I have not been able to think about refreshing my old experiences — not least because of my illness — I have decided, regardless of all the considerations that my so visibly advancing age brings with it (and perhaps precisely because of this), first to go to Italy in the fall for four or five weeks, so that I might give my children and Dr. Bing an approximate notion of fifteenth-century Florence. For a long time now, Dr. Bing has had the most legitimate claim to being given access to the pictorial material that, with great intelligence, she has directly helped us to work on: systematic by nature and by education, she has given us invaluable help, especially in compiling the immensely difficult indexes of our many publications. But only when she has experienced the foundation of the pictorial element of Antiquity and of Italy for herself will she receive the enrichment she deserves. ~~I only hope that the ten days set aside for her, after spending the previous fourteen days alone in Florence, will be sufficient~~.

For Saxl, the matter also stands thus: he urgently needs a renewed immersion in Italian art, from the perspective of the survival of Antiquity. Only after spending three months in Florence or Rome could he make clear to students, in a series of lectures in America — though for now it is too soon to say what form these should take — the significance of European scholarship to America. Just as, similarly, an organization like the Fogg Museum will

333

show how a practical sense of things, without presuppositions, can facilitate matters for a student in search of truth.

Now, as for "poor me," not having been there since the war, a trip of four to five weeks will be the minimum amount of time for the most necessary work required to complete my preparatory studies on Italy. In any case, I hope to be far enough along in the spring of 1928 to be able to spend three months in America, where I have an agreement with Boas to speak in New York on the significance of American ethnological research for a general understanding of the study of culture, in a series of three or four lectures, which I may also give in Washington.

From another perspective, I will also speak in Boston, in conjunction with the Fogg Museum, on the ancient pagan tradition as reflected in European art. Unfortunately, there will probably not be enough time for me to make an excursion to New Mexico and Arizona. That I do not travel well is something that I must accept; but it has become apparent that if I am given careful and reliable assistance, I can manage to give a fairly good oral presentation. However, it would be very desirable for Alber to accompany me, both on the trip there and on the return. As I pointed out above, it is equally necessary for Dr. Bing to gain knowledge of America not only in relation to the tradition but also concerning the technical aspects of the libraries, so that our institute may operate at the highest level — and I am not thinking primarily of mechanical refinements. For this reason, it would be desirable for her to travel to America at the same time, even if she had to go to places that I would not include in my itinerary. At the same time, it would be very desirable, or in fact absolutely necessary, for her to supervise the introduction of the slides into my lectures.

After I have returned from America, Professor Saxl will have about six months to prepare for a trip to America, where he may stay for perhaps half a year. I believe I can be certain that when he

returns, our institute will have risen to meet the highest standards as an observation tower, which, from its platform in Hamburg, looks out over all the migratory routes of cultural exchange / of symbolic culture / between Asia and America.

Figure 111. Aby Warburg in Rome, winter
1928–1929, a few months before his death.
"Beneath the dark flutter of the griffin's wings
we dream — between gripping and being gripped
— the concept of consciousness." Aby Warburg
on *Mnemosyne*, journal, May 1928.

Notes

FOREWORD: KNOWLEDGE-MOVEMENT

1. See in particular Dieter Wuttke, "Aby M. Warburg — Bibliographie: Schriften, Würdigungen, Archivmaterial," in Aby Warburg, *Ausgewählte Schriften und Würdigungen*, ed. Dieter Wuttke (Baden-Baden: Valentin Koerner, 1980), pp. 517–76; Werner Hofmann, Georg Syamken, and Martin Warnke, *Die Menschenrechte des Auges: Über Aby Warburg* (Frankfurt: Europäische Verlagsanstalt, 1980); Horst Bredekamp, Michael Diers, and Charlotte Schoell-Glass (eds.), *Aby Warburg: Akten des internationalen Symposions, Hamburg 1990* (Weinheim: VCH, 1991). Also see the collections in *Vorträge aus dem Warburg-Haus* (Berlin: Akademie, 1997–).

2. On this aspect, see Dieter Wuttke, *Aby M. Warburgs Methode als Anregung und Aufgabe*, 3rd ed. (Göttingen: Gratia, 1979).

3. Henri Focillon, *Moyen Age, survivances et réveils: Etudes d'art et d'histoire* (Montreal: Valiquette, 1945).

4. André Chastel, *Art et humanisme à Florence au temps de Laurent le Magnifique: Etudes sur la Renaissance et l'humanisme platonicien* (Paris: PUF, 1959), pp. 308–13; also see André Chastel, *Fables, formes, figures* (Paris: Flammarion, 1978), whose index of names omits Warburg. Warburg's reference to the *Pathosformel* is also missing from the article by André Chastel, "L'Art du geste à la Renaissance," *Revue de l'art* 75 (1987), pp. 9–16.

5. See William S. Heckscher, "The Genesis of Iconology" (1967), in *Art and Literature: Studies in Relationship* (Baden-Baden: Valentin Koerner, 1985), pp.

337

253–80; Serge Trottein, "La Naissance de l'iconologie," in *Symboles de la Renaissance, II* (Paris: Presses de l'Ecole Normale Supérieure, 1982), pp. 53–57.

6. Pierre Francastel, *La Réalité figurative: Eléments structurels de sociologie de l'art* (Paris: Denoël-Gonthier, 1965), pp. 201–81. Reference is made (p. 396, n. 100) to George Riley Kernodle (*From Art to Theatre: Form and Convention in the Renaissance* [Chicago: University of Chicago Press, 1944]) and, before him, to Emile Mâle (*L'Art religieux de la fin du Moyen Age en France: Etude sur l'iconographie du Moyen Age et sur ses sources d'inspiration* [Paris: Armand Colin, 1908]), considered the initiator of the problematic: "The question of the relationships between art and theater in the Middle Ages was treated for the first time by M. Emile Mâle." Also see Pierre Francastel, *La Figure et le lieu: L'Ordre visuel du Quattrocento* (Paris: Gallimard, 1967), pp. 265–312, where Warburg is again ignored. Aby Warburg, "The Theatrical Costumes for the Intermedi of 1589" (1895), in *The Renewal of Pagan Antiquity*, trans. David Britt (Los Angeles: Getty Research Institute, 1999), pp. 349–403.

7. Now you can find Aby Warburg's *The Renewal of Pagan Antiquity*, trans. David Britt (Los Angeles: Getty Research Institute, 1999).

8. See Georges Didi-Huberman, *Devant l'image: Question posée aux fins d'une histoire de l'art* (Paris: Minuit, 1990), pp. 263–64; and Georges Didi-Huberman, "Pour une anthropologie des singularités formelles: Remarque sur l'invention warburgienne," *Genèses: Sciences sociales et histoire* 24 (1996), pp. 145–63. As a result of this situation, monograph works on Warburg, often of great quality, coexist without any reference to each other (see the bibliography established by Wuttke, "Aby M. Warburg — Bibliographie"). Another result is the remarkable *nonuse value* of Warburg's concepts.

Let us simply note — regarding the problem of gesture and movement — the following: Warburg's ideas about the "survival of the ancient gesture" do not appear in the works of Moshe Barash (*Gestures of Despair in Medieval and Early Renaissance Art* [New York: New York University Press, 1976]); Warburg's nymph and serpent (see below, pp. 67 and 221–23) are not mentioned in the works of David Summers ("*Maniera* and Movement: The *Figura Serpentinata*," *Art Quarterly* 35 [1972], pp. 269–301); the relationship between contemplation

and theatricality, a product of the ancient polarity between ethos and pathos, is overlooked by Michael Fried (*Absorption and Theatricality: Painter and Beholder in the Age of Diderot* [Berkeley: University of California Press, 1980]); the *Pathosformel* does not appear to be known by the semioticians of the *pathème* (see Algirdas Julien Greimas and Jacques Fontanille, *The Semiotics of Passions: From States of Affairs to States of Feeling*, trans. Paul Perron and Frank Collins [Minneapolis: University of Minnesota Press, 1993]) or even by cultural historians (see Jean-Claude Schmitt, "Introduction and General Bibliography," *History and Anthropology* 1, no. 1 [1984], pp. 1–28; and Jan Bremmer and Herman Roodenburg (eds.), *A Cultural History of Gesture from Antiquity to the Present Day* [Cambridge, MA: Polity Press, 1991]) . . . to mention but a few examples.

9. It was at the initiative taken by a philosopher that the first translation of Warburg's essays appeared in French. See Eveline Pinto, introduction to Aby Warburg, *Essais florentins*, trans. Sybille Muller (Paris: Klincksieck, 1990), pp. 7–42. And thirty years ago, Panofsky was translated at the initiative taken by a philosopher (Bernard Teyssèdre) and a sociologist (Pierre Bourdieu).

10. Elsewhere I have compared the Warburg atlas of *Pathosformeln* to the practice of montage of certain avant-garde filmmakers at the end of the 1920s. See Georges Didi-Huberman, *La Ressemblance informe; ou, Le Gai Savoir visuel selon Georges Bataille* (Paris: Macula, 1995), pp. 296–97 and 379–83.

11. Gilles Deleuze, *Cinéma 1: L'Image-mouvement* (Paris: Minuit, 1983).

12. See Giorgio Agamben, "Aby Warburg and the Nameless Science," in *Potentialities: Collected Essays in Philosophy*, trans. Daniel Heller-Roazen (Stanford, CA: Stanford University Press, 1999), pp. 89–103.

13. See Edgar Wind, "Warburg's Concept of Kulturwissenschaft and Its Meaning for Aesthetics" (1930–1931), in *The Eloquence of Symbols: Studies in Humanist Art* (Oxford: Clarendon, 1983), pp. 21–35.

14. See Roland Recht, "Du style aux catégories optiques," *Relire Wölfflin* (Paris: Musée du Louvre-Ecole Nationale Supérieure des Beaux-Arts, 1995), pp. 31–59.

15. See Georges Didi-Huberman and Patrick Lacoste, "Dialogue sur le symptôme," *L'Inactuel* 3 (1995), pp. 191–226.

16. Aby Warburg, "The Art of Portraiture and the Florentine Bourgeoisie," in *Renewal of Pagan Antiquity*, pp. 185–221.

17. Aby Warburg, "Sandro Botticelli's *Birth of Venus* and *Spring*," in *ibid.*, p. 103; and Warburg, "Art of Portraiture and the Florentine Bourgeoisie," p. 187.

18. See Erwin Panofsky, "The History of Art as Humanistic Discipline" (1940), in *Meaning in the Visual Arts* (New York: Doubleday, 1955), pp. 1–25. Also see Didi-Huberman, *Devant l'image*, pp. 134–45. On Warburg and Nietzsche, see Yoshihiko Maikuma, *Der Begriff der Kultur bei Warburg, Nietzsche, und Burckhardt* (Königstein: Hain, 1985).

19. Sigmund Freud and Ludwig Binswanger: *Briefwechsel, 1908–1938*, ed. Gerhard Fichtner (Frankfurt: Fischer, 1992), p. 175. The letter is cited in part by Michaud (see below, p. 365 n.6). Also see Ulrich Raulff, "Zur Korrespondenz Ludwig Binswanger–Aby Warburg im Universitätsarchiv Tübingen," in Bredekamp, Diers, and Schoell-Glass, *Aby Warburg: Akten des internationalen Symposions*, pp. 55–70; and Karl Königseder, "Aby Warburg im Bellevue," in Robert Galitz and Brita Reimer (eds.), *Aby M. Warburg: "Ekstatische Nymphe — trauernder Flussgott": Portrait eines Gelehrten* (Hamburg: Dölling und Galitz, 1995), p. 84.

20. See Didi-Huberman, *Devant l'image*, pp. 169–269; and Didi-Huberman, "Pour une anthropologie des singularités formelles," pp. 148–49.

21. See Franz Cumont, *Recherches sur le symbolisme funéraire des Romains* (Paris: Librairie Orientaliste Paul Geuthner, 1942), pp. 319, 346, 409 (the butterfly: symbol of the soul).

22. The word *imago* designates the definitive state of insects in "complete metamorphosis," such as the butterfly.

23. See Warburg, "Sandro Botticelli's *Birth of Venus* and *Spring*," pp. 405–30; Aby Warburg, "Dürer and Italian Antiquity" (1905), in *Renewal of Pagan Antiquity*, pp. 553–59; and Aby Warburg, "The Emergence of the Antique as a Stylistic Ideal in Early Renaissance Painting," in *ibid.*, pp. 271–75.

24. Warburg, "Emergence of the Antique as a Stylistic Ideal in Early Renaissance Painting." Also see F. Antal and Edgar Wind, "The Maenad Under the Cross," *Journal of the Warburg Institute* 1 (1937), pp. 70–73.

25. Warburg, "Emergence of the Antique as a Stylistic Ideal in Early Renais-

sance Painting." Warburg posits that only since the seventeenth century have we become accustomed to seeking such desires for bizarre sensations.

26. *Ibid.*, p. 273: "A tragic sense of *classical unrest* was basic to the culture of Greco-Roman Antiquity" (emphasis added).

27. Warburg, "Dürer and Italian Antiquity," p. 555.

28. Warburg, "Sandro Botticelli's *Birth of Venus* and *Spring*," p. 141.

29. Gertrud Bing, introduction to Aby Warburg, *La rinascita del paganesimo antico: Contributi alla storia della cultura*, ed. Gertrud Bing, trans. Emma Cantimori (Florence: La Nuova Italia, 1966), p. xxvi.

30. See Sigrid Schade, "Charcot and the Spectacle of the Hysterical Body: The 'Pathos Formula' as an Aesthetic Staging of Psychiatric Discourse — a Blind Spot in the Reception of Warburg," *Art History* 18 (1995), pp. 499–517. On Charcot and his use of the pathos formula in classical and Baroque art, see Georges Didi-Huberman, "Charcot: L'Histoire et l'art," postface to Jean-Martin Charcot and Paul Richer, *Les Démoniaques dans l'art* (1887; Paris: Macula, 1984), pp. 125–211.

31. See Salvatore Settis, "Pathos und Ethos, Morphologie und Funktion," *Vorträge aus dem Warburg-Haus* (Berlin: Akademie, 1997), vol. 1, p. 40: "*Pathos ist Augenblick, Formel bezeichnet Dauer* [Pathos is the instant; formula the duration]."

32. I am attempting to synthesize a group of theoretical propositions, many of which were formed in a dialogue with the thought of Pierre Fédida (see in particular *Crise et contre-transfert* [Paris: PUF, 1992], pp. 227–65). In the field of psychoanalysis, an echo of this thought is found in the work of Monique David-Ménard ("Symptômes et fossiles: La Référence à l'archaïque en psychanalyse," in Pierre Fédida and Daniel Widlöcher (eds.), *Les Evolutions: Phylogenèse de l'individuation* [Paris: PUF, 1994], pp. 245–54) and Catherine Cyssau (*Au lieu du geste* [Paris: PUF, 1995]).

33. The reference to Marey and to the image in motion (including Marcel Duchamp's *Nude Descending the Staircase*) is already found in Hechscher's study "Genesis of Iconology," pp. 267–72. In addition, it was within the framework of the Warburg Institute that Beaumont Newhall published his first studies on the history of chronophotography; see Beaumont Newhall, "Photography and the

Development of Kinetic Visualization," *Journal of the Warburg and Courtauld Institutes* 7 (1944), pp. 40–45.

34. See below, pp. 82–84.

35. See Henri Maldiney, "Comprendre" (1961), *Regard, Parole, Espace* (Lausanne: L'Age d'Homme, 1973), pp. 70–71.

36. Antonin Artaud, "En marge de la 'Culture indienne,'" *Oeuvres complètes* (Paris: Gallimard, 1974), vol. 12, p. 245.

INTRODUCTION

1. Aby Warburg, "Sandro Botticelli's *Birth of Venus* and *Spring*," in *The Renewal of Pagan Antiquity*, trans. David Britt (Los Angeles: Getty Research Institute, 1999).

2. J.J. Winckelmann, *Reflections on the Imitation of Greek Works in Painting and Sculpture*, trans. Elfriede Heyer and Roger C. Norton (La Salle, IL: Open Court, 1989), p. 33. Warburg cited and criticized this very passage at the end of an essay published in 1914, "The Emergence of the Antique as a Stylistic Ideal in Early Renaissance Painting."

3. Aby Warburg, "On *Imprese Amorose* in the Earliest Florentine Paintings," in *Renewal of Pagan Antiquity*, p. 174.

4. Friedrich Nietzsche, *The Birth of Tragedy*, trans. Walter Kaufmann (New York: Vintage, 1967), p. 33.

5. Aby Warburg, "Grundlegende Bruchstücke zu einer pragmatischen Ausdruckskunde" (Ground-laying fragments for a pragmatic study of expression). I am indebted to Serge Trottein for calling my attention to this unpublished work, which will appear in German in *Gesammelte Schriften*, ed. Bernhard Buschendorf and Claudia Naber (Berlin: Akademie, forthcoming).

6. In his biography of Warburg, Gombrich defines the function of these notes within the economy of the published texts and the scope of the art historian's intellectual contribution: "In Warburg's essay [the study of Botticelli] — and in those that were to come — the line of argument has to be dug out of the mass of textual and visual documentation under which it almost disappears. To Warburg these documents spoke with such immediacy that he felt that he had

sance Painting." Warburg posits that only since the seventeenth century have we become accustomed to seeking such desires for bizarre sensations.

26. *Ibid.*, p. 273: "A tragic sense of *classical unrest* was basic to the culture of Greco-Roman Antiquity" (emphasis added).

27. Warburg, "Dürer and Italian Antiquity," p. 555.

28. Warburg, "Sandro Botticelli's *Birth of Venus* and *Spring*," p. 141.

29. Gertrud Bing, introduction to Aby Warburg, *La rinascita del paganesimo antico: Contributi alla storia della cultura*, ed. Gertrud Bing, trans. Emma Cantimori (Florence: La Nuova Italia, 1966), p. xxvi.

30. See Sigrid Schade, "Charcot and the Spectacle of the Hysterical Body: The 'Pathos Formula' as an Aesthetic Staging of Psychiatric Discourse — a Blind Spot in the Reception of Warburg," *Art History* 18 (1995), pp. 499–517. On Charcot and his use of the pathos formula in classical and Baroque art, see Georges Didi-Huberman, "Charcot: L'Histoire et l'art," postface to Jean-Martin Charcot and Paul Richer, *Les Démoniaques dans l'art* (1887; Paris: Macula, 1984), pp. 125–211.

31. See Salvatore Settis, "Pathos und Ethos, Morphologie und Funktion," *Vorträge aus dem Warburg-Haus* (Berlin: Akademie, 1997), vol. 1, p. 40: "*Pathos ist Augenblick, Formel* bezeichnet Dauer [Pathos is the instant; formula the duration]."

32. I am attempting to synthesize a group of theoretical propositions, many of which were formed in a dialogue with the thought of Pierre Fédida (see in particular *Crise et contre-transfert* [Paris: PUF, 1992], pp. 227–65). In the field of psychoanalysis, an echo of this thought is found in the work of Monique David-Ménard ("Symptômes et fossiles: La Référence à l'archaïque en psychanalyse," in Pierre Fédida and Daniel Widlöcher (eds.), *Les Evolutions: Phylogenèse de l'individuation* [Paris: PUF, 1994], pp. 245–54) and Catherine Cyssau (*Au lieu du geste* [Paris: PUF, 1995]).

33. The reference to Marey and to the image in motion (including Marcel Duchamp's *Nude Descending the Staircase*) is already found in Hechscher's study "Genesis of Iconology," pp. 267–72. In addition, it was within the framework of the Warburg Institute that Beaumont Newhall published his first studies on the history of chronophotography; see Beaumont Newhall, "Photography and the

Development of Kinetic Visualization," *Journal of the Warburg and Courtauld Institutes* 7 (1944), pp. 40–45.

34. See below, pp. 82–84.

35. See Henri Maldiney, "Comprendre" (1961), *Regard, Parole, Espace* (Lausanne: L'Age d'Homme, 1973), pp. 70–71.

36. Antonin Artaud, "En marge de la 'Culture indienne,'" *Oeuvres complètes* (Paris: Gallimard, 1974), vol. 12, p. 245.

INTRODUCTION

1. Aby Warburg, "Sandro Botticelli's *Birth of Venus* and *Spring*," in *The Renewal of Pagan Antiquity*, trans. David Britt (Los Angeles: Getty Research Institute, 1999).

2. J.J. Winckelmann, *Reflections on the Imitation of Greek Works in Painting and Sculpture*, trans. Elfriede Heyer and Roger C. Norton (La Salle, IL: Open Court, 1989), p. 33. Warburg cited and criticized this very passage at the end of an essay published in 1914, "The Emergence of the Antique as a Stylistic Ideal in Early Renaissance Painting."

3. Aby Warburg, "On *Imprese Amorose* in the Earliest Florentine Paintings," in *Renewal of Pagan Antiquity*, p. 174.

4. Friedrich Nietzsche, *The Birth of Tragedy*, trans. Walter Kaufmann (New York: Vintage, 1967), p. 33.

5. Aby Warburg, "Grundlegende Bruchstücke zu einer pragmatischen Ausdruckskunde" (Ground-laying fragments for a pragmatic study of expression). I am indebted to Serge Trottein for calling my attention to this unpublished work, which will appear in German in *Gesammelte Schriften*, ed. Bernhard Buschendorf and Claudia Naber (Berlin: Akademie, forthcoming).

6. In his biography of Warburg, Gombrich defines the function of these notes within the economy of the published texts and the scope of the art historian's intellectual contribution: "In Warburg's essay [the study of Botticelli] — and in those that were to come — the line of argument has to be dug out of the mass of textual and visual documentation under which it almost disappears. To Warburg these documents spoke with such immediacy that he felt that he had

only to present them for their meaning to be clear. Here is the root of that discrepancy between the public image of Warburg as an erudite scholar who knew how to connect some out-of-the-way texts with the images of the past, and the picture that emerges from a reading of his notes, where the theoretical concerns are always openly formulated. This discrepancy was ultimately to lead to the abortive project of Warburg's last years in which he hoped to explain his philosophy of civilization in terms of a picture 'Atlas' with scarcely any comment." Ernst Gombrich, *Aby Warburg: An Intellectual Biography* (London: Warburg Institute, 1970), p. 59.

7. "Zuerst ist die Kunstthätigkeit, wenn sie Menschen bildet, oft nichts als der die Oberfläche der Dinge selbst wieder reproduzierende Causalitätsdrang."

8. Aby Warburg, *Bildniskunst und florentinisches Bürgertum: Domenico Ghirlandaio in S. Trinita; Die Bildnisse des Lorenzo de' Medici und seiner Angehörigen* (Leipzig, 1902); and Aby Warburg, "The Art of Portraiture and the Florentine Bourgeoisie," in *Renewal of Pagan Antiquity*, pp. 185–221.

9. Aby Warburg, "The Theatrical Costumes for the Intermedi of 1589," in *Renewal of Pagan Antiquity*, pp. 349–403.

10. Aby Warburg, *Images from the Region of the Pueblo Indians of North America*, trans. Michael P. Steinberg (Ithaca, NY: Cornell University Press, 1995), p. 48.

11. Warburg nevertheless conducted a seminar in his library in Hamburg; gave lectures in Berlin, Hamburg, and Rome; and regularly participated in international congresses of art history. He was even an active participant in the 1912 Rome congress; see *Renewal of Pagan Antiquity*, p. 563.

12. Cited by Ron Chernow, *The Warburgs* (New York: Random House, 1993), p. 285. See above, p. 143. An iconographic trace of the Italian Concordat is found in *Mnemosyne*, pl. 78 (see figure 52).

13. Aby Warburg "Il 'Déjeuner sur l'herbe' di Manet: La funzione prefigurante delle divinità pagane elementari per l'evoluzione del sentimento moderno della natura" (1929), *Aut aut* 199–200 (1984), pp. 40–45.

14. Aby Warburg, "Italian Art and International Astrology in the Palazzo Schifanoia," in *Renewal of Pagan Antiquity*, p. 585.

15. For a history of visual devices in lectures on art history, see Trevor

Fawcett, "Visual Facts and the Nineteenth-Century Art Lecture," *Art History* 6, no. 4 (Dec. 1993), pp. 442–60.

16. On the heuristic value of the analytic method elaborated by Warburg for cinematographic studies, see Maurizia Natali, *L'Image paysage: Iconologie et cinéma* (Saint-Denis: Presses Universitaires de Vincennes, 1992).

17. See Michael P. Steinberg, "Aby Warburg's Kreuzlingen Lecture: A Reading," in Warburg, *Images from the Region of the Pueblo Indians*, p. 62.

18. From Hollis Frampton, *Circles of Confusion* (Rochester, NY: Visual Studies Workshop Press, 1983), pp. 171–76. The text, written in 1973–1975, is dedicated to Jane and Stan Brakhage. In 1989, the latter made a twenty-minute film devoted to the ruins of the Hopi villages: *Vision in Meditation 2: Mesa Verde* (copy at the New York Filmmakers Coop.).

CHAPTER ONE: NEW YORK: THE MOVIE SET

1. Cited by Beaumont Newhall, "Photography and the Development of Kinetic Visualization," *Journal of the Warburg and Courtauld Institutes* 7 (1944), p. 40.

2. Daniele Barbaro, *La prattica della perspettiva* (Venice, 1568). Cited by Beaumont Newhall, *The History of Photography* (New York: Museum of Modern Art, 1964), p. 11.

3. Deuteronomy 4.15–20.

4. Samuel F.B. Morse, *New-York Observer*, April 20, 1839, cited by Newhall, *History of Photography*, p. 16.

5. *Foreign Quarterly Review* 23 (April 1839), pp. 213–18, cited in Newhall, "Photography and the Development of Kinetic Visualization."

6. We find the same ontological suppositions in the art theory of the Cinquecento. In his introduction to *Lives*, when he defines drawing, Vasari logically refuses the representation of movement and writes: "[H]e who would learn thoroughly to express in drawing the conceptions of the mind and anything else that pleases him, must after he has in some degree trained his hand to make it more skilful in the arts, exercise it in copying figures in relief either in marble or stone, or else plaster casts taken from life, or from some beautiful antique statue,

or even from models in relief of clay, which may either be nude or clad in rags covered with clay to serve for clothing and drapery. All these objects being motionless and without feeling, greatly facilitate the work of the artist, because they stand still, which does not happen in the case of live things that have movement." Giorgio Vasari, "What Design is, and how good Pictures are made and known, and concerning the invention of compositions" in *Vasari on Technique*, trans. Louisa S. Maclehose (New York: Dover Publications, 1960), pp. 207–208.

7. William Lake Price, *A Manual of Photographic Manipulation* (London, 1858), p. 174.

8. On the contradictions of spontaneity, see Clément Chéroux, "Vues du train: Vision et mobilité au XIXè siècle," *Etudes photographiques* 1 (Nov. 1996), pp. 73–88. The author cites in particular the work of Josef-Maria Eder, *La Photographie instantanée* (1884), trans. O. Campo (Paris: Gauthier-Villars, 1888). In a chapter on the photography of moving trains, Eder writes, "Those who began to take instantaneous photographs tried to capture fast-moving trains. This was, however, a thankless task, for if the proof obtained was in focus, the train seems absolutely still, and the mere fact of the photographer's word, more than the plume of trailing steam, vouches for the instantaneity of the pose" (p. 87).

9. Dickson's first note on the kinetoscope, cited by Gordon Hendricks, *The Edison Motion Picture Myth* (New York: Arno, 1971), p. 71.

10. *Ibid.*, p. 55.

11. William Kennedy Laurie Dickson and Antonia Dickson, *History of the Kinetograph, Kinetoscope, and Kinetophonograph* (1895; facs. ed., New York: Museum of Modern Art, 2000), p. 19. Dickson himself designed the bands and prints of the photograms reproduced in the work. A more circumstantial account is found in an article by Dickson that appeared in 1933; see Hendricks, *Edison Motion Picture Myth*, pp. 89–90.

12. "The Kinetograph," *New York Sun*, May 28, 1891, cited by Hendricks, *Edison Motion Picture Myth*, p. 112.

13. "He also painted for public view in his city, with the use of mirrors, himself and his contemporary Dante Alighieri, on the wall of the chapel of the palace of the Podestà," *Vite d'uomini illustri florentini* [*De Origine Civitatis Florentinae et*

eiusdem famosis civibus, v. 1400]. Cited by Jacob Burckhardt, "Das Porträt in der Malerei," in *Beiträge zur Kunstgeschichte von Italien* (Basel, 1898), p. 151.

14. See below, p. 103.

15. See below, pp. 98–100.

16. Dickson and Dickson, *History of the Kinetograph*, p. 16.

17. Sigmund Freud, *The Interpretation of Dreams*, *The Standard Edition of the Complete Psychological Works of Sigmund Freud*, ed. James Strachey (London: Hogarth Press, 1973), vol. 4, p. 31. On the threshold of the construction of the first topic, Freud explicitly sketches a comparison between the unconscious and the camera obscura: "I propose simply to follow the suggestion that we should picture the instrument which carries out our mental functions as resembling a compound microscope or a photographic apparatus." *Standard Edition*, vol. 5, p. 536.

18. On this phase of film aesthetics, see Charles Musser, *The Emergence of Cinema: The American Screen to 1907* (Los Angeles: University of California Press, 1990). Also see David Robinson, *From Peep Show to Palace: The Birth of American Film* (New York: Columbia University Press, 1996).

On the survival of infra-mimetic elements in contemporary experimental cinematography and their relationship to the origins of cinema, see Arthur Cantrill and Corinne Cantrill's description of a film they made, which in a single composition mixed real flowers in the foreground with painted flowers in the background: "La Séparation bichrome," in Nicole Brenez and Miles McKane (eds.), *Poétique de la couleur* (Paris: Auditorium du Louvre–Institut de l'Image, 1995): "To create certain still lifes we used reproductions of paintings and extended the subjects represented onto those toward the back of the composition. One of the most interesting examples is a film using a painting of eucalyptus flowers by Margaret Preston, in which an ambiguity was created between the real flowers in the 'living' composition in the foreground and the painted flowers in the background. We had looked for a painting that evoked three-dimensionality, and then combined it with a three-dimensional material in order to see it re-created in cinematic two-dimensionality, whose properties differ from those of fixed photography and two-dimensional painting" (p. 118).

19. Dickson and Dickson, *History of the Kinetograph*, pp. 19–20.

20. *Ibid.*, p. 22.

21. Gordon Hendricks put an end to the story in "A New Look at an 'Old Sneeze,'" *Film Culture* 21 (1960), pp. 90–95. Until 1912, films in the United States were copyrighted in the form of prints on paper: an emulsion-covered paper the same length and width as the negative was used. The paper print was then developed like a photograph. See Kemp R. Niver, *Early Motion Pictures: The Paper Print Collection in the Library of Congress* (Washington, DC: Library of Congress, 1985). The rediscovery of paper prints in the 1930s made it possible to reconstruct preserved film copies, to some extent reversing the copyrighting procedure.

22. Charles Musser, *Edison Motion Pictures, 1890–1900: An Annotated Filmography* (Washington, DC: Smithsonian Institution Press, 1997), p. 88. Also see Robinson, *From Peep Show to Palace*, p. 42.

The "publication" of *Sneeze* demonstrates the contingent nature of projection both in the definition and in the reception of film. It was not until the late 1950s and the structural films of Peter Kubelka that the tradition of exhibiting films, as opposed to projecting them, found aesthetic expression. "The first exhibition of raw filmic material, which seems to be a first in the history of cinema, took place in 1958 in the Semaines d'Alpbach (Tirol): Kubelka nailed the film for *Adebar* directly onto a row of pickets in the open fields and invited the spectators to take the film into their hands. Today, at each showing of *Adebar*, *Schwechater*, or *Arnulf Rainer*, the naked celluloid ribbon is still attached directly to the wall, with nails in the perforations of the film." Christian Lebrat, *Peter Kubelka* (Paris: Paris Expérimental, 1990). In the 1970s, Paul Sharits exhibited his *Frozen Film Frames*, made up of strips of film affixed between two sheets of Plexiglas.

23. Edward B. Tylor, in *Primitive Culture* (New York: Harper, 1958), vol. 1, p. 97, devotes a section to ritual sneezing: through many examples borrowed from various cultures and eras, the author shows that sneezing is frequently associated with the presence or expulsion of a good or evil spirit; it is the sign that the subject has been stripped of his self-mastery. I owe this reference to Georges Didi-Huberman.

24. Dickson and Dickson, *History of the Kinetograph*, p. 19.

25. *Ibid.*, p. 22.

26. *Ibid.*, p. 24.

27. *Ibid.*, p. 25.

28. Julius von Schlosser, *Tote Blicke: Geschichte der Porträtbildnerei in Wachs: ein Versuch,* ed. Thomas Medicus (1911; Berlin Akademie Verlag, 1993).

29. See below, pp. 120–21.

30. The films are about 15 yards long, or approximately twenty seconds long, at eighteen images per second.

31. Dickson and Dickson, *History of the Kinetograph*, p. 37. Musser does not give any information on the Omaha war dance.

32. On Franz Boas and Aby Warburg, see below pp. 178–79, 334.

33. See G.W.F. Hegel, *The Phenomenology of Mind*, trans. J.B. Baille (London: George Allen Unwin, 1971), pp. 702–3 . See also Jacques Derrida's analysis in *Glas* (Paris: Galilée, 1974). In a note written on January 27, 1896, at the Palace Hotel in Santa Fe, Warburg wrote that Pueblo Indian thought is characterized by the refusal of subjective differentiation, a rejection that leaves them free to communicate with the forms of nature (see below, p. 191).

34. G.W.F. Hegel, *Lectures on the Philosophy of Religion*, ed. Peter C. Hodgson (Berkeley: University of California Press, 1987), vol. 2, pp. 239–40.

35. "Loie Fuller, through instinct, with exaggeration, with the [recesses] of her skirt or wing, creating a space." Stéphane Mallarmé, "Autre étude de danse: Les Fonds dans le ballet," in *Crayonné au théâtre, Oeuvres complètes* (Paris: Gallimard, 1945), p. 309.

36. This organic movement of three bodies grouped together to suggest the unity of a single body is symbolically undone in the images of surfers filmed in the early twentieth century by the Edison cameramen in Hawaii, black points scattered on the white expanse of the ocean, which in the image obeys no principle of composition.

37. *New York Herald Tribune*, Sept. 25, 1894, cited by Musser, *Edison Motion Pictures*, pp. 128–29.

38. The same James Mooney who, three years later in Washington, would tell Warburg about the snake ritual. See below, p. 177.

39. James Mooney, "The Ghost-Dance Religion and the Sioux Outbreak of

1890," *Fourteenth Annual Report of the Bureau of Ethnology* (Washington, DC: Smithsonian Institution, 1896), p. 653.

40. *Ibid.*, p. 657.

CHAPTER TWO: FLORENCE I: BODIES IN MOTION

1. The ode, composed between 1476 and 1478 for Giuliano de' Medici and commemorating the tournament held in honor of Simonetta Vespucci in 1475, remained unfinished after Giuliano's murder in 1478. The first book depicts the realm of Venus, the second the apparition of the nymph who must transform Giuliano from hunter to lover. See Aby Warburg, "Sandro Botticelli's *Birth of Venus* and *Spring*," in *The Renewal of Pagan Antiquity*, trans. David Britt (Los Angeles: Getty Research Institute, 1999), n. 8. On Vespucci, see below, p. 116.

2. Eugenio Garin, "La Culture florentine à l'époque de Léonard de Vinci," in *Moyen Age et Renaissance* (1954; Paris: Gallimard, 1989), pp. 242–43. Also see Eugenio Garin, "L'ambiento del Poliziano," in *Il Poliziano e suo tempo: Atti del IV convegno di studi sul Rinascimento* (Florence, 1957).

3. Aby Warburg, "Sandro Botticelli," in *Renewal of Pagan Antiquity*, p. 159.

4. "Homeric Hymn to Aphrodite" cited in Warburg, "Sandro Botticelli's *Birth of Venus* and *Spring*," p. 93; also see p. 92.

5. Warburg, "Sandro Botticelli's *Birth of Venus* and *Spring*," p. 102. In a disquieting way, Warburg's description anticipates that of the young girl depicted on the bas-relief from Antiquity that appeared in Wilhelm Jensen's novel *Gradiva*, published in 1903: "Her head, whose crown was entwined with a scarf which fell to her neck, inclined forward a little; her left hand held up lightly the extremely voluminous dress." Wilhelm Jensen, *Gradiva, a Pompeiian Fancy*, in Sigmund Freud, *Delusion and Dream*, trans. Helen Downey (New York: Moffat, Yard, and Company, 1917), p. 46. I thank Jean-Pierre Criqui for drawing my attention to this. Just as the protagonist in Jensen's novel sees the figure depicted in the bas-relief come to life, Warburg would slowly be led during the course of his research from the question of movement to that of the reconstruction of the past.

6. Heinrich von Kleist, "On the Marionette Theatre," trans. Thomas G. Neumiller, *Drama Review* 16, no. 3 (Sept. 1972), p. 24.

7. *Ibid.*, p. 23.

8. Warburg is careful to cite the name of the photographer, Adolph Braun, responsible for the reproduction of the drawing on which he based his argument — a sign of his consciousness, new to art historians, of the role of photographic reproduction in the analysis of works of art.

Warburg specifies that the bas-relief, now in Woburn Abbey, was formerly among the antique reliefs "built into the stairway of S. Maria Araceli in Rome" ("Sandro Botticelli's *Birth of Venus* and *Spring*," p. 107). On the importance of staircases as a cosmological reference, see below, pp. 196–97.

9. Warburg, "Sandro Botticelli's *Birth of Venus* and *Spring*," p. 107.

10. Warburg, "Sandro Botticelli," p. 159. One finds a synthetic reformulation of the question in this short text, which Warburg published in 1898.

11. Edgar Wind, *Pagan Mysteries in the Renaissance* (New York: Norton, 1968), pp. 113–40.

12. Cited in *ibid.*, p. 115.

13. *Ibid.*, p. 115.

14. *Ibid.*, p. 115.

15. *Ibid.*, p. 117.

16. *Ibid.*, p. 118–19.

17. On three-dimensional symmetry, see David Summers, "Figure Come Fratelli: A Transformation of Symmetry in Renaissance Painting," *The Art Quarterly* 1 (1977), pp. 59–88.

18. Aby Warburg, "The Art of Portraiture and the Florentine Bourgeoisie," in *Renewal of Pagan Antiquity*, p. 202.

19. Warburg borrows this term from Robert Vischer, *Über das optische Formgefühl* (On the optical sense of form), published in 1873. On empathy in German aesthetics at the end of the nineteenth century, see Harry Francis Mallgrave and Eleftherios Ikonomou (eds.), *Empathy, Form, and Space: Problems in German Aesthetics, 1873–1893* (Los Angeles: Getty Center for the History of Art and the Humanities, 1994), and Andrea Pinotti, *Estetica et Empatia* (Milan: Guerini, 1997).

20. Warburg, "Sandro Botticelli," p. 157.

21. On the "Bruchstücke" (Fragments), see pp. 37–38 above.

22. "Die Kunst der Frührenaissance kommt durch die Einführung von sich vorwärtsbewegenden Figuren auf den Weg ihren 'wissenschaftlichen' Charakter zu verlieren. Und die Künstler geben sich dieser Richtung hin, weil sie sich an die 'Antike' anzuschliessen glaubten.

"Mit der Einführung sich vorwärtsbewegender Figuren wird der Zuschauer gezwungen: die vergleichende Betrachtung mit der anthropomorphistischen zu vertauschen. Es heisst nicht mehr: 'Was bedeutet dieser Ausdruck?' sondern 'Wo will das hin?'

"Das Auge vollführt den Figuren gegenüber Nachbewegung, um die Illusion zu erhalten, als ob der Gegenstand sich bewegte.

"Figuren, deren Kleidungsstücke oder Haare bewegt sind, können diese Bewegung durch eigene Körperbewegung oder ohne diese durch den Wind erhalten oder durch beide zusammen. Bewegen dieselben sich in der Ebene parallel zum Zuschauer, so kann der Zusch. nur dann an Vorwärtsbewegung glauben, wenn er die Auge bewegt."

23. "Bew. Haare u. Gewd. sind das Zeichen gesteigerter persönl. Bwg. oder — starken Windes. Man kann daher mit Recht auf die gesteigerte Thätigkeit der dargestellten Personen schliessen, aber auch mit Unrecht diese Bewg. vom Willen der Person abhängig machen und so auf persönliches schliessen, wo keines ist."

24. "Verleihung der Bwg. Um einer sich nicht bew. Fig. Bwg. zu verleihen, ist es nötig, selbst eine aufeinander folgende Reihe v. erlebten Bildern wieder zu erwecken — kein einzelnes Bild: Verlust d. ruhigen Betrachtung. Zuschauer u. Gewdg. Bei bew. Gewdg. wird jeder Theil d. Contour als Spur einer sich vorw. bew. Person angesehen, die man von Schritt zu Schritt verfolgt."

25. J.W. Goethe, *Goethe on Art*, trans. John Gaze (Berkeley: University of California Press, 1980), p. 81.

26. J.J. Winckelmann, *Reflections on the Imitation of Greek Works in Painting and Sculpture*, trans. Elfriede Heyer and Roger C. Norton (La Salle, IL: Open Court, 1989), p. 33.

27. G.E. Lessing, *Laocoön* (New York: Dutton, 1961), p. 14.

28. Goethe, *Goethe on Art*, pp. 83 and 81.

29. Etienne-Jules Marey, *Le Mouvement* (Paris: Masson, 1894; repr. Nîmes: Jacqueline Chambon, 1994), p. 78. In the 1994 edition, the logical sequence of the images is made difficult to follow by a series of unacknowledged manipulations. Many images have been omitted (in particular the fencers and Greek dancers as well as all the plates not in the text: "Man seated on the ground," "Twenty-four phases of an airplane take-off," "Zoosporic movement," "Movement of red globules"). The illustrations of the 1894 texts are replaced by plates of an unknown origin (with the captions remaining the same), plates at times quite different from the original illustrations: thus the nude performers of 1894 appear dressed in white one century later.

30. *Ibid.*, p. 42.

CHAPTER THREE: FLORENCE II: THE PAINTED SPACE

1. Cesare Guasti (1822–1889), in Aby Warburg, "The Art of Portraiture and the Florentine Bourgeoisie," in *The Renewal of Pagan Antiquity*, trans. David Britt (Los Angeles: Getty Research Institute, 1999), p. 216.

2. Jacob Burckhardt, *Beiträge zur Kunstgeschichte von Italien* (Basel, 1898). This volume is made up of three essays devoted, respectively, to the altarpiece (*pala*), the painted portrait, and the collections: "Das Altarbild," "Das Porträt in der Malerei," and "Die Sammler." For the second essay, the one used by Warburg, see the Italian edition: Jacob Burckhardt, *L'arte italiana del Rinascimento*, ed. Maurizio Ghelardi and Susanne Müller (Venice: Marsilio, 1994), pp. 161–324.

3. Warburg, "Art of Portraiture and the Florentine Bourgeoisie," p. 186.

4. Jacob Burckhardt, *The Civilization of the Renaissance in Italy* (London: Phaidon, 1960); Jacob Burckhardt, *Der Cicerone* (Leipzig: E.A. Seeman, 1909–1910).

5. Burckhardt, "Das Porträt," pp. 150 ff.

6. "In den dargestellten Mönchen leben ohne Zweifel manche damalige Dominikaner von S. Maria Novella [There are no doubt many Dominicans of that time from Santa Maria Novella who live among the monks represented]," *ibid.*,

pp. 15 and 155. Burckhardt still sees the hand of Simone Martini in these fres-
coes; today they are attributed to Andrea di Bonaiuto and his assistants (c. 1355).

7. Warburg, "Art of Portraiture and the Florentine Bourgeoisie," p. 187.

8. *Ibid.*, p. 187.

9. Cited by André Bazin, "Le Mythe du cinéma total" (1946), *Qu'est-ce que
le cinéma?* (Paris: Cerf, 1981), p. 22.

10. Eadweard Muybridge, *Animals in Motion* (New York: Dover, 1957), p. 15.

11. Cited by Gordon Hendricks, *The Edison Motion Picture Myth* (New York:
Arno, 1971), p. 158.

12. Cited by Charles Musser, *Filmmaking for Edison's Kinetoscope, 1890–1895*
(New York: Center for Film and Historical Research, 1994).

13. Cited by Hendricks, *Edison Motion Picture Myth*, p. 18.

14. Warburg, "Art of Portraiture and the Florentine Bourgeoisie," p. 187.

15. Aby Warburg, "Flemish and Florentine Art in Lorenzo de' Medici's
Circle Around 1480," *Renewal of Pagan Antiquity*, p. 305.

16. But it is not a rigorously linear evolution and sometimes artists would
deliberately return to compositional schemes previous to perspective, as will be
seen in the triptych by Hugo van der Goes painted for Tommaso Portinari
around 1475 (see below, p. 140 and figure 47).

17. Warburg, "Art of Portraiture and the Florentine Bourgeoisie," p. 187.

18. *Ibid.*, p. 188. In *Tomb Sculpture* (New York: Abrams, 1964), Erwin Panof-
sky would in turn write: "The Renaissance formally sanctioned rather than
merely tolerated the principle of individual (as opposed to what I have called
institutional and 'gentilitial') commemoration; and that a maximum of posthu-
mous recognition came to be considered a reward not only for sanctity or at
least piety but also for political, military, literary, and artistic achievement, in
certain cases even for mere beauty" (p. 73).

19. Warburg, "Art of Portraiture and the Florentine Bourgeoisie," p. 190.

20. *Ibid.*, p. 191.

21. Cited by Eve Borsook and Johannes Offerhaus, *Francesco Sassetti and
Ghirlandaio at Santa Trinita, Florence: History and Legend in a Renaissance Chapel*
(Doornspijk: Davaco, 1981), p. 11.

22. Aby Warburg, "Francesco Sassetti's Last Injunctions to His Sons," *Renewal of Pagan Antiquity*, pp. 230–31.

23. Borsook and Offerhaus, *Francesco Sassetti and Ghirlandaio at Santa Trinita, Florence*, p. 18.

24. One recognizes the same setting in Geneva in a portrait of Sassetti with his son Teodoro by Ghirlandaio now in the Metropolitan Museum of Art in New York.

25. For a detailed analysis of the cycle, see Charles de Tolnay, "Two Frescoes by Domenico and David Ghirlandaio in Santa Trinita in Florence," *Wallraf-Richartz-Jahrbuch* 23 (1961); Borsook and Offerhaus, *Francesco Sassetti and Ghirlandaio at Santa Trinita, Florence*, p. 19.

26. "The pagan spirit of these marginal reliefs as well as that of the *bucrania* adorning the darkly lustrous sarcophagi themselves is, moreover, exorcised, as it were, by the paintings of Ghirlandaio which dominate the chapel as a whole." Panofsky, *Tomb Sculpture*, p. 86.

27. On Buontalenti, see below, p. 155.

28. Ludovico Zorzi, *Il teatro e la città* (Turin: Einaudi, 1977), p. 91.

29. Warburg, "Art of Portraiture and the Florentine Bourgeoisie," p. 189.

30. *Ibid.*, p. 191.

31. Warburg, "Francesco Sassetti's Last Injunctions to His Sons," pp. 223–62.

32. Ernst Gombrich, *Aby Warburg: An Intellectual Biography* (London: Warburg Institute, 1970), p. 118.

33. *Ibid.*, pp. 125–26.

34. Aby Warburg, "Sandro Botticelli's *Birth of Venus* and *Spring*," in *Renewal of Pagan Antiquity*, pp. 133–42.

35. See above, p. 349, n.1.

36. See Warburg, "Sandro Botticelli's *Birth of Venus* and *Spring*," p. 136. In a recent monograph devoted to Piero, Sharon Fermor undertakes to prove, on the basis of factual arguments, that the Chantilly portrait represents not Simonetta but Cleopatra (*Piero di Cosimo: Fiction, Invention, and Fantasia* [London: Reaktion, 1993], pp. 93–101). Warburg's method destroys this type of interpretation and reveals its underlying mechanisms: it rests on a naive positivism that applies the

laws of nature to representation and presupposes that a portrait cannot represent many models at the same time, and that it has meaning only on the level of signification. Warburg, while giving his discourse the appearance of iconographism, shows, on the contrary, works of art to be sites of superimpositions and crossings among heterogeneous forces of which they are not necessarily the reflection but with which they sometimes maintain relationships of resistance or conflict.

37. Warburg, "Art of Portraiture and the Florentine Bourgeoisie," pp. 191 and 193.

38. *Ibid.*, p. 189.

39. *Ibid.*, p. 189.

40. Warburg, "Francesco Sassetti's Last Injunctions to His Sons," p. 189.

41. Georges Didi-Huberman, "Pour une anthropologie des singularités formelles: Remarque sur l'invention warburgienne," *Genèses: Sciences sociales et histoire* 24 (1996), pp. 145–63.

42. Warburg, "Art of Portraiture and the Florentine Bourgeoisie," p. 190.

43. Julius von Schlosser, *Tote Blicke: Geschichte der Porträtbildnerei in Wachs: ein Versuch,* ed. Thomas Medicus (1911; Berlin, Akademie Verlag, 1993).

44. Thomas Medicus, "La Mort à Vienne," postface to *ibid.*

45. Warburg, "Art of Portraiture and the Florentine Bourgeoisie," p. 203. Georges Didi-Huberman has drawn attention to the arrangement of Ghirlandaio's fresco, to the point of making it the organizing principle of the cycle as a whole. Beyond the theatricalized space seen in it by Warburg, he places the emphasis on the metaphysical signification of the *frons scaenae*: "The emerging of these children on the threshold of a ground floor and basement must be compared with other specific features of the fresco: the resuscitated child, just below, who rises from his deathbed; the Christ-child born beside a Roman tomb; the figures of Sassetti and his wife emerging in profile beside their own tombs.... The 'mute life' of which Warburg speaks is therefore not reduced to the identity of the figures depicted: it proliferates from the formal thresholds of the representation, the problematic articulation of the ground floor and the basement, for example, which seems to point toward the no less problematic articulations of the public and the private, death and life, the earthly and the

celestial — everything Ghirlandaio tackles everywhere in his cycle in the Sassetti Chapel." Didi-Huberman, "Pour une anthropologie des singularités formelles," p. 161; and, more recently, *L'Image survivante: Histoire de l'art et temps des fantômes* (Paris: Minuit, 2002), pp. 484ff.

46. Aby Warburg, "Flemish Art and the Florentine Early Renaissance," in *Renewal of Pagan Antiquity*, p. 289.

47. Max Friedländer, *From Van Eyck to Bruegel*, trans. Marguerite Kay (New York: Phaidon, 1956), p. 46.

48. Warburg, "Flemish Art and the Florentine Early Renaissance," p. 289.

49. The same premeditated confusion is found between the space of representation and the universe of the senses in another work by Memling, the panel of the *Last Judgment*, in Danzig (now Gdansk), in which Catarina Tani appears, in a portrait also drawn for the Florentine colony in Flanders. Warburg writes, "Madonna Catarina Tani, whose portrait now hangs in a church in a harsh Northern clime,... at the age of eighteen." The portrait is animated with a life of its own: it is sensitive to the conditions of its exhibition, as if the figure were freed from the painting's surface and frame. *Ibid.*, p. 288.

50. In *Portrait of an Old Woman* by Hans Memling in the Louvre, the veil and the headdress are even more insistent than in the portrait of Maria, rigidly defining the contours of the face.

51. Warburg, "Flemish Art and the Florentine Early Renaissance," p. 292.

52. *Ibid.*, p. 292.

53. Aby Warburg, "Flemish and Florentine Art in Lorenzo de' Medici's Circle around 1480" (1901), in *Renewal of Pagan Antiquity*.

54. Pliny, *Natural History*, trans. H. Rackham (Cambridge, MA: Harvard University Press, 1952), p. 327.

55. Galen, *De Temperamentis*, 2.182 (Leipzig: Teubner, 1904), pp. 46–47.

56. Bianca Hatfield Strens, "L'arrivo del Trittico Portinari a Firenze," *Commentari* 19 (1968), pp. 314–19; Borsook and Offerhaus, *Francesco Sassetti and Ghirlandaio at Santa Trinita, Florence*, p. 34.

57. Warburg, "Flemish and Florentine Art in Lorenzo de' Medici's Circle Around 1480," p. 307.

58. On *Mnemosyne*, see below, pp. 240–46.

59. Cited by Gombrich, *Aby Warburg: An Intellectual Biography*, p. 272.

60. Warburg, "Flemish Art and the Florentine Early Renaissance," p. 301, n.43.

61. Perhaps the analysis of the portraits of Maria had autobiographical resonance. In the margin of a note of the "Bruchstücke" from January 22, 1898, Warburg wrote: "Florenz / Vial. Margherita 42, / P. t. sin. / nebenan ciseliert / Mary." Mary Hertz was Aby's wife. He had met her in Italy at the end of 1880 while she was studying art. After their marriage, they lived in Florence, on Viale Margherita, from 1897 to 1904. In 1899, their first daughter, Marietta, was born.

62. The same schema is found in a drawing of the snake god made for Warburg by Cleo Jurino in New Mexico in 1895. As in the image of Maria, Warburg wrote the names of the snake in a column running down the length of the drawing. During the lecture in Kreuzlingen in 1923, Warburg would identify the snake as a symbol of fecundity (see below, pp. 194–96 and fig. 69).

63. Jacques Mesnil, "L'Influence flamande chez Domenico Ghirlandaio," *La Revue de l'art* 29, 5th year, no. 166 (1911), p. 64.

64. Warburg, "Flemish Art and the Florentine Early Renaissance," p. 301, n.44.

65. Warburg, "Art of Portraiture and the Florentine Bourgeoisie," p. 218, n.19.

66. See above, pp. 30–31 and 82–83.

67. Erwin Panofsky, *Early Netherlandish Painting* (Cambridge, MA: Harvard University Press, 1966), vol. 1, p. 331.

68. *Ibid.*, p. 332.

69. *Ibid.*, p. 334.

70. On the opposition between Panofsky's German period and his American period, see Georges Didi-Huberman, *Devant l'image: Question posée aux fins d'une histoire de l'art* (Paris: Minuit, 1990), pp. 107–68: "L'historien de l'art dans les limites de sa simple raison."

71. Arnaldo Momigliano, "How Roman Emperors Became Gods," *American Scholar* 55 (Spring 1986), p. 181; cited in Aby Warburg, *Images from the Region of*

the Pueblo Indians of North America, trans. Michael P. Steinberg (Ithaca, NY: Cornell University Press, 1995), p. 108.

72. One finds the same type of anachronism in a study devoted to airships and submarines in the Renaissance published by Warburg in 1913, as a prediction of the world war to come ("Airship and Submarine in the Medieval Imagination" [1913], in *Renewal of Pagan Antiquity*, pp. 333–38), and of course in the plates in *Mnemosyne*, which rest, to a great extent, on a staging of the tensions between images of different time periods.

CHAPTER FOUR: FLORENCE III: THE THEATRICAL STAGE

1. *Der "Tod des Orpheus": Bilder zu dem Vortrag über Dürer und die italienische Antike: Den Mitgliedern der archäologischen Sektion ... überreicht von A. Warburg*, 3 plates, large folio (The *Death of Orpheus*: Plates to illustrate the lecture on Dürer and Italian Antiquity. Presented by A. Warburg ... to the members of the Archaeological Section) [*Ausgewählte Schriften und Würdigungen*, ed. D. Wuttke (Baden-Baden: Valentin Koerner, 1980), pp. 517–76]. The two works are exhibited side by side today (as in 1906?) at the Kunsthalle in Hamburg. Also see Aby Warburg, "Dürer and Italian Antiquity," in *The Renewal of Pagan Antiquity*, trans. David Britt (Los Angeles: Getty Research Institute, 1999), pp. 553–59.

2. Aby Warburg, "Sandro Botticelli's *Birth of Venus* and *Spring*," in *Renewal of Pagan Antiquity*, p. 124.

3. Burckhardt, cited in *ibid*., p. 125. "Darf man annehmen, dass das Festwesen dem Künstler jene Figuren körperlich vor Augen führte, als Glieder wirklich bewegten Lebens, so erscheint der künstlerisch gestaltende Prozess naheliegend.... Man erkennt hier, was Jakob Burckhardt auch hier unfehlbar im Gesamturtheil vorgreifend gesagt hat: 'Das italienische Festwesen in seiner höheren Cultur ist ein wahrer Übergang aus dem Leben in die Kunst.'" This analysis of Renaissance festivals continued in a group of notes drafted between 1903 and 1906 titled "Das Festwesen als vermittlender Ausbildner der gesteigerten Form" (The festival as an expression and transmission of the completed form).

4. See above, pp. 68–69.

5. Aby Warburg, "The Theatrical Costumes for the Intermedi of 1589" (1895), in *Renewal of Pagan Antiquity*, pp. 349–403.

6. James M. Saslow, *The Medici Wedding of 1589: Florentine Festival as Theatrum Mundi* (New Haven, CT: Yale University Press, 1996).

7. Girolamo Bargagli, *The Female Pilgrim*, trans. Bruno Ferraro (Doverhouse, 1988).

8. On soccer in sixteenth-century Florence, see Horst Bredekamp, *Florentines Fussball: Die Renaissance der Spiele* (Frankfurt: Campus, 1993).

9. Warburg, "Theatrical Costumes for the Intermedi of 1589," p. 350. Isabella's glossolalia found perhaps a distant echo in an episode from Warburg's later years: On June 13, 1928, on his sixty-second birthday, his family and friends were gathered with him in the library on 116 Heilwigstrasse in Hamburg. In the middle of the small celebration, Warburg disappeared for more than half an hour. When he returned, he had changed his city clothes for beggar's rags, which were dirty and torn. Next he improvised a scene in which he expressed himself not in German or even classical Italian but in Neapolitan dialect. Incident reported by René Dromert in Robert Galitz and Brita Reimers (eds.), *Aby Warburg: "Ekstatische Nymphe — trauernder Flussgott": Portrait eines Gelehrten* (Hamburg: Dölling und Galitz, 1995), p. 17.

It is possible that the character Warburg created was a memory of the figure who appeared dressed in rags on the fresco of March (first decan of the Ram) in Palazzo Schifanoia in Ferrara, a figure reproduced in the illustration of a lecture given in 1912, "Italian Art and International Astrology in the Palazzo Schifanoia, Ferrara," in *Renewal of Pagan Antiquity*, pp. 563–92. Perhaps the rags with which Warburg dressed himself were also intended to recall the "decaying splendor," to use his own terms, of the *boti* hanging from the vault of Santissima Annunziata.

10. Annamaria Testaverde Matteini, "L'officina delle nuvole: Il Teatro Mediceo nel 1589 e gli *Intermedi* del Buontalenti nel Memoriale di Girolamo Seriacopi," *Musica e Teatro: Quaderni degli amici della Scala* 11–12 (June–Oct., 1991).

11. The Camerata included poets (Ottavio Rinuccini, Giovanni Battista Strozzi), philologists such as Girolamo Mei, composers, musicians, and music

theorists (Giulio Caccini and Jacopo Peri). All of them, to varying degrees, participated in the creation of the Intermedi.

12. In the second volume of the *Trattati di musica* by Giovanni Battista Doni (Florence, 1763), one finds an essay by Giovanni de' Bardi, "Sopra la musica antica e il cantar bene" (see below, pp. 157, 165, and 362 n.26). On Doni, "the most important historian to consult regarding musical reform in Florence," see Romain Rolland, *Les Origines du théâtre lyrique moderne: Histoire de l'opéra en Europe avant Lully et Scarlatti* (1895; Geneva: Slatkine, 1971), p. 66, n.1.

13. Bastiano de' Rossi, *Descrizione del'apparato e degli Intermedi: Fatti per la Commedia rappresentata in Firenze: Nelle nozze de'Serenissimi don Ferdinando Medici, e Madama Cristina di Lorena Gran Duchi di Toscana* (Florence: Anton Padovani, 1589).

14. Warburg, "Theatrical Costumes for the Intermedi of 1589," p. 354.

15. On the development of the living spectacle in the culture of power in the sixteenth century, see Roy Strong, *Art and Power: Renaissance Festivals, 1450–1650* (Berkeley: University of California Press, 1984); and *Il Luogo teatrale a Firenze: Brunelleschi, Vasari, Buontalenti, Parigi*, preface by Ludovico Zorzi, exhibition catalog of the Museo Mediceo (Florence: Electa, 1975).

16. On this arrangement, see Robert Klein and Henri Zerner, "Vitruve et le théâtre de la Renaissance italienne," in Robert Klein, *La Forme et l'intelligible* (Paris: Gallimard, 1970), pp. 294–309, esp. pp. 304–309.

17. "It is a thin veil, finely woven, dyed whatever color pleases you, and with larger threads in the parallels you prefer. This veil I place between the eye and the thing seen, so the visual pyramid penetrates through the thinness of the veil." Leon Battista Alberti, *On Painting*, trans. John R. Spencer (New Haven, CT: Yale University Press, 1966), p. 68.

18. "Greek theater already contained, in embryonic form, the rudiments of the later forms of opposition between actor and spectator. Indeed, in it the orchestra was already partially cut off by the rectilinear platform of the 'stage.' And an ever-increasing tendency toward doubling and the opposition of these two elements was expressed in the fact that the action, starting from the orchestra, took place more and more on these platforms; the spectators then began to

invade the orchestra, which they transformed into 'the pit,' leaving but a simple band for the future orchestra pit and pressing themselves against the '*skena*' — henceforth parallel to the public.

"The placement of the stage parallel to the room certainly reflected their still more violent opposition (a wall set against another wall): this penchant is here expressed more clearly even than in the previous phase." "Du cinéma en relief," in François Albéra and Naoum Kleiman (eds.), *Le Mouvement de l'art* (Paris: Cerf, 1986), p. 113.

19. Filippo Baldinucci (d. 1696), "Vie de Bernardo Buontalenti," in *Notizie* (Florence, 1974), vol. 2, pp. 490–532, esp. pp. 493–94. On Buontalenti, also see Gherardo Silvani, *La vita del Signor Bernardo Buontalenti*, in *ibid.*, vol. 7, pp. 11–20.

20. Baldinucci, "Vie de Bernardo Buontalenti."

21. "If I wanted to mention here all the machines, chariots, triumphal arches, and other noble inventions perfected by Bernardo Buontalenti between 1585 and 1600, for comedies, jousts and tournaments, clown acts, masquerades, sports, banquets and royal festivities, magnificent state funerals and other sacred services, I would never be done." *Ibid.*, p. 516.

22. Aristotle, *Poetics* 6.1450b.20, ed. Jonathan Barnes (Princeton, NJ: Princeton University Press, 1984), vol. 2.

23.• Vasari went so far as to compare Buontalenti, as a scenographer, to Brunelleschi installing angels on strings in his church decorations. *Le vite de'più eccellenti pittori, scultori, ed architettori*, ed. Gaetano Milanesi, vol. 2, pp. 375ff.; vol. 3, pp. 198ff. (the text is not included in the English edition).

24. On Serlio and the representation of the stage, aside from the article by Klein and Zerner, see Hubert Damisch, "Suspended Representation," in *The Origin of Perspective* (Cambridge, MA: MIT, 1994), pp. 155–407.

25. "These effects best responded to the Baroque ideal of illusory perspectives to infinity and continuous change. The plastic and constructive elements of sixteenth-century stage sets, in which the horizon was encumbered by architecture, gave way to pictorial effects, with the backdrop becoming the main instrument for creating the illusion of space. Aerial perspective gradually replaced

linear geometry. The periaktoi, imperfect instruments in a set designed for rapid changes in the Intermedi, gave way to flat side wings, which were lighter and born of the same principle as the form open in the middle." Hélène Leclerc, "La Scène d'illusion et l'hégémonie du théâtre à l'italienne," in Guy Dumur (ed.), *Histoire des spectacles* (Paris: Gallimard, 1965), p. 598. Also see Hélène Leclerc, *Les Origines italiennes de l'architecture théâtrale moderne: L'Evolution des formes en Italie de la Renaissance à la fin du XVIIème siècle* (Paris: Droz, 1946). According to Saslow, *Medici Wedding of 1589*, p. 83, Buontalenti did not use periaktoi for the Intermedi, but only sliding wings.

26. Giovanni de' Bardi, in Doni, *Trattato della musica scenica*, ch. 4, in *Trattati de musica*, vol. 2, p. 16.

27. Buontalenti's studies are watercolors on paper, measuring about 57 cm by 47 cm, now in the Biblioteca Nazionale of Florence. The figures intended to serve as models for the characters in the representations measure about 27 cm for the most part.

28. "The model is something that has being for all eternity, while it, on the other hand, has been, is, and shall be for all time, forevermore. Such was the reason, then, such the god's design for the coming to be of time, that he brought into being the Sun, the Moon and five other stars, for the begetting of time. These are called 'the wanderers,' and they came to be in order to set limits to and stand guard over the numbers of time. When the god had finished making a body for each of them, he placed them into the orbits traced by the period of the Different — seven bodies in seven orbits." Plato, *Timaeus* 38, trans. Donald J. Zeyl, in *Plato, Complete Works* (Indianapolis: Hackett, 1997), p. 1242. Also see the cosmological deductions preceding it, as well as *Republic* 10.616, the myth of Er the Pamphylian, who describes the structure of the universe after returning from the land of the dead.

29. On the music of the Intermedi, see D.P. Walker (ed.), *Les Fêtes du mariage de Ferdinand de Médicis et de Christine de Lorraine — Florence 1589, I: La Musique de "La pellegrina"* (Paris: CNRS, 1963).

30. Rossi, *Descrizione del'apparato e degli Intermedi*, p. 33.

31. Baldinucci, "Vie de Bernardo Buontalenti," p. 517.

32. Ovid, *Metamorphoses* 5.294.

33. On how to make mountains emerge from beneath the stage, see Nicola Sabbatini, *Pratica di fabricar scene e macchine ne' teatri*, ed. Elena Povoledo (Rome: Bestetti, 1955), bk. 2, ch. 24. Sabbatini devotes the first book of his treatise on comedies to fixed sets, based on the principle of verisimilitude and using depth of field and perspective, and the second to the Intermedi, based on the mobility of the sets and supernatural special effects.

34. On gushing water represented by curling strips of cloth, see *ibid.*, bk. 2, chs. 35–36.

35. Rossi, *Descrizione del'apparato e degli Intermedi*, p. 35.

36. "[T]he scene . . . was basically and originally thought of as a *vision*; the chorus is the only 'reality' and generates the vision." Friedrich Nietzsche, *The Birth of Tragedy*, trans. Walter Kaufmann (New York: Vintage, 1967), no. 8, p. 65.

37. This, and the following passages, are from Warburg, "Theatrical Costumes for the Intermedi of 1589," pp. 376–79.

38. Warburg used, and wanted to reproduce, Serjacopi's *Ricordi e memorie* in the German edition of his study. A complete transcription is found in Matteini, "L'officina delle nuvole," pp. 174–249.

39. Serjacopi adds, "The above quotations being rather high, M. Valerio Cioli has been commissioned to do the work, which he will begin on 8 February." Warburg, "Theatrical Costumes for the Intermedi of 1589," p. 516.

40. Pollux, *Onomasticon* 4.84 (Leipzig: Teubner, 1900), pp. 225–26; Rossi, *Descrizione del'apparato e degli Intermedi*, pp. 42–48; Warburg, "Theatrical Costumes for the Intermedi of 1589," p. 397. A trace of this episode survives into the nineteenth century in the history of opera: "One might say that even Wagner wrote his *Pythicon* with the combat between the hero and the dragon Fafner." Rolland, *Origines du théâtre lyrique moderne*, p. 62, n.1. Also see Raphael-Georg Kiesewetter, *Schicksale und Beschaffenheit des weltlichen Gesanges, vom frühen Mittelalter bis zu der Erfindung des dramatischen Styles und den Anfängen der Oper* (Leipzig, 1841), pp. 34ff.

41. Rossi, *Descrizione del'apparato e degli Intermedi*, pp. 42–48.

42. On how to make hell appear, see Sabbatini, *Pratica di fabricar scene e macchine ne' teatri*, bk. 2, chs. 22–23.

43. Rossi, *Descrizione del'apparato e degli Intermedi*, p. 52.

44. "The Dinner of the Seven Wise Men," in *Plutarch's Moralia*, trans. Frank Cole Babbitt (Cambridge, MA: Harvard University Press, 1949–1976), vol. 2.

45. On Botticelli's Venus, see above, pp. 69–71. On how to depict dolphins, "which in swimming seem to breathe water," see Sabbatini, *Pratica di fabricar scene e macchine ne' teatri*, bk. 2, ch. 34. Chs. 28–34 are devoted to the representation of the ocean.

46. Rossi, *Descrizione del'apparato e degli Intermedi*, p. 72.

47. Saslow, *Medici Wedding of 1589*, pp. 158–60.

48. De' Bardi, in Doni, *Trattati di musica*, vol. 2, pp. 233–48.

49. Warburg, "Theatrical Costumes for the Intermedi of 1589," p. 369.

50. See Annamaria Testaverde Matteini, "Creatività e tradizione in una sartoria teatrale: L'abito scenico per le feste fiorentine del 1589," in Dora Liscia Bemporad (ed.), *Il costume nell'età del Rinascimento* (Florence: Edifir, 1988), pp. 170–81.

51. Warburg, "Theatrical Costumes for the Intermedi of 1589," p. 396.

52. *Ibid.*, p. 366.

53. *Ibid.*, p. 367; Rossi, *Descrizione del'apparato e degli Intermedi*, p. 40.

54. For Warburg's study on Maria Portinari, see above, pp. 124ff.; for the *Imprese amorose*, see Aby Warburg, "On *Imprese Amorose* in the Earliest Florentine Engravings" (1905), in *Renewal of Pagan Antiquity*, pp. 169–85; and for his taste in costumes and makeup, see above, n.9, and below, p. 333 n.10 and figs. 62 and 92.

55. See the reliefs by Agostino di Duccio for Alberti's Tempio Malatestiano (see below, p. 222).

56. On the relationship between the Intermedi and the trip to New Mexico and Arizona, see Kurt Forster, "Die Hamburg-Amerika-Linie oder: Warburgs Kunstwissenschaft zwischen den Kontinenten," in Horst Bredekamp, Michael Diers, and Charlotte Schoell-Glass (eds.), *Aby Warburg: Akten des internationalen Symposions, Hamburg, 1990* (Weinheim: VCH, 1991), pp. 11–38; and Philippe-Alain Michaud, "Florence in New Mexico: The Intermezzi of 1589 in the Light of Indian Rituals," *Photography at the Frontier: Aby Warburg in America*

1895–1896, eds. Benedetta Cestelli Guidi and Nicholas Mann (London: Warburg Institute, 1998), pp. 53–63.

CHAPTER FIVE: AMONG THE HOPI

1. In 1914, Freud noted that the Kreuzlingen clinic, directed by Ludwig Binswanger, the future founder of *Daseinsanalyse*, was one of the first public institutions open to psychoanalysis. "On the History of the Psychoanalytic Movement," *The Standard Edition of the Complete Psychological Works of Sigmund Freud*, ed. James Strachey (London: Hogarth Press, 1966), vol. 14, p. 34. On the effects of the war on Warburg's thought and the workings of the library, which he transformed into a sort of observatory of the conflict, see Michael Diers, "Kreuzlinger Passion," *Kritische Berichte* 4–5 (1979), pp. 5–14.

2. Warburg is alluding to the arrival of the Spartacists at the Warburg home in Hamburg. It is said that he welcomed them by offering them a drink. Ron Chernow, *The Warburgs* (New York: Random House, 1993), p. 209.

3. Cited by Karl Königseder, "Aby Warburg im Bellevue," in Robert Galitz and Brita Reimers (eds.), *Aby M. Warburg: "Ekstatische Nymphe — trauernder Flussgott": Portrait eines Gelehrten* (Hamburg: Dölling und Galitz, 1995), p. 84.

4. Ernst Gombrich, *Aby Warburg: An Intellectual Biography* (London: Warburg Institute, 1970), p. 110.

5. Aby Warburg, "On *Imprese Amorose* in the Earliest Florentine Engravings," in *The Renewal of Pagan Antiquity*, trans. David Britt (Los Angeles: Getty Research Institute, 1999), p. 176. In a lecture he gave in Rome in 1912 on the frescoes in the Palazzo Schifanoia, Warburg reworked the same theme, again with regard to Baccio Baldini's astrological calendar. Noting a change in style in the treatment of the female figure between the first edition (in 1465) and the second, Warburg wrote: "From the Burgundian cocoon springs the Florentine butterfly, the 'nymph,' decked in the winged headdress and fluttering skirts of the Greek maenad or of the Roman Victoria." "Italian Art and International Astrology in the Palazzo Schifanoia," in *ibid.*, p. 585.

6. Ludwig Binswanger to Sigmund Freud, Nov. 8, 1921, cited in Königseder, "Aby W. im Bellevue," pp. 85–86. For the *Luther*, see Warburg, *Gesammelte*

Schriften, ed. Bernhard Buschendorf and Claudia Naber (Berlin: Akademie, forthcoming), pp. 199–299.

7. Aby Warburg, "Bilder aus dem Gebiet der Pueblo-Indianer in Nord Amerika," in *Schlangenritual: Ein Reisebericht*, ed. Ulrich Raulff (Berlin: Wagenbach, 1988). Established by Fritz Saxl and Gertrud Bing, the text is based on the sketches and projects Warburg sent them from Kreuzlingen. The lecture was published for the first time in English in the *Journal of the Warburg Institute* in 1938–1939, vol. 2, pp. 277–90, in an abridged form. An American edition of the lecture appeared in 1995, *Images from the Region of the Pueblo Indians of North America*, trans. Michael P. Steinberg (Ithaca, NY: Cornell University Press), with a postface by Steinberg (pp. 59–114), who brings in much unpublished material and develops an interpretation of the lecture — a questionable one — based on Warburg's assimilation of Hopi culture and Judaism.

8. James Loeb, lover of Greek art and a student of Bernard Berenson's at Harvard, appeared as an enigmatic double to Warburg. Co-founder of the Institute of Musical Art (the future Juilliard School of Music) in 1905 and of the Loeb Classical Library in 1910, he financed, starting in 1920, the German Institute for Psychiatric Research in Munich. From 1905 on, he lived in Germany, where his fragile health (he was an epileptic) often forced him to stay in sanatoriums. See Chernow, *Warburgs*, pp. 77–80. On the history of the Warburg family, see *ibid.*, esp. pp. 35–206 for the period concerning Aby.

9. Gombrich, *Aby Warburg*, p. 130.

10. *Ibid.*, p. 114.

11. See below, Appendix 3.

12. Cyrus Adler was the librarian of the Smithsonian Institution. Warburg had conversations with Frank Hamilton Cushing on the meaning and the function of ornamentation; from Cushing he obtained firsthand information on the lifestyle of Native Americans. James Mooney told him about the snake dance among the Pueblos of New Mexico. Last, Frederick Webb Hodge is the author of the monumental *Handbook of American Indians North of Mexico* (Washington, DC: Government Printing Office, 1907–1910).

The last great cholera epidemic in Europe was in 1892.

13. See below, Appendix 4.

14. Cited by Alison Griffiths, "'Journeys for Those Who Can Not Travel': Promenade Cinema and the Museum Life Group," *Wide Angle* 18.3 (July 1996), pp. 64–65. I thank Ken Jacobs for pointing out this text to me. The displays designed by Boas still exist.

15. Franz Boas, "Address at the International Congress of Arts and Sciences," St. Louis, Sept. 1904, cited in George W. Stocking Jr. (ed.), *A Franz Boas Reader: The Shaping of American Anthropology 1883–1911* (Chicago: University of Chicago Press, 1989), pp. 23ff.

16. See Appendix 3 above p. 293. Also see Claudia Naber, "Pompeji in Neu-Mexiko: Aby Warburgs amerikanische Reise," *Freibeuter* 38 (1988), pp. 88–97; and Salvatore Settis, "Kunstgeschichte als vergleichende Kulturwissenschaft: Aby Warburg, die Pueblo-Indianer und das Nachleben der Antike," in *Kunsthistorisches Austausch — Akten des XVIII internationalen Kongresses für Kunstgeschichte*, Berlin, July 1992, pp. 139–58.

17. Aby Warburg, "The Theatrical Costumes for the Intermedi of 1589," in *Renewal of Pagan Antiquity*, p. 350.

18. See above, pp. 110–111.

19. Frank McNitt, *Richard Wetherill: Anasazi, Pioneer Explorer of the Southwestern Ruins* (1957; Albuquerque: University of New Mexico Press, 1995), p. 347. Most of the objects discovered by Wetherill are now in the University of Pennsylvania Museum, the Colorado State Museum in Denver, and the National Museum of Helsinki.

20. Cited by Naber, "Pompeji in Neu-Mexiko," p. 91.

21. See above, pp. 158–59.

22. An exhibition of the photographs Warburg took in America was held in Hamburg, in the former Kunstwissenschaftliche Bibliothek Warburg, by Nicholas Mann and Benedetta Cestelli Guidi. See Benedetta Cestelli Guidi and Nicholas Mann (eds.), *Photographs at the Frontier, Aby Warburg in America, 1895–1896* (London: Warburg Institute, 1998).

From Timothy H. O'Sullivan and John K. Hillers in the 1870s to Adam Clark Vroman and, of course, Edward S. Curtis at the beginning of the twentieth

century, photographs were taken in the Pueblo region focusing on artistic or anthropological motifs. In the Warburg Institute Archive, one finds, under files 47.2.4.1, 47.3.2, 48.12, and 48.13, a series of photographs in circular format (probably made with a Kodak no. 2 snapshot camera, commercialized in 1890) that the Reverend Henry R. Voth, from Keams Canyon, sent to Warburg after his return to New York. Another group of these photos, depicting Pueblo ceremonies, was published in two works by Voth: *The Oraibi Powamu Ceremony* and *The Mishongnovi Ceremonies of the Snake and Antelope Fraternities* (Chicago: Field Columbian Museum, 1901 and 1902). Voth, one of the foremost experts on Hopi culture and ritual, was largely responsible for the creation of the collection in the Field Columbian Museum.

Warburg's photo-journalizing was also part of the rising trend in amateur photography, which took off in the 1890s. According to his lecture on January 21, 1897, at the Gesellschaft zur Förderung der Amateur-Photographie (Society for the Development of Amateur Photography) in Hamburg, Aby used a "Kodak Box Camera," one of the first cameras commercially mass-produced by Kodak. On the beginnings of amateur photography, see Michel Frizot (ed.), *A New History of Photography* (Cologne: Könemann, 1988); and on its relation to Native American ethnology, see Paula Richardson Fleming and Judith Luskey, *The North American Indians in Early Photographs* (New York: Barnes and Noble, 1992), pp. 138–46.

23. Naber, "Pompeji in Neu-Mexiko," p. 95.

24. One might look for the origin of this transposition in Gustaf Nordenskiöld's book, which devotes a long chapter to the civilization of the Pueblos in the sixteenth century: "The Pueblo Tribes in the Sixteenth Century," in *Cliff-Dwellers of the Mesa Verde, Southwestern Colorado* (Stockholm: Norstedt, 1893), pp. 144–46.

25. Naber, "Pompeji in Neu-Mexiko," pp. 88–89.

26. Fritz Saxl, "Warburg's Visit to New Mexico" (1929–1930), in *Lectures* (London: Warburg Institute, 1957), vol. 1, p. 327. See Maria Sassi, "Dalla scienza delle religioni di Usener ad Aby Warburg," in Arnaldo Momigliano (ed.), *Aspetti di Hermann Usener, filologo della religione* (Pisa: Giardini, 1982), pp. 65–91.

Usener's influence, if one agrees with the importance Saxl grants to the New Mexican experience in Warburg's thought, bears directly on that of the theorists of knowledge (Adolf Bastian, Tito Vignoli ...) to whom Gombrich, in his biography, grants an importance I find exaggerated. In an article published in 1902 in the *Hessischer Blätter für Volkskunde*, Usener went so far as to compare the figures in Greek comedies to the ritual dancers in Zuni and Hopi ceremonies. Cited by Peter Burke, "History and Anthropology in 1900," in Guidi and Mann, *Photographs at the Frontier*, p. 26.

27. See below, Appendix 3. Warburg did not want his lecture to be published, as he noted in an April 6, 1923, letter, cited in Warburg, *Schlangenritual*, p. 60.

28. Warburg, *Images from the Region of the Pueblo Indians*, p. 2.

29. Emil Schmidt, *Vorgeschichte Nordamerikas im Gebiet der Vereinigten Staaten* (Brunswick, 1894), pp. 179ff., cited in Warburg, *Images from the Region of the Pueblo Indians*, p. 4. The copy of Schmidt's book in the London institute has a note in Warburg's hand, written in Santa Fe, which shows that he took Schmidt's book along with him. The passage he cited in his lecture is the only one underlined in the whole book.

30. In the southwest of the region explored by Warburg, the Painted Desert stretched all along the railroad lines. See the map reproduced above, figure 63.

31. Carl Georg Heise, *Persönliche Erinnerungen an Aby Warburg* (New York, 1947), p. 15.

32. Nordenskiöld, *Cliff-Dwellers of the Mesa Verde*, p. 10.

33. Wilhelm Jenson, *Gradiva, a Pompeiian Fancy*, in Sigmund Freud, *Delusion and Dream*, trans. Helen Downey (New York: Moffat, Yard, and Company, 1917).

34. Philippe Morel, *Les Grottes maniéristes en Italie au XVIe siècle* (Paris: Macula, 1998).

35. Warburg used the German spelling, *kiwa*.

36. Warburg, *Images from the Region of the Pueblo Indians*, p. 10.

37. *Ibid.*, p. 9. *Estufa* (sweating room) is the Spanish name for kiva, named for the fires that burn there.

38. *Ibid.*, p. 13.

39. One imagines that the halting rhythm of the lecture and the abrupt shifts in the chain of ideas followed the sequences of photographs. In the succession of images that appeared one after the other and immediately disappeared in short-lived returns of memory, one detects a sort of hypnotic state that might also echo the preparatory phase of the lecture. Warburg indicated in the margins of his notes that they were drafted under the influence of opium (see Appendix 3).

40. Warburg, *Images from the Region of the Pueblo Indians*, p. 14. Traces of this episode can be found in the great study Warburg published in 1912, "Italian Art and International Astrology in the Palazzo Schifanoia," in *Renewal of Pagan Antiquity*, pp. 563–93.

41. Warburg, *Images from the Region of the Pueblo Indians*, p. 15.

42. See above, p. 102.

43. "[Black Mesa] rises out of the Painted Desert more than seven thousand feet.... It takes its name from the seams of coal exposed in its towering cliffs, but its colors are the grays and greens of sage, rabbit brush, and the dark green of creosote brush, mesquite, pinon, and (in a few places where springs flow) pine and spruce." Tony Hillerman, *The Dark Wind* (Thorndike, ME: Thorndike, 1982), pp. 167–68.

44. Warburg, *Images from the Region of the Pueblo Indians*, p. 11.

45. See above, pp. 120–21.

46. In chapter 179 of the *Libro dell'arte*, Cennino Cennini mentioned a practice characterized by the same distinction between figures in paintings, painted men, and doll mannequins: "This chapter introduces us to an unusual custom of the times, that of painting human faces not only with tempera but also with oil paint and varnish," notes Giuseppe Tambroni (Cennini's nineteenth-century Italian editor), cited by Colette Déroche, *Le Livre de l'art* (Paris: Berger-Levrault, 1991), p. 320.

This introduction of bodies into the representation, with all its funerary and soteriological connotations, culminates, in Cennini's text, in the chapter on wax self-portrait: "You can also mold your person in the following manner: Prepare a quantity of clay or wax, well mixed and clean; knead like a supple unguent; and spread over a large table, such as a kitchen table. Then put it on the floor, creat-

ing a thickness of a half-arm's length. Then lie on top of it, either on the front or back, or on your side. And if this clay or wax receives you well, remove yourself from it carefully, evenly, without moving to the left or right" (pp. 334ff).

In Warburg's conception of the imitative magic of the Pueblo Indians in 1923, one recognizes the influence of *Totem and Taboo*, Freud's 1913 essay (and furthermore inspired by James Frazer), to which Warburg certainly had access in the Kreuzlingen sanatorium. See in particular "Animism, Magic, and the Omnipotence of Thoughts," in *Totem and Taboo, Standard Edition* (1966), vol. 13, pp. 75–100. Warburg began to collect Freud's works for his library at the beginning of the twentieth century.

47. Warburg, *Images from the Region of the Pueblo Indians*, p. 6. Commenting on a photo he had taken of kachinas, Warburg remarked that a broom was hung right in the midst of the dolls, an emblem of modernity and a symbol of the disappearance of Native American cultures. The analysis of contradictions found within the representations leads to a method based on a technique of montage in the picture plane.

48. See above, p. 148.

49. Bastiano de' Rossi, *Descrizione del'apparato e degli Intermedi: Fatti per la Commedia rappresentata in Firenze: Nelle nozze de'Serenissimi don Ferdinando Medici, e Madama Cristina di Lorena Gran Duchi di Toscana* (Florence: Anton Padovani, 1589), p. 40. See above, pp. 165–68.

50. For a comparison of the prophylactic nature of bells and percussive sounds in Greek Antiquity, see A.B. Cook, "The Gong of Dodona," *Journal of Hellenistic Studies* 22 (1902), p. 5.

51. Warburg, *Images from the Region of the Pueblo Indians*, p. 27.

52. Elias Canetti, *Crowds and Power*, trans. Carol Stewart (New York: The Viking Press, 1963), p. 135: "The rain dances are increase dances intended to procure rainfall. They, as it were, stamp the rain up out of the ground. The pounding of the dancers' feet is like the fall of rain. They go on dancing through the rain if it begins during the performance. The dance which represents rain finally becomes it. Through rhythmic movement a group of about forty people transforms itself into rain."

53. Warburg, *Images from the Region of the Pueblo Indians*, p. 34.

54. On the *chiffonetti*, another major group of clown dancers, identifiable by the horizontal black and white stripes with which they are covered and by the two tufts of hair gathered on either side of their heads with cornstalks, see Virginia More Roediger, *Ceremonial Costumes of the Pueblo Indians* (1941; Berkeley: University of California Press, 1991), pp. 228–34.

55. Jesse Walter Fewkes, "Tusayan Katcinas," *Annual Report of the Bureau of Ethnology, 1893–1894* (Washington, DC: Smithsonian Institution, 1897), p. 294.

56. Warburg, *Images from the Region of the Pueblo Indians*, p. 17. Also see above, pp. 184–85, and fig. 65.

57. Friedrich Nietzsche, *The Birth of Tragedy*, trans. Walter Kaufmann (New York: Vintage, 1967), no. 8, p. 62.

58. *Ibid.*, no. 9, p. 67.

59. *Journal of the Royal Anthropological Institute* 68, reprinted in Marcel Mauss, *Sociologie et anthropologie* (Paris: PUF, 1950), pp. 331–62. Mauss notes (p. 337) that his studies on the notion of personhood originated in the study of ritual ceremonies among the Pueblo Indians.

60. Raymond Bloch, "Etrurie, Rome, et monde romain," *Le Masque*, exhibition catalog, Musée Guimet (Paris, 1960), p. 80.

61. Mauss, *Sociologie et anthropologie*, pp. 353–54. Faced with the burlesque and morbid *phersu*, the chained slave appears to illustrate the precept "*Servus non habet personam*": he is deprived of personality and even the possession of his own body.

62. Jacob Burckhardt, *Beiträge zur Kunstgeschichte von Italien* (Basel, 1898), p. 351.

63. Aby Warburg, "Dürer and Italian Antiquity," in *Renewal of Pagan Antiquity*, p. 558.

64. According to Salvatore Settis, the concept of the pathetic formula elaborated by Warburg is based on a tension between the *Pathos*, which designates a transitory movement of affection, and the form in which it is inscribed, which presupposes duration. The *Pathosformeln* thus designate the repertory of figures capable of accounting for the appearance of a body in search of its own modifi-

cations. This repertory designates both the way in which Renaissance artists interpreted models of Antiquity and the way in which historians of modern art —and Warburg in particular—sought to elucidate the mechanisms of this transmission. "Pathos und Ethos, Morphologie und Funktion," in *Vorträge aus dem Warburg-Haus* (Berlin: Akademie, 1997), vol. 1, pp. 31–73, esp. pp. 40–41.

On Apollo and Python in the third Intermedio, see above, pp. 159–62.

65. "The Snake Ceremonials at Walpi," *A Journal of American Ethnology and Archeology*, vol. 4 (Boston: Houghton Mifflin, 1894). In that text, Fewkes describes the ritual he witnessed in Walpi in 1891. He devoted another text to a comparative study of the serpent ritual in Cipaulovi and Oraibi. "Tusayan Snake Ceremonies," in the *Annual Report of the Bureau of Ethnology* (Washington, DC: Smithsonian Institution, 1897), pp. 273–312, is based on his research in 1894–1895. It is to this text that most commentators on Warburg refer. Eleven years after Fewkes, in 1902, a cameraman from the Edison Company, James H. White, filmed the successive phases of the serpent ritual in Arizona, in a series of very short documents made almost indecipherable by the distance of the camera: *Parade of the Snake Dancers Before the Dance* (42″), *The March of Prayer and the Entrance of the Dancers* (1′26″), *Lineup and Teasing of the Snakes* (1′10″), *Carrying the Snakes* (58″). Copies in the Library of Congress, Washington, DC. In 1903, Edward S. Curtis filmed the ritual, actually taking part in the dance: he shot in the piazza, in the middle of the dancers.

Voth simultaneously describes the rituals he witnessed in Oraibi in 1896, 1898, and 1900. In *Sun Chief*, Don C. Talayesva describes the presence of Voth in Oraibi, on the occasion of the serpent ceremony of 1912, in very hostile terms: "The land was very dry, the crops suffered, and even the Snake dance failed to bring much rain. We tried to discover the reason for our plight, and remembered the Rev. Voth who had stolen so many of our ceremonial secrets and had even carried off sacred images and altars to equip a museum and become a rich man. When he had worked here in my boyhood, the Hopi were afraid of him and dared not lay their hands on him or any other missionary, lest they be jailed by the Whites. During the ceremonies this wicked man would force his way into the kiva and write down everything that he saw. He wore shoes with solid heels,

and when the Hopi tried to put him out of the kiva he would kick them. He came back to Oraibi on a visit and took down many more names. Now I was grown, educated in the Whites' school, and had no fear of this man. When I heard that he was in my mother's house I went over and told him to get out. I said, 'You break the commandments of your own God. He had ordered you never to steal or to have any other gods before him. He has told you to avoid all graven images; but you have stolen ours and set them up in your museum. This makes you a thief and an idolator who can never go to heaven.' I knew the Hopi Cloud People despised this man, and even though he was now old and wore a long beard, I had a strong desire to seize him by the collar and kick him off the mesa." Don C. Talayesva, *Sun Chief*, ed. Leo W. Simmons (New Haven, CT: Yale University Press, 1942), p. 252.

Warburg might also have used the work by George Wharton James, *The Mokis and Their Snake Dance* (1898), and a charming little book by Walter Hough, *The Moki Snake Dance* (1898), where the photographs of Wharton James, Hillers, Vroman, and Voth were published. Both were found in the Warburg Library.

66. Henry R. Voth, *The Oraibi Summer Snake Ceremony* (Chicago: Field Columbian Museum, 1903), p. 280.

67. *Ibid.*, pp. 341–42.

68. Fewkes, "Tusayan Katcinas," pp. 61ff.

69. Voth, *Oraibi Summer Snake Ceremony*, p. 340.

70. *Ibid.*, p. 346.

71. Fewkes, "The Snake Ceremonies at Walpi," p. 87.

72. As shown in the photographs taken by Voth during the rituals of 1896, 1898, and 1900, the snakes were seized by the neck, without their heads entering the dancers' mouths. Voth wrote: "I have there seen dancers hold two, three, and on occasion even four snakes at one time between the teeth, the reptiles intertwining into a ball as it were in front of the dancer's mouth. On one occasion I saw a snake that was held about midway of its length trying to get into the ears and nose of the dancer; several times I noticed a man having stuffed a small snake into his mouth entirely, the head of the reptile only protruding from between his lips." Voth, *Oraibi Summer Snake Ceremony*, p. 346, n.2.

73. *Ibid.*, p. 348.

74. Friedrich Nietzsche, *Thus Spoke Zarathustra*, trans. Walter Kaufmann (New York: Penguin, 1954), pt. 3, ch. 2, "On the Vision and the Riddle," pp. 159–60.

75. Leon Battista Alberti, *On Painting*, trans. John R. Spencer (New Haven, CT: Yale University Press, 1966), p. 81. On the serpentine form in the Renaissance, see David Summers, "The Figora Serpentinata," *The Art Quarterly* 35.3 (1972), pp. 269–301.

76. Friedrich Nietzsche, *Introduction aux leçons sur l'Oedipe-Roi de Sophocle* (1870), trans. Françoise Dastur and Michael Haar (Paris: Encre Marine, 1994), pp. 37–38.

77. William H. Goetzmann, *The First Americans: Photographs from the Library of Congress* (Washington, DC: Starwood, 1991), p. 112. Mauss referred to the kachina dance in 1938, still full of life at the end of the nineteenth century in his opinion, as a spectacle now reserved for tourists. "Une Catégorie de l'esprit humain: La Notion de personne, celle de 'moi,'" in *Sociologie et anthropologie*, p. 339. On the disappearance of the ritual, see Leah Zilworth, *Imagining Indians in the Southwest: Persistent Visions of a Primitive Past* (Washington, DC: Smithsonian Institution, 1996), pp. 21–77.

78. Warburg, *Images from the Region of the Pueblo Indians*, p. 50. In his journal, on September 9, 1929, Warburg spoke of the mercury column showing the approach of a storm as a weapon against the fear of Satan. Gombrich, *Aby Warburg: An Intellectual Biography*, p. 302.

79. At this point, art history as invented by Warburg became an analysis of modernity (understood as negativity): it would find its extension in the phenomenology of surfaces and the theories of disenchantment developed simultaneously by Walter Benjamin and Siegfried Kracauer. In this regard, the correspondence between Panofsky and Kracauer reveals that the latter, during the 1930s and 1940s, at the time of his immigration to New York and his elaboration of his *Theory of Film*, had explicitly formulated the project of creating a junction between the Institut für sozial Forschung (Frankfurt School) and the Warburg Institute. He therefore appeared, from the point of view of the analysis

of contemporaneity, as the most consistent of Warburg's followers. See *Siegfried Kracauer – Erwin Panofsky: Briefwechsel, 1941–1966*, ed. Volker Breidecker (Berlin: Akademie, 1996).

80. Warburg, *Images from the Region of the Pueblo Indians*, p. 54.

CHAPTER SIX: HAMBURG: THE ART HISTORY SCENE

1. Fritz Saxl, "The History of Warburg's Library (1886–1944)," in Ernst Gombrich, *Aby Warburg: An Intellectual Biography* (London: Warburg Institute, 1970), p. 327. On this point, see the fundamental article by Salvatore Settis, "Warburg *continuatus*: Description d'une bibliothèque," in Marc Baratin and Christian Jacob (eds.), *Le Pouvoir des bibliothèques: La Mémoire des livres en Occident* (Paris: Albin Michel, 1996), pp. 122–69. On the configuration and meaning of the library, see Martin Jesinghausen-Lauster, *Die Suche nach der symbolischen Form: Der Kreis um die Kulturwissenschaftliche Bibliothek Warburg* (Baden-Baden: Valentin Koerner, 1985), who considers the library a symbolic structure in which each element, each arrangement, is charged with philosophical or occult meaning.

Tilmann von Stockhausen disagrees with this interpretation. He minutely reconstructs the genesis of the library, which he imagines as a rational process integrating the most recent and sophisticated technological advances: concrete structure, internal system of communication, electrical transmissions, projection systems. *Die Kulturwissenschaftliche Bibliothek Warburg – Architektur, Einrichtung, und Organisation* (Hamburg: Dölling und Galitz, 1992), esp. p. 26.

Also see Hermann Hipp, "Strebende und tragende Kräfte: Die Fassade der K.B.W.," in *Porträt aus Büchern* (Hamburg: Dölling und Galitz, 1993). This essay puts the construction of the library into the context of contemporary German architecture.

2. Fritz Saxl, "Der Kulturwissenschaftliche Bibliothek in Hamburg," in Ludolph Brauer et al. (eds.), *Forschungsinstitute – ihre Geschichte, Organisation, und Ziele* (1930; Vaduz/Liechtenstein: Topos Verlag, 1980), vol. 2, pp. 355–58.

3. *Mnemosyne: Beiträge zum 50: Todestag von Aby M. Warburg* (Göttingen: Gratia, 1979), pp. 16–17. In 1933, a former student of Warburg's, Werner Kaegi,

described the strange impression Warburg made on him when he first encountered him in Kreuzlingen, in autumn 1921. The student was returning from a course of study in Florence and was visiting a friend. Walking one morning in the sanatorium park, he saw "a small human form [*eine kleine männliche Gestalt*]" coming toward him: "He was surprisingly small, of a robust and healthy constitution, with the features of his face giving a mixed impression of suffering, struggle, violent constraint, and a magical will to power precipitated in marble." Werner Kaegi, "Das Werk Aby Warburgs," *Neue schweizer Rundschau* (1933), notebook 5, pp. 283–93.

4. Ernst Cassirer, "The Subject-Object Problem in the Philosophy of the Renaissance," in *The Individual and the Cosmos in Renaissance Philosophy,* trans. Mario Domandi (New York: Harper & Row, 1963), p. 127. One might consider, alongside *The Individual and the Cosmos*, another important text in the tradition of Warburg, Raymond Klibansky, Erwin Panofsky, and Fritz Saxl's *Saturn and Melancholy* (London: Nelson, 1964), as a portrait based on the founder of the Kunstwissenschaftliche Bibliothek (who is, curiously enough, cited but marginally).

5. Aby Warburg, *Images from the Region of the Pueblo Indians of North America*, trans. Michael P. Steinberg (Ithaca, NY: Cornell University Press, 1995), p. 2.

6. Cited by Gombrich, *Aby Warburg: An Intellectual Biography*, p. 91.

7. *Ibid.*, p. 138.

8. Recounted in *ibid.*, p. 46.

9. Cited by Stockhausen, *Kulturwissenschaftliche Bibliothek Warburg*, p. 51.

10. *Ibid.*, p. 154.

11. Saxl, "The History of Warburg's Library," p. 329.

12. "The masked dance is danced causality," Warburg wrote in the notes to his lecture, in very Maussian terms; see *Images from the Region of the Pueblo Indians*, p. 48. Also see Jesinghausen-Lauster, *Die Suche nach der symbolischen Form*; and Stockhausen, *Kulturwissenschaftliche Bibliothek Warburg*, pp. 36ff.

13. Carl Georg Heise, *Persönliche Erinnerungen an Aby Warburg* (New York, 1947), p. 50.

14. Warburg, *Ausgewählte Schriften und Würdigungen*, p. 592, no. 99. The text was published in Italian in Milan in 1971 in the only issue of *Adelphiana* (reprinted in *Aut aut* 199–200 [1984], pp. 46–49). One might see this strange phrase as a displacement of the "wave" theory (*Wellentheorie*) of the neo-grammarian Johannes Schmidt (*Die Verwandtschaftsverhältnisse der indogermanischen Sprachen* [Weimar, 1872]), according to which the transformation of a linguistic module occurs not, as his great predecessor August Schleicher claimed, in a family-tree-like pattern (*Stammbautheorie*) but in successive waves that evolve from the center of the system and spread out to its peripheries. On the relationship between Warburg and the German school of neo-grammarians, see Omar Calabrese, "Geografia di Warburg: Note su linguistica e iconologia," *Aut aut* 199–200 (1984), p. 113.

15. On Fino, see Charles Andler, *Nietzsche: Sa Vie et sa pensée* (Paris: Gallimard, 1958), vol. 2, p. 676. On dolphins in the Intemedi of 1589, see above, p. 163. In his *Leçons sur l'hystérie virile*, published in 1859 (Paris: Le Sycomore, 1984), Charcot described the attacks of one of his patients, who was fifty-six years old and employed by the railroad, in terms reminiscent of the Turin episode: "The hysterical attack is seen here in the no less typical form of vertigo, with loss of consciousness preceded by an evolution of phenomena characteristic of *aura*: 'The noises coming from the streets, a cry, the sound of a whip bring on my attacks,' he said, '. . . I'm forced to lean against a wall. Sometimes I've even lost consciousness for a few seconds, and this happened, in particular, the other day on rue La Fayette following an emotion I felt when a horse fell. It was impossible for me to return home without the help of a friend accompanying me'" (p. 188).

16. Cited by Gombrich, *Aby Warburg: An Intellectual Biography*, p. 303.

17. See Sigmund Freud, "Mourning and Melancholia," *The Standard Edition of the Complete Psychological Works of Sigmund Freud*, ed. James Strachey (London: Hogarth Press, 1966), vol. 14, pp. 237–59; and Ludwig Binswanger, *Melancholie und Manie; phänomenologische Studien* (Pfullingen: Neske, 1960).

18. Saxl, "Warburg Besuch in Neu Mexico," in Warburg, *Ausgewählte Schriften und Würdigungen*, p. 319.

19. *Grundlegende Bruchstücke zu einer pragmatischen Ausdrückskunde* (unpublished), Feb. 11, 1889.

20. Warburg, *Ausgewählte Schriften und Würdigungen*, p. 592, nos. 102–107. At the time of Warburg's death, in 1929, the atlas, which remained incomplete, included several dozen panels, on which about one thousand photographs were attached. Aside from Martin Warnke and Claudia Brink (eds.) (Berlin: Akademie, 2000), see Marianne Koos et al., eds., *Begleitmaterial zur Ausstellung "Aby M. Warburg, Mnemosyne"* (Hamburg: Dölling und Galitz, 1994). Also see the fine study by Giorgio Agamben, "Aby Warburg and the Nameless Science," in *Potentialities: Collected Essays in Philosophy*, trans. Daniel Heller-Roazen (Stanford, CA: University Press, 1999); Roland Kany, *Mnemosyne als Programm: Geschichte, Erinnerung und die Anadacht zum Unbedeutenden im Werk von usener, Warburg und Benjamin* (Tübingen: Niemeyer, 1987). Dorothée Bauerle, *Gespenstergeschichten für ganz Erwachsene: Ein Kommentar zu Aby Warburgs Bilderatlas Mnemosyne* (Münster: Lit, 1988); and Gombrich, *Aby Warburg: An Intellectual Biography*, p. 283–306.

21. Cited by Gombrich, *Aby Warburg: An Intellectual Biography*, p. 302.

22. Warburg, *Images from the Region of the Pueblo Indians*, pp. 7–8.

23. See above, pp. 30 and 68ff.

24. See above, p. 115.

25. Gombrich, *Aby Warburg: An Intellectual Biography*, p. 287.

26. These panels are found in *Begleitmaterial zur Ausstellung "Aby M. Warburg, Mnemosyne"*; see p. 235, n.1.

27. On the *Pathosformeln*, see Salvatore Settis, "Pathos und Ethos, Morphologie und Funktion," in *Vorträge aus dem Warburg-Haus* (Berlin: Akademie, 1997), vol. 1, pp. 31–73.

28. Warburg used the phrase in his 1929 journal. Cited by Gombrich, *Aby Warburg: An Intellectual Biography*, p. 253.

29. Ulrich Raulff, "Zur Korrespondenz Ludwig Binswanger — Aby Warburg im Universitätsarchiv Tübingen," in Horst Bredekamp, Michael Diers, and Charlotte Schoell-Glass (eds.), *Aby Warburg, Akten des internationalen Symposions, Hamburg, 1990* (Weinheim: VCH, 1991), p. 66.

30. The Warburg family had interests in the HAPAG shipping company, which has since become an aviation firm, whose planes can be seen at the Hamburg airport. *Mnemosyne*, p. 77.

31. Warburg, *Images from the Region of the Pueblo Indians*, p. 30.

32. *Ibid.*, p. 64.

33. These drawings, now in the Hamburger Völkerkunde Museum (see Warburg, *Ausgewählte Schriften und Würdigungen*, p. 319), were part of an exhibition of children's drawings, *Das Kind als Künstler*, organized at the Hamburg Kunsthalle in 1898. The preface to the catalog reproduced Warburg's explanatory remarks, which he had sent from Florence to accompany the presentation of the drawings: "They demonstrate a remarkable memory for forms, a fertile imagination, an intelligence for motifs in motion, and remarkably fine expressive characteristics. On an ethnological plane, it is interesting to note that some of the children drew lightning in the shape of an arrow or snake with a pointed, arrow-shaped head, and clouds in the systematic manner in which their tribes depict them, even today, in the sand paintings in the underground rooms in which they gather" (p. 2).

34. Heise, *Persönliche Erinnerungen an Aby Warburg*, pp. 32–33.

35. See above, pp. 194–97.

36. See below, Appendix 3.

37. Heise, *Persönliche Erinnerungen an Aby Warburg*, p. 50.

APPENDIX ONE: *ZWISCHENREICH*

This text is a revised version of a lecture given at the Ecole normale supérieure in January 1999 for the conference "Aby Warburg and the Anthropology of Images," organized by Giovanni Careri and Carlo Severi. It was published in *Les Cahiers du Musée national d'art moderne* 70 (Winter 1999–2000).

1. There are three different versions of the atlas, as well as Warburg's notes on the project, at the Warburg Institute. See Peter van Huisstede, "Der Mnemosyne-Atlas: Ein Laboratorium der Bildgeschichte," in Robert Galitz and Brita Reimers (eds.), *Aby M. Warburg: "Ekstatische Nymphe — trauernder Flussgott": Portrait eines Gelehrten* (Hamburg: Dölling und Galitz, 1995), pp. 130–71; and Clau-

dia Naber, "Heuernte bei Gewitter: Aby Warburg, 1924–1929," in *ibid.*, pp. 104–29.

2. Ernst Gombrich, *Aby Warburg: An Intellectual Biography* (London: Warburg Institute, 1970), p. 253.

3. *Ibid.*, p. 284. Van Huisstede (in "Mnemosyne, Atlas," p. 168, n.1) notes that he has found no trace of Saxl's participation in the *Mnemosyne* project in the Warburg Institute Archive.

4. See the album of photographs taken in the American West edited by Benedetta Cestelli Guidi and Nicholas Mann, *Photographs at the Frontier: Aby Warburg in America, 1895–1896* (London: Warburg Institute, 1998).

5. On Warburg's time in the clinic directed by Ludwig Binswanger, see Karl Königseder, "Aby Warburg im Bellevue," in Galitz and Reimers, *Aby M. Warburg: Portrait eines Gelehrten*, pp. 74–98. Kurt Forster goes so far as to sketch a parallel between the structure of the Hopi altars and that of the panels of *Mnemosyne*: "The atlas was, to a certain extent, clearly an instrument of conjuration, and as such its panels, with their carefully arranged objects, share many traits with the Hopi ceremonial altars. Although they are worlds apart, both the altar and the atlas present *attempts at order* — attempts to present, by means of specific objects, the greatest 'energetic' relations that govern the world." (Kurt Forster, "Warburgs Versunkenheit," in Galitz and Reimers, *Aby M. Warburg: Portrait eines Gelehrten*, p. 200.)

6. See Appendix 3, p. 314.

7. Sigmund Freud, "Totem and Taboo," *The Standard Edition of the Complete Psychological Works of Sigmund Freud*, ed. James Strachey (London: Hogarth Press, 1966), vol. 13, p. 1.

8. Fritz Saxl, "Warburg's Visit to New Mexico" (1929–1930), in *Lectures* (London: Warburg Institute, 1957), vol. 1, p. 327.

9. Werner Hofmann, "Der Mnemosyne-Atlas: Zu Warburgs Konstellationen," in Galitz and Reimers, *Aby M. Warburg: Portrait eines Gelehrten*, pp. 172–83.

10. Martin Warnke challenged Gombrich's idea that, inspired by Semon's theory of memory, Warburg sought to give his theory of memory a biological foundation (see Martin Warnke, "Vier Stichworte: Ikonologie, Pathosformel,

Polarität und Ausgleich, Schlagbilder und Bilderfahrzuge," in Werner Hofmann, Georg Syamken, and Martin Warnke (eds.), *Die Menschenrechte des Auges: Über Aby Warburg* (Frankfurt: Europäische Verlagsanstalt, 1980).

11. The magic nature of the theme of resurgence is balanced by the implicit criticism of the fetishism of the original suggested in the use of photographic reproductions (See Hofmann, "Mnemosyne-Atlas," pp. 172–73).

12. One finds again the motif of the Farnese Hercules in the project for an exhibition devoted to the history of the heavens sketched out by Warburg for the Hamburg planetarium. It was presented, posthumously, in 1930, using the tabular arrangements of *Mnemosyne*. Aby Warburg, *Bildersammlung zur Geschichte von Sternglaube und Sternkunde im Hamburger Planetarium*, ed. Uwe Fleckner, Robert Galitz, Claudia Naber, and Herwart Nöldeke (Hamburg: Dölling und Galitz, 1993), pp. 224–27.

13. Aby Warburg, "The Art of Portraiture and the Florentine Bourgeoisie," in *The Renewal of Pagan Antiquity*, trans. David Britt (Los Angeles: Getty Research Institute, 1999), pp. 185–221. See above, pp. 102–24.

14. Van Huisstede, "Mnemosyne-Atlas," p. 130.

15. See above, pp. 85ff.

16. Aby Warburg, "Texte de clôture du séminaire sur Jacob Burckhardt," trans. D. Meur, *Les Cahiers du Musée national d'art moderne* 68 (Summer 1999), p. 21–23.

17. On Marey's "dynamograph," see Philippe-Alain Michaud, "Etienne-Jules Marey et la question des mobiles," *Cinémathèque* 10 (Autumn 1996), pp. 104–16; and Georges Didi-Huberman, *L'Image survivante: Histoire de l'art et temps des fantômes selon Aby Warburg* (Paris: Minuit, 2000), pp. 117ff.

18. Hugo von Hofmannsthal, "Der Dichter und diese Zeit" (The poet and the present time), in *Brief des Lord Chandos* (Frankfurt: Insel, 2000), pp. 201–202. The lecture was given in Munich, Frankfurt, Göttingen, Berlin, and Vienna.

19. *Ibid.*, p. 184.

20. *Ibid.*, p. 196.

21. *Ibid.*, p. 201.

22. Forster, "Warburgs Versunkenheit," p. 190. The same phenomenon is found in the world of a comic of this period, *Krazy Kat* by George Herriman, whose action is situated in Hopiland, in the "enchanted mesa." See Philippe-Alain Michaud, "Krazy Katcina," *Les Cahiers du Musée national d'art moderne* 66 (Summer 1998), pp. 11–29.

23. See Gombrich, "Aby Warburg und der Evolutionismus des 19. Jahrhunderts," in Galitz and Reimers, *Aby M. Warburg: Portrait eines Gelehrten*, pp. 52–73, and his still fundamental biography, *Aby Warburg: An Intellectual Biography*.

24. Jean-Luc Godard, *Histoire(s) du cinéma* (Paris: Gallimard/Gaumont, 1999). This text is the "paper" version of the video series of the same name. The quotation is not found in the final version of *Histoire(s)*. As Jacques Aumont, *Amnésies: Fictions du cinéma d'après Jean-Luc Godard* (Paris: P.O.L., 1999), has aptly said, "To montage is to manipulate the images . . . in such a way as to draw out the virtual in them" (p. 18).

25. Jean-Luc Godard, *Histoire(s) du cinéma*, vol. 1, pp. 241–43.

26. *Ibid.*, vol. 4, p. 225.

27. Aby Warburg, "The Theatrical Costumes for the Intermedi of 1589," in *Renewal of Pagan Antiquity*, pp. 349–403. See above pp. 147–70

28. Warburg, "Theatrical Costumes for the Intermedi of 1589," p. 369.

29. In particular see Peter Burke, "History and Anthropology in 1900," in Cestelli Guidi and Mann, *Photographs at the Frontier*, p. 26.

30. See below, pp. 385 n.3. Mallery is also the author of an article published in *Popular Science Monthly*, Feb.–March 1891, "Israelite and Indian," which supports Steinberg's theory on Warburg's identification of the Jewish community of Hamburg with the Hopi Indians, but which the American editor of the lecture on the snake ritual, curiously, does not cite. Mallery also wrote a monumental study of Native American petroglyphs.

31. *Narrative of an Expedition to the Source of St. Peter's River, Lake Winnepeek, Lake of the Woods, etc.: Performed in the Year 1823, by Order of the Hon. J.C. Calhoun, Secretary of War, Under the Command of Stephen H. Long, Major U.S.T.E., Compiled from the Notes of Major Long, Messrs. Say, Keating, and Calhoun by William H. Keating* (Philadelphia, 1824).

32. Until 1880, see the bibliography in Garrick Mallery, *Sign Language Among North American Indians, Compared with That Among Other Peoples and Deaf-Mutes* (1881; The Hague: Mouton, 1972).

33. *Ibid.*, p. 271. Emphasis added.

34. *Ibid.*, p. 271. Emphasis added.

35. Warburg, *Images from the Region of the Pueblo Indians*, p. 7; see above, p. 240.

36. See above, p. 58.

37. Mallery, *Sign Language Among North American Indians*, pp. 289–90.

38. *Ibid.*, pp. 290–91.

39. Nicola Savarese, "Theatre in the Lightroom," cited in Eugenio Barba and Nicola Savarese, *A Dictionary of Theatre Anthropology: The Secret Art of the Performer*, trans. Richard Fowler (New York: Routledge, 1991), p. 110.

40. J.W. Goethe, "Laocoön," in *Artemis-Gedankausgabe zu Goethes 200. Geburtstag am 28. 1949*, eds. Ernst Beutler et al. (Zurich, 1961–66), vol. 13, pp. 161–74.

41. Antonin Artaud, *The Theatre and Its Double, Collected Works*, trans. Victor Corti (London: Calder and Boyars, 1974), vol. 4, p. 42.

42. *Ibid.*, p. 59.

43. Aby Warburg, "Grundlegende Bruchstücke zu einer pragmatischen Ausdruckskunde" (Ground-laying fragments for a pragmatic study of expression). I am indebted to Serge Trottein for calling my attention to this unpublished work, which will appear in German in *Gesammelte Schriften*, ed. Bernhard Buschendorf and Claudia Naber (Berlin: Akademie, forthcoming).

APPENDIX TWO: CROSSING THE FRONTIERS: MNEMOSYNE BETWEEN ART HISTORY AND CINEMA

This text first appeared in *Trafic* 43 (Spring 2003).

1. Aby Warburg, *Der Bilderatlas Mnemosyne*, eds. Martin Warnke and Claudia Brink (Berlin: Akademie, 2000).

2. Aby Warburg, "Peasants at Work in Burgundian Tapestries," in *The Renewal of Pagan Antiquity*, trans. David Britt (Los Angeles: Getty Research Institute, 1999), p. 319.

3. Siegfried Kracauer, *Mass Ornament*, ed. Thomas Y. Levin (Cambridge, MA: Harvard University Press, 1995).

4. Siegfried Kracauer, *Theory of Film: The Redemption of Physical Reality* (Princeton, NJ: Princeton University Press, 1997).

5. *Siegfried Kracauer — Erwin Panofsky Briefwechsel*, ed. Volker Breideker (Berlin: Akademie, 1996), pp. 52–53.

6. Erwin Panofsky, "Style and Medium in the Motion Pictures," in *Three Essays on Style*, ed. Irving Lavin (Cambridge, MA: MIT Press, 1995), pp. 91–126.

7. Kracauer, "Photography," in *Mass Ornament,* p. 51.

8. *Kracauer — Panofsky Briefwechsel*, pp. 54–55.

9. Kracauer, "Photography," p. 58.

10. Leon Battista Alberti, *On Painting*, trans. John Spencer (New Haven, CT: Yale University Press, 1956), p. 56.

11. *Kracauer — Panofsky Briefwechsel*, p. 23.

12. *Allgemeinen Ideen*, p. 20 in Ernst Gombrich, *Aby Warburg: An Intellectual Biography* (London: Phaidon, 1986), p. 248.

13. Sergei Eisenstein, *Selected Works*, vol. 1, trans. Richard Taylor (London: BFI, 1988), p. 78.

14. Bela Balazs, *L'Esprit du cinéma*, trans. J.-M. Palmier (Paris: Payot, 1977), pp. 164–65.

15. Annette Michelson, "The Wings of Hypothesis: On the Montage and the Theory of Interval, " in *Montage and Modern Life, 1919–1942*, ed. Matthew Teitelbaum (Cambridge, MA: MIT Press, 1992).

16. Pietro Montani in Sergei Eisenstein, *Il Montaggio* (Venice: Marsilio, 1992), p. 18, n.4.

17. Sergei Eisenstein, "Beyond the Shot," in *Selected Works*, vol. 1, trans. Richard Taylor (London: BFI, 1988), p. 138.

18. *Ibid.*, p. 139.

19. Lev Kuleshov, *The Art of Cinema* [1929] in *Kuleshov on Films: Writings of Lev Kuleshov* (Berkeley: University of California Press, 1974), p. 91.

20. "Beyond the Shot," p. 145.

21. Aby Warburg, *Le Rituel du serpent* (Paris: Macula, 2002).

22. Sergei Eisenstein, "Laocoön," in *Selected Works*, vol. 2, trans. Michael Glenny (London: BFI, 1988), p. 114,

23. *Ibid.*, p. 168. According to Orphic mythology, the young Dionysus was put to death by Titans covered with gypsum, who lured the child with toys (jointed dolls, rhombs, tops, knucklebones, a mirror), and took advantage of his distraction to strike, dismember, and boil him. His resurrection is associated with the cycles of nature and the seasons. Marcel Détienne, *Dictionnaire des mythologies*, vol. I, *Dionysius* (Paris: Flammarion, 1981), pp. 305–307; G.-B. Duchenne de Boulogne, *Mécanismes de la physionomie humaine* (Paris, 1862), pl. 7: Expressive movements of the eyebrow and forehead.

24. The eucharistic version of the same story is found in *Boireau bonhomme en pain d'epice* (1913), a film from Deed's French period, in which the actor, pursued by an enraged mob, hides in a baker's oven, from which he emerges as a gingerbread man which two little girls split before eating.

25. Philippe-Alain Michaud, "Krazy Katcina," *Cahiers du Musée national d'art moderne* 64 (Summer 1998), pp. 11–29.

26. Kurt W. Forster, "Warburgs Versunkenheit," in *Ekstatische Nymphe . . . trauernder Flussgott: Porträt eines Gelehrten*, eds. Robert Galitz and Brita Reitmers (Hamburg: Dölling and Galitz, 1995), pp. 184–206.

27. Benjamin Buchloh, "Gerhard Richter's Atlas: The Anomic Archive," in Benjamin H.D. Buchloh, Jean-François Chevrier, Armin Zweite, Rainer Rochlitz, *Photography and Painting in the Work of Gerhard Richter: Four Essays on Atlas* (Barcelona: Museu d'Art Contemporani de Barcelona, 2000), pp. 11–30.

28. In a reworking of documentary and fictive images taken from 9.5 mm copies (Pathé-Baby), *Karagöz* (1979–1981) attempts to uncover the latent Darwinian principles in the way in which the cinema of the 1910's and 1920's treats the adaptation of the figure to the representational space; *Du Pôle à l'Equateur* (1986), made from the archives of a 1910's Italian cameraman, Luca Comerio, outlines an analytic catalog of aggressive acts (hunting, predation, colonial oppression, and so on) which form a sort of cinematographic equivalent of Warburg's pathos formula. See Sergio Toffetti (ed.), *Yervant Gianikian, Angela Ricci-Lucchi* (Florence and Turin: Hopefulmonster/Museo Nazionale del Cinema, 1992).

29. See Michael Witt, "Montage, My Beautiful Care, or Histories of the Cinematograph," *The Cinema Alone, Essays on the Work of JLG* (1985–2000), eds. Michael Tempel and James S. Williams (Amsterdam: Amsterdam University Press, 2000, pp. 229–30, n.62.

30. "L'image," *Nord-Sud* (March 13, 1918), in Pierre Reverdy, *Nord-Sud, Self-Defence et autres écrits sur l'art et la poésie* (1917–1926) (Paris: Flammarion, 1975), pp. 73–75.

APPENDIX THREE: MEMORIES OF A JOURNEY THROUGH THE PUEBLO REGION

1. Ludwig Binswanger, no doubt. — ED.

2. This is probably a first list of the slides that Warburg was planning to project during his lecture. — ED.

3. There is an important and well-known work by Mallery on the sign language of the Indians.

(Warburg is referring to Garrick Mallery [1831–1894], whose work on the Indians' sign language may have influenced him in his study of *Pathosformeln*. See *Introduction to the Study of Sign Language Among the North American Indians, as Illustrating the Gesture Speech of Mankind* [Washington, DC: Government Printing-Office, 1880]. Mallery also wrote "Israelite and Indian," published in *Popular Science Monthly*, Feb.–March 1891, an article of which Warburg was certainly aware. — ED.)

4. See the book by Krause, *The Pueblo Indians*. (Fritz Krause, *Die Pueblo-Indianer: Eine historisch-ethnographische Studie* [Halle, 1907]. — ED.)

5. Max Slevogt (1868–1932) was a late German Impressionist. Warburg's interest in him can be related to his considerations on Manet. See Aby Warburg, "Il 'Déjeuner sur l'herbe' di Manet: La funzione prefigurante delle divinità pagane elementari per l'evoluzione del sentimento moderno della natura" (1929), *Aut aut* 199–200 (1984), pp. 40–45. — ED.

6. The Leatherstocking Tales are a series of five novels by James Fenimore Cooper (including *The Last of the Mohicans*) published between 1823 and 1841. — ED.

7. Tito Vignoli, *Mito e scienza* (Milan, 1879). For Vignoli's influence on Warburg's thought, see Ernst Gombrich, *Aby Warburg: An Intellectual Biography*

(London: Warburg Institute, 1970), pp. 68ff. As Gombrich points out (p. 71), Warburg was fascinated by the role Vignoli assigned to fear in the process of forming representations. — ED.

8. The Bafiote are inhabitants of the Senegal basin, living along the Bafing River? — ED.

9. "Harmonikal": a form peculiar to Warburg. — FRENCH TRANS.

10. In *Sartor Resartus* by Thomas Carlyle (1795–1881), one of Warburg's favorite books, Professor Teufelsdröckh elaborates a philosophy of clothing. We may recall Warburg's pronounced taste for disguises, which is manifest in the anecdote about the Neapolitan beggar (see above, p. 359 n.9, note [1]), in the photograph taken in New Mexico showing the art historian wearing a kachina mask (see above, fig. 62), and in the handwritten notes addressed to his tailor and his boot maker, kept in London, in which Warburg describes in great detail the kinds of clothes he wanted to wear. These notes clearly resonate with the analysis of the notebooks of Girolamo Serjacopi, the administrator of the 1589 Intermedi (see above, pp. 166–67). — ED.

11. This passage recalls a project Warburg formulated in 1902: to reconstruct, to the point of producing effects of presence, the personalities of the models appearing in Quattrocento painting, based on an intersection of archives and visual works in which, he says, the voice and appearance of the deceased are set down (see above, p. 96). — ED.

12. Ewald Hering, *Über das Gedächtnis als eine allgemeine Funktion der organisierten Materie* (1870; Leipzig, 1921). In this text, Hering describes heredity and memory as two different forms of one function of identity. — ED.

13. Henry R. Voth, *The Oraibi Powamu Ceremony* (Chicago, 1901). See above, ch. 5, n. 21. — ED.

14. Robert Vischer (1847–1933) was one of the first to propose a theory of empathy, which he developed in the thesis he defended at the University of Tübingen in 1872: *Über das optische Formgefühl* (Stuttgart, 1873). — ED.

15. In the manuscript, there is no section marked "1" preceding sections 2 and 3. — ED.

16. Here begins a cosmogonic myth involving Ti-yo, the "snake hero," a story

that Warburg included as an appendix to his notes and that was probably taken from Jesse Walter Fewkes, "The Snake Ceremonials at Walpi," *Journal of American Ethnology and Archaeology* (Boston and New York, 1894), pp. 106–24. — ED.

17. Pahos (or Bahos) are prayer rods. — ED.

18. A pon-ya is an altar consisting of a mound of sand on which is placed an ear of sacred corn (the tiiponi or ti-po-ni). It is often associated with sand painting. See Armin W. Geertz, *Hopi Indian Altar Iconography* (Leiden: Brill, 1987), p. 17. — ED.

APPENDIX FOUR: ON PLANNED AMERICAN VISIT (1927)
This is an unpublished text, of five typewritten pages, kept in Warburg's personal archive (catalog number 93.8). We know that while he was working on *Mnemosyne*, he had begun to plan another trip to America, a plan that Binswanger convinced him to abandon. See above, p. 246.

1. Julius Sachs (1849–1934) studied in Germany, then went to the United States, where he specialized in questions of education and published a series of articles on ancient Greek literature. — ED.

2. On Franz Boas, see above, pp. 179–80.

3. Brother of Julius Sachs, Paul Sachs was the director of the Fogg Museum in Boston at the time. The American Warburgs (especially Felix, Aby's younger brother) provided significant financial support to the museum. — ED.

4. Adolph Goldschmidt (1863–1944), one of the leading experts on medieval art history in Germany during the first half of the twentieth century, gave a lecture in 1921 at the Warburg Library on the afterlife of ancient forms in the art of the Middle Ages: "Das Nachleben der antiken Formen im Mittelalter," *Vorträge der Bibliothek Warburg* 1 (1921–1922), pp. 40–50. — ED.

5. Warburg, "Italienische Antike im zeitalter Rembrandt," still unpublished, dates from 1926. See the bibliography in *Ausgewählte Schriften und Würdigungen*, ed. Dieter Wuttke (Baden-Baden: Valentin Koerner, 1985), p. 592, no. 97; and Ernst Gombrich, *Aby Warburg: An Intellectual Biography* (London: Warburg Institute, 1970), p. 345. — ED.

Index

Designed by Bruce Mau with Sarah Dorkenwald and Julie Fry
Typeset by Archetype
Printed and bound by Maple-Vail